MICHELANGELO

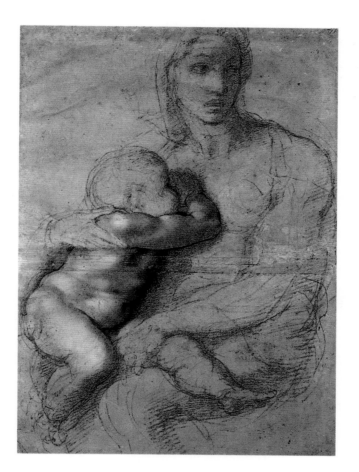

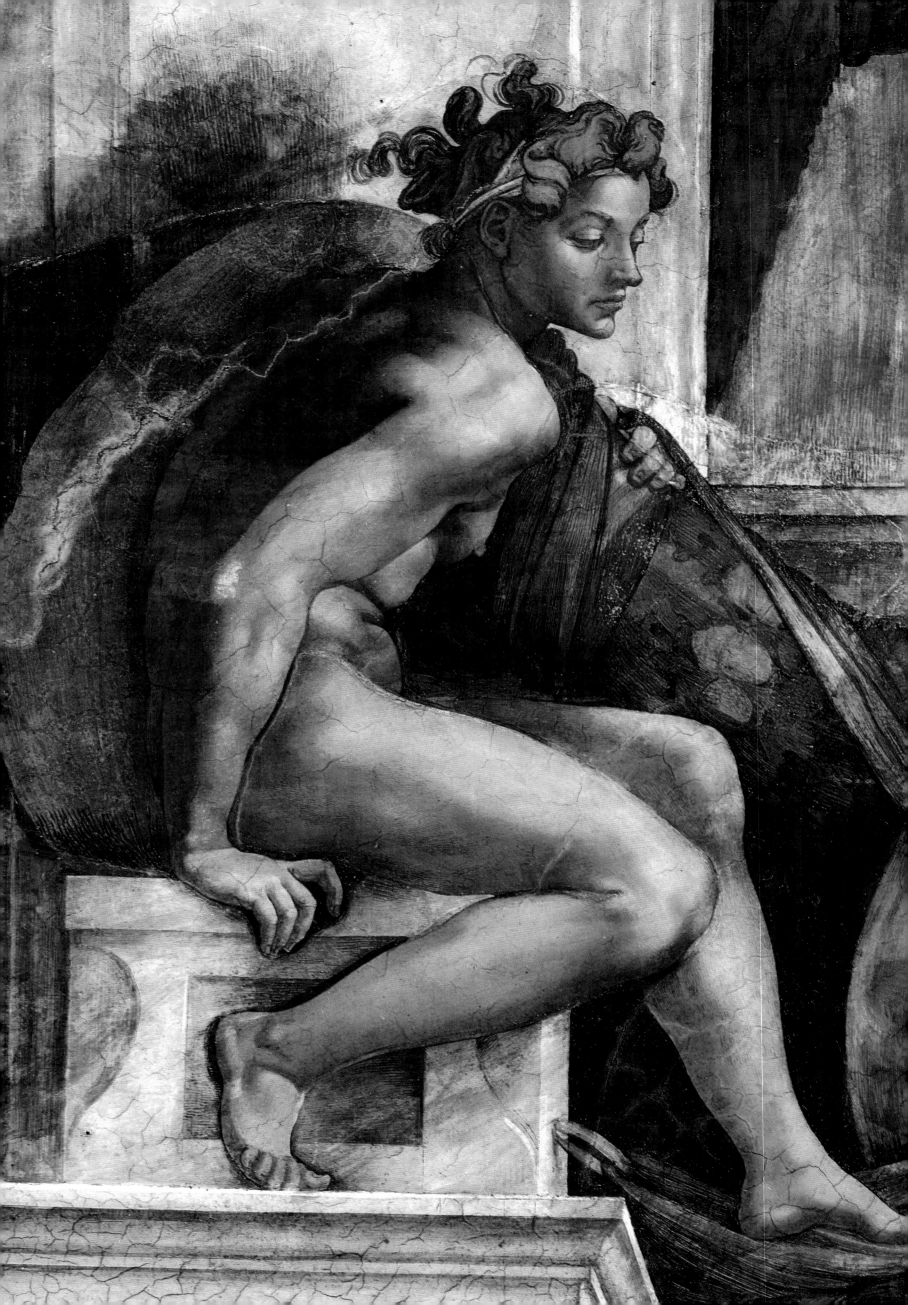

MICHELANGELO

Lucinda Hawkins Collinge
& Annabel Ricketts

MALLARD PRESS

An Imprint of
BDD Promotional Book Company, Inc.
666 Fifth Avenue
New York, N.Y. 10103

Copyright © 1991 by Brompton Books Corporation

First published in the United States of America in 1991
by The Mallard Press
Mallard Press and its accompanying design and logo are
trademarks of BDD Promotional Book Company, Inc.

ISBN 0-7924-5208-9

Printed in Hong Kong

FOR B.A.M. WITH LOVE

Page 1: Drawing for the Doni Madonna.

Page 2: *Ignudo* to the left above Joel, detail of
the Sistine Chapel ceiling.

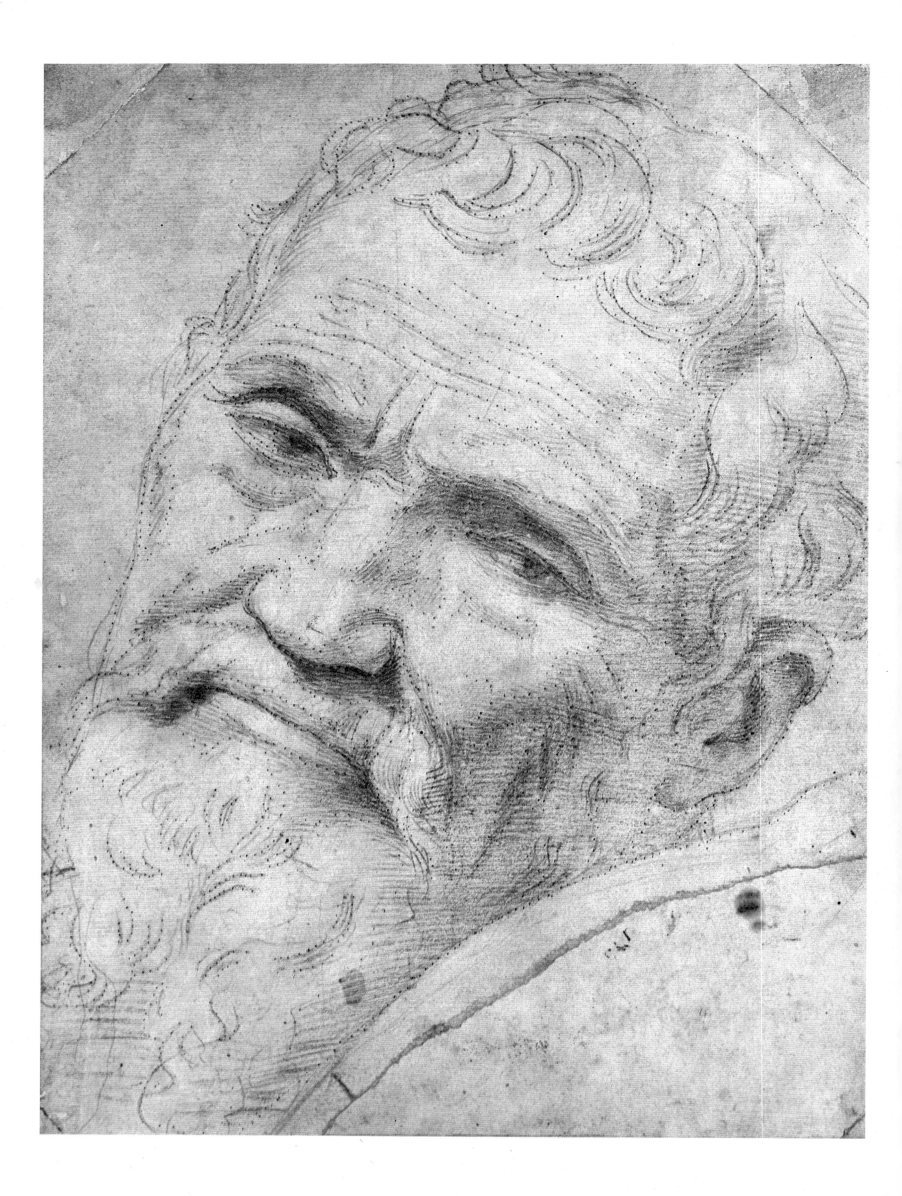

Painting and Sculpture: Early Works

MICHELANGELO's origins and training were unusual for an artist of his time, and these factors proved significant both for his own development and for the future of the profession as a whole. In the first place it was unusual for an artist to come from an aristocratic family, even an impoverished one such as the Buonarroti. Although the social status of visual artists rose during the fifteenth century, in Michelangelo's youth in the 1480s making art was still regarded as manual work, and thus not a suitable occupation for a gentleman. Indeed, Michelangelo's father Lodovico Buonarroti considered work of almost every sort beneath his station and seldom did any. Secondly, because of his family's social position Michelangelo had more formal education than his artist contemporaries, most of whom began workshop apprenticeships at the age of eight or nine. As the Buonarroti family strongly disapproved of Michelangelo's interest in art, they insisted he remain at school until he was about 14. He received further academic tuition during his years in the Medici household, a position he may have owed to his family background as well as to his talent.

Michelangelo's natural intelligence and seriousness, strengthened by this privileged education, gave his art an intellectual rigor which set new standards for the profession. Although he defied family opposition to become an artist, he remained sensitive to class conventions and was later to devote considerable effort to securing his family's social position as well as to improving the status of artists. Both efforts were notably successful. Ironically, the fortunes and reputation of the Buonarroti family were restored by the art they so despised; while by the mid-sixteenth century, aided by the remarkable achievements of Michelangelo, the visual arts were accepted as an intellectual rather than simply a manual occupation and one which, like poetry, was worthy to be practised by a nobleman.

Family and First Years

The Buonarroti Simoni were an old Florentine family, mainly traders and moneychangers, whose rise was linked with that of the Guelphs, a group of merchants who took over the government of Florence in the thirteenth century and endeavored to maintain her as an independent republic. Michelangelo's adherence to the family tradition of republicanism was to complicate relations with his major patrons, the Medici, who were its principal opponents. In the fifteenth century the Buonarroti fortunes declined. Most of their wealth was lost by Michelangelo's grandfather, and his father, too proud to seek work, barely supported the family on his small inheritance. It was not until the birth of his first child that Lodovico essayed employment, a brief appointment as *podesta*, or mayor, of Caprese, a small town near Arezzo. There a second son, baptized Michelagnolo di Lodovico Buonarroti Simoni, was born on 6 March 1475.

A few weeks after Michelangelo's birth the family returned to live in Florence, near the church of Sta Croce in a house they shared with Lodovico's mother and his married brother. The infant Michelangelo was dispatched to a wetnurse, at a small family farm at Settignano on the outskirts of the city. The use of a wetnurse was not peculiar to the Buonarroti but was then common practice in urban middle-class families in Italy. After baptism, the newborn was delivered to the nurse, who was usually a peasant woman living outside the town. Distance meant that the baby was unlikely to have regular contact with its own family during its stay with the nurse. Often a wetnurse had lost her own baby or had other small children to mind, or both, and would give the newcomer less than wholehearted attention. The nurse usually kept the child until it was weaned, that is for up to two years. The child would then be removed from this surrogate mother and returned to its own, unfamiliar, family. However common the practice, the effect of separation from its mother and then from its wetnurse must have been extremely distressing for the child. We do not know how long Michelangelo remained with his nurse, but it is interesting that she is given greater prominence in his recorded reminiscences than his own mother. His wetnurse was from a family of stonemasons and Michelangelo was fond of claiming that his passion for carving came from her milk, as the Italian painter Ascanio Condivi relates in his *Life of Michelangelo* published in 1553:

The wetnurse was the daughter of a stonemason and was also married to a stonemason. For this reason Michelangelo is wont to say, perhaps facetiously or perhaps even in earnest, that it is no wonder that the chisel has given him so much gratification, for it is known that the nurse's milk is so powerful in us that often, by altering the

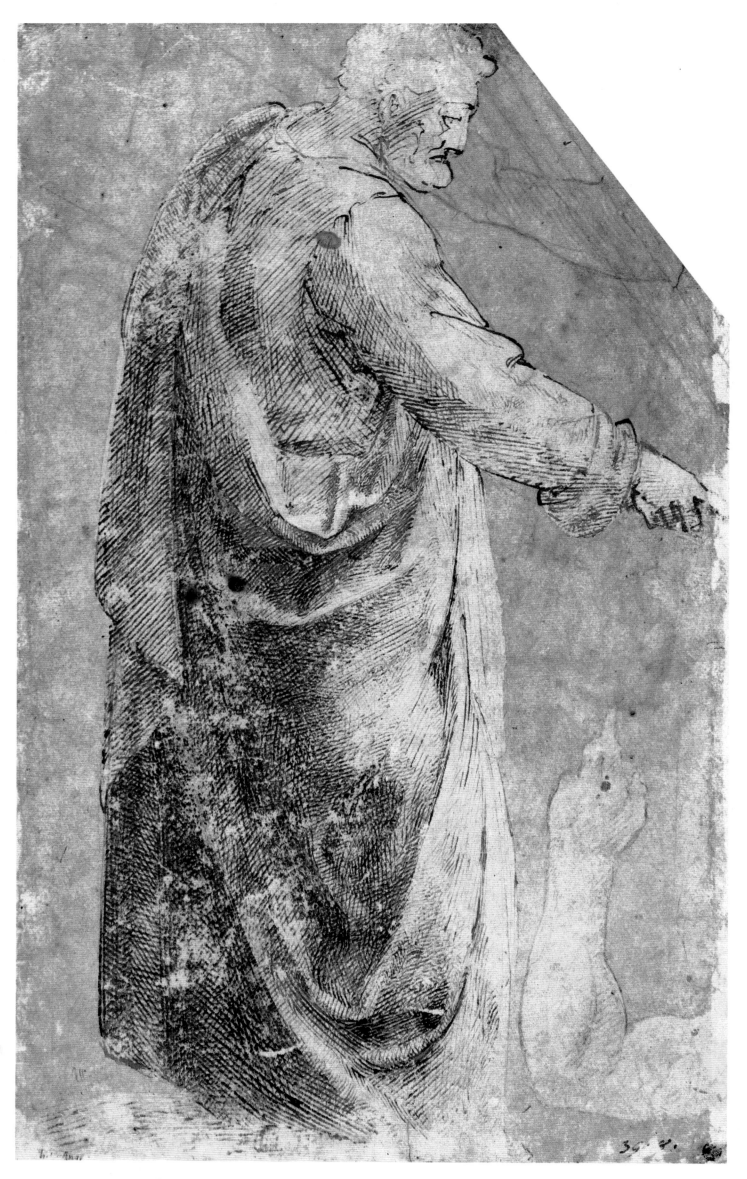

LEFT: Drawing of *St Peter*, c. 1490, pen and red chalk, 12 × 7 inches (31 × 18.5 cm), Staatliche Graphische Sammlung, Munich. One of Michelangelo's earliest surviving drawings, made when he was about fourteen, this figure copied from Masaccio's fresco of *The Tribute Money* in the Brancacci Chapel shows his precocious skill as a draftsman.

BELOW: Domenico Ghirlandaio, *The Birth of the Virgin*, 1485-90, fresco, Tornabuoni Chapel, Sta Maria Novella, Florence. Part of the fresco series Ghirlandaio was painting during the period of Michelangelo's apprenticeship in his workshop. Ghirlandaio's interest in setting and decorative detail was not taken up by his famous pupil.

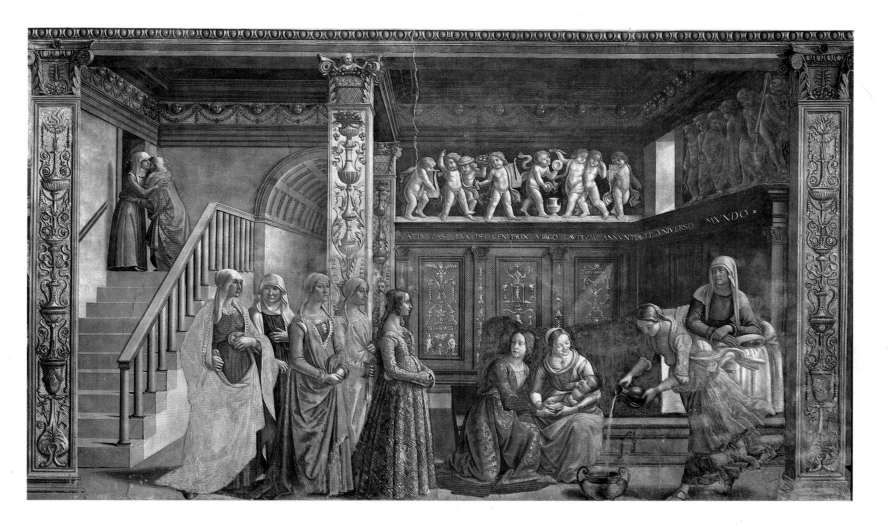

temperature of the body which has one propensity, it may introduce another, quite different from the natural one.

The notion that the milk of a wetnurse had magical properties was a popular superstition, but Michelangelo's reference to it can be linked to another aspect of his personal mythology, the idea that his destiny had been shaped by some force other than his parents, both of whom caused him grief. We know about Michelangelo's difficulties with his father from written reminiscences and from the many letters they exchanged. About his mother almost nothing is known apart from her name, Francesca di Neri di Miniato del Sera. We know that after Michelangelo's birth she produced three more sons in quick succession, which gave her little time for the second-born before she died, when he was six. The fact that only one of his numerous surviving letters mentions her does not suggest that they were close, and although his father remarried, there is no evidence that Michelangelo was attached to his stepmother either. What we do know about Michelangelo's childhood suggests that he did not have a strong, sustaining relationship with his own mother or with a substitute. We can only speculate about the effect of this lack, but it may well have bearing on the fact that Michelangelo and three of his brothers never married, and that with a single exception his intimates were exclusively male. There are also reverberations in Michelangelo's art, in which the Madonna and Child is a recurrent theme. It is the subject of his earliest and last works, and there is a peculiar poignancy about his treatment which is expressive of something personal as well as universal.

In addition to the loss of his mother, Michelangelo experienced great conflict with his father and family over his interest in art. There were no artists or scholars among Buonarroti ancestors and the family were anxious that Michelangelo should not jeopardize their already somewhat precarious social status by taking up what they viewed as only manual work. Lodovico, determined that Michelangelo

LEFT: Masaccio, *The Tribute Money* (detail of St Peter), 1425/6, fresco, Brancacci Chapel, Sta Maria del Carmine, Florence. Masaccio's austere sculptural style, with its echoes of Giotto, influenced Michelangelo and a number of his contemporaries, who used the Brancacci Chapel frescoes as an informal art school.

RIGHT: Domenico Ghirlandaio, *Girl Pouring Water*, c. 1487, pen and ink on paper, 8½ × 6 inches (21.9 × 15.8 cm), Uffizi, Florence. A study for the figure at the far right in *The Birth of the Virgin* showing Ghirlandaio's use of cross-hatched lines for modelling, which was boldly adapted by Michelangelo and became characteristic of his drawing style.

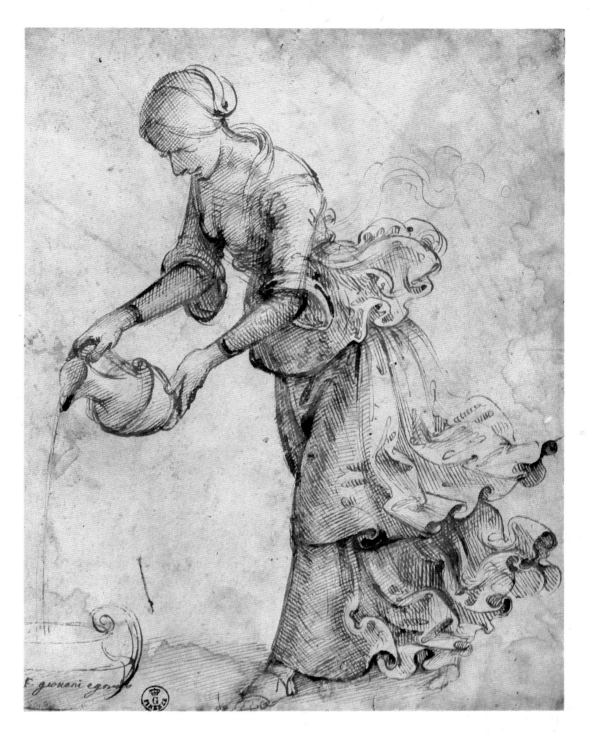

should be educated in letters, sent him to the grammar school of the humanist scholar Francesco da Urbino in Florence when he was about ten. Michelangelo was said to have been a poor student, preferring drawing to lessons, but this is a traditional story, a *topos*, told about earlier artists and it is belied by the evidence. He wrote well, in a fine hand, was an accomplished poet and, unusually for an artist, he knew Latin. Although Michelangelo often complained that he could not express himself adequately in words, 'the pen cannot even approach one's intent', he said similar things about sculpture, of which he was an undisputed master. In any case, after several years Michelangelo abandoned his grammar studies because, Condivi relates: 'nature and the heavens . . . were drawing him toward painting' and for this reason he was 'often beaten unreasonably by his father and his father's brothers who, being impervious to the excellence and nobility of art, detested it and felt its appearance in their family was a disgrace'. Michelangelo's determination to become an artist survived even these unreasonable beatings and he was at last permitted to begin training for the profession of his choice. It is in accounts of his artistic training that the myth of Michelangelo begins.

Biography and Myth

In stories of Michelangelo's life it is often difficult to disentangle the man from the myth. His fame was so great that the first account of his life, a brief one in Latin by Paolo Giovio, was published in 1527. Aside from his own writings, our main sources of information about him are the biographies by Giorgio Vasari (1511-74) and Ascanio Condivi (d.1574). Both writers knew Michelangelo and their accounts of his accomplishments are heavily hagio-graphical. Vasari was a painter and architect from Arezzo whose collection of artists' biographies, first published in 1550 and expanded in 1568, is a foundation text of modern art history. Vasari's *Lives of the Most Excellent Painters, Sculptors and Architects* was written to raise the status of the visual arts and also to demonstrate the superiority of the Central Italian tradition, of which he considered Michelangelo the apogee. Michelangelo was virtually the only living artist included in the first edition of Vasari's *Lives*, but this honor did not inhibit him from objecting to what he considered inaccuracies in the text and inducing Condivi to produce a rival biography, in 1553. Condivi was Michelangelo's assistant and his book is not so much an authorized biography as a disguised autobiography of this artist derived, as he put it 'from the living oracle'. It opens with a lengthy account of the noble lineage of the Buonarroti family traced back, somewhat optimistically, to the fourteenth century saint, Matilde, Countess of Canossa. The family's objection to Michelangelo's artistic inclination is stressed, as well as the mysterious forces compelling him to become an artist. Michelangelo, in attributing his artistic tendencies to his wetnurse, or to nature and the heavens, is implying the intervention in his destiny of a higher power, of divine inspiration. Many admirers agreed and the appellation the 'divine Michelangelo' was already used in his lifetime.

Artistic Training

Michelangelo was an old man when these accounts of his life were written and fading memory may have caused some discrepancies. Others, however, were deliberate attempts to tailor the facts to the myth. The Condivi/Michelangelo version differs most significantly

RIGHT: *The Madonna of the Steps*, c. 1491, marble relief, 21½ × 15½ inches (55.5 × 40 cm), Casa Buonarroti, Florence. One of Michelangelo's first sculptures, made during his years in the Medici household, this relief has a monumental quality which belies its small size. Like so many of his later works, it was left unfinished.

nificantly from Vasari on the question of Michelangelo's artistic training. During his time as a grammar student Michelangelo became friendly with Francesco Granacci, a slightly older boy who was a pupil of Domenico Ghirlandaio (c.1449-94), then the leading painter of Florence. Granacci encouraged his interest in art, taking him to the workshop and bringing him drawings to copy. Michelangelo's persistence finally overcame family objections and, according to Vasari, in 1488 he was apprenticed to Ghirlandaio. In later life Michelangelo liked to give the impression that his divine gift was never subject to a mortal master; this notion of the artist who had no teacher is another *topos*, first told by the elder Pliny about the sculptor Lysippus. Thus in Condivi's account there is no mention of the apprenticeship and Michelangelo complains that Ghirlandaio was jealous of his skill and 'gave him no help whatever'. Vasari, however, produced a contract signed by Lodovico which stated that Michelangelo would be apprenticed to Ghirlandaio for a period of three years and that he was to be paid. The mention of payment, and the fact that at 13 Michelangelo was older than the usual novice apprentice, suggests that his talent was clearly evident and that he had already acquired some skill.

Although Michelangelo served only about a year of his apprenticeship with Ghirlandaio, he seems to have profited from it both technically and stylistically. Ghirlandaio had just been commissioned by the Florentine banking family, the Tornabuoni, to paint the high altar chapel in Sta Maria Novella. It has been suggested that Michelangelo's hand can be detected in certain figures of these frescoes, though Condivi does not mention it and Vasari reports only that his drawing of the scaffolding was praised by his master. However, it was certainly during this time that Michelangelo learnt the technique of fresco painting, which he was to use to such advantage on the ceiling of the Sistine Chapel. Ghirlandaio was also a notable draftsman and collector of drawings. His novel use of crosshatched lines to define forms was taken up by Michelangelo in an even bolder style, as seen in his early copies of figures by Giotto and Masaccio. This preference for modelling with crosshatching rather than calligraphic line indicates a sculptor's sensibility to the depiction of volume. This is also clear from the artists whose work he chose to copy. The solid, elemental forms of Giotto's frescoes in Sta Croce, and Masaccio's massive figures in the Brancacci Chapel, were clearly more sympathetic to Michelangelo than Ghirlandaio's somewhat decorative, descriptive style. Michelangelo's irreverent attitude to his teachers, and his confidence in his own ability, can be seen in the 'corrections' he made to copies of drawings thought to be after some by Ghirlandaio. Such high-handedness was not always appreciated by his fellow artists, as we shall see.

During this time Michelangelo began to make a reputation as an expert copyist. He copied works by various artists, sometimes ageing his drawings with smoke so that he could exchange them for the originals. Vasari reports that Michelangelo was not content merely to equal the original drawings, but 'sought to surpass' them. This is an early indication of Michelangelo's unusual determination to extend the possibilities of a medium, rather than being content to accept standards set in the past. Like other Italian artists in this period, he was intrigued by prints from northern Europe. Vasari mentions that his drawing of an engraving of the *Temptation of St Anthony* by 'Martin the German' (Martin Schongauer 1430-91, German painter and engraver) was much admired. He adds that Michelangelo's preparations for the drawing included buying exotic fish to use as models for the devils, evidence that he drew from nature as well as from the conventional copybooks. In the fifteenth century and earlier, imitation of the work of other artists was not the suspect activity it seems today, when there is such a premium on originality. Copying drawings and drawing sculpture, rather than working from nature, was the usual method for an apprentice to learn his craft. The workshop 'textbooks' were bound volumes of drawings which apprentices copied and used for reference. The contents of these workshop books reflect the changes in the artistic interests and practices of succeeding generations. The patternbook of the medieval workshop was essentially an archive, an assemblage of subjects and motifs designed to be copied exactly in paintings. In fourteenth-century studio modelbooks there was particular concentration on detailed drawings of natural forms, mainly animals and birds taken from other works of art, and only occasionally from life. Gradually the emphasis of the books shifted from accurate copying to a looser, livelier form of drawing more like the modern sketchbook, although the tradition of copying works of art continued in the fifteenth century. A volume of drawings, the *Codex Escurialensis*, used by the Ghirlandaio workshop and now in Madrid, shows the survival of this tradition as well as the contemporary interest in antique art; it is entirely composed of motifs from classical antiquity. An interest in antique art was one of the most important results of Michelangelo's apprenticeship with Ghirlandaio; it was an interest that was considerably strengthened during the next stage of his artistic education, in the Medici garden.

The Medici family had consolidated their power in Florence some 40 years

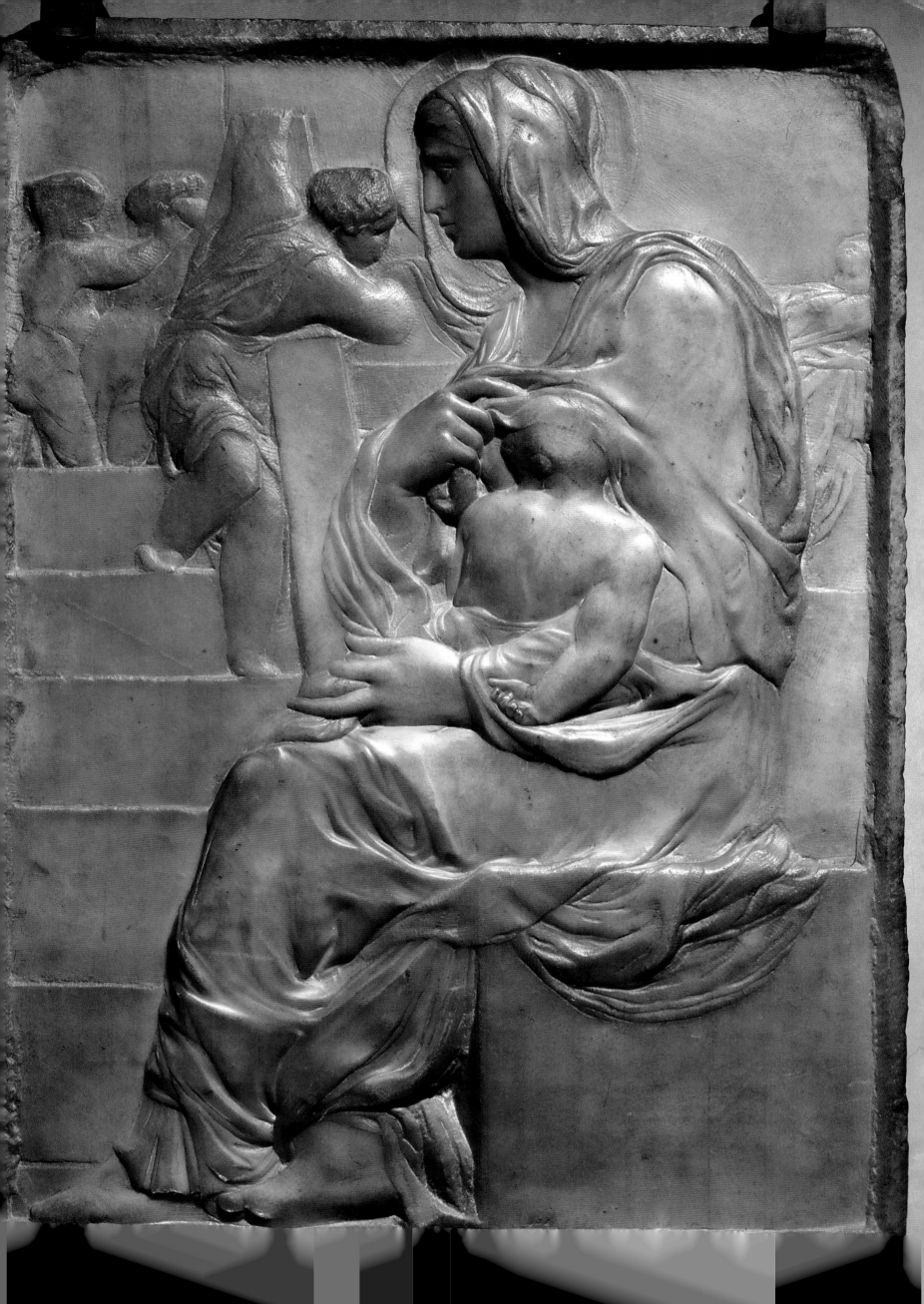

before Michelangelo's birth, in 1434, with the return from exile of Cosimo de' Medici, who came to be known as the *Pater Patriae*. Cosimo, following family custom, was not an overtly political leader and did not hold public office. Florence was governed officially by an oligarchy, but Cosimo controled the city financially, using the Medici bank to tax his opponents into submission. Promoting a policy of peaceful expansion for Florence, he devoted considerable attention and immense riches to the patronage of literature and art. Like most patrons of the time he concentrated on religious works, employing masters including Filippo Brunelleschi (1377-1446) and Donatello (1386-1466) in the building and embellishing of churches for the glory of God and in the hope of saving his own soul. Cosimo also founded an academy for the study of Platonic philosophy and assembled a collection of manuscripts, oriental as well as classical, which later formed the basis of the Laurentian Library.

Medici domination of Florence became overt in the next generation and in Michelangelo's youth the city was headed by Cosimo's grandson Lorenzo, whose even more lavish patronage earned him the soubriquet the Magnificent. In keeping with the new spirit of the times, Lorenzo's patronage had a more secular emphasis than that of his grandfather; he made important additions to the family library, notably 200 manuscripts from the monastery at Mount Athos in Greece, and the academy he founded and his advocacy of the printing press aided the dissemination of classical literature thoughout Europe. As an art patron, Lorenzo played an influential role in the artistic renaissance in Florence. Although her libraries made Florence a center for the revival of interest in the literature of the ancient world, unlike Rome she had few antique buildings or works of art to

stimulate a similar revival in the visual arts. Lorenzo determined to provide Florentine artists, particularly sculptors, with antique exemplars. He assembled a collection of antique statues and gems in a house and garden near the monastery of San Marco where promising artists were permitted to work and study. Vasari's description of the Medici garden as a formal school, effectively an art academy, is no longer credited but the collection was a vital influence in the development of Florentine artists, including the young Michelangelo.

Vasari and Condivi give conflicting accounts of how Michelangelo came to the attention of Lorenzo de' Medici. Condivi again makes no mention of the role of Ghirlandaio, but says it was his friend Granacci who brought Michelangelo to the garden. According to Vasari, however, it was Ghirlandaio who recommended both Granacci and Michelangelo to Lorenzo when asked if he had any apprentices who showed an aptitude for sculpture. In any event, after roughly a year in the Ghirlandaio workshop, Michelangelo, who was then about 14, left to work in the Medici sculpture 'school'. There he and Granacci joined other promising pupils including Giovanni Franceso Rustici, who later worked for Michelangelo's rival Leonardo and then for Francis I at Fountainebleau; Baccio da Montelupo, the father of Michelangelo's assistant Raffaelo; and Pietro Torrigiano, who visited England to make the lavish gilt bronze tomb of Henry VII in Westminster Abbey. Today Torrigiano is perhaps best known as the man who broke Michelangelo's nose, an episode he recounted with pride to Benvenuto Cellini. This affected Michelangelo's productivity and limited the number and scale of works he could complete and thus contributed to the *non finito*, that is the large number of works he left incomplete. Torrigiani told Cellini how

he and Michelangelo used to study Masaccio's frescoes in Sta Maria del Carmine together, but that:

Buonarroti had the habit of making fun of anyone else who was drawing there, and one day he provoked me so much that I lost my temper more than usual, and, clenching my fist, gave him such a punch on the nose that I felt the bone and cartilage crush like a biscuit. So that fellow will carry my signature till he dies.

As indeed he did. Although Cellini was outraged by Torrigiani's action, his account shows that already as a young man Michelangelo had the abrasive manner and critical intolerance which made it difficult for him to work with other artists as either assistants or collaborators. This character trait had important ramifications in his art. Without such assistance, the scale and quantity of works Michelangelo could produce was curtailed and an unusually large number was left unfinished. And as he did not pass on his methods and ideas directly in a workshop or school, his influence on other artists was delayed and diluted.

The young artists working in the Medici garden were supervised by Bertoldo di Giovanni (c. 1420-91), a second master whose influence Michelangelo was later to discount. The aged Bertoldo, who had been a pupil of the great fifteenth-century sculptor Donatello, worked in bronze, a technique in which the work is first modeled in clay. Michelangelo later disdained mere modellers and claimed that true sculpture was carving in stone, although he himself began as a modeller; Vasari reports that the first works he made in the garden were clay figures designed to rival some by the jealous Torrigiani. The success of these encouraged Michelangelo to attempt carving. Condivi relates that he begged a piece of marble from masons working on the Medici library and used it to make a

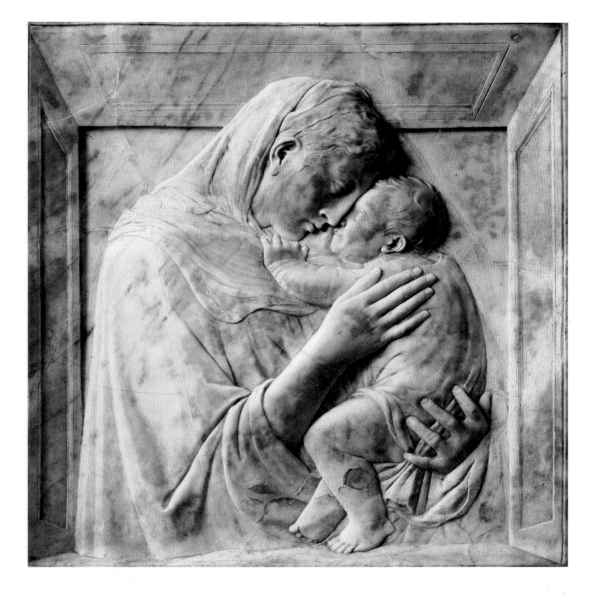

RIGHT: Donatello, *Pazzi Madonna*, c. 1430, marble, Staatliche Museen, Berlin. The figure style and the low-relief technique of Michelangelo's Madonna derive from works by the great fifteenth-century Florentine sculptor Donatello.

copy of one of the sculptures in the garden, an antique faun's head. The precocious skill shown by Michelangelo's copy was noted by Lorenzo de' Medici, who then teasingly suggested to the boy that the faun was too old to have all his teeth. On his next visit to the garden Lorenzo was amused to discover that Michelangelo had taken his advice seriously and had drilled away one of the faun's teeth. Impressed both by his talent and his keenness, Lorenzo sent for Michelangelo's father and asked permission to move the boy into the palace and bring him up with his own sons, an offer Lodovico did not refuse. Lorenzo also arranged for Lodovico to work as a clerk in the Customs Office, a position he held for four years until the Medici lost power. (This was the only time he had a steady job; afterwards he worked only sporadically, and for the last thirty years of his life he was supported almost entirely by Michelangelo and the art he had disdained). Thus for the next few years Michelangelo lived and was educated in a princely household which was also at the center of Florentine artistic and intellectual life.

His period in the Medici Palace was crucial in determining the course of Michelangelo's development, artistic, intellectual and spiritual. Life in Lorenzo's court was rich in every sense and the experience clearly set Michelangelo apart from his peers. While his contemporaries continued to labor as apprentices, Michelangelo was free to work as he chose, to study at leisure the Medici collections of antique coins and jewels as well as the sculpture garden, and to learn from the family's many distinguished visitors. It was here that he began to explore classical themes in his art, and here that he encountered the ideas of the Neoplatonists which influenced his life and work. In addition to Bertoldo, the household included the humanist poet Agnolo Poliziano,

who was tutor to the Medici children. Although Poliziano's ideas were more influenced by Aristotle than by Plato, leading Neoplatonists and humanists were frequent visitors to the Medici court. These included the specialist in Dante and Virgil, Cristoforo Landino; the brilliant, eclectic scholar and philosopher Pico della Mirandola, who sought to draw together Platonic and Christian thought; and the central figure of the Neoplatonist circle, the philosopher Marsilio Ficino, who was the first translator of Plato from Greek into a European language and who, like Pico, attempted to syncretize Christian belief and the ideas of the Platonists. The Neoplatonists saw intellectual discipline, both sacred and secular, as the key to man's redemption from original sin. Through learning man's soul could be raised from the base, material world to a higher, immaterial one closer to God. The earth was regarded as a prison for the soul and worldly things as inherently inferior. Ficino asserted the superiority of Platonic love over mere sensual love which impeded the soul's progress. Art, too, was a necessarily imperfect imitation of God's vision, though beauty and light were seen as reflections of divinity. The Neoplatonist ideas absorbed by Michelangelo during

his stay with the Medici remained central to his art, particularly his poetry, until late in his life. The atmosphere at Lorenzo's court was a heady mixture for an adolescent artist, stimulating and hedonistic. Ficino entertained with his lyre; Lorenzo himself acted in pageants, wrote poetry and dabbled with architecture. These men remained devout Christians but their humanist beliefs conveyed an exhilarating sense of new possibilities for man, a theme for which Michelangelo was to find dramatic visual expression.

Another important effect of Michelangelo's years with the Medici was on his attitude to patrons. In the fifteenth century, the contents and appearance of a work of art were still largely determined by the patron. The artist was seen simply as a craftsman, who was given detailed specifications and expected to execute them exactly. The contract might even stipulate that the artist must add nothing of his own invention. The name of the artist often went unrecorded as it was the patron who was seen as the creator of the work of art. The artist/patron relationship reflected the difference in their social status and also the values instilled in the artist by his workshop training, with its emphasis on copying the style

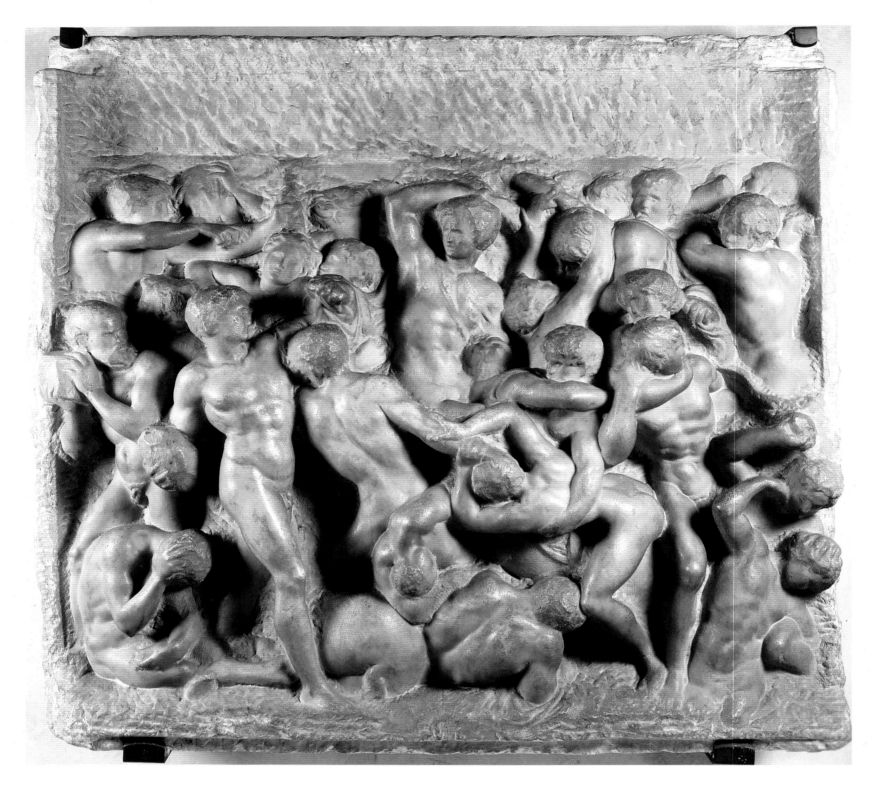

of the master rather than on originality. Michelangelo, as we have seen, was from a family of some social pretension. He had more formal education than most artists of his generation and had spent little time working under a master. During his years with Lorenzo de' Medici he became a familiar of distinguished scholars and educated patrons, who treated art as an intellectual discipline and encouraged him to do the same. His Medici 'brothers' included two future popes: Giovanni, who became Leo X, and Giulio, who was to be Clement VII. This unusual background had a number of effects: it meant that Michelangelo was used to dealing with ideas and to treating art as an intellectual activity; it gave him the chance to approach each piece in his own way, without a style or technique imposed by a master; it also gave him

the confidence to defend his ideas even to the most powerful patrons. This insistence on originality and independence, coupled with his extraordinary vision and skill, made Michelangelo the first artist from whom clients, even kings, were prepared to accept any work by his hand, without specification of materials, size or subject. By his example the view of the artist as a humble craftsman began to give way to one of the individual creative genius, working on his own terms.

Early Florentine Works

Two works are generally agreed to date from the period of Michelangelo's stay in the Medici Palace, when he was about 16. Both the *Madonna of the Steps* (page 13) and the *Battle of the Centaurs* are reliefs carved in marble but they

show the young Michelangelo experimenting with different techniques. The smaller of the two, and perhaps the earlier, the *Madonna of the Steps*, is in the extremely shallow form of relief (*rilievo schiacciato*, literally 'squashed relief') perfected by Donatello. Bertoldo's master was an obvious model for Michelangelo to challenge and the *Madonna of the Steps* recalls both Donatello's *Pazzi Madonna* and the *Madonna and Child* now in Boston. The background motif of a staircase with a figure leaning over it also echoes another Donatello relief, the *Feast of Herod* now in Lille. The resemblance of Michelangelo's work to the Boston *Madonna* and the *Feast of Herod* lends weight to the suggestion that these may be identified as the two Donatello reliefs mentioned in the inventory of Lorenzo's collection made after his death.

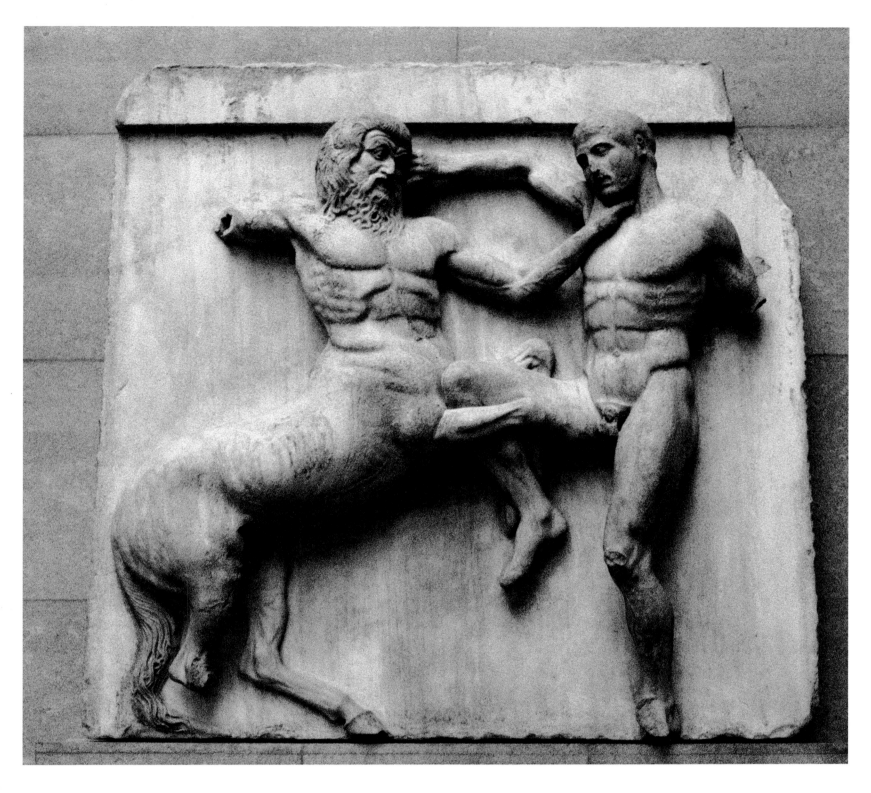

ABOVE LEFT: *Battle of the Centaurs*, 1491-92, marble relief, 33 × 35½ inches (84.5 × 90.5 cm), Casa Buonarroti, Florence. A second very early work, its antique subject gave Michelangelo an opportunity to depict male nudes in a variety of dramatic poses, which became one of the major themes of his art.

ABOVE RIGHT: Metope (square section of a Doric frieze), c. 435 BC, marble relief, Parthenon, Athens. Scenes from a mythical battle between centaurs and Greeks were carved on the Parthenon and the story of the battle, which followed the centaurs' drunken disruption of a wedding, was later retold by Ovid and Boccaccio.

The Madonna and child was a popular subject in fifteenth-century art but Michelangelo's treatment is novel. Eschewing the comforting, even cloying, sweetness of many contemporary examples, Michelangelo drew on the emotional intensity of Donatello, but expressed in simple, massive shapes derived from Masaccio. The work also shows the influence of antique art, with the Madonna shown seated in severe profile like mourning figures on ancient Greek grave stelae. She is an awesome figure, whose body fills the frame and gives an appearance of monumentality to the small relief. She is also remote, both from the viewer and from the infant she nurses so absentmindedly, staring into space. Although traditionally the Madonna may regard her child with sorrow, in foreknowledge of his death, Michelangelo's preoccupied

Madonna is distanced from her child in a way that speaks more of his own experience than of pictorial convention. The Christ child too resembles classical models; he is not a cuddly rounded baby but an infant Hercules who, oddly, turns his muscular back on the viewers he was born to save. His powerful arm is bent back awkwardly, making him seem helpless. Figures of innate strength rendered powerless by mysterious forces were to occur repeatedly in Michelangelo's art, most notably the *Slaves* for the Julius tomb project, and they too suggest a connection with Michelangelo's own life, with its heroic ambitions and frustrations. The *Madonna of the Steps* has another quality found in so many works by Michelangelo; it is unfinished. The Madonna and infant Christ are carved in some detail but the

17

BELOW: Bertoldo di Giovanni, *Battle*, c. 1475, bronze relief, Museo Nazionale (Bargello), Florence. Michelangelo's battle relief was modeled on one by his second master, Bertoldo, a bronze sculptor who had been a pupil of Donatello and who was in charge of the Medici sculpture collection at San Marco.

setting and background figures are only roughly indicated. This pattern of focusing on the body, or just a part of the body, intensified in Michelangelo's subsequent works, including the *Battle of the Centaurs*.

Condivi tells us that the tutor Poliziano took a particular interest in Michelangelo, encouraging him in his studies and in his art. Poliziano is said to have suggested the subject of one of Michelangelo's earliest extant works, a marble relief of the *Battle of the Centaurs* (page 16). The relief was carved just before the death of Lorenzo de' Medici in April 1492, when Michelangelo was about 16. The story of the disruption of the wedding feast of the Lapith king by drunken centaurs was a popular theme in antique art, notably on the Parthenon and the temple of Apollo at Bassae in the Peloponnese, and was later recounted in Ovid's *Metamorphoses*. Michelangelo's depiction of the subject is characteristically unusual, in that he

has virtually eliminated the female wedding guests and the equine parts of the centaurs which figure so prominently in earlier versions. What remains is Michelangelo's first important essay on the major subject of his life's work, the male nude. The *Battle of the Centaurs* owes something to the bronze relief of a battle by Bertoldo di Giovanni, which was then in the main room of the Medici Palace; this in turn is derived from a Roman sarcophagus in the Campo Santo, Pisa.

Michelangelo's treatment of this very early piece already shows many characteristics typical of his mature work. There is no longer even a sketched indication of background or setting such as in the *Madonna of the Steps*. There is no attempt at perspective, no landscape or scenery, no costumes or props. Instead, the entire surface of the cream-colored block is occupied by a writhing mass of intertwined bodies in a variety of dramatic poses, some in low relief and some

nearly in the round. The composition of the battle relief is similar to the pre-Renaissance classicized reliefs on pulpits in Pisa and Siena by the thirteenth-century sculptor Nicola Pisano and his son Giovanni. Although influence from the Pisani can be inferred in certain later works by Michelangelo, however, it is not clear that he had seen their work at this early date. The Pisani pulpits quote antique figures to enrich a religious narrative, but Michelangelo was using them to attempt something more ambitious. With the pretext of a classical theme Michelangelo was free to concentrate on what really interested him, the use of the male nude as an expressive language in its own right.

The battle relief was said to have been completed, or rather left unfinished, just before the death of Lorenzo de' Medici.

Michelangelo returned to his father's house for a time after the death of Lorenzo; as his older brother Lionardo

RIGHT: *Crucifix*, c. 1492, polychromed wood, h. 52½ inches (134.5 cm), Casa Buonarroti, Florence. This crucifix, found in the monastery of Sto Spirito in Florence, has recently been identified with one Michelangelo is reported to have carved for the monastery, which was thought to have been lost.

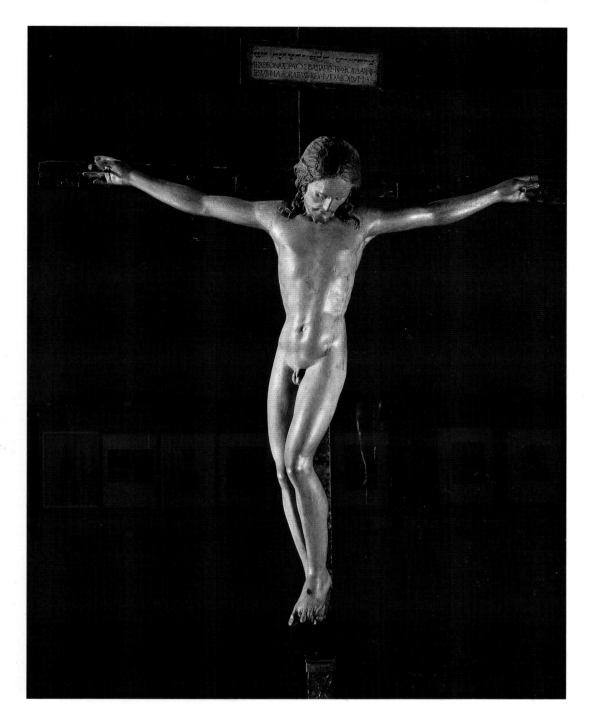

had become a Dominican friar in 1491, he assumed the role of the eldest son, a responsibility he took increasingly seriously. He was also on better terms with his father, whose ferocious disapproval of his son's artistic vocation was transformed by Michelangelo's association with the Medici. According to Vasari, 'his father, seeing him in such favor with the great, clothed him much more sumptuously than before'. During this time, Michelangelo concentrated on improving his understanding of anatomy by practising dissection. This form of anatomical study became one of his lifelong passions and he told Condivi he had often considered composing a textbook on the subject for use by artists. As an old man he was delighted to be presented with the corpse of a particularly handsome young Moor to dissect. Dissections had been performed by artists of the previous generation, including Pollaiuolo, Verrocchio and Leonardo, but the practice was discouraged by the authorities. Although the Church did not ban dissection outright, it did forbid the exhumation of corpses and fresh bodies were not easy to obtain. A new, more flexible attitude in the Church may be inferred from the fact that a sympathetic prior at the Ospedale of Sto Spirito provided Michelangelo with cadavers 'than which nothing could have given him greater pleasure', wrote Condivi.

To express his gratitude for the prior's provision of these visual aids, Condivi reports, Michelangelo carved a wooden crucifix which was hung over the high altar of the church of Sto Spirito. It remained there until about 1600, when it was replaced by another by Caccini and then apparently lost. It was not until 1964 that a wooden crucifix hanging in a corridor of the Sto Spirito monastery was identified as the missing Michelangelo. The identification has been accepted by many scholars, but some object that the Crucifix

simply does not look like a Michelangelo, that the body of Christ is too slender and the musculature understated and inaccurate. Some note that the Crucifix resembles the work of an older artist, Benedetto da Maiano (1442-97), who may have been one of Michelangelo's unacknowledged sculpture teachers. Others suggest that the elongated forms and proportions of the Christ derive from the work of a younger artist, Jacopo Pontormo (1494-1557) and assign the piece a date in the 1530s. Certainly the Crucifix is a surprisingly mild and conventional work for Michelangelo whose earliest sculptures already demonstrate a bold, individual approach. It was found in the monastery for which it was planned, however, and some of its atypical qualities may be due to the material; it is the only wood carving known by Michelangelo and the only piece of sculpture which was painted, again perhaps a reflection of the material, as wood sculptures were commonly polychromed. It

could also be seen as presaging his drawings of the Crucifixion (page 154) and his late, attenuated 'gothic' style of sculpture (page 159). We do not know why the Sto Spirito Crucifix was removed from its place over the altar. Perhaps, like the nude figures of the *Last Judgment*, the nudity of Christ offended viewers of a later period, although the addition of a loin cloth would have been a less drastic remedy. As Michelangelo's reputation has remained strong, the substitution of his work – especially for one by a relatively minor artist – and its subsequent disappearance is mysterious.

Curiously, the other major work known to have been done by Michelangelo in this period also disappeared but has never been found. In 1493 he bought a block of marble about eight feet high to carve a figure of his own choosing. It was unusual for a young sculptor to make a large work in expensive material without a commission

and Michelangelo's bold act may have been provoked by the need to attract new patrons after the death of Lorenzo. The huge *Hercules* he carved from the block, probably based on an antique marble in the Medici collection, was bought by another influential Florentine family, the Strozzi. Michelangelo had known Filippo Strozzi since childhood and the family employed his brother in their wool business. The *Hercules* stood in the courtyard of the family palace until 1529, when it was sent to the King of France. The only record of its appearance is in an engraving by Israel Silvestre of the *Jardin de l'Etang* at Fontainebleau, where it was the central feature. When the garden was rebuilt in 1713 the *Hercules* disappeared and is thought to have been destroyed. How such a large work by Michelangelo could have met such a fate is, again, a mystery.

While he was working on the *Hercules*, Michelangelo received his only recorded commission from Lorenzo de' Medici's heir, Piero, known to history as Piero the Unfortunate. Even as a youth he had alienated the Florentines with his recklessness and arrogance and these qualities proved predictably disastrous when he became their leader. The eldest of Lorenzo's seven children and a near contemporary of Michelangelo, Piero had also been tutored by Poliziano but did not imbibe his father's interest in learning and the arts, preferring horses and sports instead. Some indication of his sensibility may be inferred from his attitude to Michelangelo. In January 1494 there was a particularly heavy snowfall in Florence and Piero sent for Michelangelo, asking him to build a giant snowman in the courtyard of the Medici Palace (another work from this period which disappeared). Piero then invited Michelangelo to return to live in the Medici household, which the sculptor did for some months. Although he

seems to have made no other use of Michelangelo's talents, Piero was said to have held him in the highest regard, an honor otherwise reserved for a Spanish groom who could outrun Piero's horse.

Michelangelo was born toward the end of a relatively peaceful period in Italian history, a 40-year golden age after the 1454 Peace of Lodi. Lorenzo, with great diplomatic skill, had negotiated a delicate balance of power between the major Italian city states during the latter part of his reign, but he was less successful in controling his own city. When Piero de' Medici inherited his father's position Florence was in a period of crisis, including doubts about the solvency of the Medici bank. Revivalist preachers attracted huge numbers of Florentines with their sermons denouncing the secularization of the Church and the materialist excesses of civic and religious leaders. The most famous of these preachers was the Dominican Prior of San Marco, Girolamo Savonarola (1452-98), whose terrible eloquence attracted thousands of listeners including the young Michelangelo. Even as an old man Michelangelo claimed he could remember the sound of Savonarola's voice.

Savonarola's apocalytic visions contrasted strongly with the rational, positive teachings Michelangelo had encountered in Medici circles and the conflict was a major force in his life and art, expressed most dramatically in the frescoes of the Sistine Chapel. Savonarola was openly critical of the great wealth of the Medici court, and he organized public bonfires of luxury items or 'vanities' as a corrective. The threat of a French invasion of Italy, regarded by Savonarola as divine liberation, added to the disquiet of the Florentines. Piero's rule was already unpopular and his vacillating and treacherous behavior in the face of the

French threat was the last straw. After attempting to make defensive alliances with Naples and Venice, Piero lost courage and in October 1494 he signed a treaty turning over all Tuscan fortresses to the French king. The terms of the treaty so enraged the Florentines that they drove him out of the city. The Medici Palace was stripped of its treasures and the family's 60-year rule over Florence came to an ignominious end. By this time Michelangelo, alarmed by the predictions of Savonarola and by the possible implications of his Medici links, had fled the city.

Bologna 1494-95

It is indicative of both his temperament and the troubled times that this was the first of many such flights by Michelangelo. He and two companions went first to Venice, which was then an important center for the exchange of artistic ideas between Northern Europe and Italy. The leading figure in the Northern Renaissance, the brilliant young Nuremberg artist Albrecht Dürer (1471-1528) was also in Venice at this time. It is not recorded that the two met, but Michelangelo later expressed admiration for Dürer's work. Dürer too was interested in anatomy and wrote a book on the subject, focusing on measurement and proportion in the Early Renaissance manner. Michelangelo's approach to anatomy indicated the way for the next generation of artists, who had mastered the accurate representation of nature and wanted to go beyond it. Using his understanding of the mechanics of the human body as a tool, he concentrated on exploring its expressive possibilities. He was prepared to sacrifice mere accuracy, if necessary even to distort or exaggerate, to achieve this higher goal. This attitude is reflected in the works he produced in the next few years, which led the way to a new era in art.

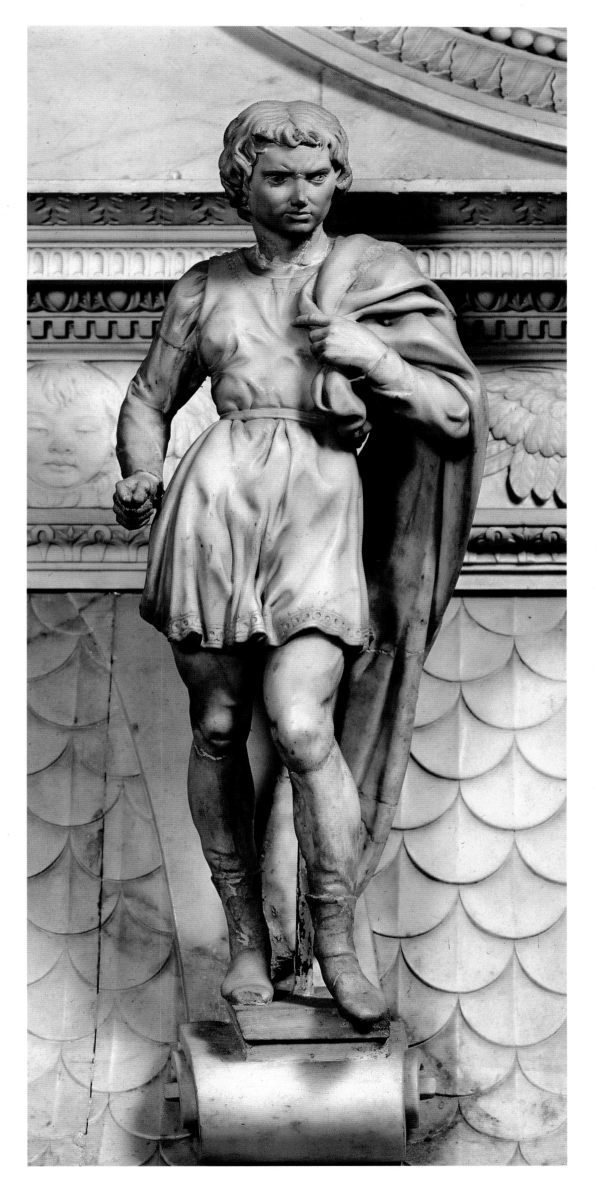

After a few weeks in Venice with no prospect of work, Michelangelo and his companions set off for Bologna. There they fell foul of a petty city regulation and received a fine which they could not pay. They were rescued by Gianfrancesco Aldrovandi, a Bolognese nobleman who had lived in Florence and was an admirer of Florentine art. Learning that Michelangelo was a sculptor, he invited him to live at his house. Michelangelo stayed there for more than a year and, according to Vasari, Aldrovandi particularly enjoyed using his protegé as his personal Book at Bedtime, to read aloud Dante and other poetry in his Tuscan accent. These readings instilled in Michelangelo a great admiration for Dante, and even as an old man he could recite long passages from memory.

Aldrovandi also arranged a sculpture commission for Michelangelo, to work on the shrine of St Dominic in Bologna. The shrine, begun by Nicola Pisano in the thirteenth century, had been left incomplete at the death of the leading Bolognese sculptor Niccolò dell'Arca in 1494 a few months before Michelangelo's arrival. The elaborate freestanding tomb is nearly 20 feet high and the figures carved by Michelangelo, which are about two feet high, are only a small part. Their small stature is not evident from photographs as, like the *Madonna of the Steps*, they give an impression of monumentality belied by their size. It is as if, even at this early stage, Michelangelo's ideas required realization on an heroic scale.

The shrine figures by Michelangelo include the two local saints, *St Petronius* and *St Proculus*, and a kneeling angel holding a candlestick. His *St Petronius* shows the influence of a statue of the same saint on the portal of the church of San Petronio in Bologna, the masterpiece of the Sienese sculptor Jacopo della Quercia (c.1374-1438). The dramatic intensity and preoccupation with

RIGHT: *Angel Bearing a Candlestick*, 1495, marble, h. 22 inches (56.5 cm), Shrine of St. Dominic, S Domenico, Bologna. The simple full forms of Michelangelo's sturdy *Angel* contrast strongly, perhaps by intention, with the detailed decoration of the tomb of Niccolo dell'Arca.

the human figure of Quercia's work were evidently sympathetic to Michelangelo and there are quotations from the same portal on the ceiling of the Sistine Chapel. Michelangelo's St Petronius has a strong *contraposto* stance, weight on one leg and the other relaxed and slightly bent, which imparts a sense of harmonious movement to the figure emphasized by simple drapery folds, to counterbalance the model of Bologna he carries. Of the three figures the *St Petronius*, with its sinuous lines, fits most comfortably into the decorative scheme of the shrine. However, although he was a skilled copyist, Michelangelo was not by nature a self-effacing collaborator and his other shrine figures are less accommodating in style. The *St Proculus* also has a twisted pose but as he carries no burden his stance appears unstable, like that of a slightly later work, the *Bacchus* (page 25). He is shown as a young man, with a short tunic rather than the more graceful robes of *St Petronius*, and the treatment of flesh and fabric is more fussily detailed, particularly the muscular legs with their sagging stockings. His face, with its fierce eyes and furrowed brow, which occur again on the *David* (page 37), has been proposed as a self-portrait by the young artist. Certainly it has an intense individuality which is at odds with the elegant decoration of the rest of the shrine; a quality which looks to the art of the coming century.

An even greater contrast of old and new is offered by the pair of kneeling angels, one by Niccolo dell'Arca and its mate by Michelangelo. The angel by Niccolo has a fragile feminine charm, its delicate oval face framed by luxurious long ringlets. The pose is contained and still and the heavy drapery folds convey little sense of a body beneath. Detail is decorative and sharp, especially on the complex candelabrum. Its angel partner by Michelangelo is possibly wilfully different in style. The figure is masculine in appearance, stocky and muscular, with short tousled hair. The pose is full of tension and energy – one foot barely touches the base – and the light drapery clings to the realistic body. The modelling overall is very soft, as if the material were not marble but wax. This is almost the only winged angel in Michelangelo's oeuvre and in this case wings were obviously imposed by the need to match the existing mate. Curiously, the wings were left uncarved at the back, which is easily visible from the side of the shrine. Perhaps its lack of finish is due to the haste with which Michelangelo abandoned Bologna, leaving a fourth figure still to be carved. This second flight was reportedly precipitated by threats from Bolognese sculptors, angered that a Florentine was taking work from local artists. As Michelangelo often claimed to have been the target of envy and ill will from his fellow artists (although there is little external evidence to support this), and as he was inclined to be positively uncharitable about his colleagues, it is difficult to distinguish probability from paranoia in such tales.

After the surrender of Florence by Piero de' Medici, the army of the French king Charles VIII had continued south through the Papal States to enter Naples unopposed. There, in May 1495, Charles had himself crowned king and, having installed half his army as a garrison, began the return to France. Meanwhile, alarmed at his success, his erstwhile allies had formed an anti-French alliance which inflicted heavy damages on the French forces in July at Fornovo. Although Charles' invasion ended ignominiously when he was forced to flee with the remains of his army, his exploits encouraged others to profit from the disunity of the city states. The peaceful period of Michelangelo's youth had ended and for the next century the Italian peninsula was an international battle ground.

By the winter of 1495-96 Michelangelo had returned to Florence, now a changed city from the one he had known. After the expulsion of the Medici the Florentines re-established a republican government, with a Great Council modeled on that of Venice. Work began on a council chamber which Michelangelo and Leonardo were later commissioned to decorate. Real power, however, rested with Savonarola who continued to dominate the minds of the citizens with his ferocious sermons. Under his influence the Florentines, once supporters of the lively Medici court, became sober and pious burghers. Savonarola's strictures against nudity, the antique, and 'vanities' in general did not create an atmosphere conducive to artistic patronage and, despite his growing republican sympathies, Michelangelo once again found himself dependent on Medici help. Although the reigning line of the family was in exile, minor Medici were allowed to remain in republican Florence, prudently changing their name to the more populist Popolano. One of these Medici cousins, Lorenzo di Pierfrancesco, who had been a patron of Botticelli, commissioned Michelangelo to make a young St John the Baptist, or 'Giovannino' in marble. This work is presumed lost, although it has been suggested that it may be identified with a figure of the young Baptist now in the Bargello Museum in Florence, which was long attributed to Donatello. As we have seen, Michelangelo was influenced by Donatello, but the attribution of this figure to either sculptor is unconvincing.

Also at this time Michelangelo carved a life-size sleeping *Cupid* in marble. This was much admired by Lorenzo di Pierfrancesco, who suggested that it

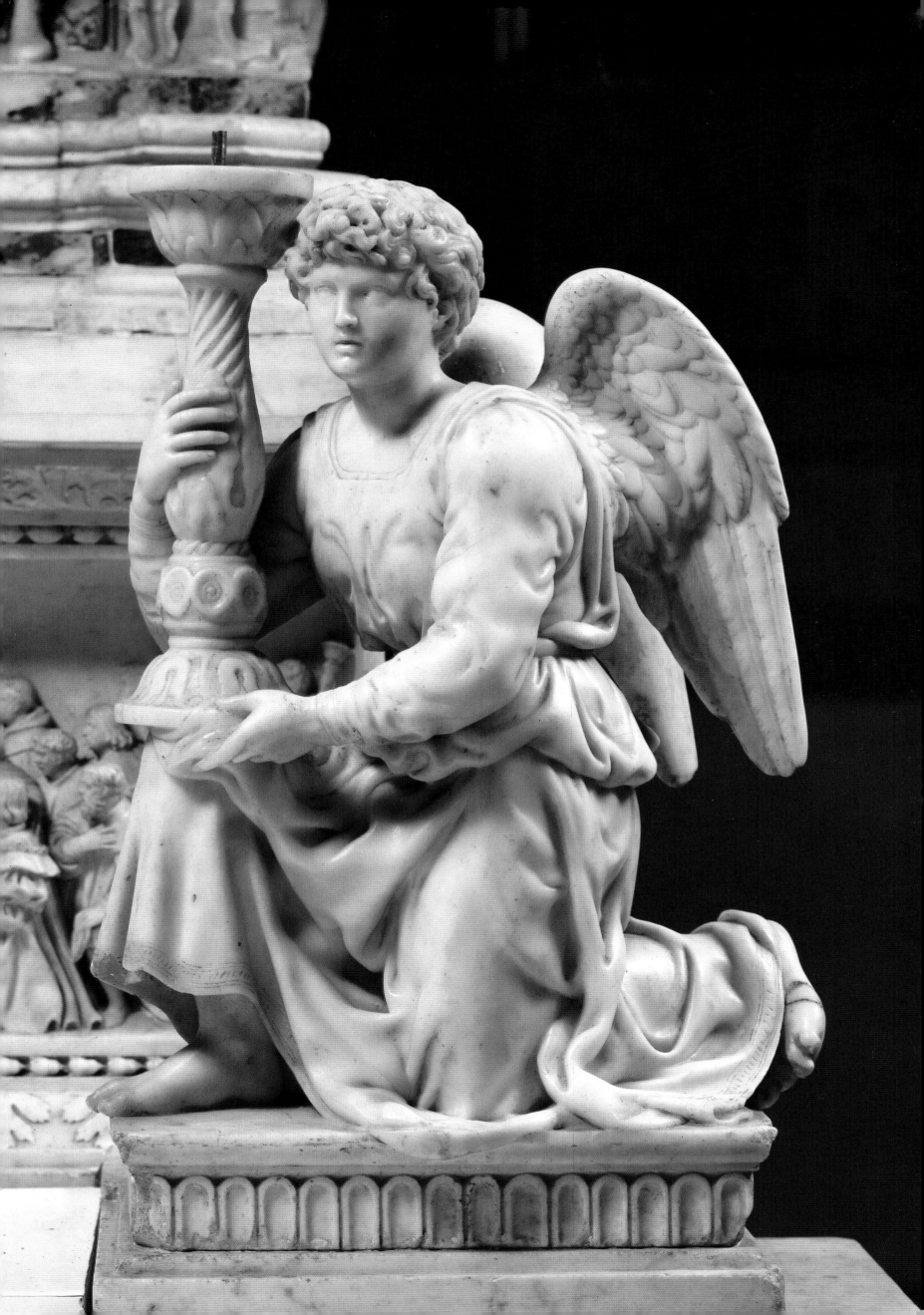

would fetch a better price if Michelangelo aged the piece by burying it and then claimed it was antique. We do not know if Michelangelo took this advice (though it would not have been out of character for someone known to have artificially aged drawings with smoke) but the *Cupid* was eventually sent to a dealer in Rome who did sell it as antique for 200 ducats, of which he paid Michelangelo only 30. The buyer, Cardinal Raffaelo Riario, a wealthy humanist and connoisseur, was outraged when he discovered the work was new; Michelangelo was outraged at being cheated by the dealer. He was also angered by this demonstration of collectors' prejudice against modern art; the *Cupid* was part of Michelangelo's long battle to surpass the art of the ancients, which was considered the supreme model for artists. There was some support for Michelangelo's position, as Riario was reportedly criticized for not acknowledging the quality of the work regardless of its age. Further vindication came when the rejected *Cupid* was acquired – in a less than scrupulous manner – by the noted collector Isabella d'Este, Marchioness of Mantua, who bought it from the captor of Urbino while she was giving refuge to its owners, the Duke and Duchess of Urbino. When the Mantua collection was bought by Charles I in 1631 the *Cupid* came to England but was lost when the royal collection was sold after his death.

The First Stay in Rome, 1496-1501

The controversy over the pseudo-antique *Cupid* spurred Michelangelo to make his first visit to Rome. He told Condivi he made the trip to seek recompense from the dealer who had cheated him and to see Rome. There were other reasons as well; the mood of Savonarolan Florence was increasingly grim, and there was little prospect of work. The

new center for artistic patronage was Rome, where wealthy families and members of the papal court were building new palaces and buying art works to fill them. Building work was also being done on churches, including a new choir for Old Saint Peter's. Although most of the ancient city buildings were in ruins, there was an unparalleled range of antique sculpture to be seen, with new finds frequent. In public view there were numerous carved sarcophagi as well as major works such as the *Horse Tamers* on the Quirinal Hill and the equestrian *Marcus Aurelius* at the Lateran Palace, which was to be the focal point of Michelangelo's Capitoline piazza. On the Capitoline hill there was a group of ancient bronze statues, including the famous wolf, which had been donated to the city in the 1470s by Pope Sixtus IV. Sixtus had inherited his predecessor's collection of antique gems, coins and statuettes but had sold most of it to Lorenzo de' Medici as there was little interest in collecting in Rome at that time. Twenty years later there were many sculpture collections in Rome, including those of Cardinal Riario and his cousin, Cardinal Giuliano della Rovere, the future Pope Julius II and patron of Michelangelo.

Michelangelo arrived in Rome in June 1496; the wisdom of his move was confirmed soon after by news that the plague had broken out in Florence. He came to the capital armed with a letter of introduction from Lorenzo di Pierfrancesco to, of all people, Cardinal Riario. Riario was completing a large new palace, one known today as the Cancelleria, where he kept a notable collection of antiquities which artists were permitted to copy, as they were in the Medici garden. The Cardinal apparently bore no grudge about the *Cupid* for, as Michelangelo wrote to Lorenzo di Pierfrancesco, he immediately welcomed the young sculp-

tor and invited him to inspect his antique statues. Riario then asked Michelangelo his opinion of the collection and if he thought he too could make a beautiful work of art. Michelangelo replied with modesty – or perhaps irony – that he could promise nothing so fine but that the Cardinal would see what he could do. His letter goes on to say that they had already bought a piece of marble for a lifesize statue, an action which undermines biographers' claims that Riario was an unsympathetic patron who never commissioned a work from Michelangelo.

Although we have no record of Michelangelo completing a statue for Riario, we do know that two statues, an *Eros* or *Apollo* (now lost) and a *Bacchus*, were owned by his neighbor Jacopo Galli, and one of these may originally have been ordered by Riario. Since Riario's real interest was in ancient sculpture he would have wished Michelangelo to produce a work which was, if not a copy, at least close to the classical in spirit. In this case the *Bacchus*, the surviving statue of the two owned by Galli, would have been a disappointment and Riario might have been relieved to hand it over to his neighbor.

The *Bacchus* is the first of two major works which established Michelangelo's reputation as a sculptor. It was originally displayed in the sculpture garden of Riario's friend and neighbor Galli, a banker who was a frequenter of humanist circles and had a collection of Roman statues, reliefs and fragments. A drawing of the garden by the Haarlem artist Maerten van Heemskerck, who was in Rome in the early 1530s, shows the *Bacchus* with its right forearm broken off, apparently to make it look more convincingly antique. The arm and drinking cup were later restored, possibly by Michelangelo himself, and the surface of the marble has weathered, but the naturalism of the detail is still clear today. The figure is

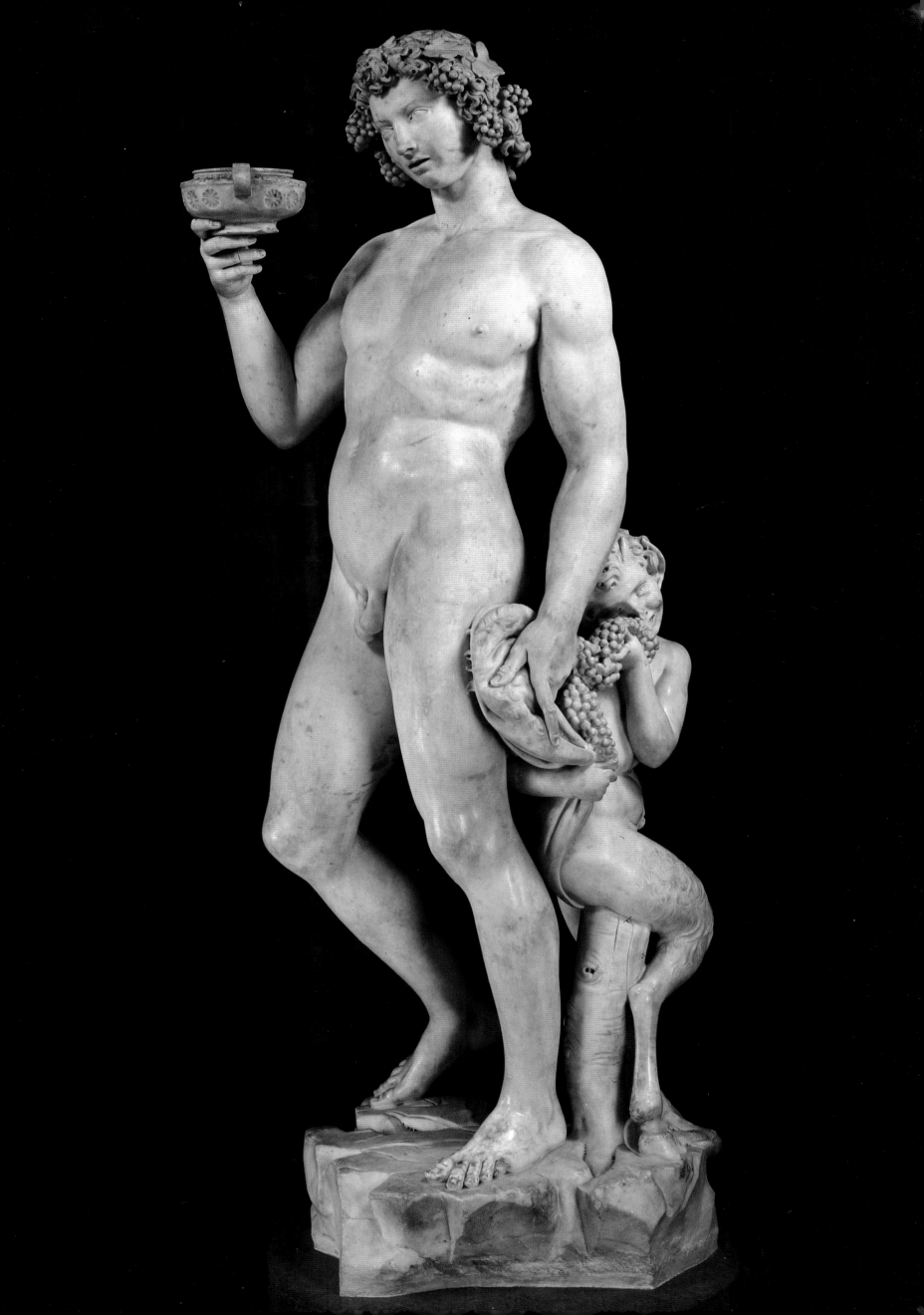

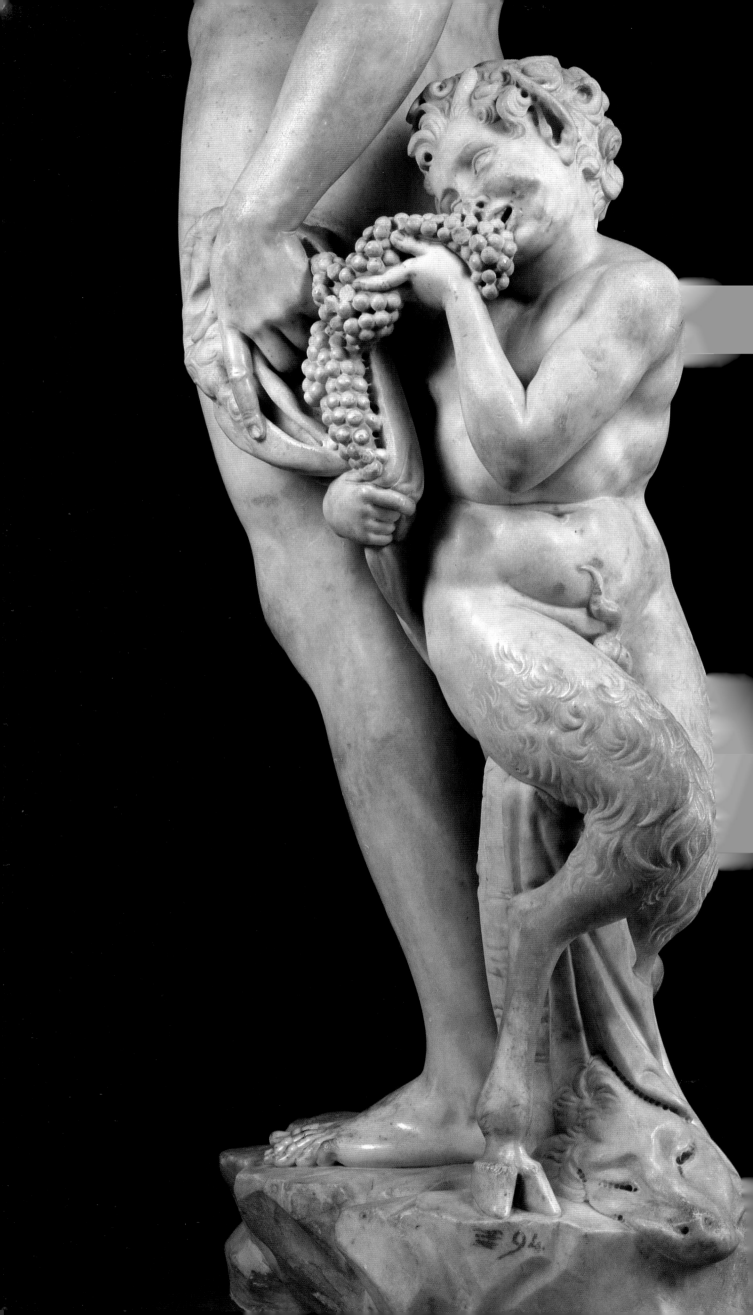

LEFT: *Bacchus* (detail). The sly little faun behind Bacchus, nibbling his grapes, shows that the statue is meant to be seen in the round, not simply from one viewpoint.

BELOW: Maerten van Heemskerck, *View of the Sculpture Garden of Jacopo Galli*, Rome, 1532-35, drawing, Staatliche Museen, Berlin. This drawing, showing the *Bacchus* in its original site with its hand broken off, is one of many Heemskerck made during his stay in Rome; these are an invaluable record of the rapidly developing city.

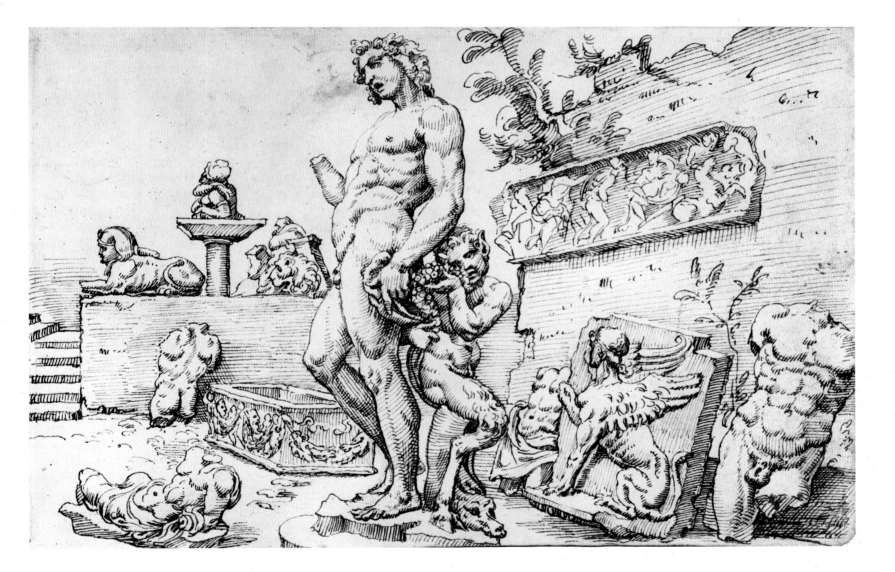

lifesize, with a soft fleshy body whose nudity is emphasized by contrast with the precisely rendered grapes of his garland. He slouches, his rather feminine belly protruding, and gazes blearily at the wine cup in his raised right hand. His left hand loosely grasps some grapes and the skin of a leopard, the animal associated with Bacchus. According to Condivi Michelangelo portrayed the skin rather than the beast itself as a reminder of the fate in store for those who indulge too freely in wine. It is also a foretaste of the awful image of St Bartholomew clutching his own skin, which Michelangelo was to use in the *Last Judgment* (page 140). Behind the tipsy young god a small satyr slyly nibbles at his grapes. For all its pagan abandon, the piece sounds a warning note about the price of excess. The face of Bacchus, gazing longingly at the cup with lips parted in anticipation of the next sip, shows he is already enslaved to wine. His wanton expression anticipates the knowing looks of the Roman rent boy Bacchuses painted by Caravaggio a century later. The pose, a reversal of the stable classical *contraposto* stance, appears distinctly wobbly. This sense that loss of balance may be imminent is a key to the meaning of the work, which is the conflict between license and restraint, the struggle of the soul to free itself from domination by man's physical nature and desires. Michelangelo treated this subject for the first time in the *Bacchus* and it became a major theme in his art.

Like the lost *Cupid*, the *Bacchus* was intended as a challenge to antique art; Condivi prefaces his description with the claim that every form and aspect of the work corresponds to the meaning of the ancient writers. This is not entirely true; the *Bacchus* is of course an antique subject, but treated in a new manner. The difference is decorum:

27

in Greek representations Bacchus is always dignified and godlike. While his followers, Silenus and the Bacchantes, abandon themselves to their orgiastic revels, Bacchus himself keeps an Olympian cool, never showing the effects of wine. Michelangelo's *Bacchus* may sport the attributes of the god, but his imminent intoxication shows he is clearly merely mortal. This quality has exercised many of Michelangelo's critics. Shelley described the statue's 'expression of dissoluteness the most revolting' as mistaking the spirit of Bacchus, a mistake he attributes to the fact that it is the conception of a Catholic. (He does not mention the more sympathetic version of Bacchus by another Catholic artist, Michelangelo's contemporary Jacopo Sansovino.) Michelangelo's biographer John Addington Symonds concludes that the piece is too grounded in the material world:

If Michelangelo meant to carve a Bacchus, he failed; if he meant to imitate a physically desirable young man in a state of drunkenness, he succeeded.

Whatever its spiritual shortcomings the *Bacchus* commands admiration for its technique, even from those who find the statue distasteful. And taste is perhaps the issue. Antique art tends to the general, the idealized; by contrast, the *Bacchus*, as Symonds suggests, is too specific, too raw. In *Bacchus* and related works Michelangelo expresses a sensuality and hedonism which he was denied, or denied himself, in the lonely and austere life described in his letters. Sensuality is implicit in the virtuoso carving, the smooth modelling of the slightly repulsively soft flesh, offset by areas of firm, exquisite detail. The young sculptor is clearly revelling in his technical mastery of the hard stone. Perhaps because of its garden site, the *Bacchus* is one of the few statues by Michelangelo which has no principal view but is intended to be seen from all

sides. This is confirmed by the irregular rounded base and the placement of the intriguing subsidiary figure at the rear, both of which invite the viewer to circulate. The spiral sense of the composition anticipates by many years the serpentine poses favoured by the Mannerist artists, for whose excesses Michelangelo's influence is often blamed. Even taking into account his preference for expressive rather than accurate anatomy, the work does show certain signs of the novice: the head is too small for the body, the unsupported right arm is vulnerable to breakage, and the whole figure has an unnatural list. To some extent these problems are the result of Michelangelo's training as a relief sculptor, compounded by his improvisatory approach to a most unforgiving material. The difficulties inherent in his working methods later contributed to his leaving a great number of works incomplete, the '*non finito*' which has puzzled so many writers. At this early stage in his career, however, he could ill afford to abandon an expensive block of marble, or to antagonize a client; the *Bacchus* is among the most highly finished of Michelangelo's sculptures, as is his next commission, the St Peter's *Pietà*. Surprisingly, despite its modern air and the continuing high reputation of its maker, the *Bacchus* was mistaken in the sixteenth century for an antique and was displayed with classical statues at the Uffizi. It remained in public collections in Florence until 1944 when the Germans attempted to remove it to Linz, where it was to be included in a museum Hitler planned in memory of his mother.

The *Bacchus* was probably finished by the summer of 1497, when Michelangelo's father asked him to return to Florence to help with a threatened lawsuit. Since his older brother had left the family to become a Dominican friar in 1491, Michelangelo was thrust into the

role of the eldest son. His family relied increasingly on his help, especially financial, and long before his father died Michelangelo had become in effect the head of the family. He often complained of this responsibility, which weighed heavily on him, but he seldom shirked it. On this occasion, however, his preparations for return were interrupted by a new commission.

A French Cardinal, Jean Villiers de la Groslaie, who was the main representative of the French Crown at the Vatican, wished to have a Pietà made for his tomb. As guarantor for this commission, Jacopo Galli wrote the rather rash prediction that Michelangelo's sculpture would be 'the most beautiful work of marble in Rome, one that no living artist could better'. These were prescient words which few would dispute now that the St Peter's *Pietà* is among the best known works of Western art. Some of its fame is due to the artist's dazzling demonstration of technique, a display not equaled again by him or by any other sculptor until Gianlorenzo Bernini (1598-1680). But the great strength of its appeal lies in Michelangelo's ineffably tender treatment of a theme which had strong religious and personal meaning for him.

The subject of Mary holding the body of the dead Christ was often used for sepulchral sculpture groups in France and Germany, but it was not common in Italy at this time. Painted versions, such as that by the Ferrarese Ercole de' Roberti (c.1450-96), had begun to appear in northern Italy but Michelangelo's great work is one of the earliest sculptural treatments. The fact that it is very difficult to make a coherent composition of the subject of one adult figure lying across another may have discouraged attempts by artists in Italy, who tended to favor more idealized images than their counterparts in northern Europe. Leonardo da Vinci's struggles with a similar problem can be

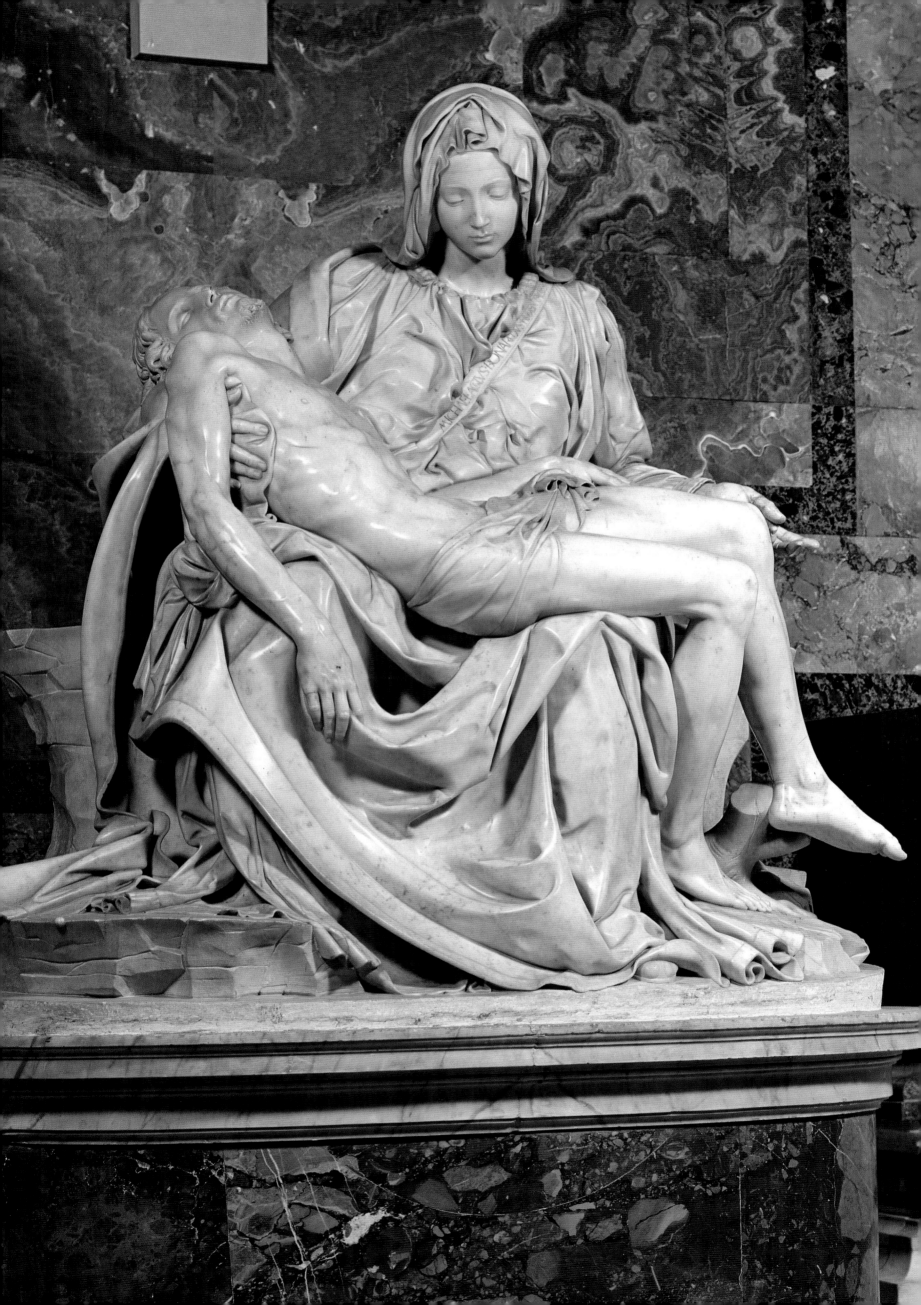

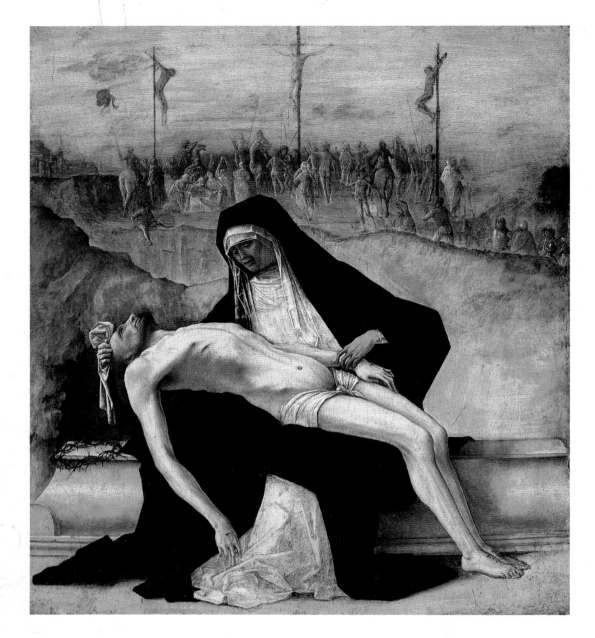

LEFT: Ercole de'Roberti (d. 1496), *Pietà*, predella panel, oil on wood, 13¼ × 12¼ inches (34.3 × 31.3 cm), Walker Art Gallery, Liverpool. Michelangelo's use of massive draperies to support the dead Christ of the *Pietà* may have been suggested by paintings such as this one, once part of an altarpiece in Bologna.

RIGHT: *Pietà* (detail). Michelangelo's pride in the *Pietà* is evident from the fact that he carved his name on the band across the Virgin's breast; it is the only work signed by him.

angelo overheard a group of people from Lombardy acclaiming it as the work of 'our hunchback', the nickname of the Milanese sculptor Cristoforo Solari. Furious at this mistaken attribution of his masterpiece, Michelangelo that night shut himself in the chapel and carved on the ribbon stretched across Mary's breast '*Michael A(n)gelus Bonarotus Florentin Faciebat*'.

The contract specified that the *Pietà* was to be completed within one year, but Cardinal de la Groslaie died in 1499 and probably did not see it finished. He was buried in the Chapel of the Kings of France and the *Pietà* was put in a niche over his tomb. When Old St Peter's was demolished to make way for the new the statue had to be moved. Its present location in a chapel off the nave does not show it as intended: the work is not in a niche, it is too high, and the baroque splendor of the setting is at odds with its classical purity. The visitor's view of the *Pietà* has been further obscured since the 1970s when plastic screens were erected around it after a madman attacked it with a hammer. Perhaps vandalism is also evidence of its enduring power.

The St Peter's *Pietà* was immediately recognized as a turning point in the history of Italian sculpture. It represents the culmination of efforts by fifteenth century artists, particularly Quercia and Verrocchio, to master images of the natural world and the classical ideal. The two works Michelangelo completed during this period established his fame as a sculptor; it was a remarkable achievement for a man not yet 25. As Vasari wrote:

During his stay in Rome he made such progress in art that his conceptions were marvelous, and he executed difficulties with the utmost ease, frightening those who were not accustomed to see such things, for when they were done the works of others appeared as nothing beside them.

seen in his slightly later cartoon, *Virgin and Child with St Anne and St John*. Sculpted *Pietàs* were often simply grotesque and a comparison with even a relatively successful effort, by Niccolo dell'Arca, shows the ingenuity of Michelangelo's solution. Like Roberti, he compensated for the small stature of the Virgin by using a mass of drapery to create an enlarged lap to support Christ's body. Their two forms are further integrated by the compact grouping and by the drapery lines, which echo the curves and angles of Christ's body. Careful examination reveals that the effect has been achieved by taking considerable liberties with anatomy – e.g. her head is too small, her hands and legs enormous – but the immediate visual impact is completely convincing. The *Pietà* was Michelangelo's first major commission for a religious work and, as if in deliberate contrast to the open, unstable pagan *Bacchus*, he presents an image of Christianity in a stable and compact pyramidal composition. The literal stability of the work reinforces its figurative meaning as Mary is shown seated on the rock of Golgotha, site of the Crucifixion. Christian writers had earlier used the image of Mary *super petram* (on the rock) to relate her to Christ as the foundation stone of the Church and Michelangelo often used a similar motif for the Virgin, beginning with the *Madonna of the Steps*.

Unlike the *Bacchus*, the *Pietà* shows no conflict or ambiguity; it expresses simply and clearly that salvation lies in unity, the unity of Mary and Christ, of mother and son. This theme is one to which Michelangelo often returned, for reasons which were private as well as spiritual. In this version, there are perhaps resonances of the early death of Michelangelo's own mother in the fact that Mary is shown as far too youthful to be the mother of the adult Christ. When the work was criticized on this account, Condivi tells us Michelangelo argued that Mary's youthful appearance was proof of her purity, as virginity was thought to delay the effects of age. Dante alludes to this in the *Paradiso* when St Bernard addresses Mary as 'Virgin Mother, daughter of your Son'. Further indication that the *Pietà* was of particular significance for him is the fact that it is the only work Michelangelo signed. Vasari relates that when it was put on display in St Peter's Michel-

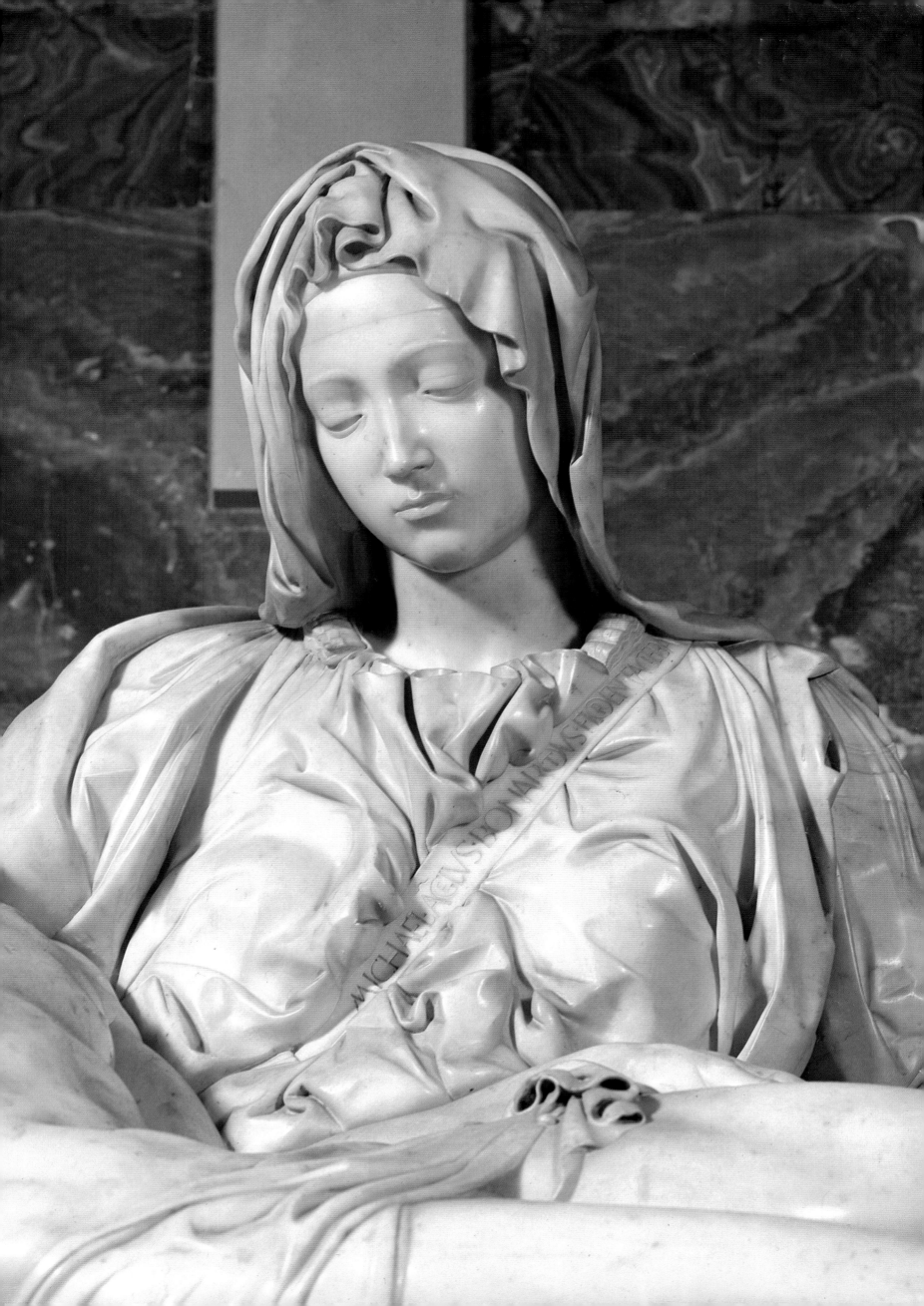

Painting and Sculpture: Florence 1501-1505

In 1501, after five years in Rome, Michelangelo returned to live in Florence. His return was probably prompted by a commission from Cardinal Francesco Piccolomini, who later became Pope Pius III. The Cardinal requested 15 statuettes, each about four feet tall, for the Piccolomini family altar by Andrea Bregno (1418-1506) in Siena Cathedral. Michelangelo probably traveled to Florence via Siena to see the altar and plan his additions. The contract, again guaranteed by Jacopo Galli, stipulated that the statuettes should be completed within three years and that Michelangelo should do no other work in this period. He was also required to submit detailed drawings of the figures in case the patron wished to suggest any changes in their clothes or gestures. It was a commission similar to his work on the Bologna shrine, but Michelangelo was no longer an unknown artist anxious to prove himself and another collaboration was now less attractive. When the commission lapsed in 1504, he had sent only four figures to Siena, two of which were by his assistants. As Michelangelo made little use of assistants, in contrast to common practice, this suggests his interest in the commission was short-lived.

There is, however, a sculpture by Michelangelo's own hand which may originally have been intended for the Piccolomini altar, the mysterious *Madonna* now in Bruges. The *Madonna* was still in his Florence studio in 1506, when Michelangelo wrote to his father from Rome asking him to pack and dispatch the work without anyone seeing it. Neither Vasarin or Condivi knew the statue, which they described as a tondo, or round relief, in bronze. The most likely explanation for his desire for secrecy is that Michelangelo had made the *Madonna* for the altar but decided to sell it separately in 1503 when Piccolomini died, a few weeks

after his election as Pope. The buyer was Alexander Mouscron, a Flemish cloth merchant with extensive Italian business interests. In Bruges Mouscron ordered a new altar to be built for the statue in the Church of Our Lady, where it stands today. From this position the downcast gaze of the Madonna is directed at the floor rather than at the viewer, an arrangement which suggests the work was designed for a much higher setting such as that at Siena.

Preliminary drawings show Michelangelo experimenting with the theme of the *Madonna Lactans*, the Virgin suckling Christ he had used in the small relief of the *Madonna of the Steps*. However, the statue as carved has a different iconography, with the Christ child standing between the Madonna's knees, poised to step away, the first step on a journey which will lead him to the cross. She holds him lightly with one hand, the other lies loosely on her lap. She makes no effort to detain him, rather her solemn expression suggests she foresees and accepts his fate. Both the remote stare of the Madonna and the Herculean quality of the Christ child recall the earlier relief, but stylistically the work is an extension of the St Peter's *Pietà*. The facial type of the Madonna and her layered headdress are close to those of the *Pietà*. Like the *Pietà*, the *Madonna* is highly finished, although the drapery is simpler with fewer incised lines to distract from the main forms. While the complex drapery of the *Pietà* Madonna acts as a foil for the smooth flesh of her son, the Bruges figures are more integrated visually. This is emphasized by the fact that the figure of the child is entirely contained in the outline of his mother's form. Despite its modest size, the greater simplicity and compactness of the Bruges *Madonna* shows Michelangelo's development toward a more monumental style. He was soon able to work on a monumental scale as well.

Florence had changed considerably during Michelangelo's years in Rome. In 1498, after four years of oppressive religious rule, Savonarola's power was broken when he was accused by the Church of heresy. On the basis of confessions extracted under torture, he and two companions were tried, condemned and hanged in the Piazza. Savonarola's death brought new troubles; his alliance with France had protected Florence from invasion but the changing leadership of the new restored republican government made her vulnerable once more. It was decided that in addition to adopting the Venetian system of the Great Council, Florence should have a *gonfaloniere*, equivalent to a doge, a single head of state to serve for life. The first person to hold this office, Piero Soderini, was elected in 1502. With Medici opposition quelled by the death of the volatile Piero de' Medici, Soderini was gradually able to restore order and financial stability to the city.

The new political situation brought new possibilities of patronage for Michelangelo. Soderini was a firm supporter of his work, while the Medici family was now led by two of his childhood companions, Lorenzo the Magnificent's son Giovanni, already a Cardinal and later Pope Leo X, and his nephew Giulio, later Pope Clement VII. Political changes in other parts of the Italian peninsula also affected two artists who were to have an important influence on Michelangelo. Both were associated with the Sforza court in Milan but fled the city when the French invaded in 1499: the architect Donato Bramante (1444-1514) settled in Rome and Leonardo da Vinci (1452-1519), artist and polymath, eventually returned to Florence.

RIGHT: *Madonna and Child*, 1503-4, marble, h. 50 inches (128 cm), Church of Notre Dame, Bruges. A more simple and compact work than earlier sculpture.

LEFT: Nicola Pisano, *Fortitude*, 1260s, marble, Baptistry pulpit, Pisa. Michelangelo's *David* is related to antique statues of *Hercules* and to figures of *Fortitude* such as this one dating from the late Medieval revival of antique types in Central Italy.

RIGHT: Donatello, *David*, 1440s, bronze h. 61¾ inches (158 cm), Museo Nazionale (Bargello), Florence. The stark simplicity of Michelangelo's *David* differs from earlier Florentine versions such as this fey bronze by Donatello, which stood in the courtyard of the Medici Palace.

The success of the *Bacchus* and the *Pietà* ensured that Michelangelo's reputation had preceded him to Florence. Among Tuscan sculptors in this period he had few serious rivals; Verrocchio and other masters of the previous generation had died, and the most talented of his contemporaries, Jacopo Sansovino (1486-1570), worked mainly in Rome and then in Venice. In these circumstances Michelangelo was the obvious choice for an important public commission, and in August 1501 he was asked by the Operai dell'Opera del Duomo, the Cathedral board of works, to make a colossal statue. He was given a 14-foot block of marble which had been in Florence since the 1460s, when Agostino di Duccio (1418-81) was commissioned to carve a giant statue for one of the apse buttresses of the Cathedral. The preliminary carving by Agostino was considered to have ruined the block and it was abandoned in the yard of the Cathedral workshop. In 1501 the Operai decided to entrust it to a new sculptor and the names of various well known artists were put forward. Michelangelo had long been interested in the block and rumors of this decision may have been another reason for his return from Rome. The statue for which the block was intended was called 'the Giant, or David'.

The Florentines had long regarded the character of David as a symbol of their civic virtue, one which had particular meaning for the newly re-established republic. They identified him not only with his biblical qualities of courage, faith and fortitude, but also with those of his antique precursor Hercules. In nearby Pisa there is a similar conflation of Christian and antique on the Baptistry pulpit by Nicola Pisano (c.1215-78), where Fortitude is represented by Hercules. Michelangelo's statue of *David* is closer to Pisano's late medieval figure than to more recent local precedents such as the bronze

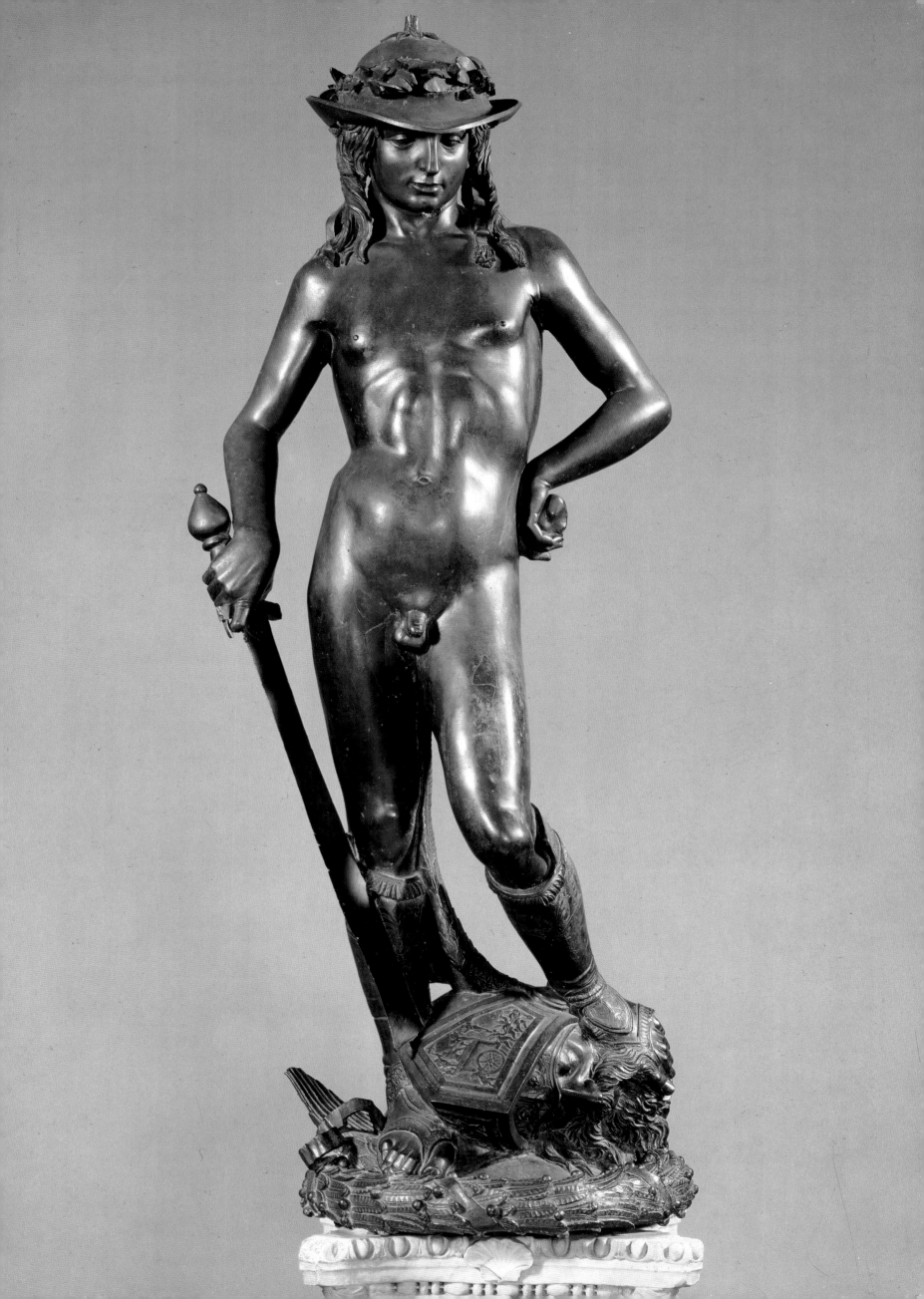

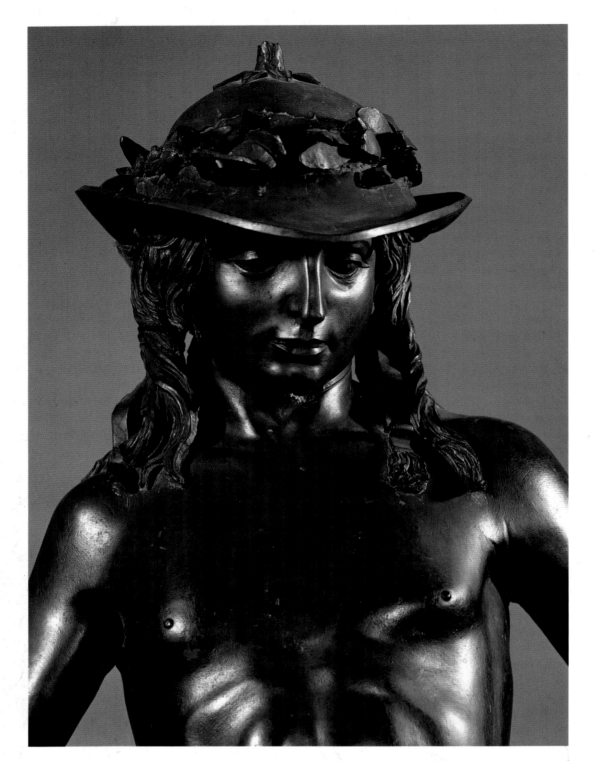

LEFT: Donatello, *David* (detail). , The nakedness of Donatello's *David* is emphasized by his garlanded hat and decorative boots, unlike the noble simplicity of Michelangelo's nude.

RIGHT: *David* (detail). The exaggerated features of Michelangelo's David were designed to be visible from a distance, as the statue was originally intended for the Cathedral facade.

It is necessary to keep one's compass in one's eyes and not in the hand, for the hands execute, but the eye judges.

This unusual working method was both a source of strength and a potential weakness. It allowed him greater freedom to experiment and to modify his designs as he went along, but it also ruled out any significant help from assistants and left a greater possibility for error. In the case of the *David* his method was successful.

As a rival to ancient art, the *David* fulfils the promise Michelangelo demonstrated in the *Bacchus*. His time in Rome had honed his technique and provided new models to whet his ambition; the *David* is his challenge to Roman giants such as the Quirinal *Horse Tamers*, the first nude on this scale to be carved since antiquity. The pose is a vigorous version of the classical *contraposto*, the weight on one leg conveying a sense both of balance and of imminent motion. The torso, the area of the male body which most interested Michelangelo, is carefully observed yet fluidly related to the whole. The two sides of the figure are contrasted, the long closed line of the right representing the passive aspect and, to the left, the jagged open profile representing the active. The legs, according to Vasari, 'are finely turned, the slender flanks divine'. What sets the statue apart from Hellenistic works is the outsize hand and head. Michelangelo's *David* is no remote godlike creature, but clearly a young man not yet grown into his limbs. The large right hand also suggests the medieval appellation 'strong of hand' (*manu fortis*).

As the *David* was originally intended for a site on the Cathedral, its exaggerated features were designed to be seen by viewers below and at a distance. Also, because of the condition of the original block, the statue has a very

David by Verrocchio, and that by Donatello which stood in the courtyard of the Medici Palace. Both Verrocchio and Donatello show the hero after his victory, sword in hand, with the severed head of his enemy at his feet. In contrast, Michelangelo has chosen to present David in the moment before battle, as a youth of latent strength who faces his future with some trepidation. The only attribute which identifies him as David is the sling resting on his shoulder. His intense expression, with fiercely furrowed brow, is very like that of the little St Proculus Michelangelo had carved in Bologna (page 21) and again it is tempting to see it as a psychological self-portrait, the young artist poised to conquer. That Michelangelo himself made such a connection can be inferred from a drawing on which he wrote, in effect, 'David conquered with his sling and I with my drill'.

Michelangelo set to work on the *David* by knocking a 'certain knot of stone' from the chest. He had a wooden shed built next to the Cathedral where he could sculpt the block without being seen. Given the tall, shallow shape of the block and the fact that it was already cut, Michelangelo's choice of poses was severely restricted. Two wax models of David now in the Casa Buonarroti show his experiments with figures it might be possible to produce from the damaged block. Once the design was decided using a small model, it was the normal practice to make a fullsize model as a guide to carving the marble. Michelangelo, however, seldom made a fullsize model; he prefered to use the method he had learned for sculpting in relief, drawing on the face of the block before carving into it. He measured only by eye, stressing the intellectual basis of his art by saying:

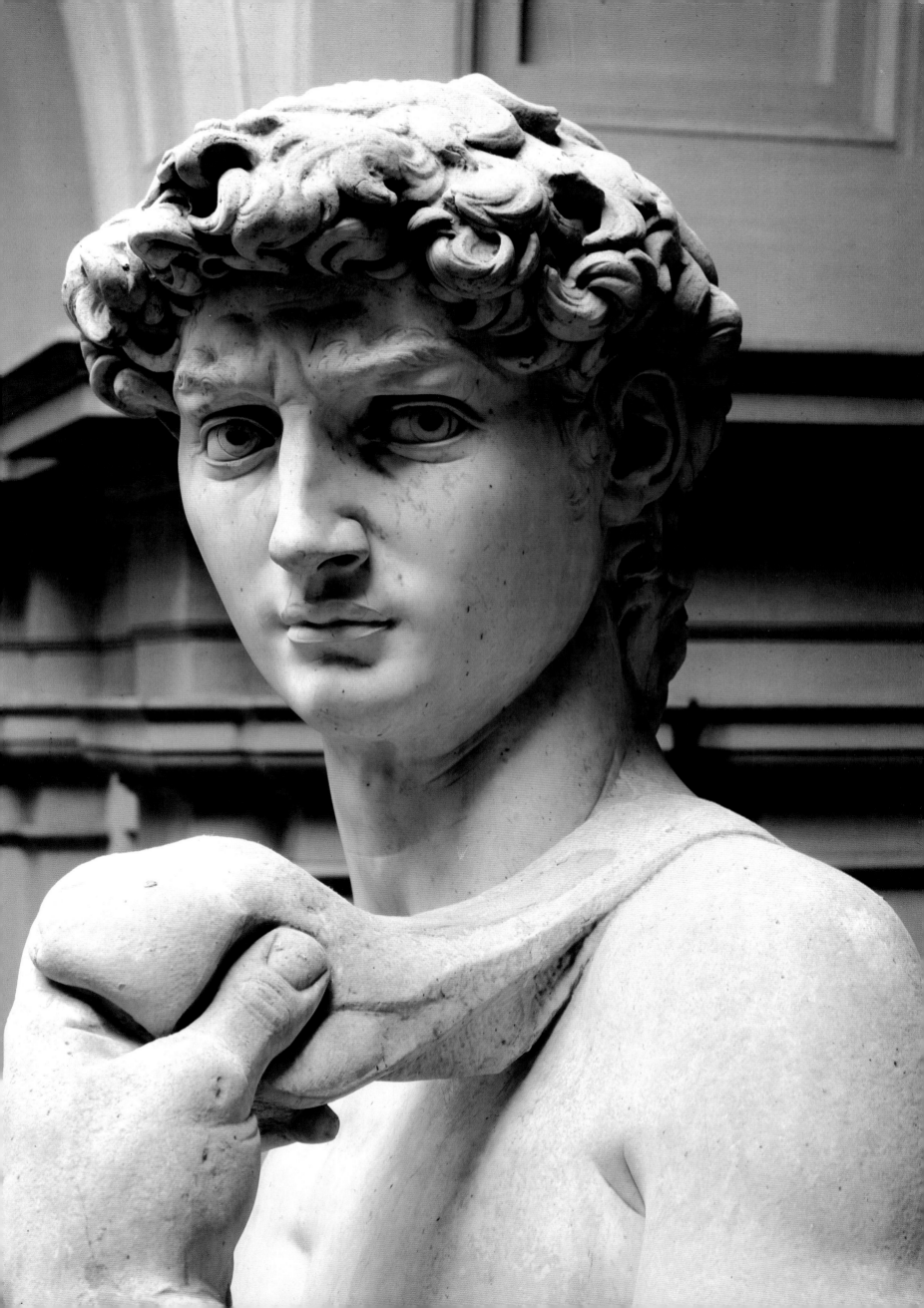

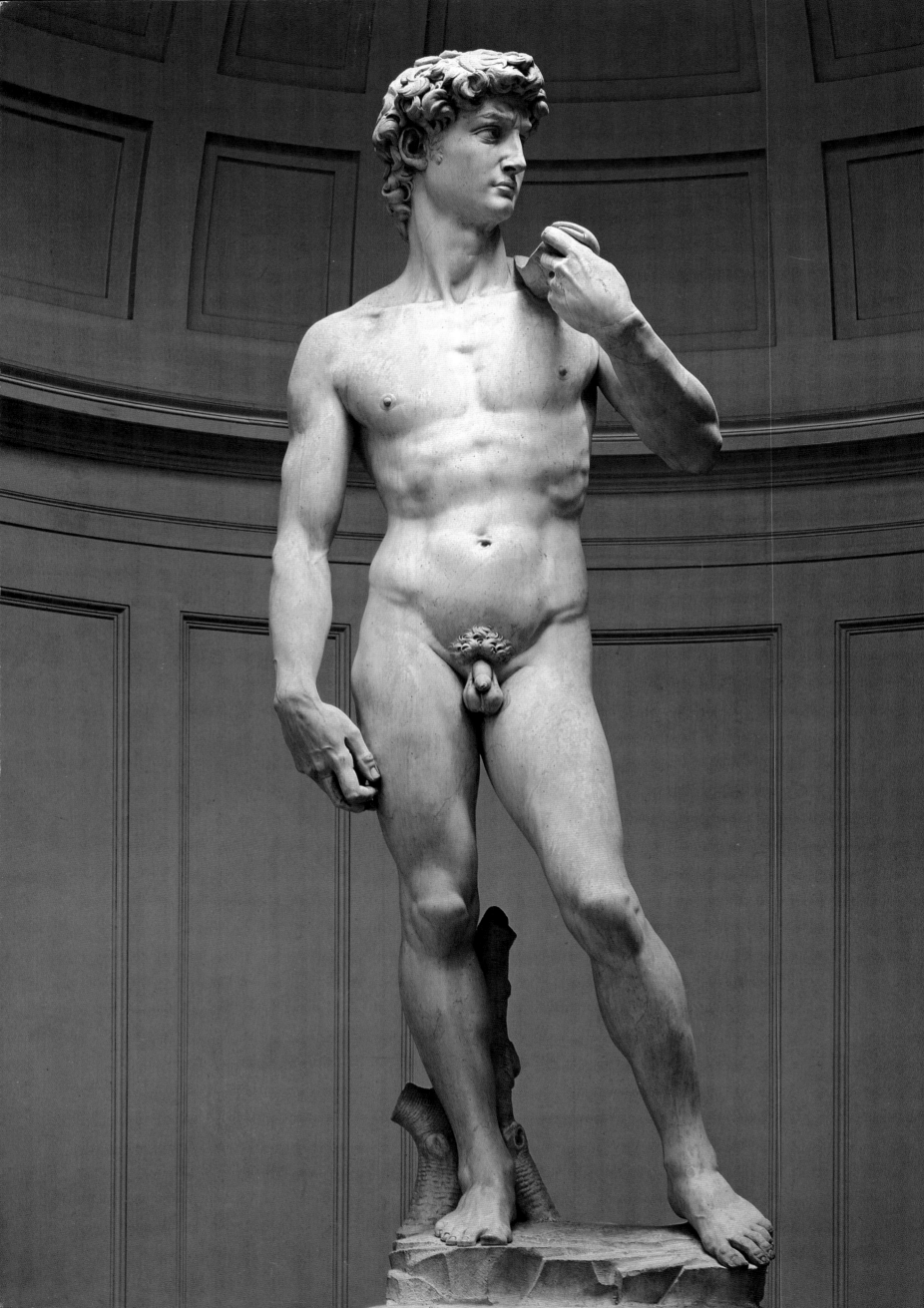

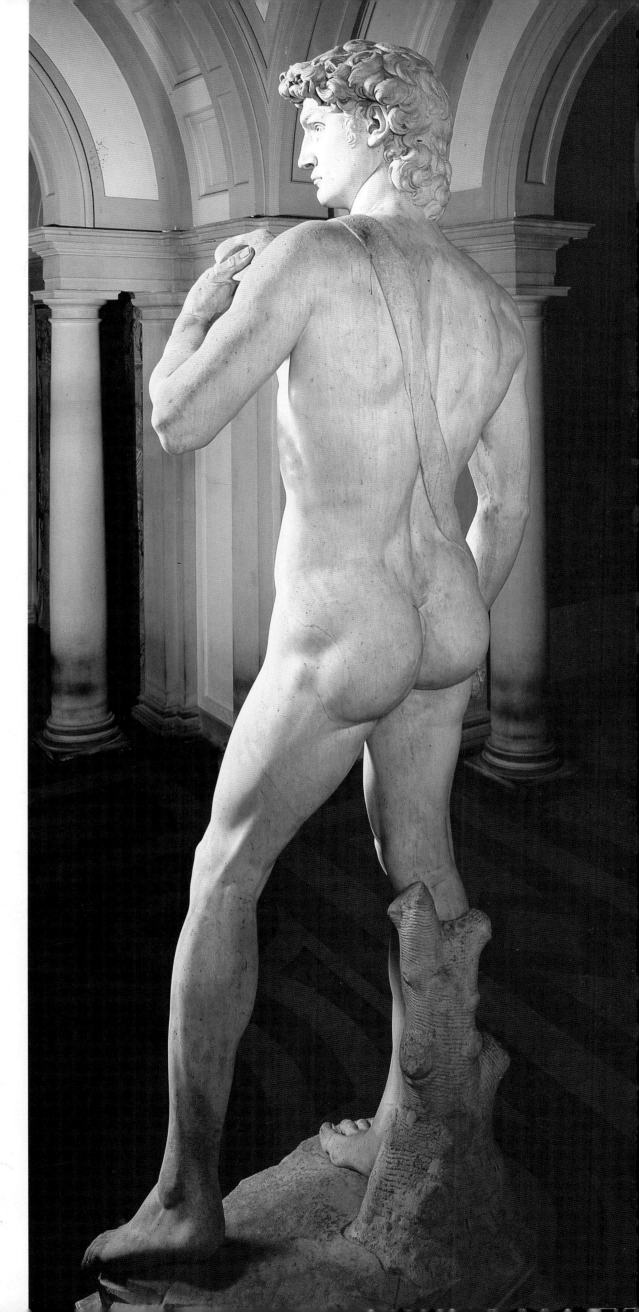

shallow side view and is best seen directly from the front. But during the two years of its gestation support grew for a plan, probably emanating from the new city government, to abandon the Cathedral site and to place the statue instead in the Piazza. In January 1504, when the *David* was nearly complete, an extraordinary meeting was held to discuss where it should be placed. At this meeting, which included Botticelli and Leonardo among other distinguished artists, it was decided that the *David* should be erected on the steps of the Palazzo Vecchio. There it would replace Donatello's statue of *Judith*, for according to the architect Filarete, "the *Judith* is an omen of evil . . . it is not proper that the woman should kill the male".

A special framework drawn by 40 men was needed to move the *David* from Michelangelo's workshop to the Palazzo Vecchio. At one point during the journey the statue was stoned by onlookers, presumably opposed to its pagan nudity or its political implications, or perhaps both. A copy of the *David* now on the Palazzo steps shows how it was then displayed, with its back to the wall and facing the Piazza. Compared to its giant companion by Michelangelo's rival Baccio Bandinelli (1493-1560), the *David* looks simple and graceful but in its present setting inside the Accademia the statue looms uncomfortably large, dwarfing the viewer. Yet even here it is easy to understand why Vasari wrote that with the David Michelangelo had succeeded in surpassing antique art:

It certainly bears the palm among all modern and ancient works, whether Greek or Roman. . . . After seeing this no one need wish to look at any other sculpture or the work of any other artist.

Vasari repeats an anecdote involving the *David* that shows the often tetchy sculptor in a diplomatic mood. When

RIGHT: View of Palazzo della Signoria, Florence. When the *David* was finished it was decided to place it in front of the Palazzo della Signoria, where a copy now stands next to the lumpem *Hercules and Cacus* by Michelangelo's rival Baccio Bandinelli.

the statue was being set up Piero Soderini, who was looking on, approached Michelangelo to say he thought its nose was a bit too big. Michelangelo immediately took up a chisel, climbed the scaffolding and pretended to trim the nose, while scattering some marble dust he had hidden in his hand. Soderini was delighted with this 'improvement', claiming that it had given the statue life. Michelangelo allowed the Gonfaloniere this little vanity, but, Vasari tells us:

He came down with feelings of pity for those who wish to seem to understand matters of which they know nothing.

Michelangelo's tactful treatment of Soderini had already proved profitable for in 1502, when the giant *David* was still under way, the Gonfaloniere obtained for him a commission for a small statue of David, in bronze. A French general, Pierre de Rohan, who had occupied the Medici Palace after the invasion of 1494, had requested a copy of Donatello's *David*, which was then in the palace courtyard. As the Florentine Republic was heavily in debt to France and the General was influential at court, Soderini was anxious to comply and he asked Michelangelo to make the statue. The idea of copying the Donatello seems to have been dropped as an early drawing for the project shows a sturdy muscular figure with one foot propped on the head of Goliath, a far cry from Donatello's effete youth and Michelangelo's own anxious adolescent giant. The technique of bronze sculpture, which involves modelling rather than carving, was unfamiliar and uncongenial to Michelangelo and even with the help of a master bronze caster he took years to complete the *David*. During this time the General fell into disgrace and another, more useful, recipient was sought. It was not until 1508 that the statue was dispatched to France, aptly to the King's secretary of.

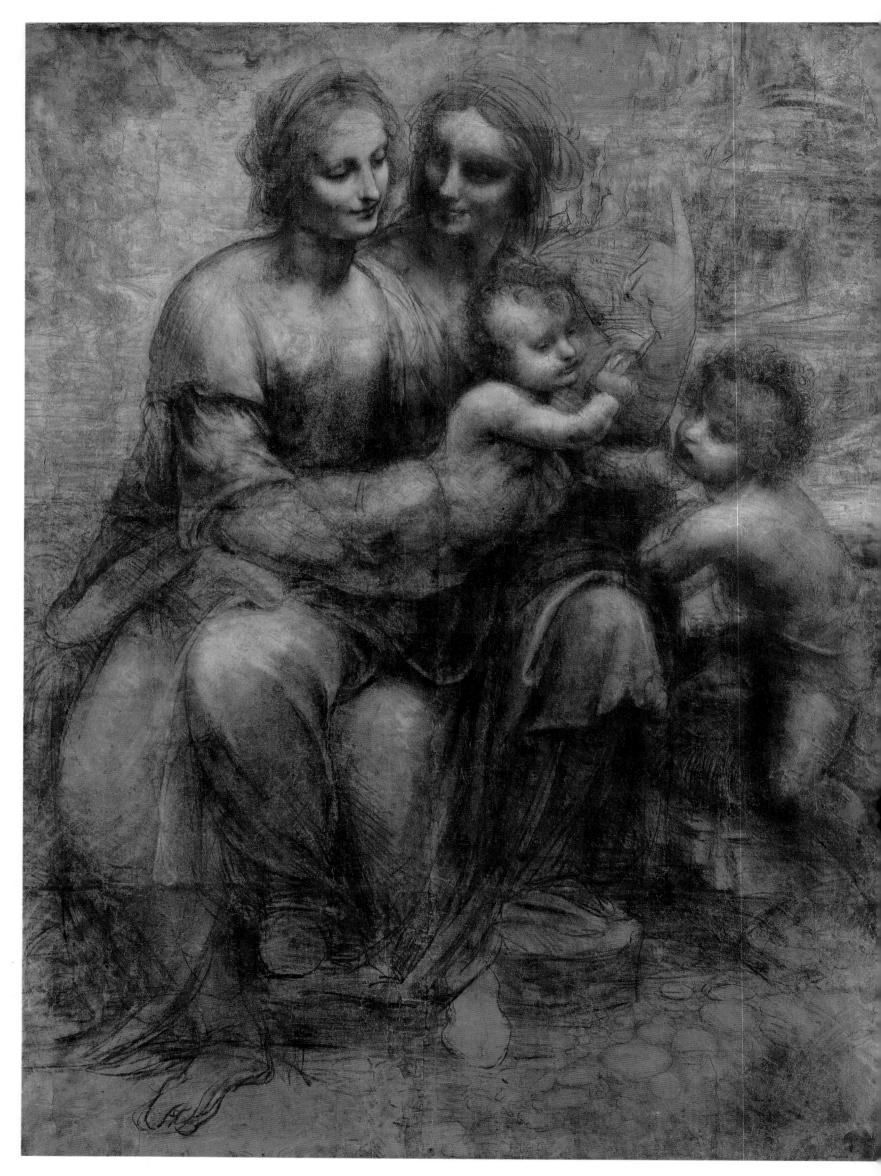

LEFT: Leonardo da Vinci, *Virgin and Child with St Anne and St John*, c. 1500, cartoon 55 × 40½ inches (141 × 104 cm), National Gallery, London. Leonardo's studies for an altarpiece of the Virgin and Child caused a sensation when they were exhibited in Florence after his return there in 1500.

RIGHT: Drawing of *Virgin and Child with St Anne*, c. 1501, pen and ink, 9¾ × 6½ (25.2 × 16.8 cm), Ashmolean Museum, Oxford. Michelangelo was one of the many artists influenced by Leonardo's cartoon, as is evident from this drawing.

finance. The bronze *David* remained in the courtyard of his chateau until the early seventeenth century when it was removed and, like the *Hercules*, simply disappeared. The only other possible trace of the project is a bronze statuette now in the Louvre which may have been cast from Michelangelo's wax model.

Leonardo had returned to Florence in 1500, a year before Michelangelo, and the exhibition of two versions of his cartoon for an altarpiece of the *Virgin and Child with St Anne and St John* attracted crowds of admirers, particularly artists. Michelangelo undoubtedly saw the cartoons and in a drawing of 1501 he experimented with a similar figure group, although his familiar fierce cross-hatch pen lines owe nothing to the soft *sfumato* (misty) modelling of the older artist. Leonardo's complex groupings of figures, related spatially and physically as well as psychologically, were an important inspiration for artists of the High Renaissance, particularly Raphael, and their influence is apparent in Michelangelo's works of this period, including three depictions of the Madonna.

One indication that Michelangelo not only drew inspiration from Leonardo but also intended to challenge him directly is the fact that he once more began to paint. The only securely attributed easel painting by him is a tondo, a circular picture probably commissioned to mark the marriage of Angelo Doni to Maddalena Strozzi in 1503. The tondo, like Raphael's slightly later pair of portraits of the couple, shows the influence of Leonardo's innovations. Evidence of Michelangelo's study of Leonardo can be seen in a preparatory study for the Doni Madonna which is in red chalk, a medium Leonardo introduced. The boldness and economy of the drawing show how quickly Michelangelo was able to master this new medium and use it in his own distinct

manner. In the painting the three members of the Holy Family are arranged in a Leonardesque pyramid. Their poses are active and artificially intertwined, with Mary and Joseph passing the Christ child between them, as if caught by a freeze-frame photograph. The figures are depicted with an unnatural clarity, so sharply defined they seem to be made of marble rather than flesh. It is wholly unlike the soft-focus, atmospheric quality of contemporary works by Leonardo, such as the *Mona Lisa* (c.1503). The crispness of the picture is also related to Michelangelo's use of the traditional tempera medium on wood panel rather than the new technique of painting with oil on canvas. The recent cleaning of the tondo has revealed the intensity of its bright shot colors, which

are reminiscent of Ghirlandaio's. Michelangelo's choice of such colors for the tondo suggests that the brilliant colors revealed in the cleaning of the Sistine ceiling are not merely the result of over-zealous restoration.

Leonardo was not the only artist from whom Michelangelo learned in this period, as is evident in the *Doni Tondo*. The tondo was a traditional form for paintings used for domestic decoration and an example by an artist whose work was sympathetic to Michelangelo, Luca Signorelli (c.1445-1523), hung in the Medici Palace when he lived there. Both Vasari and Condivi remark on Michelangelo's remarkable memory for works of art, which enabled him to 'avail himself of them so that scarcely anyone noticed'. The

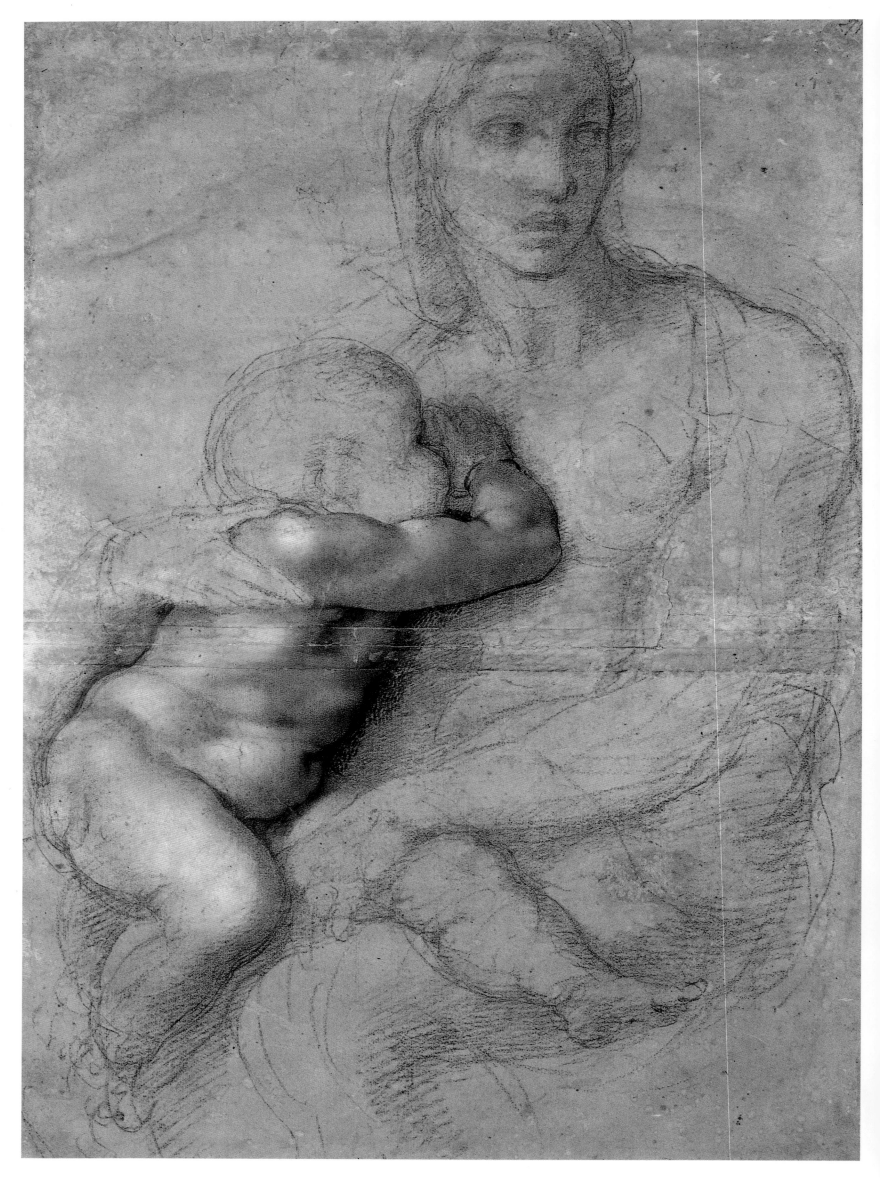

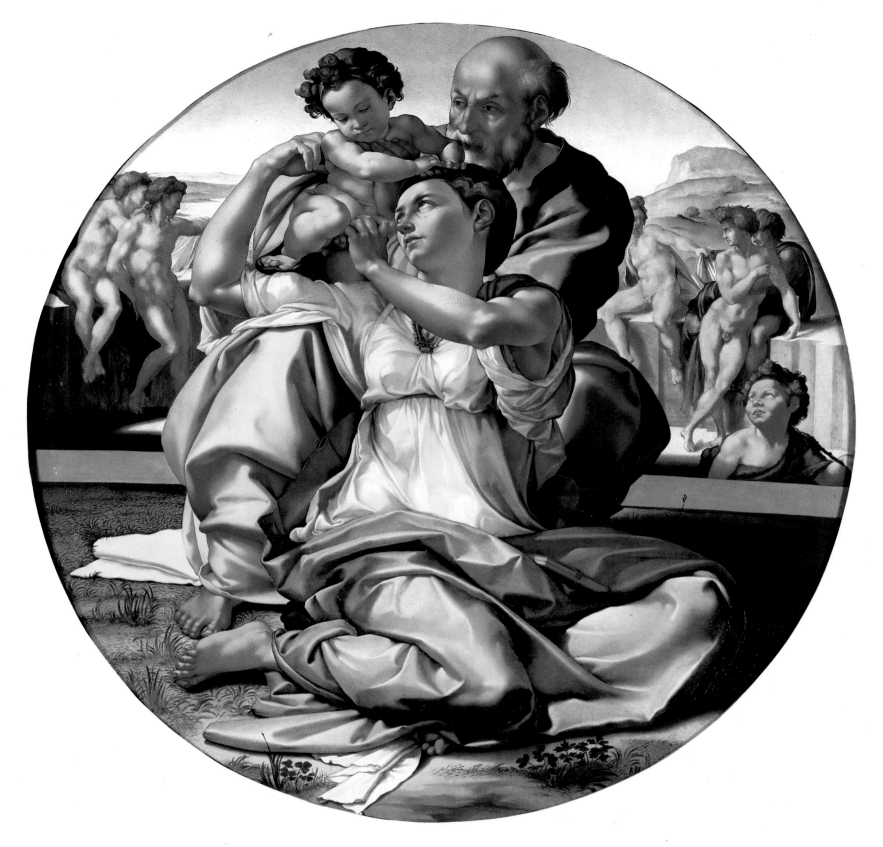

ABOVE: *Madonna and Child* (Doni Tondo), 1503-4, tempera on panel, diam. 46¾ inches (120 cm), Uffizi, Florence. The only securely attributed panel painting surviving by Michelangelo is this Leonardesque intertwined group. Its brilliant colors presage those revealed on the cleaned Sistine Chapel ceiling.

LEFT: Drawing for the Doni Madonna, red chalk, Museo Buonarroti, Florence. Michelangelo's study for the head of the Doni Madonna shows his early mastery of the red chalk medium made popular by Leonardo.

similarity to Signorelli's tondo of the Virgin and Child is particularly clear in the background of the *Doni Tondo*, with its disconcerting array of naked youths. Michelangelo shared Signorelli's interest in the nude figure, although his enthusiasm had a distinctly homoerotic overtone lacking in the older artist's work. The Doni youths have been interpreted as homosexual sinners, firmly beyond the pale of the Holy Family, but it is more likely that they are simply intended to represent pagan life before the possibility of salvation by Christ. The Baptist, as the means to that salvation, stands between the two groups. The elaborate frame of the tondo, with its sculpted heads of prophets and sibyls, echoes this comparison

of antique and Christian motifs, which Michelangelo was to explore further in the painting of the Sistine ceiling.

The *Doni Tondo* is an ambitious and impressive picture for Michelangelo's debut as a painter, but as a challenge to Leonardo it is not entirely successful. At this point Michelangelo's approach to painting was still essentially that of a sculptor, attempting to deny the flatness of the picture surface by creating a convincing imitation of three-dimensional objects.

Michelangelo often stressed his loyalty to the sculptor's profession, though there was perhaps an element of defiance in his stance as it was considered to have less status than painting. His rivalry with Leonardo was

BELOW: *Madonna and Child with the Infant St John* (Taddei Tondo), 1504-5, marble relief, 47½ inches (121.5 cm), Royal Academy of Arts, London. In this charming informal scene the infant Christ shies away from a bird held by St John, probably a goldfinch which was often used as a symbol of Christ's impending fate.

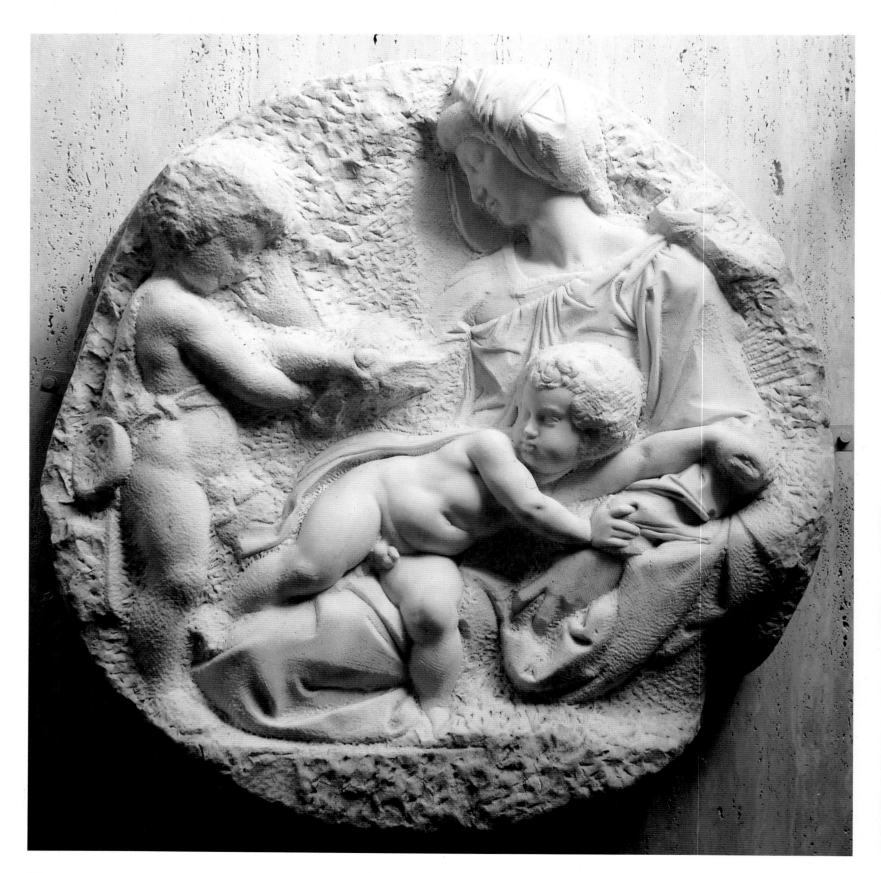

RIGHT: Raphael, *Bridgewater Madonna*, oil on canvas (ex-panel), c. 1506, 31½ × 21¾ (81 × 56 cm), Duke of Sutherland Collection, on loan to the National Gallery of Scotland, Edinburgh. The pose of the Christ child in Raphael's painting suggests that he knew Michelangelo's tondo, which was owned by Raphael's patron Taddeo Taddei.

based in part on this comparison, though there was considerable personal antipathy as well. Leonardo wrote scathingly about the difference between sculptors and painters in a passage which is a thinly disguised description of Michelangelo:

The sculptor in creating his work does so by the strength of his arm . . . by most mechanical exercise, often accompanied by great sweat which mixes with the marble dust and forms a kind of mud daubed all over his face . . . and his house is made filthy by the flakes and dust of stone.

By contrast, the painter:

Sits before his work, perfectly at ease and well dressed, and moves a very light brush dipped in delicate color . . . His house is clean and filled with charming pictures . . . not mixed with the sound of the hammer or other noises . . .

In fact, Leonardo's digs at sculptors' squalor were positively mild compared to Condivi's gruesome account of Michelangelo's unhygienic habits:

He generally went to bed with his clothes on, even to the tall boots, which he has always worn, because of a chronic tendency to cramp . . . At certain seasons he has kept these boots on for such a length of time, that when he drew them off the skin came away together with the leather, like that of a sloughing snake.

Despite its limitations as a painting, the *Doni Tondo* can be seen as Michelangelo's claim for recognition for the intellectual basis of his art. His convincing rendering of the figure group with its difficult foreshortening is a dazzling demonstration of *disegno*, a word meaning both drawing and design. *Disegno* was particularly valued by Central Italian artists, as it was a link between the lowly visual arts of painting and sculpture, and architecture, one of the high status liberal arts. During the sixteenth century painting and sculpture

also came to be accepted as liberal arts and were grouped with architecture under the general heading of the *Arti del disegno*. Michelangelo ultimately mastered all three art forms and was considered the greatest exponent of *disegno*.

Michelangelo's borrowings from other artists were always remade in his own highly individual style, his *maniera*, and his example helped free artists of succeeding generations from bondage to the past. Though the *Doni Tondo* includes ideas Michelangelo absorbed from other artists, it is a picture which could only have been made by him. Like its maker it is far from ingratiating, rather, as Symonds writes, 'it tyrannizes and dominates the imagination by its titanic power of drawing'. Michelangelo could be said to

have tyrannized the buyer as well: Angelo Doni, Vasari tells, 'although tight in other matters, spent willingly, although saving what he could, on pictures and statues'. When he baulked at paying 70 ducats for the tondo, Michelangelo asked for 100; Doni then offered to pay the original 70 but Michelangelo insisted on double, 140 ducats.

In contrast to the hard quality of the Doni painting, there is a greater sense of softness and atmosphere in the two marble tondi Michelangelo carved during this period. Although such circular marble reliefs were often used on tombs, these tondi were owned by two private collectors who simply admired Michelangelo's work, an indication of the increasing interest in art for its own sake, independent of its traditional religious function. The larger of the two

47

RIGHT: *Madonna and Child with the Infant St John* (Pitti Tondo), 1504-5, marble relief, diam 32 inches (82 cm), Museo Nazionale (Bargello), Florence. Both the Taddei Tondo and this smaller one made for Bartolommeo Pitti were left unfinished, providing interesting evidence of Michelangelo's carving technique with the claw chisel.

tondi, now owned by the Royal Academy in London, was bought and perhaps commissioned by Taddeo Taddei. Taddei was a patron of Raphael, who was often invited to his house and whose squirming Christ child in the *Bridgewater Madonna* reflects his familiarity with Michelangelo's tondo. The pose of the Christ child in the *Taddeo Tondo*, stretching across his mother's lap, recalls his pose in the Leonardo cartoon but has a different significance. In the cartoon his gesture is benedictional, while Michelangelo's Christ is cringing away from the infant John the Baptist who proffers a small bird. This bird, the goldfinch, was often used as a symbol of Christ's fate, the Passion, and the child's apprehension implies some inkling of this. Unlike the *Doni Tondo* the figures are not arranged in a tight group, instead the curving poses of the Virgin and Baptist follow the circular outline of the marble, with the Christ child forming a Leonardesque link between them. The Virgin, like the *Madonna of the Steps*, is shown in severe profile and gazing away from her son as if she too sees the future and knows she cannot protect him. The remote air of so many of Michelangelo's Madonnas is in marked contrast to the tender attentiveness shown by those of Raphael, a contrast which undoubtedly reflects differences in their early lives: Michelangelo sent to a wetnurse by the mother he scarcely knew, Raphael nursed by his own mother who was devoted to him.

The atmospheric quality of the *Taddei Tondo* is emphasized by its unfinished state. Vasari described both tondi as simply sketched out, which suggests that their lack of finish was not intentional. In the Taddeo relief the body of the child and parts of the mother are highly finished, while the infant Baptist is barely blocked out and the background is left pitted and rough. The partial finish of the tondo offers an interesting insight into Michelangelo's

technique, as it shows his use of the chisel at various stages. He was particularly skilled with the claw or tooth chisel, the *gradina*. As he chiseled round the forms, the claw left a network of lines like a web on the surface of the marble. These resemble the cross-hatch lines of his pen drawings, a variation of the same creative process. In his drawings as well as his sculpture, Michelangelo often highly worked only part of a composition, leaving the rest sketchy. Many figures have the torso finely finished while the head and limbs are scarcely roughed out. After the very polished works of the *Pietà* period, Michelangelo showed an increasing tendency to leave works incomplete. Sometimes he was compelled to abandon a piece by circumstances – a fault in the marble, or conflicting demands of patrons – but often he simply seemed to lose interest once he had worked out a solution, as if the idea were of more interest to him than the realization. We do not know why Michelangelo stopped work on the large tondo, though it may have been due to his return to Rome in 1505. Whatever the reason, it is interesting that in a period which placed a high value on finish, Taddei was willing to accept the work in its incomplete state.

The smaller marble tondo, made for Bartolommeo Pitti, is also incomplete but worked to a higher degree overall. The Virgin is seated on a stone, her body turned to the side, her head facing out at the viewer and not at the Christ child, who leans across the book she holds open on her lap. Her figure is carved in high relief, both the stone and her clearly modeled head projecting strongly into our space. Not a demure veiled Virgin with downcast eyes, she has a direct gaze and wears a curious winged headdress. As a type she is reminiscent of Pisano's sibyl and anticipates those on the Sistine ceiling (page 70). The Baptist is in very low relief,

barely scratched into the surface, so that the composition is dominated by the higher relief figures of the Virgin and child. In the *Taddei Tondo* the figures are arranged to echo the curves of the tondo shape; in the *Pitti Tondo* the seated Virgin and her child form a triangular shape which pushes against the circle and actually bursts out at the top, as if their creator had become impatient with the restrictions of the relief form and would carve a statue.

As the *David* was nearing completion in 1503, Soderini, conscious of his protegé's great talent, turned his attention to ways he might be employed afterward, for Michelangelo, he wrote to his brother, 'in his profession . . . is unique in Italy, perhaps even in the world'. The commission Soderini organized with the Wool Guild, the Arte della Lana, was an ambitious one: Michelangelo was to carve 12 over-lifesize statues of Apostles for the nave of the Cathedral in Florence. Even more extraordinary, the contract specified that all 12 statues should be completed within 12 years. The commissioners believed Michelangelo could complete the project at this unprecedented rate of one statue each year because of the speed with which he had carved the *Pietà* and the *David*. As an incentive they arranged to have a house built for him to live in rent-free for the period of the contract. At first the project went well; marble was brought from the quarry at Cararra in December 1504 and Michelangelo started work. But within a few months his progress was interrupted by unforeseen factors, including other important commissions and a demanding new patron, the Pope.

Michelangelo began carving only one of the 12 Apostle statues, the St Matthew. The massive figure is cut in rough relief on one face of the block so that it appears to be growing out of the stone. It is a most striking illustration of

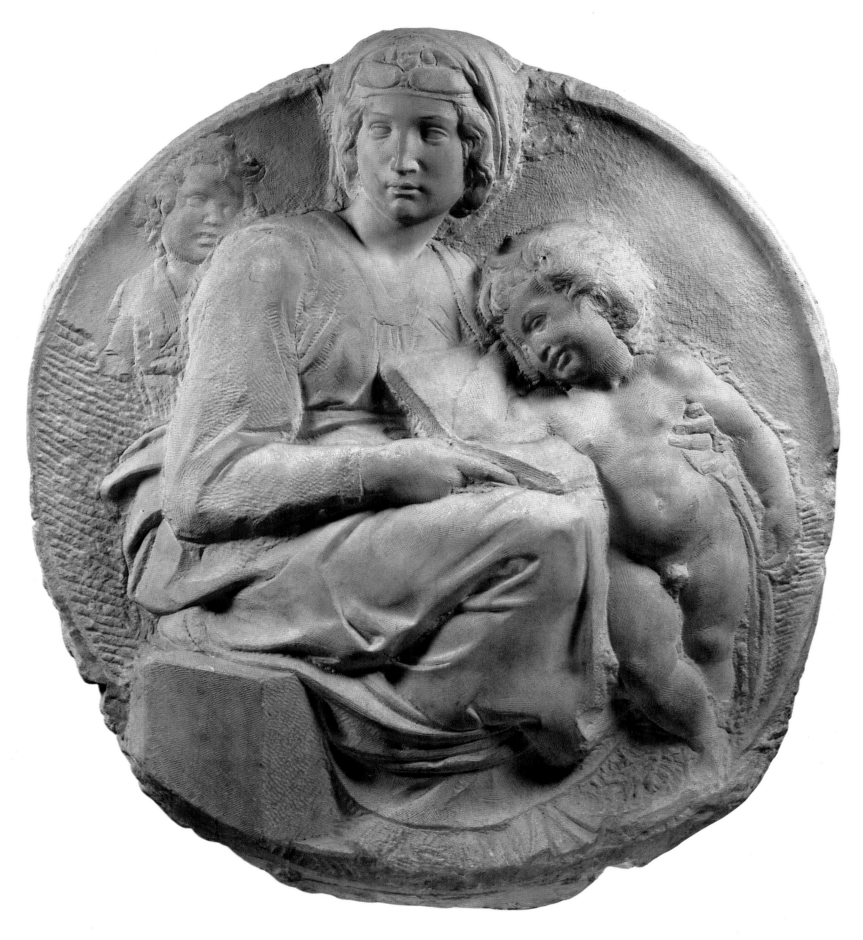

Michelangelo's method as a sculptor, working the block from the front, which Vasari described:

You first take a model . . . and place it lying in a vessel full of water . . . if you gradually lift the model, the higher parts are first exposed, while the lower parts remain submerged; precisely in the same way ought statues to be hewn out from the marble. This method was followed by Michelangelo.

This practice is a legacy of Michelangelo's training by Bertoldo in sculpting reliefs, which also may account for his tendency to design even freestanding statues with a frontal viewpoint. In Michelangelo's view a statue was not so much an invention of the sculptor as something he finds in the marble as he works. In a poem he wrote:

In hard and craggy stone the mere removal of the surface gives being to a figure, which ever grows the more the stone is hewn away.

For him the art of the sculptor was not building up a statue, but taking away the excess stone to liberate the statue it contained, for:

The best of artists hath no thought to show, that which the rough stone in its superfluous shell doth not include: to break the marble spell is all the hand that serves the brain can do.

49

RIGHT: *St Matthew*, 1503-8, marble, h. 105 inches (271 cm), Accademia delle Belle Arti, Florence. In 1503 Michelangelo contracted to carve twelve statues of the Apostles for the Cathedral in Florence, of which he began only the *St Matthew*. In its unfinished state the figure of the saint gives the impression of struggling to emerge from the marble rock.

The sturdy figure of St Matthew with its bent knee and sharply turned head introduces a new type in Michelangelo's work, a powerful figure in a twisted pose which suggests struggle against some kind of bondage, either physical or spiritual. The image may relate to the Neoplatonist idea that Man's soul is imprisoned in his body which informed much of Michelangelo's work. There are variations of the figure on the Sistine ceiling (page 86), in the Medici Chapel (page 110) and in the slaves and prisoners he carved for the tomb of Julius II (page 100). In fact its emergence coincided with the tomb commission and it may eventually have come to express Michelangelo's own frustration with his bondage to the project and its patron.

Michelangelo had worked on the St Matthew statue for only a few months when, in March 1505, he was summoned to Rome by the Pope. By the end of the year the Apostle contract was canceled because the St Matthew 'was not carved, nor will be'. The block remained in his studio and he may have worked on it again when he returned to Florence, as the figure suggests familiarity with the antique statue the *Laocoon* which was discovered only in 1506. The unfinished state of the St Matthew makes it intriguing to modern viewers, whose reaction is conditioned by works such as those by Rodin, which were left deliberately incomplete. In the Renaissance, however, great value was placed on a high degree of finish in works of art, both by patrons and by artists themselves. Michelangelo criticized Donatello for producing pieces which were not polished enough to stand close scrutiny, and the statues on which his reputation was built, the *Bacchus*, the *Pietà* and the *David*, are highly finished. This is the state to which Michelangelo intended to bring all his statues; he had no wish to send his stone offspring unformed into the

BELOW: Aristotile da Sangallo. Copy of part of Michelangelo's *Battle of Cascina* cartoon, c. 1542, grisaille on panel, Viscount Coke, Holkham Hall, Norfolk. The commission for a fresco of the Battle of Cascina gave Michelangelo an important chance to demonstrate his skill at depicting male nudes in action. His cartoon, which was greatly admired, was lost and all we known of its appearance is this copy of one section.

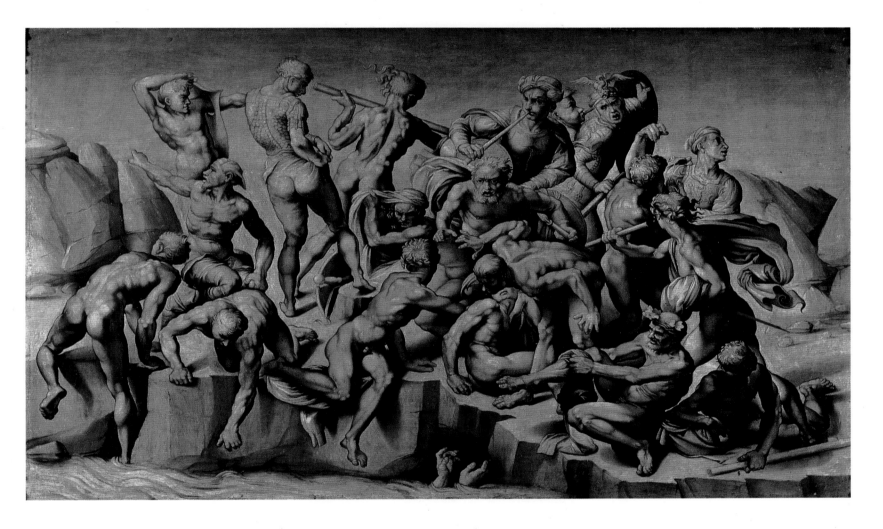

world. To him, a rough relief was in no sense a substitute for a finished freestanding statue. Nevertheless, it is undeniable that some of the statue's power is due precisely to its unfinished state, and the violence visible in the carving gives an autobiographical intensity to the tormented figure of the saint.

The rivalry between Michelangelo and Leonardo was made public in 1504 when both were asked to paint murals for the great Council Hall, the Sala del Gran Concilio, of the new republican government. Florence was then engaged in a struggle to regain control of Pisa, lost during the French invasion, and the decoration of the Sala with paintings of Florentine military vic-

tories was designed as propaganda for the government. Leonardo was commissioned to paint the battle at Anghiari, when Florentine mercenaries defeated troops of the Visconti in 1440. He was particularly known for his skill at drawing horses and his painting of the battle showed a furious *melée* of horsemen fighting for possession of a standard. Leonardo's mural was completed quickly and received great acclaim but, like the *Last Supper*, it was painted in a faulty experimental fresco technique and it deteriorated irreparably. Neither the huge mural nor his fullscale cartoon, or preparatory drawing, survive, and even its reputed size – about 20 × 60 ft – is conjectural. The influence of Leonardo's composition

lasted long after the work itself had disintegrated, however, and our only hint of its appearance is a lively free drawing of the central group of horsemen by Peter Paul Rubens, now in the Louvre.

Michelangelo's cartoon for the decoration of the Sala was equally celebrated and influential and it suffered a similar fate, though for different reasons. For his mural, which was to be the same size as Leonardo's, Michelangelo chose a subject designed to display his supreme skill as a draftsman of the male nude. The central section depicted an incident that provided the excuse for his display. This occured at Cascina in 1364, when Florentine troops bathing in the river before the

LEFT: Drawing of *A Youth Beckoning*, c. 1503-4, pen and brown ink, 14½ × 10 inches (37.5 × 23 cm), British Museum, London. An elegant study of a striding figure, this dates from the period when Michelangelo was working on the Cascina cartoon and was possibly related to that project.

one of the soldiers. Vasari's account of the work is informative about Michelangelo's use of mixed media but not about the overall scheme:

He filled it with nude figures bathing in the Arno owing to the heat . . . also nude figures with twisted draperies running to the fray, foreshortened in extraordinary attitudes, some upright, some kneeling, some bent, and some lying. There were also many groups sketched in various ways, some merely outlined in carbon, some with features filled in, some hazy or with white lights, to show his knowledge of art.

Surviving studies of groups of men and horses suggest that these may have been part of subsidiary scenes intended to challenge Leonardo's supremacy at equine anatomy.

Michelangelo worked on the vast battle drawing in a room at the Dyers' Hospital (Ospedale dei Tintori) and, typically, refused to let anyone see it. Work on the cartoon, as on the St Matthew, was interrupted by his call to Rome in 1505 but he finished it on his return to Florence the following year. He never began the wall painting and as his cartoon was moved to the Sala only after Leonardo's painting was completed, in 1508, there is no suggestion that their battle of the paintbrush was conducted face to face.

Michelangelo's cartoon was hailed as a triumph and installed in the Medici Palace, where it was used as a school by young artists. By 1516 the excessive attentions of admirers determined to copy it had torn the cartoon to shreds. Benvenuto Cellini, who saw it as a boy, was so impressed that he declared it surpassed even the Sistine ceiling:

Nothing survives of ancient or of modern art, which touches the same lofty point of excellence . . . Though the divine Michelangelo in later life finished that great chapel of Pope Julius . . . his genius never after-

battle were nearly surprised by Pisan forces led by the English mercenary Sir John Hawkwood, known as Giovanni Acuto, who was the subject of an equestrian portrait by Paolo Uccello. The hero of the day, Manno Donati, realized the Florentines were vulnerable to attacked and raised the alarm in time for them to dress and defend themselves successfully. A copy of the central bathing scene by Aristotile da Sangallo is all that remains to give us an idea of the general composition. In any case, Michelangelo tended to make preparatory drawings for particular ele-

ments rather than for the work as a whole, a tendency which proved a disadvantage in largescale projects of the sort which now increasingly occupied him.

There are, however, numerous drawings of individual figures for the mural, such as that for the spear thrower. Here Michelangelo shows his characteristic inclination to bring the torso to a higher degree of finish than the rest of the figure. The beautiful ink drawing of a youth, which clearly derives from the antique statue known as the *Apollo Belvedere*, may have been

RIGHT: *Apollo Belvedere*, 2nd century A.D., marble, h. 87½ inches (224 cm), Vatican Museum, Rome. The pose of the striding youth in the drawing derives from the famous statue of Apollo which belonged to Cardinal Giuliano delle Rovere, the future Pope Julius II.

ward attained to the force of those first studies.

Cellini's judgment, like Vasari's, reflects the contemporary Central Italian preoccupation with drawing and the male nude – of which Michelangelo's cartoon represented the pinnacle – and many critics would disagree. As in his battle relief, Michelangelo shows little indication of any interest in setting or landscape; the cartoon is treated almost as an arrangement of statues. In his enthusiasm to demonstrate his virtuosity at drawing the nude male in the greatest variety of poses, Michelangelo perhaps lost sight of the meaning the republicans wished to convey by the story, the need for an organized militia to protect the city's interests.

Michelangelo never equaled the subtle flow of Leonardo's compositions; his interests lay elsewhere. His achievement in the cartoon was to develop the limited anatomical vocabulary of fifteenth-century artists such as the Pollaiuoli into a noble language of forms which he employed to far greater effect in the Sistine Chapel. Used by him the language remained pure, but in other hands it could become exaggerated and eventually decadent. Michelangelo's pride in conquering difficulties in his quest for ideal beauty eventually led to the extreme artifice of late Mannerism, a danger understood by Leonardo who wrote of the cartoon:

O anatomical painter, beware, lest in the attempt to make your nudes display all their emotions by a too strong indication of bones, sinews, and muscles, you become a wooden painter.

There are two unfinished paintings in the National Gallery in London which are associated with this period of Michelangelo's life, though in both cases the attributions have been controversial. The most dubious is one commonly known as the *Manchester Madonna*, which shows the Virgin, Christ child and infant Baptist flanked by four angels. The style suggests it is earlier than the *Doni Tondo*, or by a lesser artist. The Virgin's rocky platform and the soft modelling of the flesh indicate the influence of Leonardo, but the old fashioned frieze-like arrangement of the figures and the crisp drawing do not. The anecdotal gesture of Christ, the coy Baptist clutching his wrap, the decorative curls of the angels' hair, and the gratuitiously exposed breast of the Virgin give the painting an ingratiating charm at odds with Michelangelo's uncompromising vision.

The larger of the two National Gallery paintings, the *Entombment*, is more convincingly attributed to Michelangelo, although it has not always been treated with respect: the pitting on the surface was caused by fly droppings and it has been suggested that at some point the picture was used as a counter in a fish stall. It is unfinished and was apparently painted in two stages as there are changes in both style and medium. During the first decade of the sixteenth century Italian painters began

ABOVE: *Entombment*, c. 1506, tempera and oil on panel, National Gallery, London. An unfinished painting, possibly intended for inclusion in an early version of the tomb for Julius II. It appears to have been painted in two stages, first in tempera and with later additions in oil.

RIGHT: *Laocoön*, c. 150 B.C. or later Roman copy, marble, h. 95½ inches (244 cm), Vatican Museum, Rome. Michelangelo was present when this marble group was discovered buried in a Roman vineyard in 1506, and its struggling bound figures influenced many of his works, possibly including the *Entombment*.

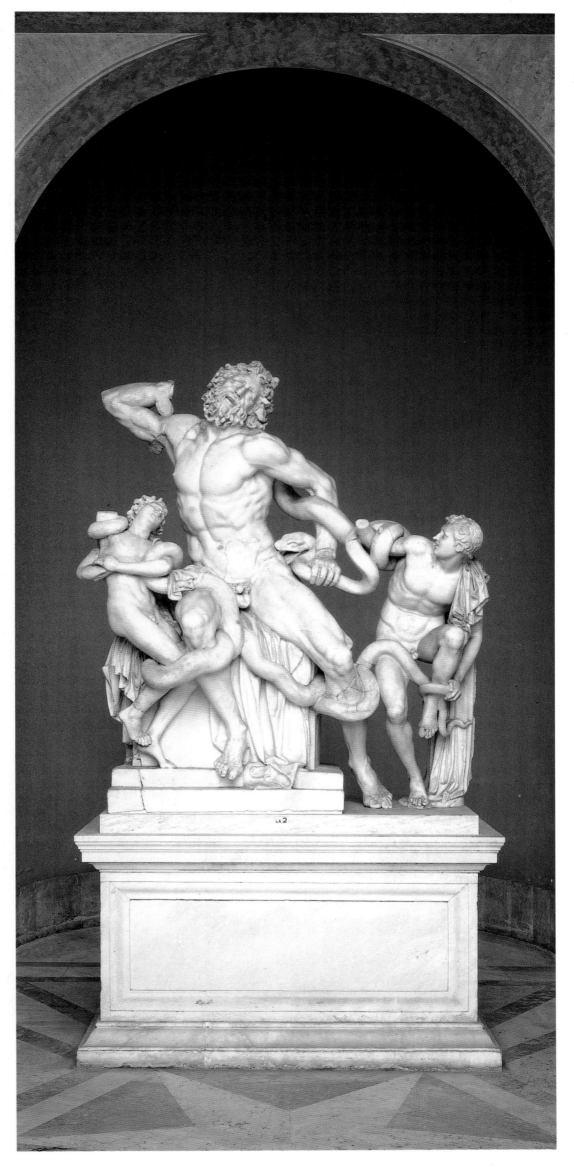

to switch from their traditional egg tempera to the new oil technique imported from northern Europe. The *Entombment* was started in the old-fashioned technique: the poplar wood panel has a thin coating of gesso and the first layers of paint are tempera but the upper layers are oil, which suggests they were painted at a later date. There are also stylistic differences between sections of the painting. The androgynous figure in red is painted in the marmoreal manner of the *Doni Tondo*, with similar bright enamel-like color and no visible brushstrokes. The haughty female in green, a color which will have dulled with age, is more loosely painted, as is the Christ. His beautiful corpse relates to the Christ in the *Pietà*, while the bearded man behind him resembles the Doni Joseph. The *Entombment* was probably begun after the tondi, in about 1505 when Michelangelo had returned to Rome to work on the Pope's tomb. It may even have been intended for the tomb at one point. The painting was interrupted for a time and the second stage of work shows clearly the influence of the writhing figures of the *Laocoon*, the antique marble group described by Pliny which was found by a peasant digging in a Roman vineyard in 1506. Michelangelo was present when the statue was dug up and identified by his friend Giuliano da Sangallo. The *Laocoon* was one of a small group of ancient statues which had a lasting fascination for Michelangelo, and its violent physical expression of a spiritual struggle is often echoed in his own work. The existence of a third stage of the painting process may be indicated by the mannered poses of the kneeling girl, for which there is a drawing, and of the lady in green. For unknown reasons the *Entombment* was never finished and it offers only hints of the painting skill Michelangelo was to demonstrate so triumphantly in the Sistine Chapel.

Painting and Sculpture: Rome 1505-1564

The Sistine Chapel Ceiling

MICHELANGELO did not want to paint the ceiling of the Sistine Chapel. Pope Julius had mentioned the possibility as early as May 1506, but Michelangelo had set his heart on sculpting the papal tomb and did not want to be fobbed off with a painting project, especially such a difficult one. Despite his training with Ghirlandaio and the success of the Cascina cartoon he insisted that painting was not his trade. He had not had extensive experience in fresco technique or as a colorist and he knew painting the huge vault would be particularly awkward. Condivi claims Michelangelo was so anxious to avoid the commission that he urged the Pope to give it to Bramante's man, Raphael. As Michelangelo suspected that Bramante had encouraged the Pope to have him paint the ceiling in the hope that he would be defeated by the task, Michelangelo may have had a similar fate in mind for Raphael. But Julius insisted that Michelangelo himself should do it, and in May 1508 he very reluctantly agreed. The commission Michelangelo accepted so grudgingly was to become his triumph. In view of his reluctance it is ironic that the Sistine ceiling was the only major project ever completed by him. It is also ironic that Michelangelo, who for most of his life preferred to be known as a sculptor, is probably best known for this painting.

The Chapel Michelangelo undertook to paint was built by the uncle of Julius II, Sixtus IV, as part of his campaign to reassert the papal presence in Rome after the years of exile in Avignon during the Papal Schism. The building was begun about the time of Michelangelo's birth in 1475. In view of the immense amount that has been written about the painted decoration of the Chapel, it is interesting that the identity of the architect is not certain. It was probably designed by the supervisor of the Vatican Palace, Giovannino de' Dolci. This imbalance of information reflects the great change in attitude toward artists which took place during this period. When artists were still equated with craftsmen there was little concern to identify them with their products and it was the patron who was seen as the creator of a work of art. By the end of the fifteenth century artists and architects had risen significantly in status and their names were recorded as assiduously as those of patrons. Today, the balance has shifted to such an extent that Michelangelo is more widely identified with the Chapel than is its eponymous patron Sixtus.

The design of the Chapel reflects its functions. One of these was to act as a bastion of the Vatican, a reminder that the papal palace in Avignon had more than once been under siege. With walls nine feet thick and high windows, it loomed over the other Vatican buildings like a fortress. As the Chapel itself is so high – equivalent to the nave of a High Gothic cathedral – it is surprising to find that it is only one part of a building on three levels; below the Chapel there are barrel-vaulted chambers and above it an attic surrounded by a crenellated guards' walkway with slits for firing. The Chapel itself is proportioned according to the description of the temple of Solomon in the *Book of Kings*: the length is three times its width and twice its height (about $132 \times 46 \times 63$ feet). Its large size was dictated by its use as a meeting place for the Papal Chapel, a group which assembles on certain ceremonial occasions, notably for papal elections, and which in Sixtus' day numbered about two hundred. These meetings were the most important public demonstrations of papal power and the Chapel was to provide a stage of suitable splendor.

The decorative scheme of the Chapel also reflects its functions. The floor is covered with a type of mosaic paving used in Early Christian churches, which later came to be known as *cosmati* work. Its geometric patterns add to the general effect of richness but they also indicate the processional route, the participants' positions in ceremonies and the division of the Chapel into two areas, one for the clergy (the presbytery) and one for the congregation. The screen which marks this division once stood on the line marked by the floor but in the 1550s it was moved eastward to enlarge the presbytery. The fenestration has also been changed. Originally there were six windows on each long wall, with two over the altar and two blind windows over the entrance, but the altar wall windows were filled in for Michelangelo's *Last Judgment*. The Chapel's dedication to Mary Assunta was reflected in the altarpiece fresco of the *Assumption* by Raphael's master Pietro Perugino, also later destroyed to make space for the *Last Judgment*. The decoration of the wall is in three tiers. At ground level there are painted curtains which were covered by tapestries on ceremonial occasions. The set of tapestries commissioned from Raphael in 1515 was dispersed after the Sack of Rome; the preparatory cartoons are in London. At the top, between the arched windows, are figures of popes who predated the first Christian Roman emperor, Constantine. The middle section is banded by two fresco cycles commissioned by Sixtus from Perugino and other leading Tuscan artists, including Ghirlandaio, Signorelli, and Sandro Botticelli. (The future Pope Julius, then still a cardinal, appears as a witness in one scene.)

RIGHT: Sistine Chapel, interior view from the east.

56

LEFT: Raphael and others. Ceiling of the Stanza della Segnatura, c. 1508-9, fresco and mosaic, Vatican Palace, Rome. At an early stage of his plans for the ceiling of the Sistine Chapel Michelangelo considered using a scheme derived from antique Roman decorations, such as this slightly later example by Raphael.

These frescoes were the dominant feature of the original decorations of the Chapel and the most important vehicle for propaganda. Designed to demonstrate the basis of papal authority, they showed scenes from the life of Moses on the south wall and parallel episodes from the life of Christ on the north. The intention was to stress the authority of the law of Moses (*tempus legis*) in the Old Testament and its legitimate succession by Christ's evangelical law, the era of grace (*tempus gratiae*) in the New Testament. The images of early popes are a reminder of the apostolic succession of the papacy from Christ and Peter; the popes are Peter's successors. This emphasis on legal succession in the decoration of the Chapel was particularly important for reestablishing the papacy after the exile in Avignon.

In contrast to the elaborate decoration ordered by Sixtus for the floor and walls, the ceiling was relatively simple: a heavenly blue ground with gold stars in the tradition of the Arena Chapel in Padua painted by Giotto. As the walls had been painted by masters of the previous century, Julius determined to have the ceiling redecorated in the modern manner. The scheme he proposed to Michelangelo, consisting of twelve Apostles on the twelve pendentives supporting the vault, was relatively modest and would have continued the apostolic theme of Sixtus' wall decoration. In his first sketch for the ceiling Michelangelo drew an Apostle seated on a throne surrounded by ornamental geometric forms. This type of geometric decoration was derived from the ceilings of the underground vaults of Nero's Golden House, which had been recently excavated in Rome. The vaults were thought to be caves (*grotte*), thus imitations of their decoration were known as *grotteschi*. The decorations of the Golden House caused great interest among artists in

59

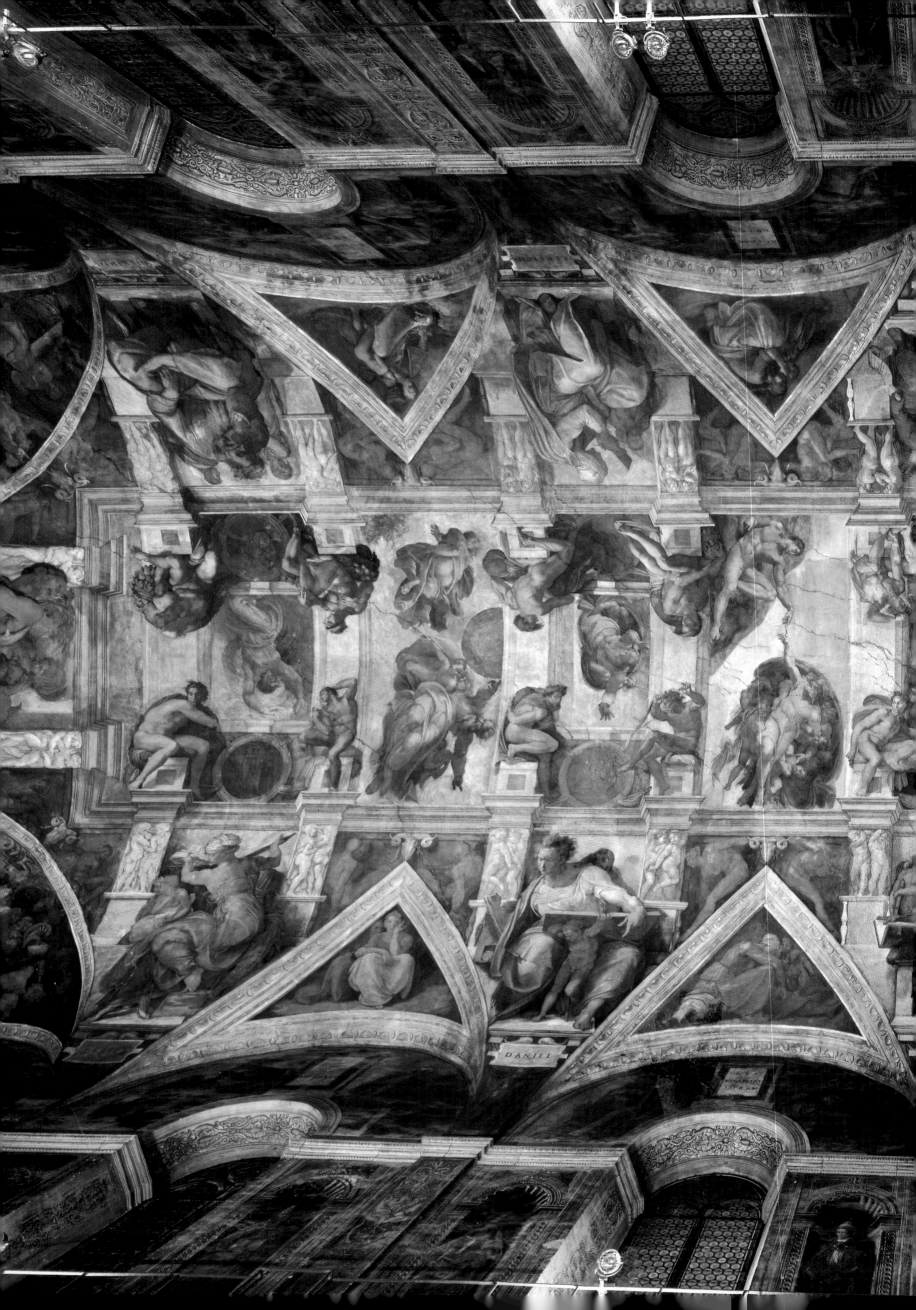

DANIEL

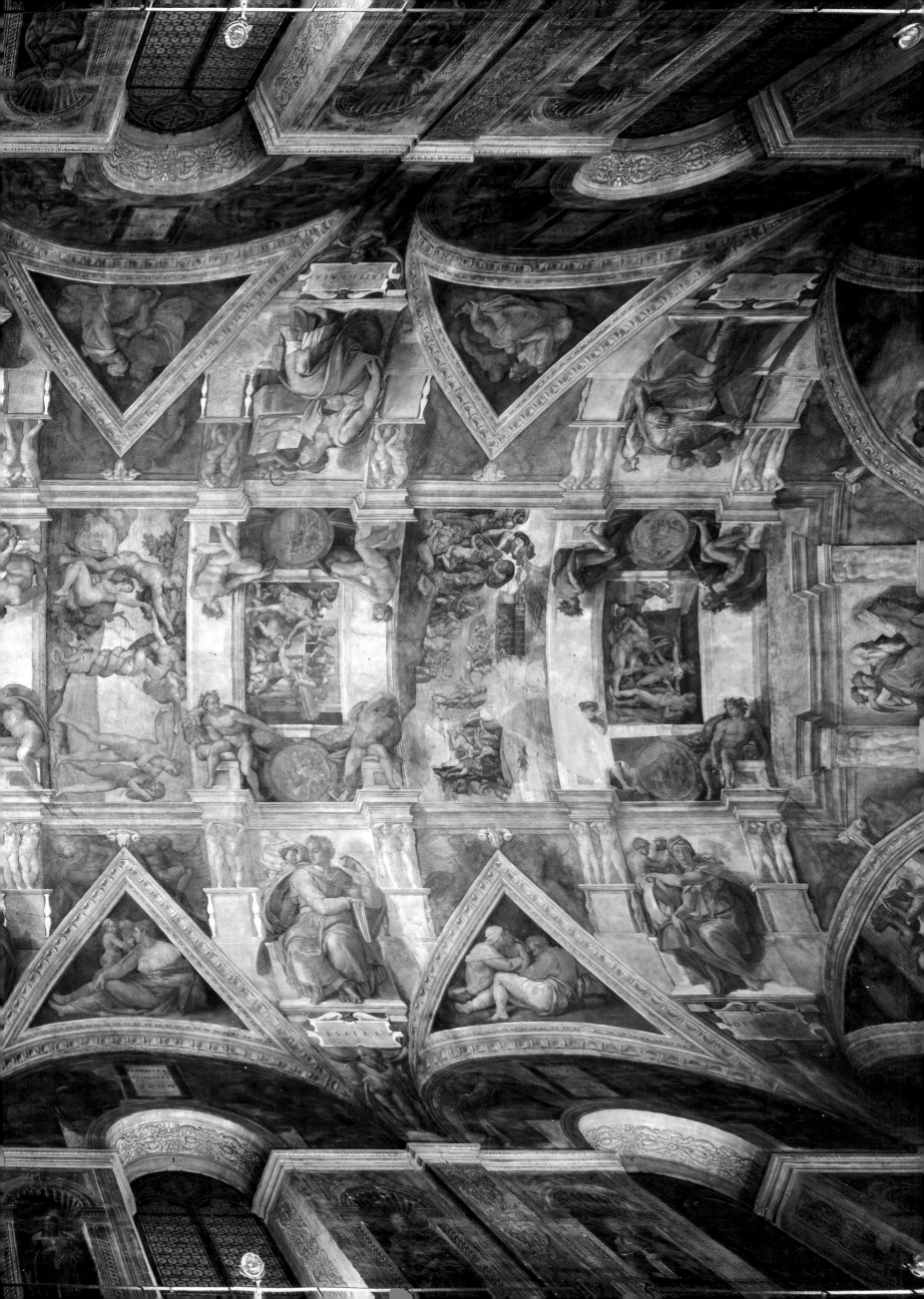

PREVIOUS PAGE: Ceiling of the Sistine Chapel, 1508-12. Michelangelo's final design for the ceiling is based on an illusionistic architectural structure, which provides a unified setting for a complex composition including paintings and fictive sculpture.

RIGHT: Sistine Chapel ceiling, east end. Michelangelo began painting the ceiling at the east end, and the scenes he completed first – the *Drunkeness of Noah*, the *Deluge*, and *Noah's Sacrifice* – are difficult to decipher as they contain many small figures, a problem he corrected in sections painted later.

Rome and some, like Raphael, descended on ropes to view them. Modern versions of the vaults were painted about this time by Bernardo Pinturicchio in Sta Maria del Popolo in Rome, and by Raphael in the Vatican Stanza della Segnatura. Michelangelo was soon dissatisfied with this first plan and complained to the Pope that it would be a 'poor thing' because, he added nonsensically, the Apostles themselves were poor.

Julius agreed to a change of design, though Michelangelo's claim that the Pope then 'let him do what he wanted' should not be taken literally. Michelangelo was unusually well educated for an artist but he would not have been allowed to determine on his own the iconographical content of the principal papal chapel. The subtle and complex program of the ceiling must have been worked out with the help of a theologian, whom Michelangelo in typical fashion does not credit. Two important contemporary religious writers have been proposed as authors of the program: the Augustinian leader and classical scholar Egidius of Viterbo; and Santi Pagnini, a biblical scholar and disciple of Savonarola. Only Michelangelo, however, could have been responsible for the unprecedented grandeur of the visual expression given to the program, the greatest pictorial ensemble in the history of Western art.

Michelangelo did not begin work on the ceiling until the winter of 1508-9, having spent the intervening months drawing and buying materials. Bramante, as the palace architect, was asked to prepare the scaffolding and, because the floor of the Chapel needed to be left free for services, he decided to suspend a platform from the vaults by ropes. Michelangelo scoffed at this arrangement and pointed out that when the ropes were removed they would leave holes which could not be filled. He insisted on using a structure of his own design, which resembled a wooden bridge projecting from the walls on brackets near the top of the windows. From the steps and platform of this bridge he could reach all the surfaces he needed to paint: the arches over the windows, known as lunettes; the triangular areas over the windows, the spandrels; the four larger corner spandrels; the pendentives supporting the vault; and the vault itself. Vasari claims Michelangelo's scaffolding design was so successful that it was taken up for vault-building by architects including even Bramante, though it is more likely that it was an adaptation of a type already in use for that purpose. Nevertheless, its effectiveness is demonstrated by the fact that the recent cleaning of the walls and ceiling was done from a similar scaffold built in modern materials.

While the Chapel was being prepared, Michelangelo arranged for five painters, including his old friend Francesco Granacci, to come from Florence to act as his assistants on the huge project. The assistants were more experienced than Michelangelo in fresco technique but he quickly found fault with their work and, according to Vasari, 'locked himself up in the Chapel, and determined to complete the work in solitude'. The phrase 'in solitude' is misleading. Michelangelo did paint all the most important ceiling figures himself, but he did not work entirely on his own. He did not grind his own colors or prepare the *giornate* (daily measures) of plaster; later remarks by Vasari make it clear that he had workmen for such tasks. What he did dispense with, indeed could not tolerate, was any significant artistic assistance. His inability to cultivate a group of coworkers or to run a studio school was a serious shortcoming which he only partially overcame by heroic effort over a long life. Successful rivals such as Raphael employed many assistants and

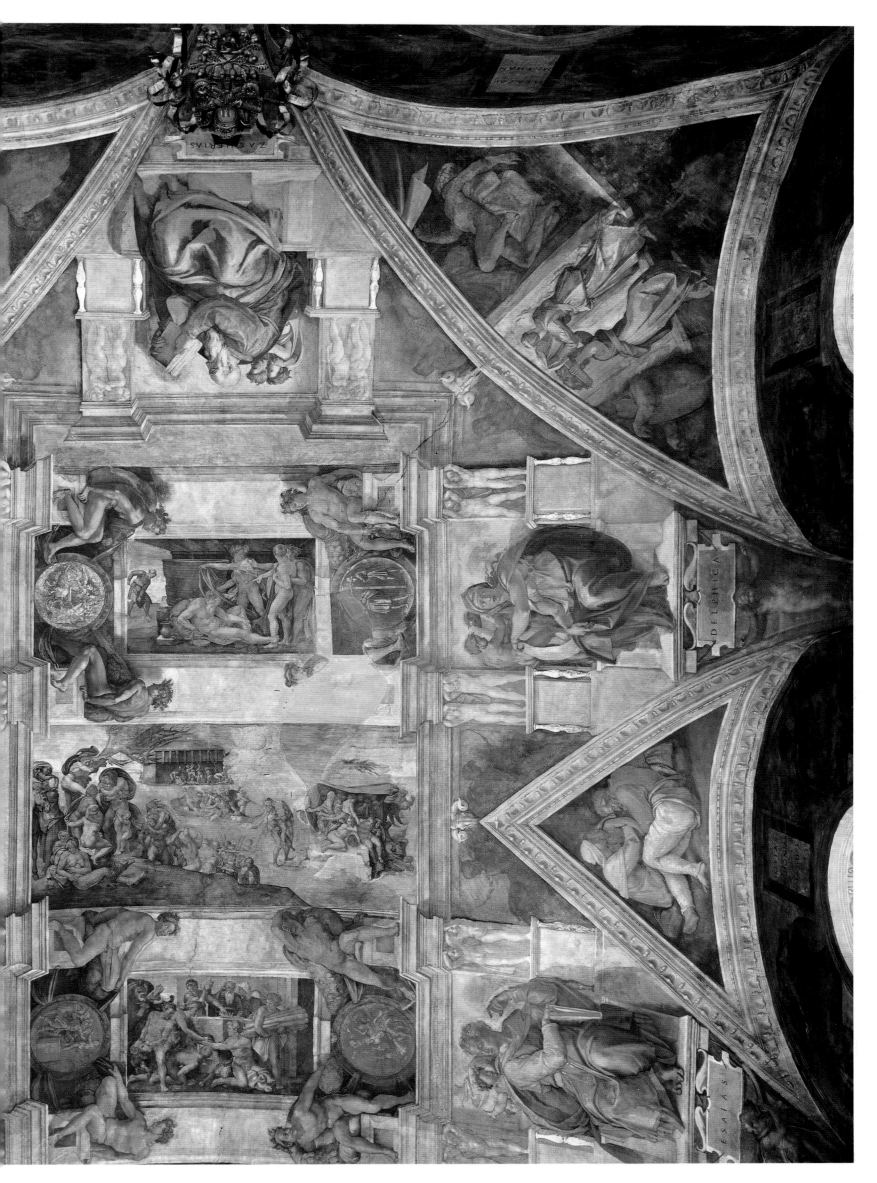

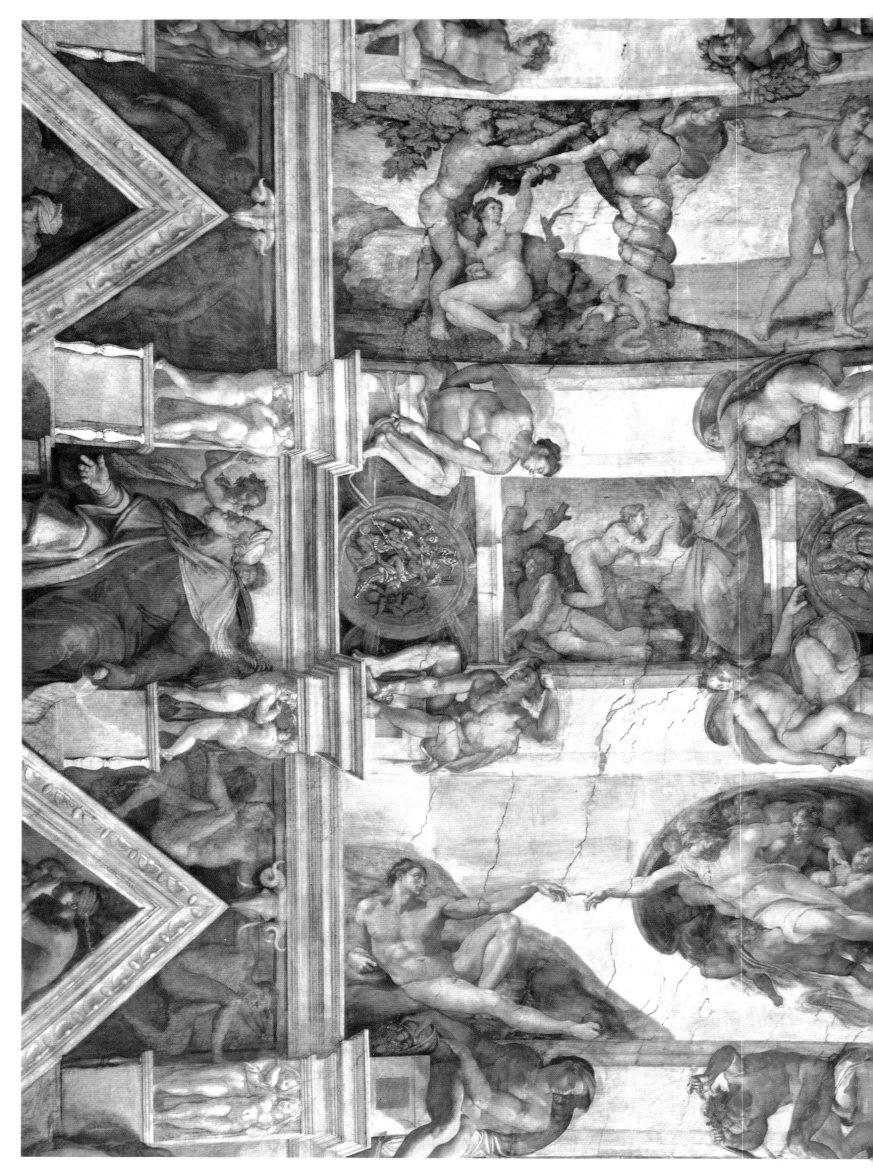

LEFT: Sistine Chapel ceiling, central section. The vault panels at the center of the Chapel show scenes of Adam and Eve: The *Temptation of Eve* and the *Expulsion from Paradise* are combined in one panel; the *Creation of Eve*; and, perhaps the most famous image from the ceiling, the *Creation of Adam*.

with their help were able to complete numerous large projects. Michelangelo was given many important commissions which he simply did not have the temperament and organization to carry out. This aspect of his personality particularly affected sculptural projects, which were far more time-consuming and physically demanding. Although he once wrote dismissively of painting as suitable only for women and lazy men, it was precisely the relative ease of the painting technique, even fresco painting, which permitted Michelangelo to complete this one great project of the many he began.

Michelangelo's working methods were sometimes unconventional and unpredictable in their results. It was the usual practice for an artist planning a fresco to begin by making sketches of the whole composition and then more detailed drawings of various sections and individual elements. These drawings would be used to make fullscale cartoons which assistants could transfer to the wet plaster as a guide for painting. Transferring was done by incision, tracing over the cartoon with a sharp instrument, or by pouncing, dusting charcoal through tiny holes pricked along the outlines of the cartoon. (The holes made for pouncing can be seen in the frontispiece portrait cartoon of Michelangelo by Daniele da Volterra.) By carefully planning the entire composition in advance, much of the actual painting could be delegated to assistants and large projects could be completed relatively quickly and efficiently. Michelangelo, working without assistants, was necessarily less efficient, but he was able to be more improvisory in his approach and the completedceiling shows that he made significant modifications when the painting was already well under way. Although it may indicate what his biographer Symonds called 'remarkable want of foresight', the evidence of the

surviving drawings suggests that even for a project on this vast scale Michelangelo followed his usual practice of concentrating on the trees not the woods – on individual figures rather than the general composition. More surprising, the recent cleaning has revealed that he did not always use pricked or pounced cartoons but instead may have drawn freehand directly on the wall. Such spontaneity was risky as true fresco, like marble carving, is an unforgiving medium in which it is very difficult to make corrections. If the artist is dissatisfied with a particular passage, he must hack off a whole section of plaster and wait for the new plaster to set before he continues. The evidence of the *giornate* suggests that Michelangelo did exactly this in some parts of the ceiling.

The iconographical scheme followed by Michelangelo for the ceiling was developed in relation to the two earlier fresco cycles on the Chapel walls which, as we have seen, illustrate the history of Man under the old law of Moses and under the new law revealed by Christ. The ceiling depicts incidents from the beginning of the world, before the old law (*ante legem*). Along the center of the vault are nine panels illustrating the Creation and Fall of Man, its destruction in the Flood and salvation in the chosen family of Noah. The last scene, the *Drunkenness of Noah*, signifies Man's perpetual return to sin and need for redemption. In the places originally intended for the twelve Apostles, Michelangelo painted the pagan sibyls and Hebrew prophets who predicted the arrival of a Messiah. Muscular male nudes, the *ignudi*, clasp garlands and drapes supporting bronze medallions which illustrate scenes from the Old Testament. Between prophets and sibyls, and in the window lunettes below, are the ancestors of Christ, a gloomy lot representing humanity waiting in darkness for the light of hope.

LEFT: Jacopo della Quercia, *Creation of Eve*, 1430-34, istrian stone, facade of San Petronio, Bologna. Quercia's facade for San Petronio, which Michelangelo knew from his early days in Bologna, clearly influenced his design for the Sistine scene of the *Creation of Eve*.

RIGHT: Drawing for *Adam*, c. 1511, red chalk, 7½ × 10 inches (19.3 × 25.9 cm), British Museum, London. A working drawing of a model for the figure of Adam. Typically it is more highly finished in the torso than in the extremities.

Michelangelo had long been involved in plans for Julius' tomb when he began designing the ceiling and it has often been observed that its painted architecture and sculpture reflects ideas he had developed originally for the tomb, which was also based on single figures in an architectural setting. There are similar resonances in his designs for the facade of San Lorenzo and for the Medici Chapel. He treated the entire ceiling as an imaginary architectural structure which appears to extend above the Chapel and open to the sky. The ancestor lunettes and spandrels are separated from the main vault by fictive stone frames. On the pendentives between these the prophets and sibyls are seated on thrones linked by a cornice which bands the entire ceiling. Above the cornice the *ignudi* perch on pedestals, in front of pilasters which extend across the vault to form a grid enclosing the central scenes. This architectural structure gives unity to the large and complex composition and at the same time establishes three separate zones for figural painting. The zones can be read as a kind of hierarchy of reality. The lunettes and spandrels are the lowest zone, the closest to the viewer's world. The prophets and sibyls of the second zone are also painted with foreshortening which relates to the viewer on the floor. The nine vault scenes, however, represent a different level of reality, each one treated as an independent picture with its own perspective. The variety of perspective and of figure scale, together with the great height of the Chapel, make it very difficult for the casual viewer to make sense of the composition. It is useful to examine its parts separately, beginning at the west end, where the visitor usually enters and where Michelangelo began to paint.

The central scenes of the ceiling were painted in the reverse order of the narrative, from the end to the beginning,

from Noah to the Creation. The scaffolding first extended from the west door halfway down the Chapel to the point at which the screen then marked the entrance to the area reserved for the clergy. This portion of the ceiling was apparently painted in less than two years, between the end of 1508 and August 1510. The restorers who have recently completed work on the ceiling concluded that Michelangelo first painted one of the central scenes, then the adjacent prophets and sibyls, and then the spandrels and lunettes. From the sequence of the *giornate*, the daily applications of plaster, they deduced that he followed this pattern for the whole Chapel, always beginning at the top of the vault and working down to the walls.

In this first half of the ceiling Michelangelo painted the three stories of Noah, the *Fall of Man* and the *Expulsion from Paradise*, and the *Creation of Eve*. On technical and stylistic grounds it seems likely that the *Flood* was painted first. In any case the scene is out of place in the narrative sequence, probably because Michelangelo preferred to set it in the larger rectangular space.

His depiction of the *Flood* is reminiscent of the Cascina cartoon (page 51), with many nude figures in dramatic attitudes emerging from the water and landscape elements kept to a minimum. The Ark itself is consigned to the background, its shape a reminder that Noah's escape prefigures Christ's escape from the tomb. Typically, Michelangelo has concentrated on the human figure. On the left, a procession of the damned struggles on to the land with their few possessions. In the middle of the picture, a distinctly unseaworthy boat holds a woman who seems to be fending off other refugees with a club. On the right, another group huddles under a makeshift tent, while an old man approaches carrying the limp body of a young one. This pair recalls the antique statue of *Hercules and Antaeus* which Julius had brought to the Vatican that year. Even with this scene completed, Michelangelo was still hoping to be relieved of his task. When a film of mold appeared on the surface of the *Flood* 'to such an extent that the figures could hardly be seen through it', according to Condivi, he appealed to the Pope to release him: 'I already

told Your Holiness that painting is not my trade; what I have done is spoiled'. Instead the Pope sent for Sangallo, who saw that the plaster for the fresco had been applied too wet. 'So the excuse helped him nothing', adds Condivi.

A composition as complex and detailed as the *Flood* was difficult to read from a distance, as Michelangelo seems to have realized, since the figures in the two vault scenes he painted next, the *Drunkenness of Noah* and the *Sacrifice* are fewer and larger. In general his treatment of the ceiling showed an increasing tendency to simplicity and clarity, with greater dramatic effect, as the work progressed. The subject of Noah's sacrifice is rare in art, which is probably why both Condivi and Vasari misidentified this scene. Like all the vault scenes, the episode illustrated is from the *Book of Genesis*. This picture too has references to the antique; it is clearly derived from classical reliefs showing sacrifices and one of the central figures even wears a laurel wreath. There are other references to antique sacrificial rites in the ox skulls, *bucrania*, incorporated in the decorations of the spandrels. In con-

trast to the *Flood*, the composition is denser and more coherent, with the tightly interrelated group of figures filling most of the space. In this panel the individual figures are very carefully drawn, with detailed treatment of hair and flesh.

As he proceeded with the ceiling, Michelangelo progressively discarded detail and painted in a freer, more energetic way. The *Drunkenness of Noah* shows a drastic reduction in the number of figures used, in keeping with the requirements of the narrative, and also in the elaboration of the elements. Again from *Genesis*, the story is intended to stress the necessity of respect for age and authority. Noah, who had planted a vineyard, became drunk from the wine and fell asleep naked in his tent. There he was discovered by his son Ham, who summoned his brothers to cover their father, without looking at him. But as Ham had already, if inadvertently, seen the forbidden sight of his father's nakedness, his son Canaan was cursed by Noah. Despite the fact that the story emphasizes the distinction between the clothed and unclothed, Michelangelo's enthusiasm for the male nude was such that all the characters are naked, apart from notional drapes. It is a sign of the liberality or perhaps worldliness of the Church at this time that his tendency to introduce nudity without textual justification seems to have gone unremarked. This situation was to change markedly in the course of Michelangelo's lifetime.

The scenes painted next are the *Fall of Man* and the *Expulsion from Paradise*, on one panel. The combining of consecutive episodes, known as continuous representation, occurs in many earlier paintings but it was by this time very old-fashioned and must have been used for reasons of space. In the *Fall*, Adam seems far keener that the languid Eve to grasp the forbidden fruit.

Her difficult twisted pose apparently intrigued the young Venetian painter Titian, who may have known it from drawn copies, as he used it for one of the figures in his Padua frescoes. The two episodes of the narrative are separated by the Tree of Knowledge, though they are linked visually by the outstretched arms of the figures. The condemned couple inevitably evokes comparison with Masaccio's Adam and Eve in the Brancacci Chapel in Florence, where Michelangelo drew as a youth. In keeping with his lack of interest in landscape, the Garden of Eden is represented only by a rocky outcrop. The serpent, for reasons best known to Michelangelo, is clearly a close relation of the human female, complete with long hair.

Masaccio's continuing influence can be seen in the *Creation of Eve*, the last scene painted on this half of the ceiling; the massive draped figure of God would not have looked out of place in his fresco of the *Tribute Money*. The bulky form so fills the space that there seems to have been no room to paint a head large enough for the body, a problem that may have resulted from Michelangelo's casual attitude to the use of cartoons. God is gravely summoning Eve from the side of the sleeping Adam. She approaches with her hands in an attitude of prayer, as if thanking her creator. The composition of the three figures derives from Jacopo della Quercia's portal panel from San Petronio in Bologna (page 66) where Michelangelo had installed his bronze statue of the Pope in 1508. Like Masaccio, Quercia favored simple powerful forms and the elimination of extraneous detail, qualities which Michelangelo also valued and which he found increasingly useful in his work on the ceiling. The *Creation of Eve* is the central scene of the ceiling, aligned with the original position of the screen dividing the Chapel. The placement of this scene

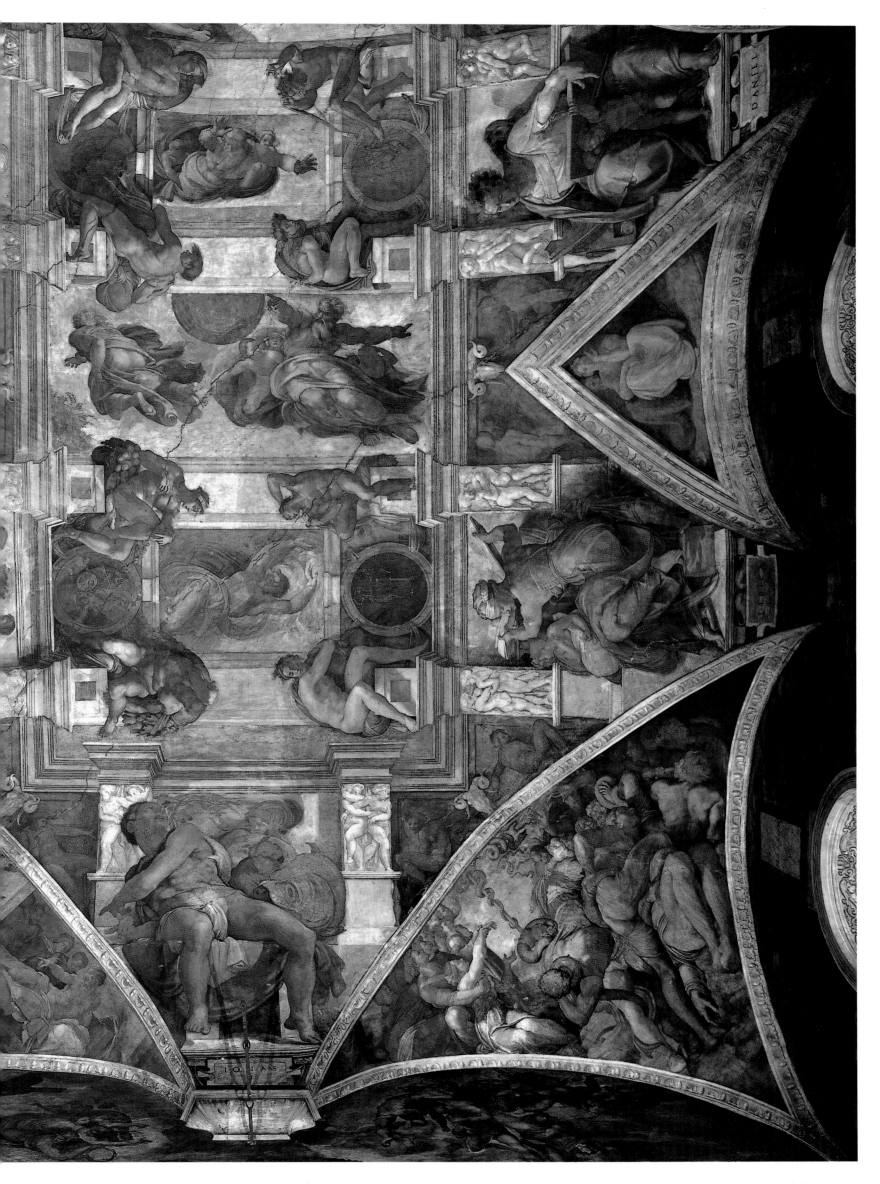

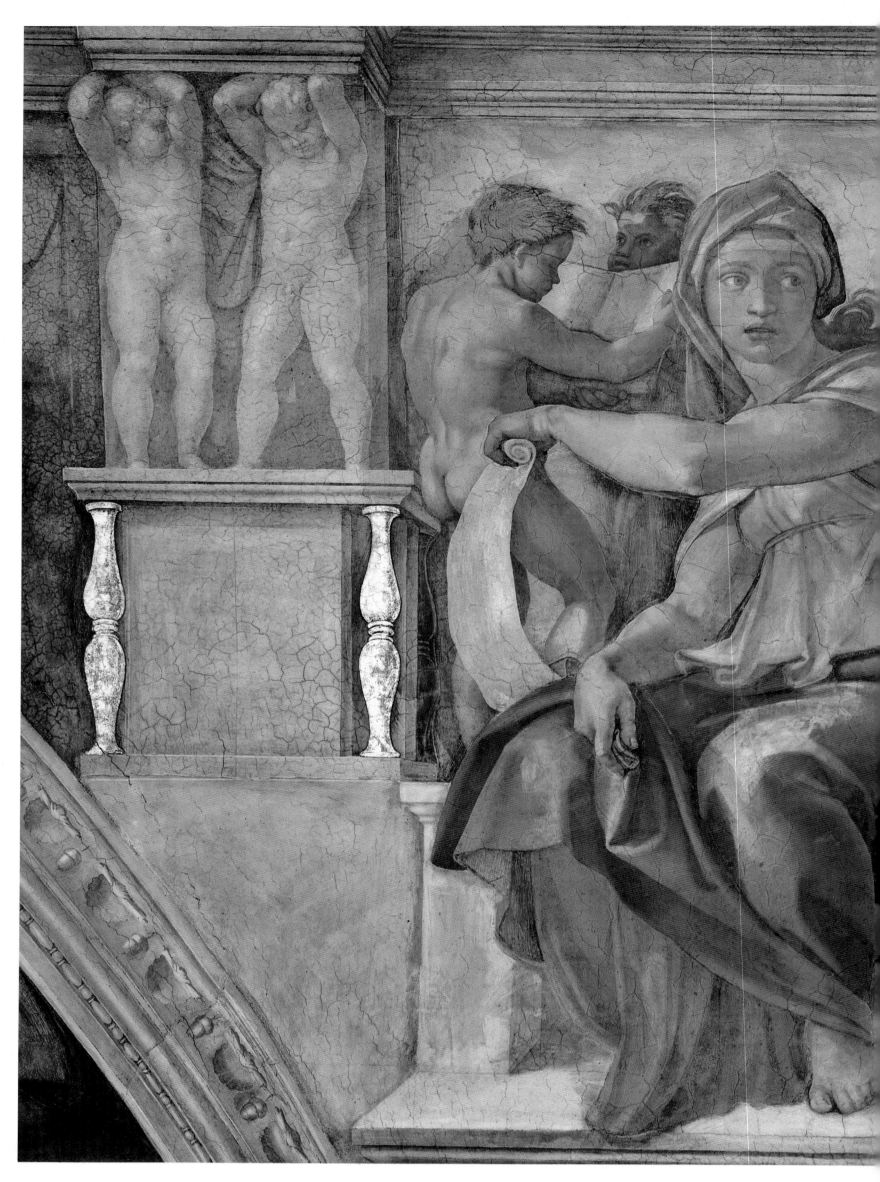

LEFT: Sistine Chapel ceiling, *Delphic Sibyl*. The most prominent elements on the ceiling are the pairs of enthroned biblical prophets and ancient female seers. The *Delphic Sibyl*, one of the earliest painted, has a bold twisted pose but is neatly contained in its architectural frame.

reflects the importance of its symbolism. Theologians commonly interpreted the Virgin Mary as the new Eve, who redeemed the sin of her predecessor. Mary was also equated with the Church, and the Creation of Eve was thus associated with the foundation of the Church. The position of the scene over the screen emphasized the division between the two zones of the Chapel, and between those saved by Christ and those excluded from salvation.

Condivi tells us that while Michelangelo was painting, Pope Julius often came to check on progress and, despite his great age, insisted on climbing up the ladder to the top of the scaffolding.

And, like one who was of a vehement nature, and impatient of delay, when but one half of the work was done . . . he insisted upon having it uncovered, although it was still incomplete . . .

However, after this first part of the ceiling was completed, probably by September 1510, work was interrupted for some months. The Pope was involved in bitter warfare in the north of Italy and spent much time in Bologna, where Michelangelo twice traveled to try to persuade him to provide money for his keep and for moving the scaffolding to the other half of the Chapel. The military campaign absorbed most of the Pope's attention and funds, and it was not until February 1511 that money was made available for rebuilding the scaffolding.

The uncovering of the ceiling and removal of the scaffolding enabled Michelangelo for the first time to view the work from a distance and to judge the success of the overall design. As a result, when he resumed work he further increased the dynamism and clarity of the images. The contrast is particularly apparent in the juxtaposed scenes of the *Creation of Eve* and that of Adam. The *Creation of Adam* is perhaps

71

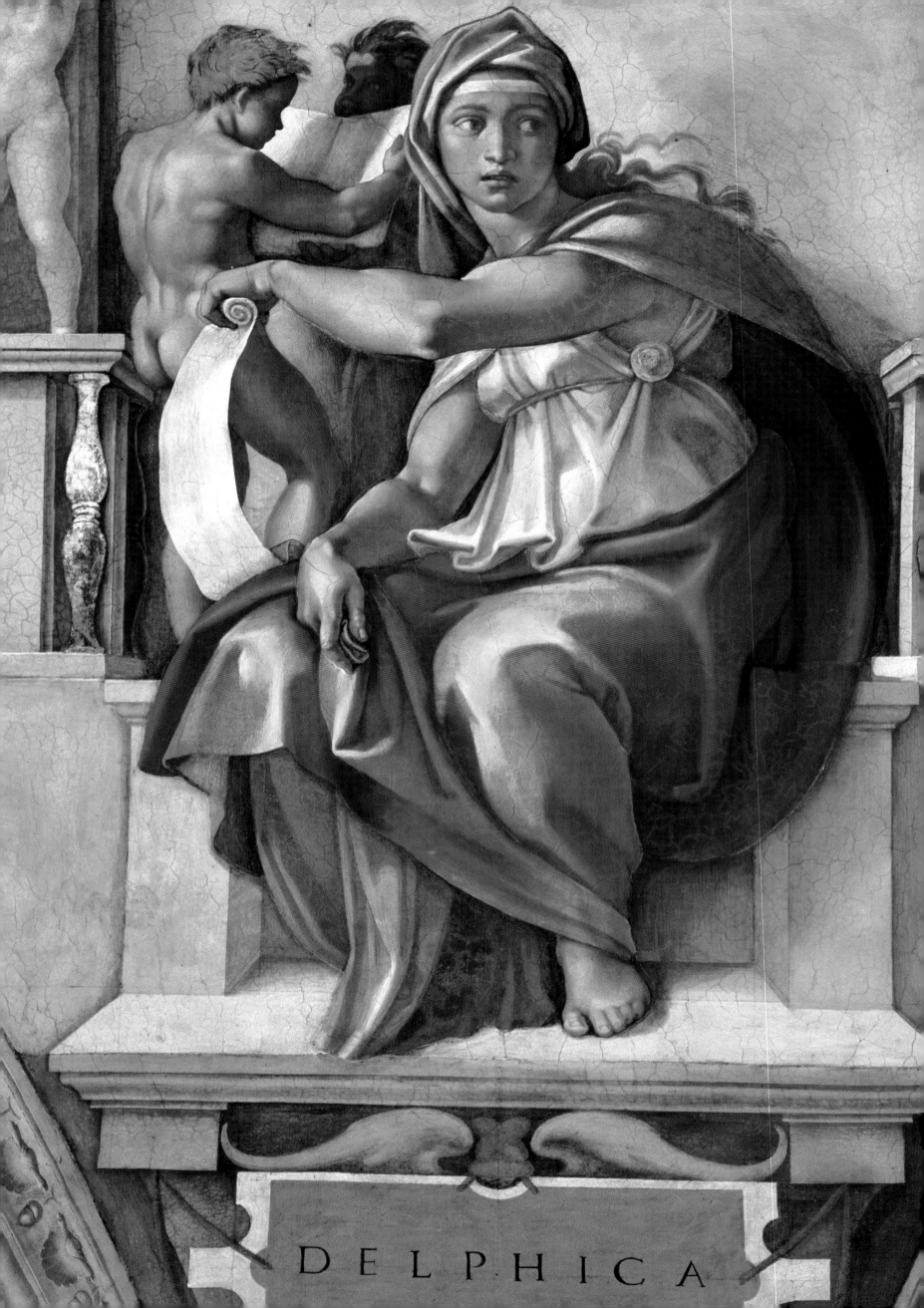

DELPHICA

LEFT: Sistine Chapel ceiling, *Delphic Sibyl*, photo © Nippon Television Network Corporation. The recent cleaning of the ceiling has revealed the brilliant contrasting colors used by Michelangelo, particularly in figures from the first phase of painting such as *The Delphic Sibyl*.

RIGHT: Giovanni Pisano. Pulpit, 1297-1301, marble, S Andrea, Genoa. Sibyls of the type Michelangelo painted on the ceiling appeared in works by members of the Pisano familiy during the medieval revival of antique types.

the most famous image made by Michelangelo. His conception of the subject is not new, but it is a transformation of the old one. Traditionally in scenes of the creation of man, God is shown standing in profile extending his hand toward Adam as if raising him to his feet. Michelangelo used this same basic scheme but placed the two main figures diagonally in opposing masses, giving the composition new drama and dynamism. Supported by a billowing crimson cloak and wingless angels, God surges across the space to animate the langorous Adam. The sole channel for the current of divine electricity is through their extended fingers. This scene is inspired less by the simple forms of Quercia and more indebted to antique models. God is no longer a primitive patriarch in bulky robes, but a svelte and distinguished eminence in a celestial shift. He is even a plausible inspiration for the beautiful cloaked god who leaps from his chariot in Titian's *Bacchus and Ariadne*. The image of Adam has undergone a similar transformation. A study for the figure (page 66), now in the British Museum, is typical of Michelangelo in its focus on the torso at the expense of head and limbs. The drawing dwells on the musculature in distracting detail, but in the painted version the detail is reduced and Adam has become an idealized male form in the mold of Apollo or Antinous. In the *Creation of Adam* Michelangelo brilliantly and concisely epitomized the Renaissance synthesis of the Christian and the classical. It is also a fitting image to express his own godlike powers as an artist.

The three scenes which follow, occupying the altar end of the vault, show God's work in creating the universe. The largest of the three, the *Creation of the Sun and Moon*, is similar in composition to the *Creation of Adam*, with two opposing diagonal masses. Like the *Fall*, it is a continuous representation in

which God appears in two different episodes. On the right he moves forward, his arms outstretched to touch with one hand the sun, with the other the moon. On the left he is seen from behind, gesturing toward the trees of the newly created Earth and giving the viewer a somewhat indecorous view of the divine *derrière*. Surrounded by his cloak of angels, he is still recognizable as the creator of Adam, but painted more loosely and with less detail. The two smaller panels are even further simplified, almost summary. In *God Separating Earth from Water*, the Creator is shown in a more exaggerated and difficult foreshortened pose, emerging from his cloak as a cyclonic force. His angelic companions now number only two and the figure of God extends to fill the entire panel, with almost no indica-

tion of the separated elements. The last panel painted is the *Separation of Light and Darkness*, at the east end of the vault over the altar. It is the simplest and most freely painted of the vault panels, the very opposite of the *Flood*, but equally difficult to read. In this scene God is shown alone, without accompanying angels. Again his pose is deliberately difficult, the figure seen directly from below, arms extended and head tilted back from the chin. This type of pose was borrowed from Michelangelo and exaggerated by the next generation of artists, which led to his being blamed for the excesses of Mannerism.

By this time the Pope was ferociously impatient with the progress of the project and it is likely that his sense of urgency was reflected in the almost cursory way the last scenes were painted.

LEFT: Sistine Chapel ceiling, *Joel*. Another figure from the first phase of the ceiling decoration, the prophet Joel has bright colored drapery and a relatively sedate pose which keeps him enclosed in the niche of the throne.

Not only are the elements of the compositions progressively reduced in number, but the execution moves from free to positively summary. The figure of God in the *Separation of Light and Darkness* is reduced to a rosy, swirling blur. The image is virtually abstract, as if the energy with which God invested Adam has itself become the subject.

The huge seated figures of prophets and sibyls, which occupy the pendentive positions originally intended for the apostles, are the most prominent elements of the ceiling and are central to its meaning. Seven biblical prophets are depicted, four major prophets and three minor ones, and the reasons behind their selection are the subject of much learned speculation. It has been suggested that they represent the seven gifts of the Holy Spirit mentioned in *Isaiah*, or that they were chosen because they made predictions related to the coming of the Messiah. The sibyls were the prophetic priestesses of Ancient Greece, whose enigmatic utterances were interpreted by theologians as connecting pagan and Christian beliefs. Their predictions too were seen as messianic, particularly the promise of the Cumaean Sibyl in Virgil's *Eclogues* of 'a new progeny from heaven' bringing a return of the 'Golden Age'.

It is likely that the five Sistine Sibyls are also intended to represent the geographical spread of these predictions: the Delphic Sibyl in Greece; Erythraean in Ionia (now Turkey); Persian in Asia; Libyan in Africa; and the Cumaean in Rome. On the ceiling each prophet and sibyl is accompanied by two much smaller figures in the background (Daniel has only one, who acts as a bookstand, though there may once have been another in a damaged area over his shoulder). These little genii may represent aspects of the figure they accompany, a device derived from the thesis of the influential writer Pico

75

RIGHT: Sistine Chapel ceiling, *Ezekiel*. In keeping with his biblical role the prophet Ezekiel is shown as a fiercely energetic figure, a characteristic emphasized by his emphatic gesture and windswept scarf.

della Mirandola that each individual has two companion genii, one for the body, one for the spirit. The pairing of the prophets and sibyls as representatives of the ancient Jewish and Gentile worlds respectively suggests the possibility that salvation extends to those who came before Christ, an idea which is in keeping with the Neoplatonists' attempts to synthesize Christian thought with that of the ancient philosophers, and with the general Renaissance interest in classical civilization. Michelangelo, with his knowledge of Neoplatonism and his strong Christian belief, was an artist ideally suited to give these ideas visual expression.

The prophets and sibyls are among Michelangelo's most powerful painted images. Descended from the prophets carved by Donatello for Florence Cathedral and sibyls such as that by Giovanni Pisano, they herald Michelangelo's own great sculpted sitting figures, the *Moses* and the Medici *Capitani*. They dominate the composition by virtue of their large size – up to twelve feet high – and the brilliant coloring of their drapery. They are also the most strongly modeled of the ceiling figures, which is in keeping with their position in the hierarchy of reality. The diminishing levels of reality represented by the different zones of the vault are emphasized by a progressive diminution in fictive relief. The elements intended to be the most real are shown in the highest relief, while those most remote are shallow, a sequence moving from the distinctly sculpturesque prophets and sibyls to the flat, pictorial central scenes. Michelangelo returned to this idea of a progression in levels of relief in later works, such as his designs for the Medici Chapel.

The changes in style shown in the central vault scenes are also visible in the prophets and sibyls. The figures painted first in the sequence are smaller and more self-contained than those

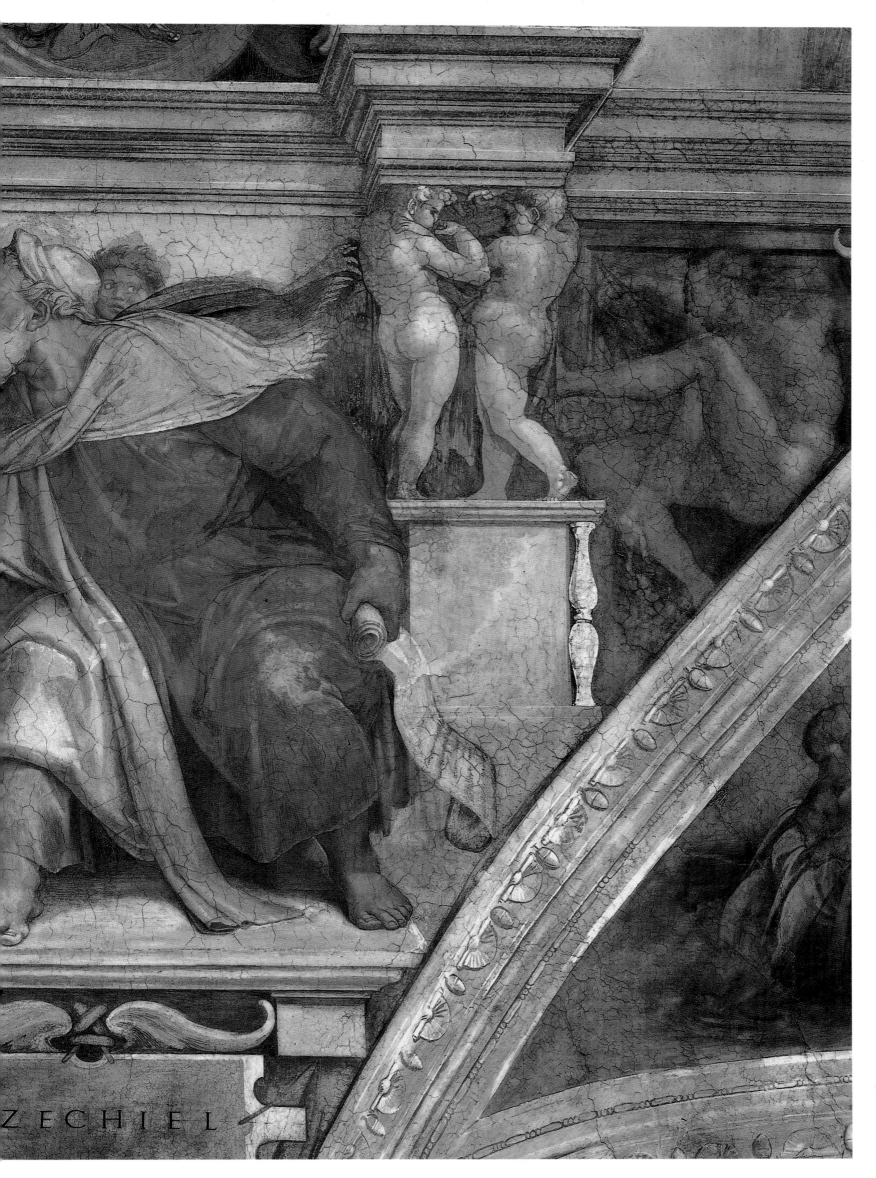

ZECHIEL

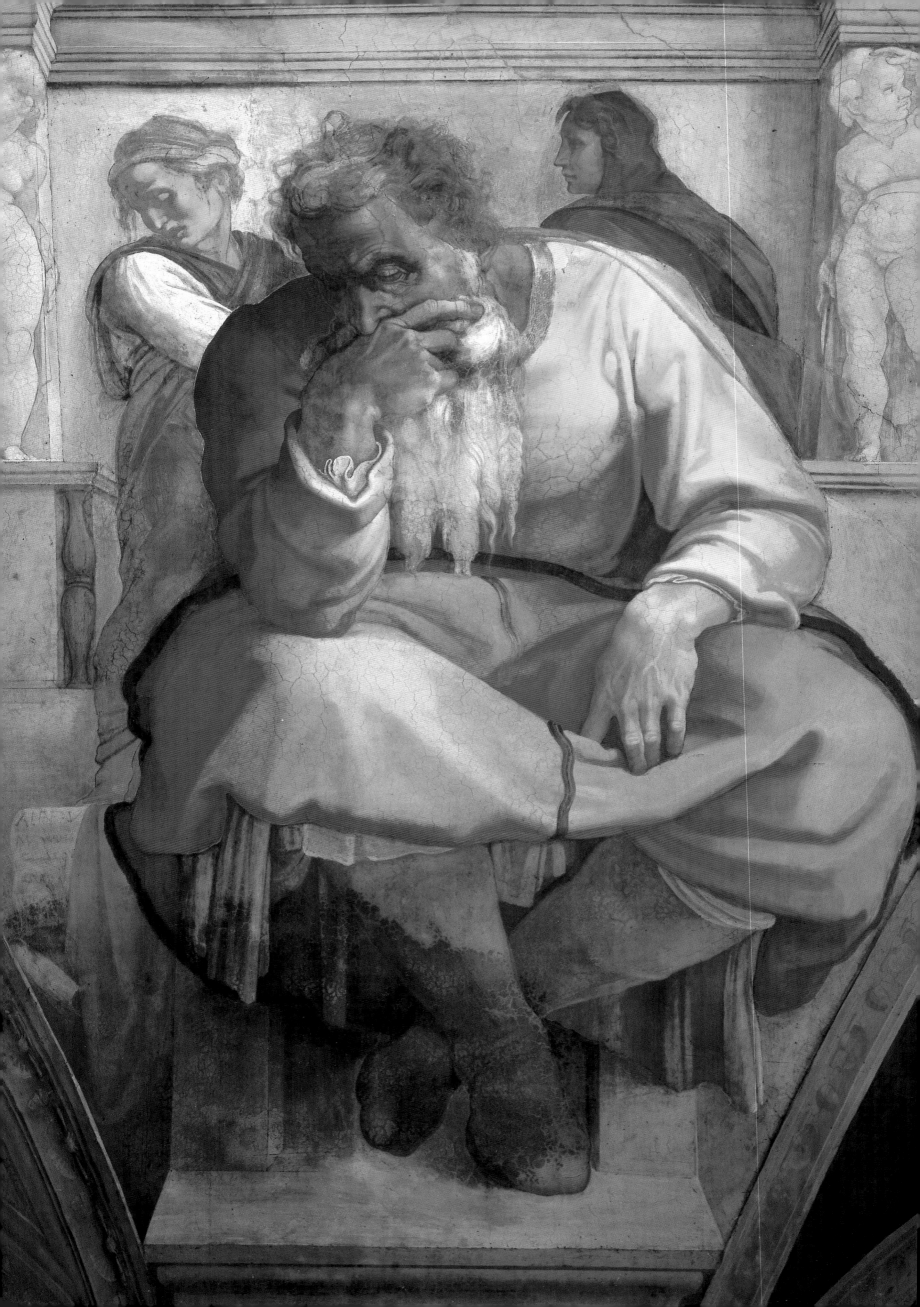

LEFT: Sistine Chapel ceiling, *Jeremiah*, photo © Nippon Television Network Corporation. One of the last prophets painted, the figure of Jeremiah is larger and extends beyond the confines of his throne. His pensive air is reflected in the demeanor of his accompanying genii and in the subtle coloring.

RIGHT: Raphael, *Isaiah*, 1512, fresco, San Agostino, Rome. Raphael was one of the first artists to see Michelangelo's ceiling and was clearly influenced by it when he painted the prophet Isaiah for the Roman church.

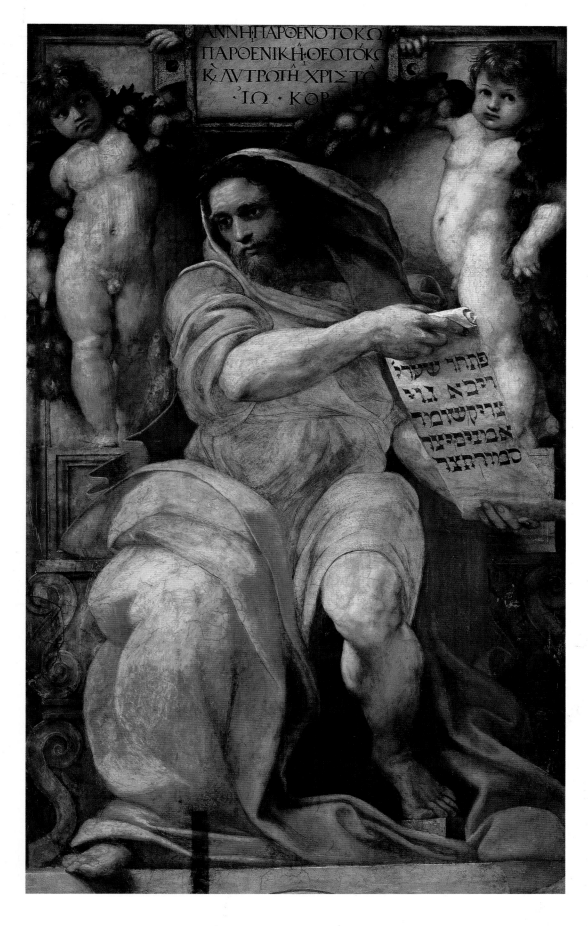

from the second half. The series begins with the prophet *Zechariah* whose position directly over the main entrance is apt as he foretold Christ's entry into Jerusalem. A scholarly bearded man, he turns toward his book while his inspirational genii peer over his shoulder. The prophet's pose is quiet and decorous, his limbs contained within the mass of drapery, and the genii lean close to him so that the group fits neatly on the throne. Along the vault, the first pair of seers painted are the *Delphic Sibyl* and the prophet *Joel*. Delphica and her genii are another close-knit group: her upper body is turned and the curve of her back is complemented by the scroll she holds and by the pose of her genius. A touch of drama is added by her outswept arm, elegantly foreshortened, and by her great rolled eyes. As a type, she is reminiscent of the Madonna in the *Doni Tondo* and is modeled in a similarly crisp way. Her partner, Joel, also holds a scroll, which he gazes at closely, the tension in his gaze emphasized by the taut horizontals of his scroll and drapery. He rests on one arm, and one foot projects slightly, but his form is still generally enclosed by the genii and the drapery forms. The bright contrasting colors of these first seers, and the degree of detail they exhibit, relate them to the earlier frescoes on the walls below, a link Michelangelo seemed less concerned to stress as work progressed.

The seers painted by Michelangelo in the center of the ceiling, such as the prophet *Ezekiel* (page 77), are in more complex, animated poses, less constrained by the frame of their thrones. Ezekiel was famed for his visions, notably of the four beasts which became the emblems of the Evangelists. He was a ferocious, raging prophet who predicted dreadful destruction and punishments for the sins of Jerusalem; Michelangelo's image of him expresses his visionary inspiration as well

as his wrathfulness. The figure is captured in action, as if rising to emphasize a point to the neighboring sibyl. His great red-robed body bursts out of the throne, his hand gesturing emphatically, his scarf flying out behind him. Ezekiel's extrovert pose is echoed in the extended arms of the attendant genius facing him, a creation of angelic beauty whose tender gaze contrasts with the fierce glare of his master. Michelangelo's portrayal of Ezekiel evokes the appearance and character of Julius himself; it has an awesome quality, the *ter-*

ribilità for which both artist and patron were known and feared.

At the altar end of the vault the footrests of the seers' thrones have been lowered to allow space for larger figures. The prophet *Jeremiah* is painted in a pensive mood, head in hand, eyes downcast, and his genii are equally somber. His mournful demeanor reflects the sorrow of his role – he foresaw the destruction of Jerusalem and was powerless to avert it – but it also expresses an aspect of Michelangelo's own character, the dark depressive

BELOW: Drawing for the *Libyan Sibyl*, c. 1511, red chalk, Metropolitan Museum, New York. One of the few surviving studies for the Sistine ceiling is this beautiful life drawing of the male model used for the *Libyan Sibyl*.

RIGHT: Sistine Chapel ceiling, *Libyan Sibyl*. The elegant Libyan Sibyl was among the last figures painted and has a particularly complicated posture presaging the serpentine poses favoured by Michelangelo's Mannerist followers.

moods which descended between periods of creative energy.

Raphael's painting of the prophet *Isaiah* shows the influence of Michelangelo's Sistine seers in the work of an artist of a very different temperament.

The forceful effect of Isaiah's muscular body is softened by his gentle expression and by the anecdotal charm of the *putti* behind him. The image has grace and beauty, but little of the Michelangelesque *terribilità*.

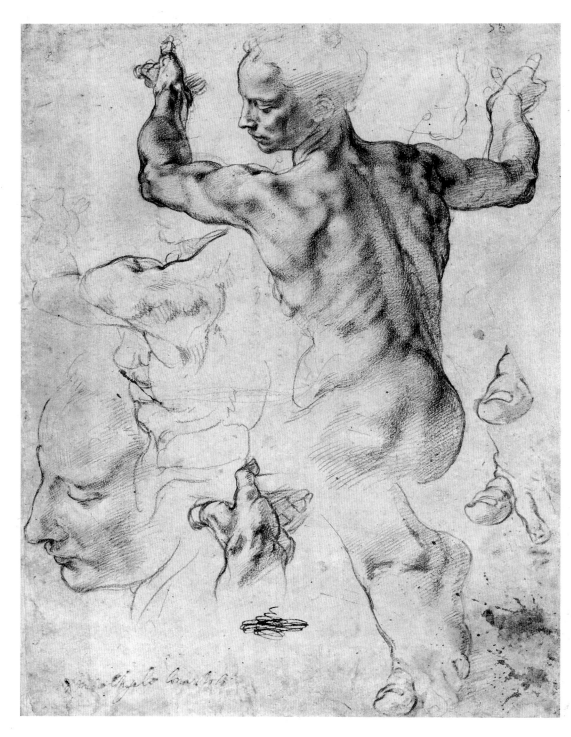

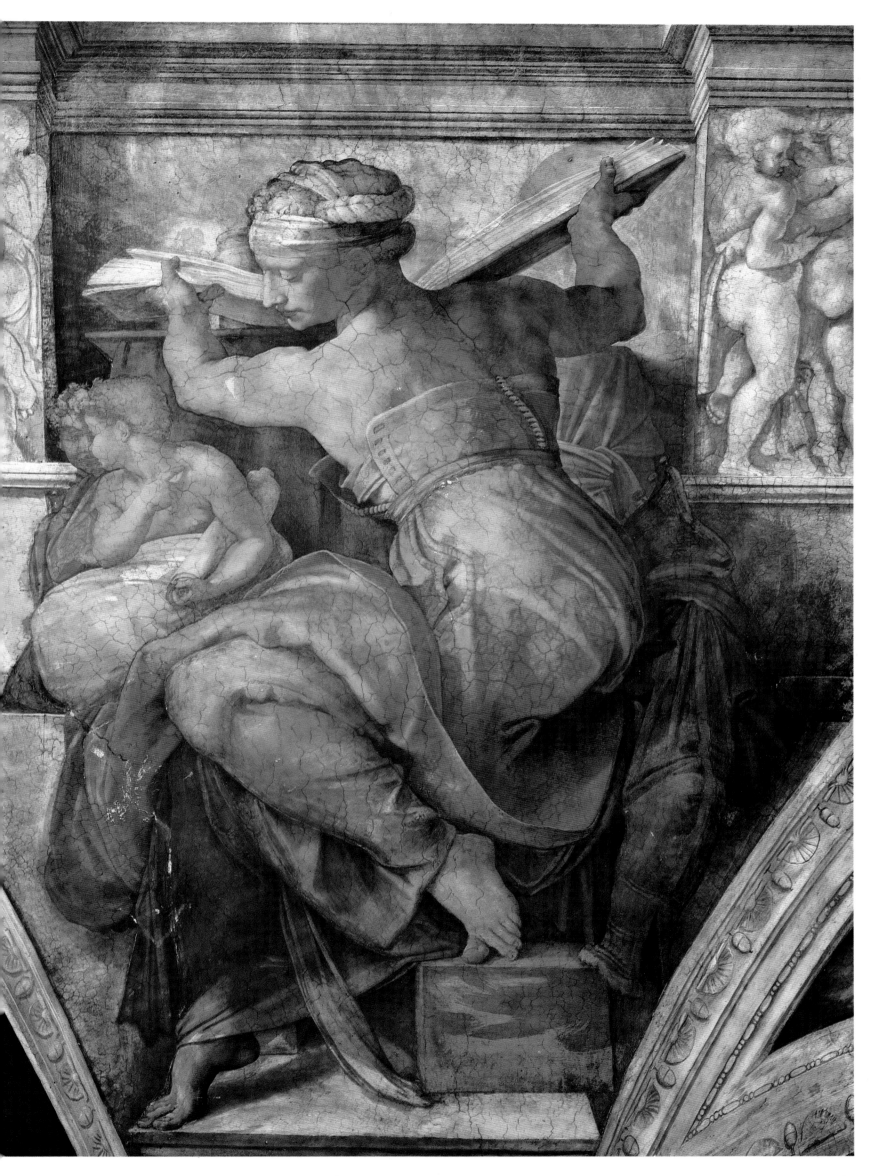

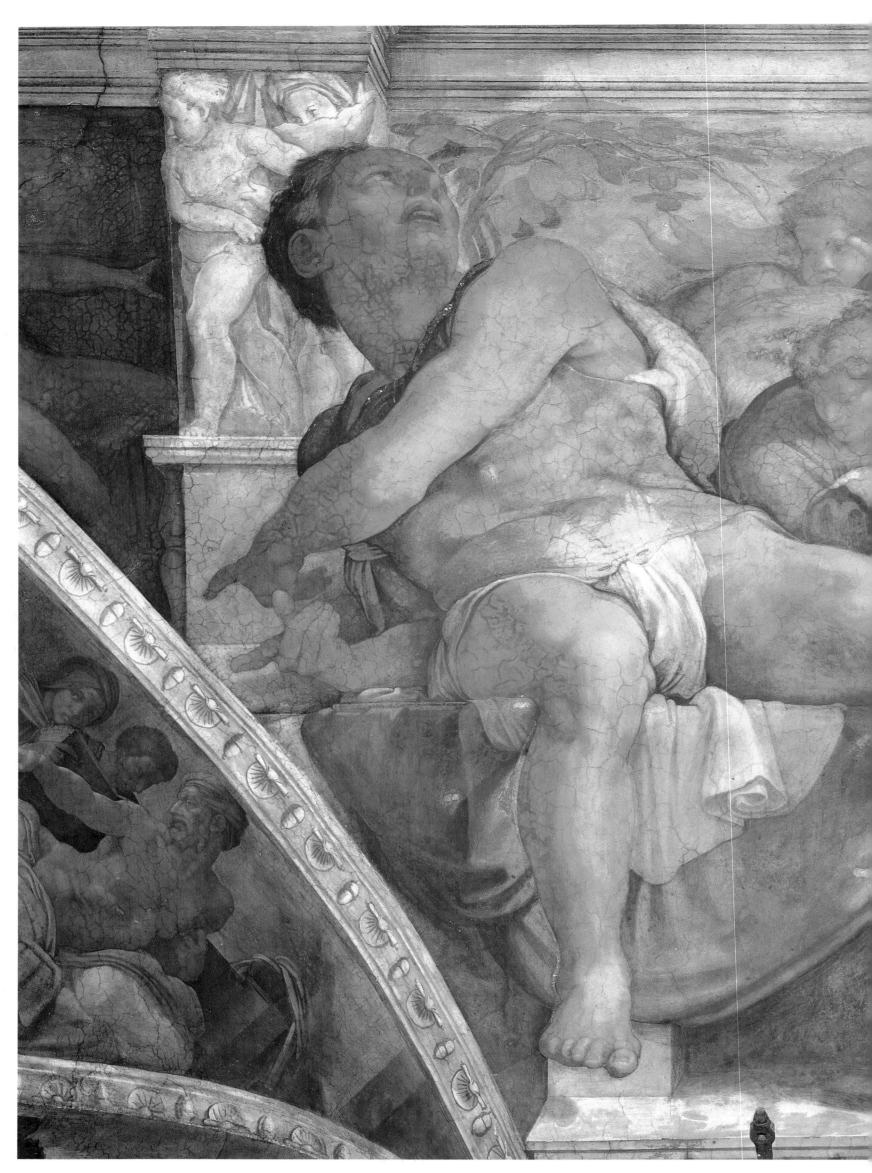

LEFT: Sistine Chapel ceiling, *Jonah*. The prophet painted directly over the altar, Jonah, was particularly admired by Michelangelo's contemporaries for its skilful foreshortening. Jonah sprawls across the seat, his head tilted back, his hands pointing down to a figure of Christ which then stood below.

In contrast to the staid gloom of Jeremiah, the *Libyan Sibyl* with whom he is paired, is full of youthful vitality. Her message is one of hope, prophesying the arrival of the day when the Queen shall hold the King on her lap. It may be possible to infer a reference to this prediction in the position of her genii, but little else seems related to her narrative role. The figure of Libyca is one of the best known of Michelangelo's ceiling images and one of the most evolved in style, her spiral stance indicating the development toward Mannerism, the art about style. A beautiful drawing for this Sibyl, one of the very few Sistine studies to survive, is evidence that she is based on a live model, albeit male. But the painting itself is far less naturalistic, with the anatomy adjusted to suit the elegant, but highly artificial, twisted pose. There is also a proto-Mannerist element of ambiguity about her movement, as in the Doni Madonna. There is no obvious need for Libyca's contorted action; it is simply designed to demonstrate the painter's skill in creating beauty out of difficulty.

An even more difficult pose is used for the figure of the prophet *Jonah*, the last to be painted and by far the most dramatic of the series. Placed directly over the altar, the prominence of Jonah's position in the Chapel is not due to his prophetic role, which is minor, but to his being seen as a precursor of Christ: he willingly accepted death to save his shipmates, and his three days in the belly of the whale and subsequent disgorging are considered prefigurations of the Entombment and Resurrection. Michelangelo's portrayal of Jonah was particularly admired by his contemporaries for the skilful use of perspective and foreshortening required by the pose. Jonah is shown sprawled across the throne, his upper body twisted, his head thrown back; he seems to recoil in horror at what he sees. His face is turned up toward God,

83

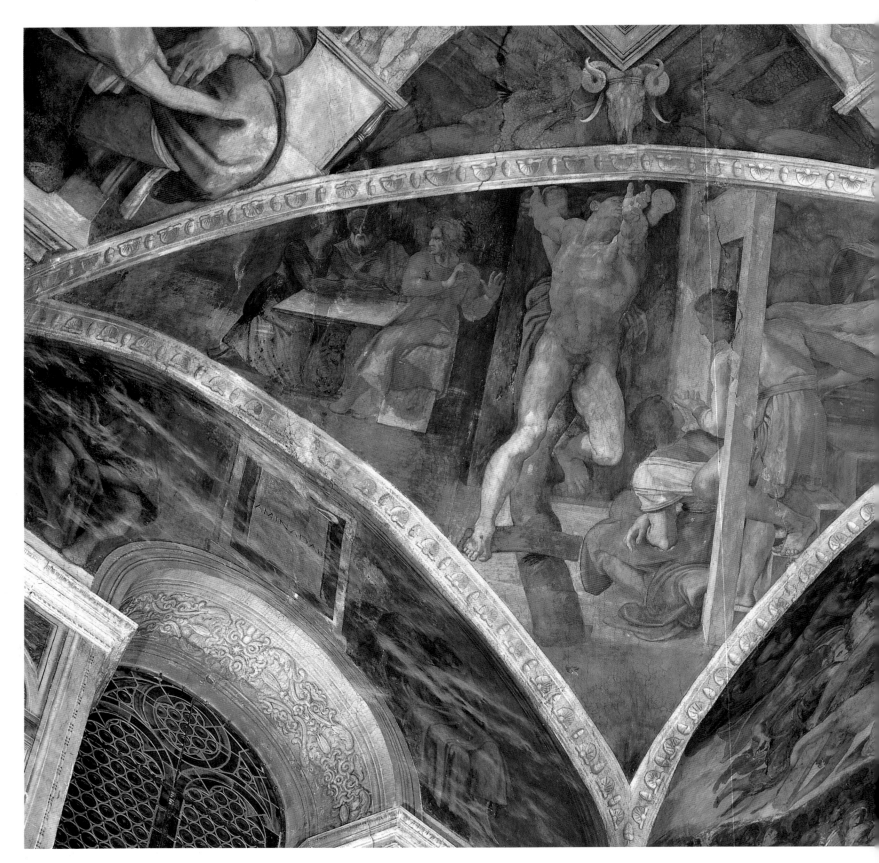

while his hands point downward, presumably at the figure of Christ which then stood below. The positioning of the hands is especially complex, again simply as an artistic challenge, and they are brilliantly executed.

A comparison of Jonah with Zechariah, the prophet painted first, at the opposite end of the Chapel, shows the extent of the development from Michelangelo's original treatment of these figures. Zechariah is smaller, static, self-contained and has blocks of bright colored drapery, qualities which relate him more closely to the Chapel's Sixtine wall frescoes. By contrast, the figure of Jonah is large and adopts an extravagant posture which extends outside the bounds of the throne. The sense of violent movement is augmented by the swirling shapes of the background leaves, his genii and the whale. The energy of the overall composition also echoes that of the neighboring scene of the *Separation of Light*. Unlike the other heavily-draped prophets, Jonah wears only a swaddling bodysuit which leaves his arms and legs exposed. His bare limbs emphasize his sprawled pose, and the preponderance of flesh to drapery leaves fewer areas of bright color. In *Zechariah* color is used to make distinct the separate parts of the composition, each element painted a different hue. In *Jonah*, broken color is used to integrate the figure with its surround. The same watery green with red appears in Jonah's suit and cloak, in the whale, and in the background genii and foliage. The figure is no longer modeled like a painted sculpture, an illusion of three-dimensional mass; it is acknowledged as a picture in its own right.

The *Jonah* was painted at the end of Michelangelo's long labors on the ceiling, at a time when he was undoubtedly physically exhausted and likely to have felt pressed for inspiration. Nonetheless the figure is the most inventive and exciting of the seer series, perhaps

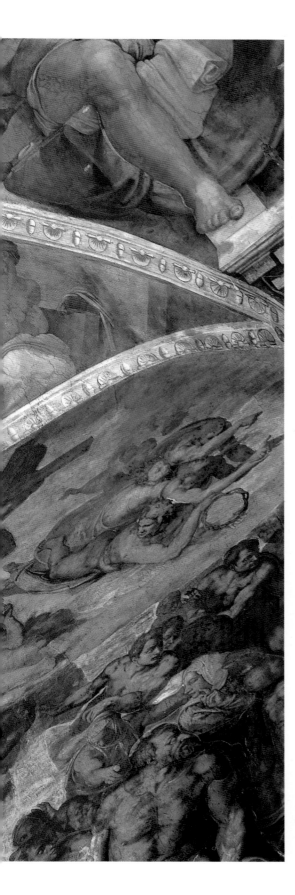

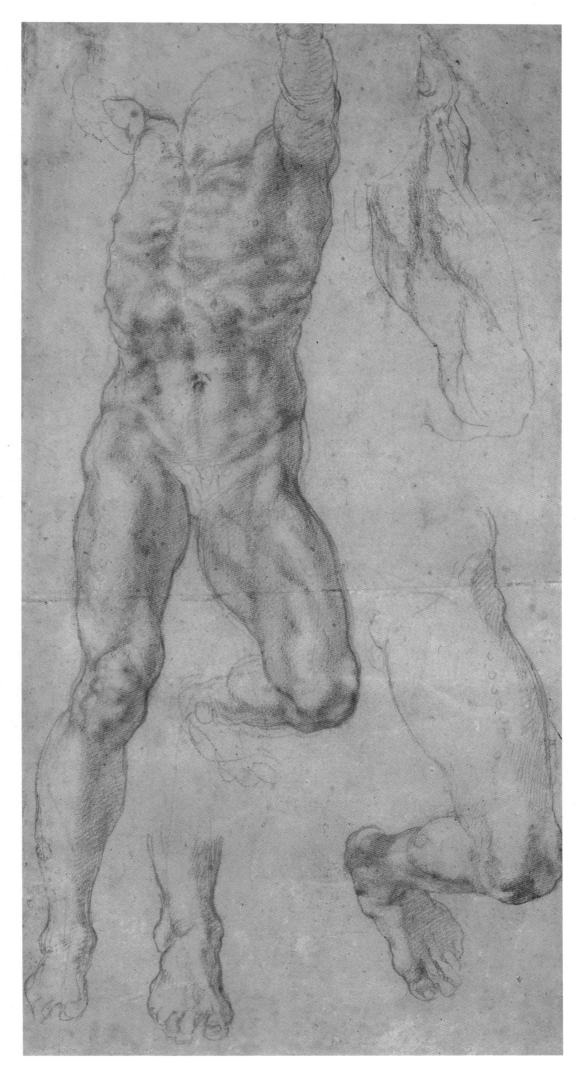

ABOVE: Sistine Chapel ceiling, *Esther and Haman* pendentive. Haman, chief minister to the Persian king, ordered a massacre of Jews, but was himself hanged after the intervention of the king's Jewish wife, Esther. Michelangelo has shown Haman's punishment as a crucifixion, perhaps as a reminder of Christ.

RIGHT: Drawing for Haman. (*Four Studies of a Crucified Man*), red chalk, 15¾ × 8 inches (40.6 × 20.7 cm), British Museum, London. The model for the crucified Haman has a difficult foreshortened pose typical of the later, proto-Mannerist figures on the ceiling.

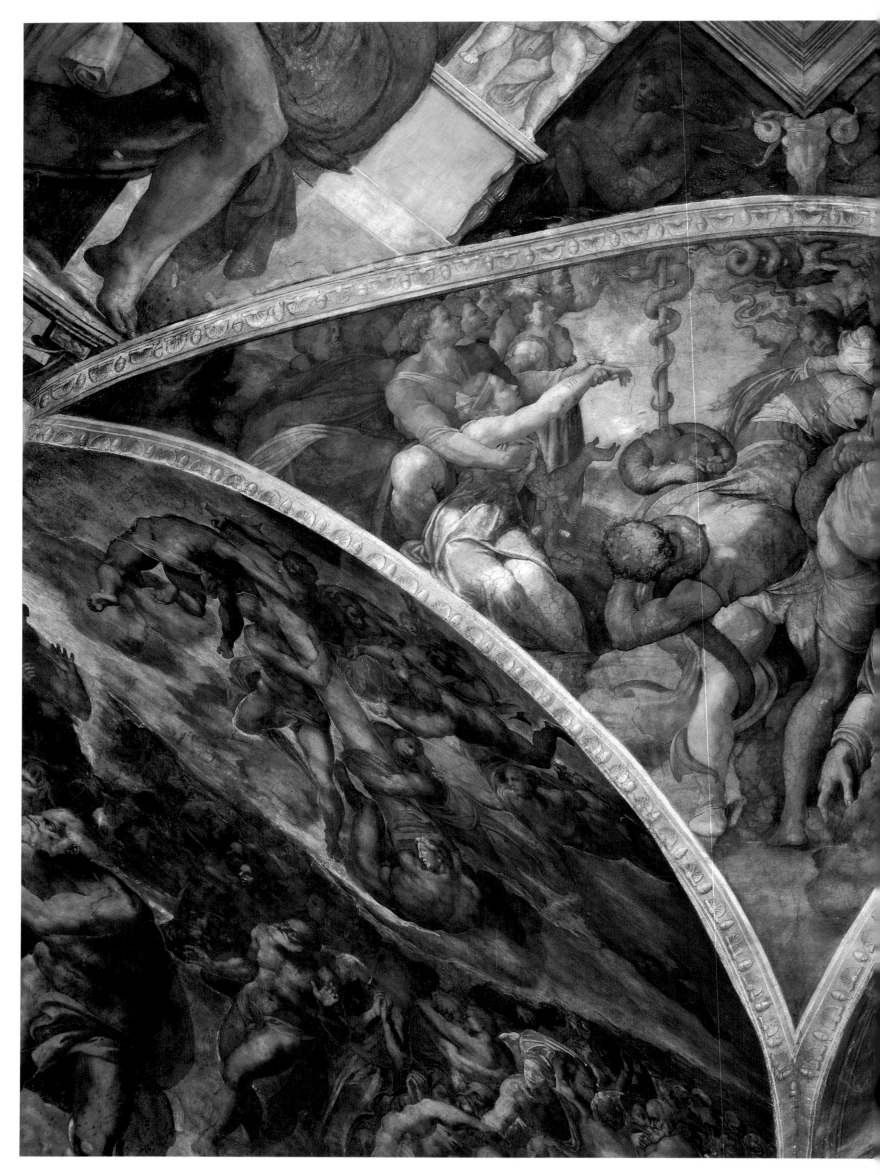

LEFT: Sistine Chapel ceiling, *Brazen Serpent* pendentive. The figures in this scene writhe and coil like the snakes sent by God, a plague from which they were saved by the brass serpent made by Moses.

because it evoked in him the strongest emotional response. A devotion to the beauty of the nude male body was one of the most powerful motivating forces in Michelangelo's life and art, and on the ceiling he was able to express this enthusiasm most freely in the muscular young nudes, the *ignudi*, which sit in pairs above the prophets and sibyls. The athletic stance and near-nudity of Jonah make him closer in spirit to the sheer physicality of the *ignudi* than to the more cerebral prophets, which may account in part for the special verve with which he is painted.

The subsidiary areas of the ceiling, the spandrels and lunettes, which are treated as separate from the central vault, are shapes in which it is difficult to construct figural compositions. Despite the restrictive formats, these too develop stylistically, if less dramatically. The four large corner spandrels depict four biblical episodes in the salvation of the Jews. In the two spandrels over the entrance, which were painted first, are the stories of *Judith and Holofernes*, and *David and Goliath*. Judith, the Jewish heroine who saved her city by seducing and then beheading the Assyrian general Holofernes, is shown gazing back at Holofernes' corpse while she covers his severed head with a cloth. Michelangelo's design is essentially rectangular and does little to incorporate the areas of the three angles, which are left in shadow. The second spandrel shows the youth David, who is often seen as prefiguring Christ, decapitating the Philistine giant Goliath with his own sword. In this composition Michelangelo does acknowledge the shape of the area by arranging the two figures in an inverted triangle, but again the corners are not integrated. The two later spandrels are designed more successfully in relation to their triangular fields. The *Punishment of Haman* (page 84) echoes the composition of the Judith spandrel in

BELOW: Sistine Chapel ceiling, spandrel of *Asa*. In the spandrels, the eight triangular coves over the windows, are figures representing the families of Christ's Ancestors to indicate that he was the legitimate successor to the leadership of Israel.

the sense that the central figures divide the space in two. In the Bible Haman, whose death prefigures Christ's sacrifice, was hanged, but Michelangelo underscores the relationship between them by showing Haman crucified. The extraordinary foreshortening of the figure of Haman is far more dramatic in the painting than in the preparatory chalk life drawing.

By far the most ambitious of the spandrel compositions is the *Brazen Serpent* (page 86), in which a group of Israelites surrounds the bronze image set up by Moses to cure believers of a plague, as Christ was to save those who believed in him. The group fills most of the triangle, its members writhing like the *Laocoön* in their efforts to extract themselves from the plague of snakes.

The interlinked curves and shapes of the design relate both to the triangular field and to the adjacent images.

The smaller triangular spandrels and the curved lunettes over the windows show the *Ancestors of Christ* and their families. The ancestors were known only from a list of names in the Bible and had never before been painted, so Michelangelo had to invent them

BELOW: Sistine Chapel ceiling, spandrel of *Roboam*. The slumped postures and general air of melancholy of the Ancestors are reminders that they lived before the possibility of redemption by Christ.

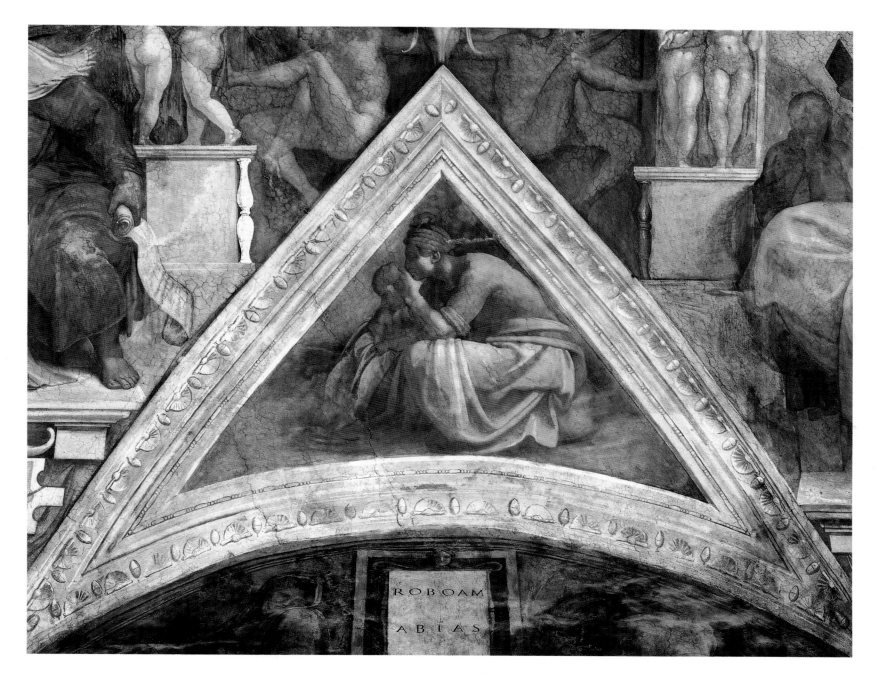

visually. These areas are relatively minor in the decorative scheme of the ceiling and, although the figures are shown in a considerable variety of poses, they are far less energetic than those of the central ceiling. The Ancestor figures were long overlooked because of their darkened state, but the recent cleaning has revealed that they were painted in bold combinations of brilliant colors. Such bright colors were in keeping with Michelangelo's training under Ghirlandaio and were clearly chosen to relate the Ancestors to the earlier wall frescoes. The colors are also similar to those used by Michelangelo in the *Doni Tondo*. It is notable that many members of Christ's family seem to be sunk in attitudes of despair or exhaustion, particularly the glowering graybearded figure of Jacob, which may well mirror Michelangelo's own feelings as he worked on his herculean task.

If the prophets and sibyls represent the intellectual aspect of human life, the *ignudi* are their corporeal counterparts, a celebration of the human body. The *ignudi* are unlikely to have been part of the theological program of the

BELOW: Sistine Chapel ceiling, lunette of *Eleazar and Nathan*. Other Ancestors figures appear on the lunettes, the arched areas over the windows.

ceiling; their purpose seems mainly visual. Condivi states clearly that the *ignudi* do not 'belong to the story', although it has been suggested that they are nude wingless angels such as those Michelangelo painted later in the *Last Judgment*. Unlike those figures, however, the *ignudi* do not perform angelic duties. Their ostensible function is to act as animated *atlantes*, hold-

ing the swags which support the bronze medallions. But the poses they strike are far more complex than are required for the performance of their task and it is probable that their function is essentially decorative. The inclusion of male nudes in the decoration of the principal papal chapel is very much in keeping, however, with the view of Renaissance theologians and rhetoricians

that man's dignity is due to his creation 'in the image or likeness' of God. According to the Neoplatonists, whose influence Michelangelo had encountered in Medici circles, the beauty of the human form and of the material world in general is a reflection of the divine. This idea provided a spiritual and philosophical justification for Michelangelo's personal obsession with male

BELOW: Sistine Chapel ceiling, lunette of *Jacob and Joseph*. The lunettes have received relatively little attention in the past, but the recent cleaning has revealed that some have the bold simple designs and brilliant coloring of Michelangelo's mature fresco style.

beauty, in which his homosexual inclinations doubtless played a part. Although it is rare for Michelangelo's writings to shed light on his work, one sonnet does make clear his belief in man as the image of God, of human beauty reflecting the divine:

God, in His grace, shows Himself nowhere more

To me, than through some veil, mortal and lovely,
Which I will only love for being His mirror.

The series of *ignudi* shows a development in style similar to the other ceiling figures; those painted first are smaller, less extravagant in attitude, and more firmly modeled. The pair over the prophet *Joel* sit firmly on their plinths, eyes downcast, apparently intent on their duties. They are painted in some detail, with elaborate hair styles and musculature. Their poses are almost mirror images, a device characteristic of earlier Renaissance artists such as Antonio Pollaiuolo (c. 1432-98). The later *ignudi*, on the second half of the ceiling, are larger, active, and more freely painted. Those near the *Persian Sibyl* assume

LEFT: Sistine Chapel ceiling, *Ignudo* to the left above the prophet Joel. One of the *ignudi*, the pairs of decorative male nudes who perch like living statues on pedestals above the prophets and sibyls.

larly dramatic attitudes which are not clearly related to their function, and the energy of the poses is emphasized by their billowing drapes and windswept hair. The figures are no longer in mirrored poses, but are more subtly balanced, with a sense of playful inter-relation of contrasting roles, one passive, one active. In a study for the right-hand *ignudo* the massive musculature of the back is drawn in detail, while in the painted version it is smoothed and simplified. As in the *Noah*, the modelling is generally soft so that the figures are integrated with their surroundings rather than shown in sharp sculptural relief.

Though the *ignudi* became increasingly less sculptural as the ceiling progressed, they are all derived from Michelangelo's study of antique sculpture; in this series he created a range of figures to rival the ancient art which inspired him. The contorted postures of the *ignudi* and the drapes which wind around them suggest the influence of the snake-entwined figures in the *Laocoön* (page 55) and the group as a whole represents variations on the theme of the antique work most admired by Michelangelo, the *Belvedere Torso* (page 124). In both the *Laocoön* and the *Torso* a powerful figure is shown in a constricted pose, caused either by visible bonds or by the suggestion of some sort of psychological bondage. The image had an enduring fascination for Michelangelo, perhaps because he saw himself as such a figure, a titanic talent constrained by the demands of patrons and by his own complex nature. The bound figures also embody the two conflicting sides of Michelangelo's personality, a formidable energy coupled with a strange passivity. The *ignudi* are among a number of bound figures which appear in Michelangelo's work and they are particularly closely linked to the statues of slaves and prisoners he designed for Julius' tomb. He was plan-

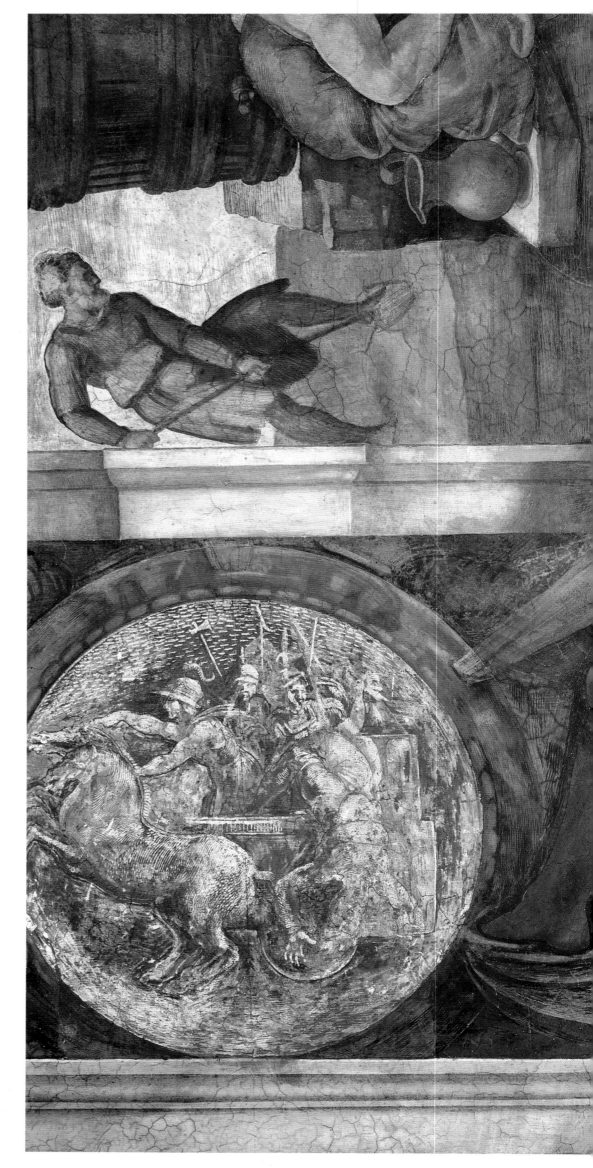

ning the tomb when he began work on the ceiling; although some of these statues were carved, the completed tomb was a travesty of the one he envisaged originally (pages 102-105). To some extent the same is true of his designs for the Medici Chapel (pages 110-127). Of the grand architectural and sculptural ensembles he planned, only the Sistine ceiling was entirely 'built', albeit in paint.

Even the Sistine ceiling is not finished to the degree Michelangelo planned, however, due to the impatience of the Pope. Condivi records that when work on the second half of the ceiling had continued for nearly two years, Julius demanded to know when Michelangelo would complete it. His reply, 'When I can', enraged the Pope, who threatened to throw him from the scaffolding. As soon as the Pope left the Chapel Michelangelo had the scaffolding dismantled, although he had not yet added the touches of ultramarine and gold. These would have been applied *a secco*, when the plaster was dry, and 'would have made it appear more rich', says Condivi. The absence of gold retouching is most noticeable on the bronze medallions and balusters behind the later prophets. Despite this dearth of glitter, the ceiling was uncovered in October 1512, on All Saints' Day, and 'all Rome crowded to admire it'.

RIGHT: Sistine Chapel ceiling, *Ignudo* to the right above the prophet Joel. The earlier *ignudi*, such as the pair above Joel, are in relatively sedate complementary poses, related to their task of supporting painted bronze medallions depicting biblical stories.

The physical task alone was titanic: in four years, working virtually on his own, Michelangelo had painted some 340 figures on a complex curved surface of about 10,000 square feet. Artistically his achievement is equally impressive. The design of the ceiling is one of the greatest decorative ensembles in the history of Western art. The power and variety of the images he painted provided a rich new visual vocabulary for succeeding generations of artists. Another aspect of his legacy to artists represented by the ceiling is the freedom of invention with which he treated each element of the composition. His intellectual understanding and appreciation of classical civilization, coupled with his intense spirituality and energy, won him a respect and independence that reflected on the profession as a whole. And in the Sistine Chapel, one of the most significant Christian sites, he created a monument to his own independent genius.

LEFT: Sistine Chapel ceiling, *Ignudo* to the left above the sibyl Persica. As the ceiling progressed, Michelangelo arranged the *ignudi* in increasingly extreme attitudes which bore less relation to their function.

97

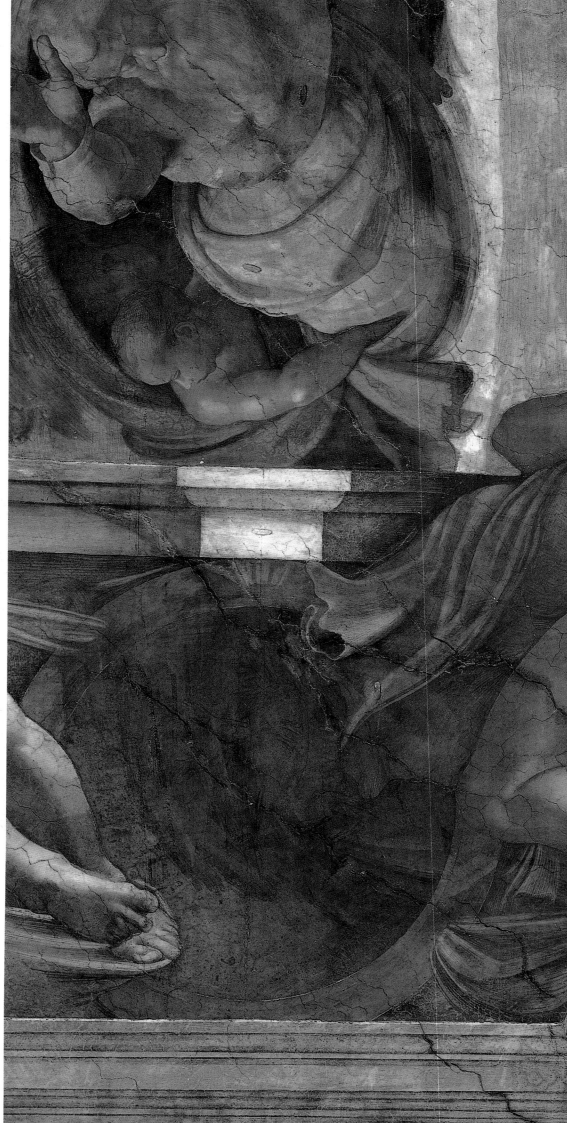

Halfway through his work on the ceiling, in 1510, Michelangelo had written to his friend Giovanni da Pistoia enclosing a caricature of himself painting and a poem lamenting its effect on his health and on his reputation as an artist. The poem complained:

I've got myself a goiter from this strain . . .
My beard toward Heaven, I feel the back of my brain
Upon my neck. I grow the breast of a harpy
And I am bending like a Syrian bow . . .
Giovanni, come to the rescue of my dead pictures . . .
And of my honor . . . I'm no painter.

His worries about his honor were unfounded. Two years later, with the triumphant reception of the ceiling, the sculptor who had taken up the brush so reluctantly had indeed become a painter. There remained only one of the three Arts of Design still to master, that of Architecture, and an opportunity soon arose.

RIGHT: Sistine Chapel ceiling, *Ignudo* to the right above the sibyl Persica. One of the later *ignudi*, the muscular back recalls the antique statue fragment known as the *Belvedere Torso*, which particularly inspired Michelangelo.

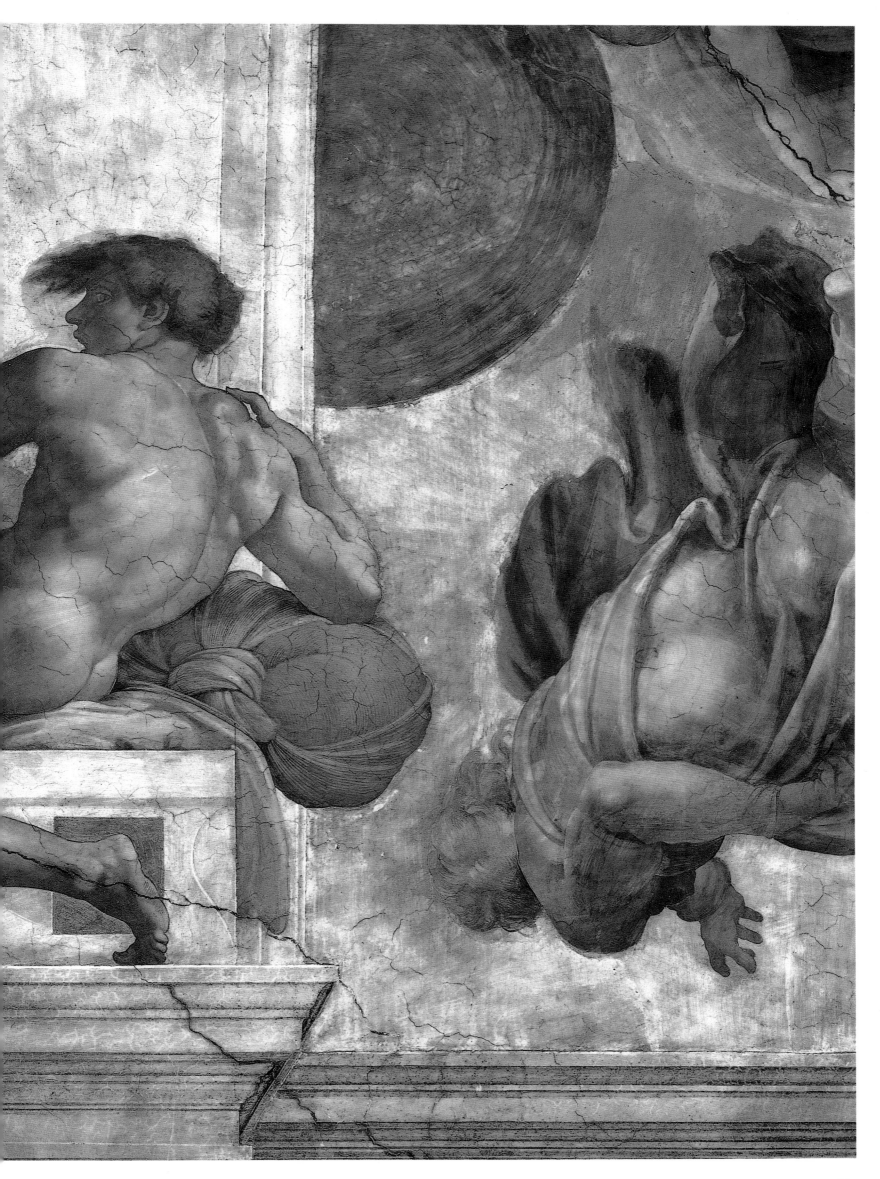

RIGHT: Giacomo Rocchetti after Michelangelo, *Drawing of 1513 project for tomb of Julius II*, Pen and ink, 20½ × 15¼ inches (52.5 × 39 cm), Staatliche Museen, Berlin. The Pope's tomb was the great tragedy of Michelangelo's artistic life. By 1513 his plan for a free-standing tomb echoing those of ancient Rome had been reduced to the large wall tomb illustrated here.

The Tomb of Pope Julius II, 1505-45

'I lost the whole of my youth, chained to this tomb', Michelangelo wrote as an old man; the story of Michelangelo and the tomb of Pope Julius was called by Condivi 'The Tragedy of the Tomb'. It was undoubtedly the deepest disappointment of his artistic life although, unlike so many of Michelangelo's grand projects, the tomb was in fact built, and built according to his design – or rather designs. As his largest sculptural commission, the tomb was the project of greatest significance to Michelangelo in his maturity. He worked on it intermittently over a period of 40 years, during which time his ideas about the tomb and about art changed considerably. These changes are cruelly apparent in the tomb as it was built, with tiers so disparate in scale and style that they appear to be the work of two different artists. To understand how this happened it is necessary to trace the progress of the project from its grandiose beginning to its sad conclusion.

The tomb as first planned by Michelangelo and Julius in 1505 was absurdly ambitious, a *folie à deux* of two great egos. No drawings of this scheme survive but Michelangelo described it to Condivi many years later. It was to have been a very tall, freestanding structure of three tiers, occupying a floor area of about 800 square feet. The decoration was to include large bronze reliefs showing scenes from the life of the Pope, as well as 40 marble statues. The huge Holy House shrine in the basilica at Loreto, designed by Bramante around 1510, may give some idea of what the two envisaged, though it is smaller and less elaborate. Like the Holy House, the tomb as planned in 1505 was modeled on antique sepulchral monuments such as those on the outskirts of Rome. The idea of a freestanding monument was probably sug-

gested by Julius' commissioning of the freestanding bronze floor tomb of his uncle Sixtus IV, completed by Antonio Pollaiuolo in 1493 just before Michelangelo's first visit to Rome. The tomb of Sixtus is surrounded by relief images of the Liberal Arts, a reference to his activities as a patron, and Julius's tomb was also to have included personifications of the arts. Michelangelo spent months selecting the marble for this version of the tomb, but the project was set aside during the years of his enforced labor on the Sistine ceiling. He continued to develop his ideas for the tomb during his work on the ceiling, even doing drawings for both projects on one sheet, and when he resumed work on the tomb his plans for it had changed. Fate soon introduced a second factor which affected the future of the tomb.

A few months after the unveiling of the ceiling, in February 1513, Julius II died. The new pope, Leo X, was Giovanni de' Medici, the son of Lorenzo the Magnificent, whom Michelangelo had known in his youth. Leo X was very different in character from the fierce energetic warrior Julius. An unabashed sensualist, he indicated his limited ambitions in his famous response to his election: 'Since God has given us the Papacy, let us enjoy it'. Great acts of literary and artistic patronage were anticipated from a Medici pope but, though Leo continued Julius's projects, he did not have his predecessor's instinct for choosing and using artists. Despite their old acquaintance – or perhaps because of it – Leo showed little interest in exploiting Michelangelo's gifts. He clearly felt a

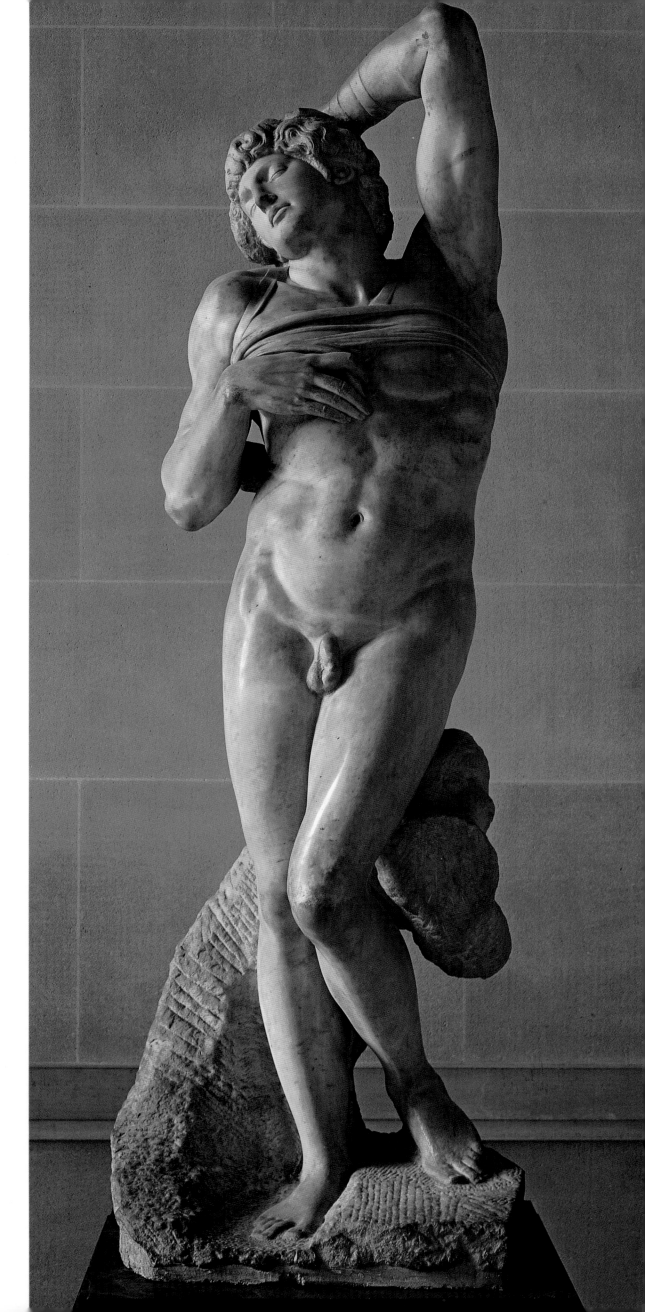

RIGHT: *Dying Slave*, 1513/16, marble, h. 89½ inches (229 cm), Louvre, Paris. The lower story of the tomb planned in 1513 was to include several bound figures, of which Michelangelo carved two. The so-called *Dying Slave* is one of his most tender and sensual representations of the male nude.

greater sympathy with the work and personality of Raphael, whom he appointed architect of St Peter's on the death of Bramante in 1514.

The new Pope's lack of enthusiasm for Michelangelo's work was in fact a blessing, for it enabled him to work on the tomb without interruption for a while. Julius had left money for the completion of his tomb and in May 1513 Michelangelo signed a new contract with his heirs. He set up his workshop in a house in the center of Rome near Trajan's column, where he lived until his death. It was demolished only in the last century when the area was cleared for the vast marble typewriter known as the Victor Emmanuel Monument. The new contract stipulated that the tomb should be completed within seven years and Michelangelo set to work at a feverish pace, writing to his brother Buonarroto that he was too pressed even to eat. This period of intensive creativity lasted for the next three years.

The 1513 plan was for a structure halfway between the first scheme, for a freestanding monument of antique inspiration, and a Renaissance wall tomb; it was like a peninsula, attached to the wall at one end. This tomb was to be both larger and smaller than the last. It was taller, with fewer and larger statues, but reduced in size overall. The Rocchetti drawing shows only the front view, with no indication of its considerable depth, which was twice the width. The upper half of the tomb had to be modified to take account of its new wall setting. On the platform the papal tomb chest and effigy faced forward feet first, surrounded by figures of double life-size, while those at the back near the tall arched structure, the *cappellatta*, were larger still. According to Vasari, the platform figures on the 1505 tomb were to be Moses, St Paul and figures of the Active and Contemplative Life, both of which are Neoplatonic pairings.

The imagery of the 1513 plan was more clearly Christian; Moses was still included but the figures presiding in the *cappellatta* were the Virgin and Child.

Of the 40 or so figures planned for the 1513 version of the tomb only three were carved, the two *Slaves* now in the Louvre and the great seated *Moses* which is on the finished tomb. The Slaves evolved from the fettered figures of the Liberal Arts in the first tomb plan, and also from the Sistine *ignudi*. The two statues were part of a planned series of twelve bound slaves representing the Arts under the patronage of Julius. Whether the Arts are being awakened by him, or languishing because of his death, is not clear; such ambiguity of meaning also occurs later in the Medici Chapel statues. There is a roughed-out ape behind one of the figures which suggests the maxim 'art apes nature' and it is likely that this statue, known as the *Dying Slave*, represents painting and the *Rebellious Slave* sculpture.

Whatever its intended meaning, the *Dying Slave* is one of the works in which Michelangelo's personal vision is communicated particularly poignantly. In this figure he combines the provocative sexuality of the *Bacchus* with the languid elegance of the Christ of the *Pietà* to create an image of poetic sensuality. Erotic and tender, it is the most hedonistic of his homages to the beauty of the ideal male body. The pose is in some respects related to that of the smaller son in the *Laocoön* but Michelangelo has used it to suggest voluptuous abandon rather than mortal struggle. The notional bonds around the upper body serve to emphasize its nudity, as the rough texture of the ape is a foil for the creamy flesh. The musculature is not emphatic as in the *David* but integrated with the smooth flow of the surface. The figure is very highly finished including even the face, though Michelangelo seldom completed the heads of his male figures, as if giving them individual features compromised his idealized image. Unusually, he also eschewed portraiture, probably for the same reason.

The statue known as the *Rebellious Slave* is less idealized and not highly finished; it was probably abandoned because of the crack running across its face and shoulder. The figure is sturdy and heavily muscled, its massive humped shoulder like the *Day* of the Medici Chapel. The pose is expressively exaggerated and the jagged angles of its profile show that the statue was meant for a site on the corner of the tomb, while the gentler lines of the *Dying Slave* made it more suitable to be seen frontally, standing by a center pilaster. In contrast to the lassitude of the *Dying Slave*, the *Rebellious Slave* is apparently struggling against his bonds, which again relates the figure to the *Laocoön* and also to images of the Christian hero St Sebastian. Paired figures representing opposing characteristics, in this case active and passive, are common in Michelangelo's work, as are bound figures. Fettered figures, especially ones resisting their condition, are often interpreted as suggesting the Neoplatonic view that man's spirit is imprisoned by the body. These ideas were current in Medici circles and were certainly familiar to Michelangelo, though his preference for pairs of bound figures has personal meaning as well as philosophical. They express his own conflicting nature, as he implies in the lines of his poem:

He cannot act who by himself is bound,
And of himself no one is freely loosed . . .
Thus outside of my bonds others bind me.

The statue of *Moses* was part both of the first plan for the tomb and of all subsequent versions, though its role changed. It was originally intended to be placed on the righthand corner of the platform, probably paired with St Paul on the left. The figure was designed to be seen from the side and from well below, hence its prominent head and dramatic facial expression, which could be read from a distance. Like the *David*, the *Moses* is over-emphatic in its present low position and seems to be glaring at something in particular instead of gazing out into space. This has led to confusion about the statue's meaning, with suggestions that Moses is raging at the Golden Calf, that he represents the active partner of a pair, or that he is a spiritual portrait of the artist.

Apart from its specific meaning, the *Moses* is a work of immense dignity and force. The seated pose of the figure is majestic yet alive with potential for action, the massive knee poised, the head alert, its horns pointing ahead like the ears of a hunting hound. There is a sense of anticipation even in Moses's gesture, sweeping aside the luxuriant beard with his surprisingly sensitive hand. The horns were a medieval convention, based on a misreading of the Hebrew word for rays of light, which was deliberately retained by Michelangelo; he may have been aware of the antique tradition of a horned head denoting power and divinity.

The *Moses* is the result of many strands of influence in Michelangelo's work, from antique sculpture to Donatello's statue of *St John the Evangelist* in Florence. But like tributaries of a mighty river, the separate strands have become merged and absorbed in his own powerful vision. Perhaps the strongest formative influence on the statue was his own experience painting the Sistine ceiling, particulary the prophets. The *Moses* has some of the energy and grace of the figure of God in the *Creation of Adam*, but not its exultation. With the *Moses*, a new somberness and pessimism can be sensed in Michelangelo's vision, which gradually overtakes the idealized beauty and

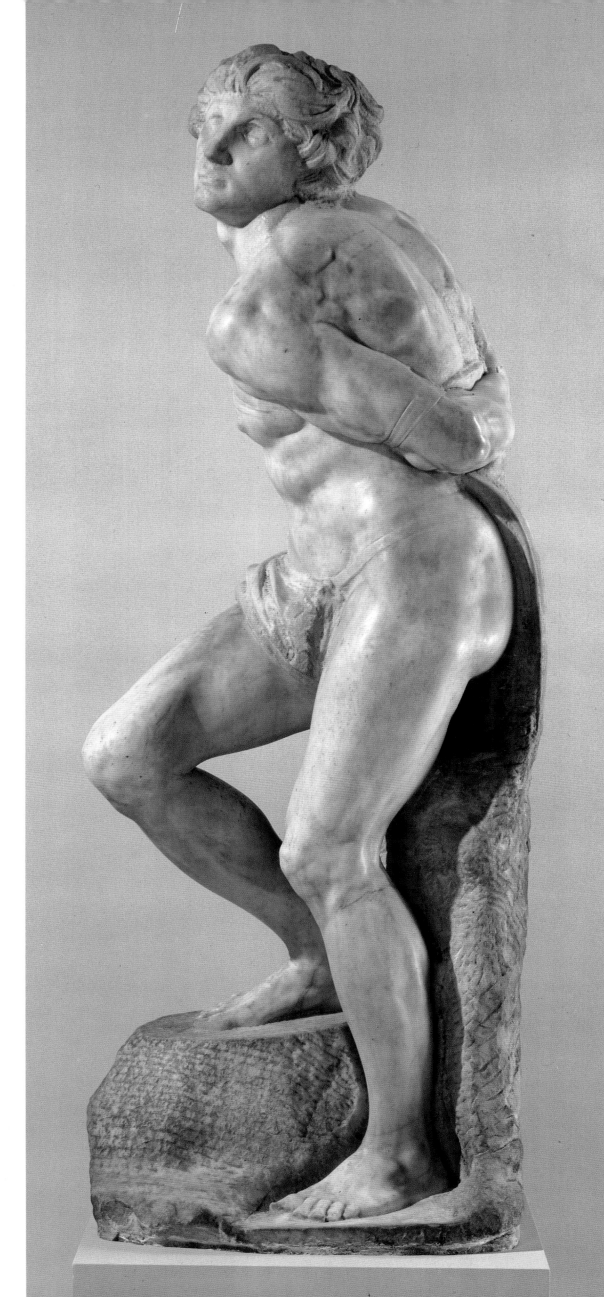

RIGHT: *Rebellious Slave*, 1513/16, marble, h. 84 inches (215 cm), Louvre, Paris. The second bound figure carved for the 1513 plan seems to struggle against his shackles, his contorted pose recalling the *Laocoön*.

optimism of his early work. And even more than the Sistine ceiling figures, the *Moses* has the *terribilità* of Michelangelo and of Julius II.

In June 1515 Michelangelo again wrote to Buonarroto about the strain of work, saying he was anxious to complete the tomb as he feared interruption; ' . . . for I think that I shall soon be obliged to enter the Pope's services'. A year later Leo X did divert Michelangelo to a new project, the facade of the Medici family church of San Lorenzo in Florence, which is discussed in the section on his architecture. Michelangelo later claimed that he was involved in the facade project against his will, but an excuse to renegotiate the tomb contract may have been welcome. By this time, 1516, with four years left on the contract, only three of the figures and some of the lower part of the structure had been carved. The lower tier was essentially unchanged from the original plan and was no longer suitable for Michelangelo's developing architectural conception of the tomb. The new contract provided for a much reduced and simplified version of the earlier schemes, and completion in nine years, by 1525. The structure was now to be only one bay deep, with the upper tier brought forward in alignment, so that it would be a true wall tomb. As there was no longer a wide platform, a seated figure of the Pope would replace the projecting effigy and tomb chest. The number of statues was halved, to 20, and their relation to the architecture was transformed: in the earlier plans the sculpture was arranged in front of an architectural backdrop, while in the 1516 version the two arts were integrated.

Work on the 1516 version of the tomb proceeded slowly, partly due to Michelangelo's increasing interest and involvement in the San Lorenzo facade, but probably also because the new

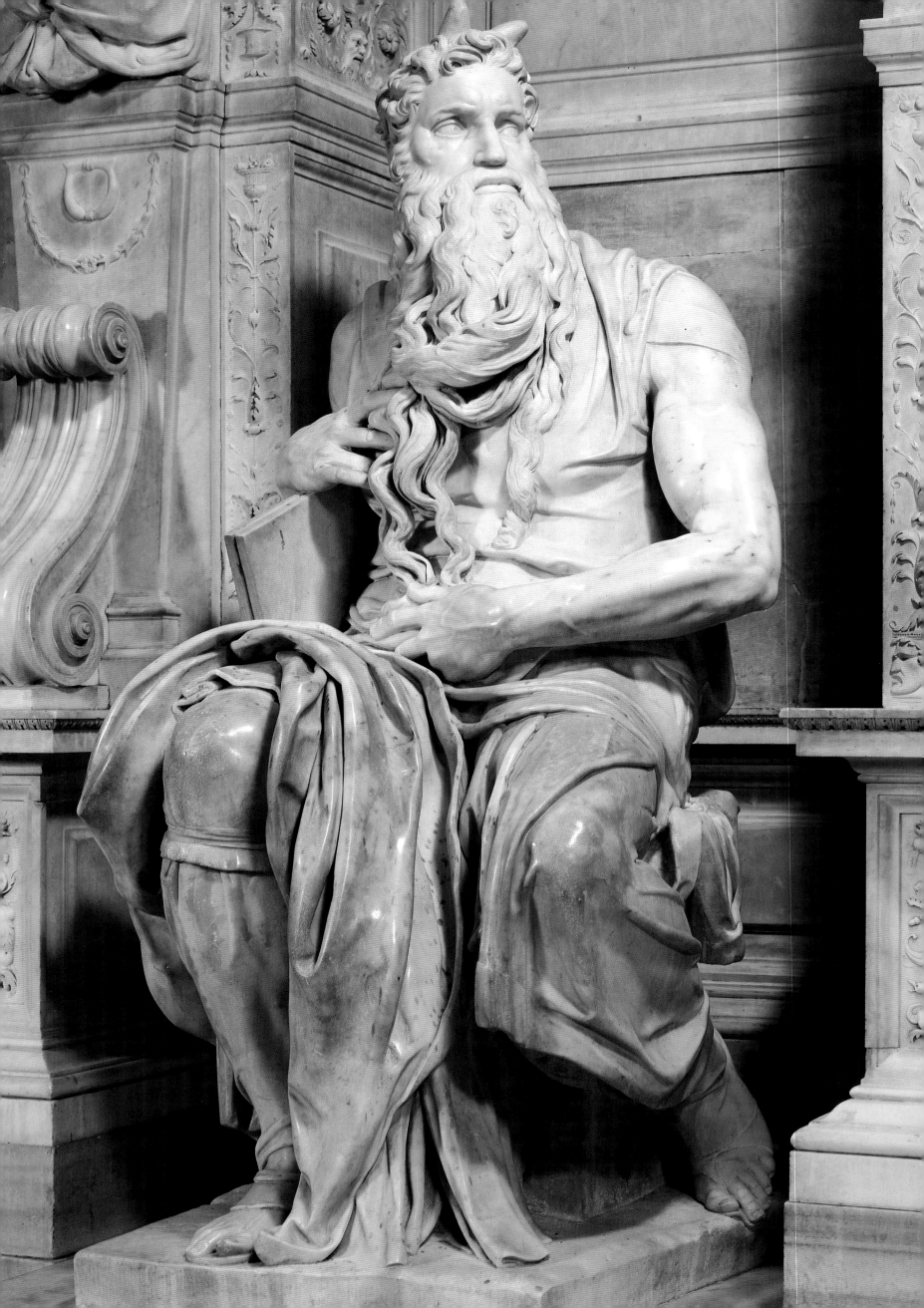

LEFT: *Moses*, 1513/16, marble h. 9¾ inches (235 cm), San Pietro in Vincoli, Rome. The great seated figure of Moses, which became the central feature of the completed tomb, was the only other figure carved for the 1513 project. Derived from the Sistine prophets, it has the fierceness characteristic of the Pope and of Michelangelo himself.

RIGHT: *Awakening Slave*, 1520-23, marble, h. 97½ inches (250 cm), Galleria dell'Accademia, Florence. Like the figure of *St Matthew*, the *Awakening Slave* seems to emerge from its block of stone as if released by Michelangelo's chisel.

architectural structure called for a revision of the sculpture. It has been suggested that Michelangelo realized the Louvre *Slaves* were not substantial enough for the new tomb structure and that he began four new larger figures to replace them. These are the *Prisoners* or *Slaves*, four now in the Accademia and one in the Casa Buonarroti in Florence. Although the statues' rough, unfinished state does convey something of Michelangelo's creative vitality, they are far too rudimentary to offer firm ground for interpretation, especially since they are not entirely his work. Some areas of carving are unmistakably Michelangelo's, but others are crude and lifeless and may well be by a studio helper. In the *Awakening Slave*, for example, only the torso and raised thigh seem to show the characteristic web of his chisel.

It is not just their larger size and unfinished state which make the *Prisoners* so different from the Louvre *Slaves*, it is their intended role in relation to the architecture. The *Slaves* were essentially sculptural decoration, while the *Prisoners* appear to have a structural function. Their popular name may imply recognition of their structural role, as in the sixteenth century the term *prigione* was used for atlas or caryatid figures. This difference is particularly clear in a comparison of the *Rebellious Slave*, which twists away from the wall, with the Prisoner intended to replace it, the so-called *Atlas* which is specifically designed to bear a load.

Interestingly, Michelangelo's unfinished statues were already highly valued in his own lifetime. The *Prisoners* were singled out for special praise in a late-sixteenth-century guidebook to Florence as superior to his finished statues because they were closer to the artist's conception. This is an indication of a revolutionary new attitude to art, no longer regarded merely as a mirror to nature but as a reflection of the

LEFT: *Atlas*, 1520-23, marble, h. 97½ inches (250 cm), Galleria dell'Accademia, Florence. For a later revision of the tomb plan, Michelangelo began to carve four larger figures of slaves or prisoners. This one, traditionally known as the *Atlas*, was clearly intended for a corner position.

RIGHT: *Victory*, c. 1530-33, marble, h. 102 inches (261 cm), Palazzo Vecchio, Florence. The figure group *Victory*, carved for a later stage of the tomb project, has an elegant spiralling pose of a type which later became characteristic of Mannerist sculptures.

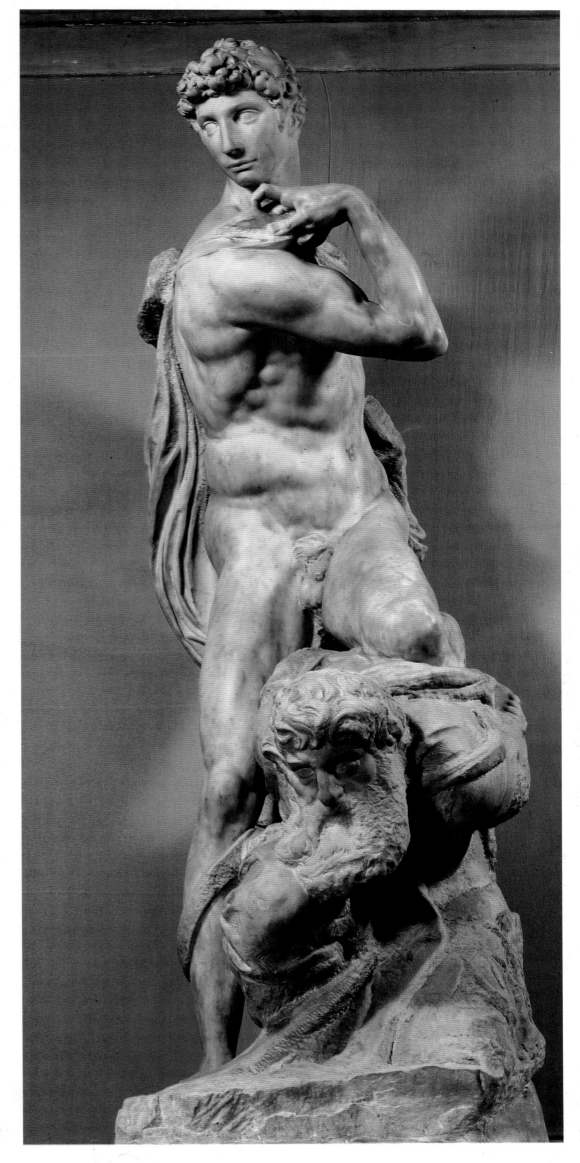

artist's inner life, which was due to a considerable extent to the influence of Michelangelo.

Of the rest of the 20-odd statues for the 1516 plan, only one was carved, the two-figure group known as the *Victory*, which was among four such groups intended for niches on the tomb. It is the same size as the *Prisoners* and is also unfinished, though to a lesser extent, and was probably intended to stand with them on the lower tier. Vasari says this figure was part of the original tomb plan; though it may have been started then, the exaggerated torsion of the pose suggests a later date. The position of the raised arm and hand is derived from the *David*, but the figure's self-conscious elegance recalls the *ignudi*. Like the *David*, the *Victory* was meant to be viewed from the front and is ingeniously designed to convey movement within this restricted range. The spiralling effect is created by contrasting the turn of the head with that of the arm and body. Michelangelo is reported to have advised a pupil to 'always make the figure pyramidal, serpentine', qualities demonstrated by the *Victory* and taken to great lengths by Mannerist artists. The miserable bearded victim on whom he rests his knee so insouciantly is roughly carved, like the *Prisoners* he resembles in type. This figure's generalized resemblance to Michelangelo led Howard Hibbard to speculate that it may be one of the 'ironic self-references' that occur in his later work.

From the early 1520s Michelangelo came under increasing pressure to complete the tomb, and he was also heavily involved in other large projects, first the Medici Chapel and then the *Last Judgment* and the Pauline Chapel. Julius II's executors put forward various proposals involving other artists, either as assistants or collaborators, but Michelangelo rejected them, saying he would prefer to repay the

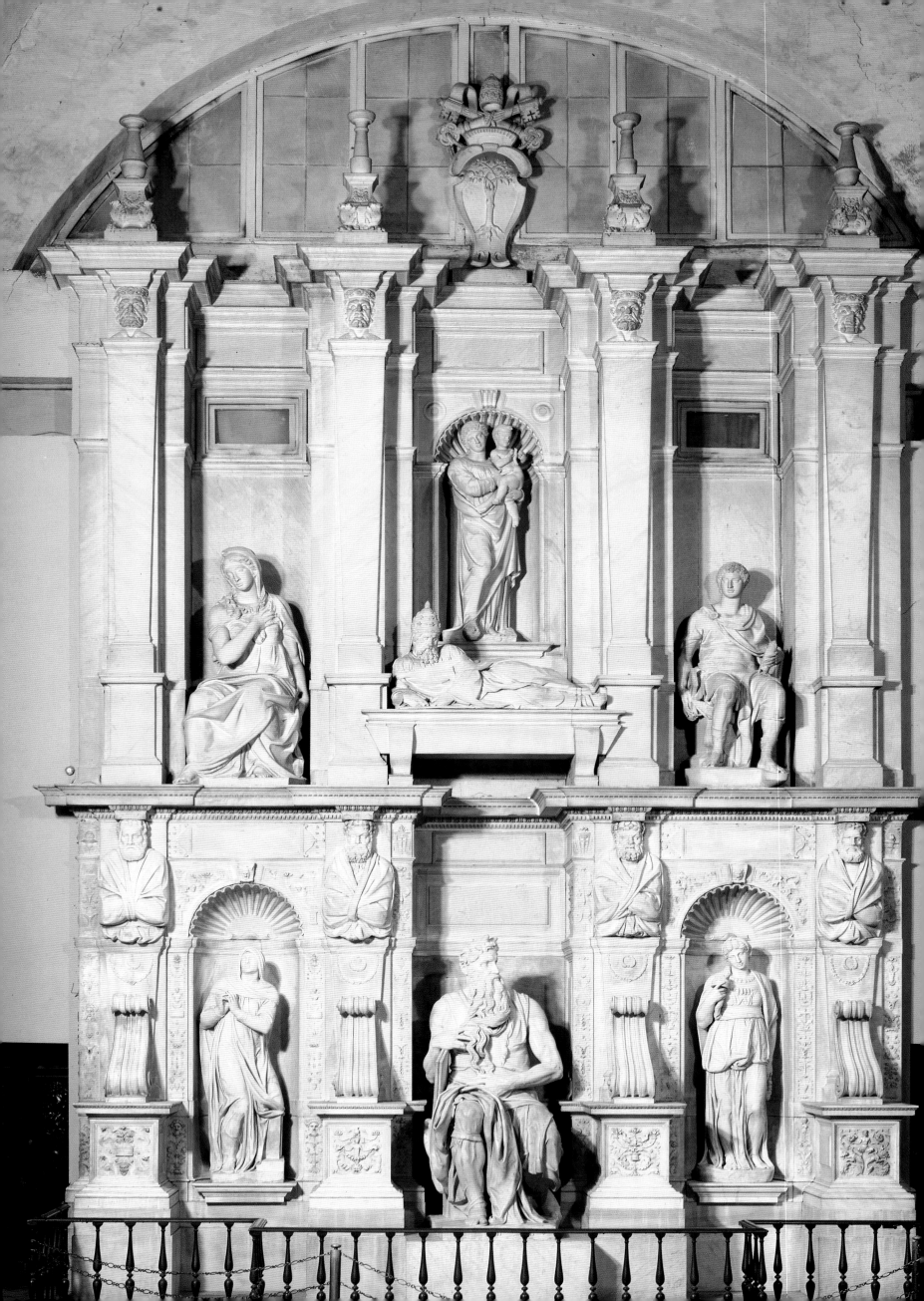

LEFT: Tomb of Julius II, marble, Rome, San Pietro in Vincoli. More than forty years after its inception, the tomb was completed, incorporating elements in different styles and scales from various stages of the design in an ill-considered assemblage.

RIGHT: The *Risen Christ*, 1519-20, marble, h. 80 inches (205 cm), Rome, Sta Maria sopra Minerva. The first version of this statue was abandoned when Michelangelo discovered a flaw in the marble and the awkwardness of this replacement may be due to its having been finished by two of his assistants.

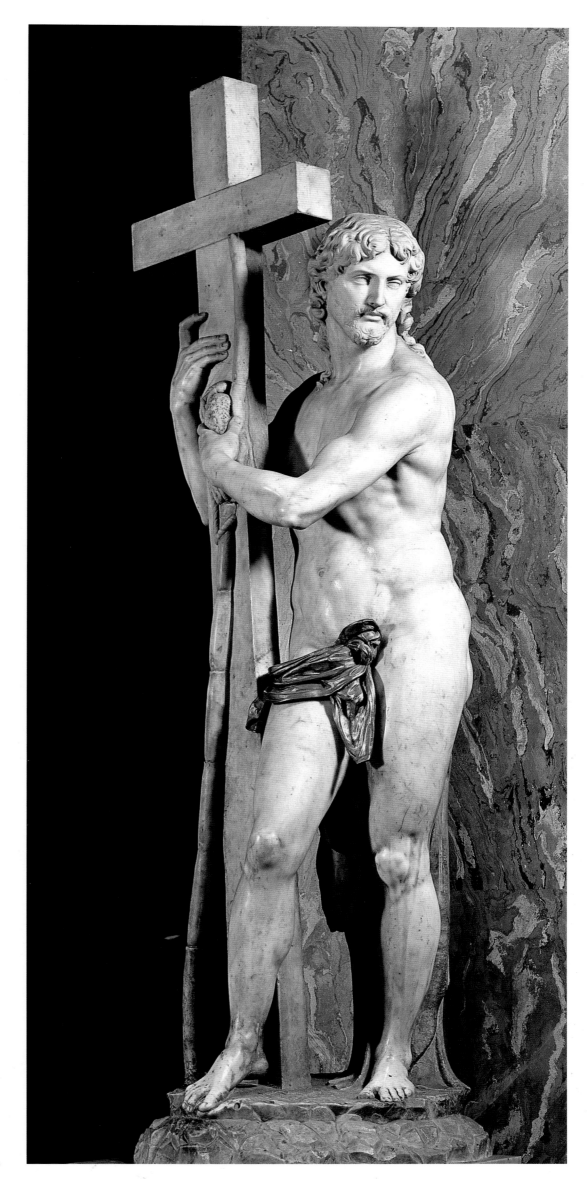

money than to have the tomb completed by others. Finally, in 1532 when his work on the Medici Chapel was particularly taxing, Michelangelo agreed to a new contract for a yet more reduced version of the tomb. It was now to consist of only six sculptures by Michelangelo, with five by other artists. The site of the tomb was also transferred from St Peter's to San Pietro in Vincoli, where it was eventually built. Again progress was slow due to other work; two years after the new plan was settled Michelangelo began the fresco of the *Last Judgment*, and when that was completed Pope Paul III insisted he begin painting the Pauline Chapel. This unsatisfactory situation continued for several years, with proposals for the tomb put forward and rejected, and Michelangelo increasingly distressed but unproductive. Pope-Hennessy suggests that, although Michelangelo was acutely aware of his moral obligation, 'In the face of his commitment he felt a sort of sublime helplessness'.

The tomb as we see it today is a strange and unsatisfactory mixture of elements from different plans made at different times. Basically, the stark upper level of 1516 rests on the elegantly decorated lower level of 1513, in which the *Prisoners* have been replaced by volutes. Only one statue from all the earlier schemes was included, the *Moses*. It is now at the center of the lower level, flanked by two smaller statues partly carved by Michelangelo, the *Rachel*, and the *Contemplative Life* or *Leah*. The remaining statues on the tomb, a dismal lot, were carved by Raffaello da Montelupo, allegedly from designs supplied by Michelangelo. The original emphasis on Renaissance interests – the antique, Neoplatonism and patronage of the arts – has been replaced by a religious one reflecting the changed times. The figures of Rachel and Leah were carved during a period of great upheaval in the Church, with

RIGHT: Tomb of Giuliano de' Medici, 1520-34, Medici Chapel, Florence, San Lorenzo. Michelangelo's elegant white marble wall tombs are framed by the dark *pietra serena* membering adapted from Brunelleschi's design.

OVERLEAF: Medici Chapel, view showing the tomb of Giuliano de' Medici, 1520-34, Florence, San Lorenzo. The Chapel is Michelangelo's most important ensemble of sculpture and architecture and even in its incomplete state it has an expressive power which anticipates the multi-art works of the Baroque era.

the Council of Trent and the Counter-Reformation in full flood. For Michelangelo, spiritual matters had become more important than artistic ones, and the energy and optimism of his early maturity had been replaced by a brooding mysticism. His mood is reflected in the lifeless piety of the figures of Rachel and Leah. These were the last statues Michelangelo ever completed and they represent a repudiation of all his previous sculpture. The tragedy of the tomb is not so much that the designs had to be changed, that Michelangelo was thwarted by patrons, circumstances or his own temperament, but that during his long involvement with the project he seemed to lose his belief in the importance of art itself.

At the height of his troubles over the tomb, Michelangelo undertook the commission for one of his least successful works, the *Risen Christ*. In July 1514 a group of Romans led by one Antonio Metello Vari asked him to carve a nude figure of the resurrected Christ for the church of Santa Maria sopra Minerva. Michelangelo had nearly completed the statue when a vein of black marble was revealed in the face, and he abandoned the work when he left for Florence in 1516. The figure now in the Minerva is a replacement which he carved in Florence in 1517-19 and shipped to an assistant in Rome, Pietro Urbano, for the final touches. Urbano, who complained that the customs offices 'wanted Christ to pay duty to enter Rome', did such poor work on the statue that Michelangelo's painter friend Sebastiano del Piombo intervened and had him stopped. The figure was finished by another sculptor, Federico Frizzi, who also designed its setting on a high pedestal in a shallow niche. In the last century the statue was moved to its present position against a pilaster, where it is seen nearly in the round and not frontally as intended.

Blame for the figure's faults is usually attributed to the misguided efforts of Urbano, particularly noticeable in the bland face, but the sharply turned head and the undignified slouching pose must have been set by Michelangelo. It is a moderate version of the spiraling pose, developed from the antique *contraposto*, which he had used to animate earlier figures including some of the *ignudi* and the *Rebellious Slave*. The motif of the arm crossing the chest is also antique, and was used in the Doni Madonna (page 45) and in the later Apollo or David (page 127). Some of the disturbing quality of the *Risen Christ* may be due to the strong influence of the antique, both in the pose and in its unabashed nudity. The body is sensually fleshy, very different from the chaste nude Christ in the *Pietà*. Without the cross the *Risen Christ* could be mistaken for a fruity Hellenistic Hermes. Michelangelo was not happy with it and later offered to replace it. Metello Vari refused and asked for the original flawed statue, which remained in his garden until at least 1556 and then disappeared. It is difficult to understand how this could happen, since by this time Michelangelo was already so famous that the mightiest patrons begged to own something by him. Alfonso d'Este had been trying to buy a work since his first glimpse of the unfinished Sistine ceiling. And in 1519, Frances I of France made it known to Michelangelo that he had 'no greater wish than to have some work, even small, of yours'. Patrons who in the previous century would have dictated detailed specifications to an artist now sought any work by Michelangelo's hand, of any subject, in any medium. The works they sought were not intended for the church but for their own collections; such art was no longer tied to a function but was appreciated for its own sake, for the expressive power given it by the valued artist.

The Sculpture of the Medici Chapel

For many years when Michelangelo was, as he wrote, 'chained' to the tomb of Julius II, he was also working on the Medici Chapel, a complex commission involving sculpture as well as architecture, his newest interest. During his work on the tomb he had become increasingly concerned with the integration of the two arts, and the Medici Chapel is his major achievement of this period. A detailed history of the chapel project, and a discussion of Michelangelo's designs for the building and its interior, are included in the section on architecture (page 176); the sculpture is discussed below.

In 1512, when Michelangelo was finishing the Sistine ceiling, the Medici family regained control of Florence and the republican government headed by his old friend Pietro Soderini was forced to resign. The family's power was further increased with the election of a Medici pope, Leo X, the following year. For a time the new pope did not employ Michelangelo on any new projects, and he continued his work on the tomb. However, by 1516 Michelangelo was involved in designs for a facade for the Medici parish church, San Lorenzo, commissioned by the Pope and his family to mark their restoration (page 172). The facade, he declared, would be 'the mirror of sculpture and architecture for all Italy'. But three years later the project was canceled, probably because the attention of the Medici had turned to a new project for San Lorenzo, a family mausoleum and memorial chapel.

It is not certain to what extent Michelangelo was responsible for the design of the exterior of the chapel or New Sacristy, but his scheme for the interior architecture was under construction by 1521. The development of his designs for the tombs followed the familiar pattern of reduction and simplification.

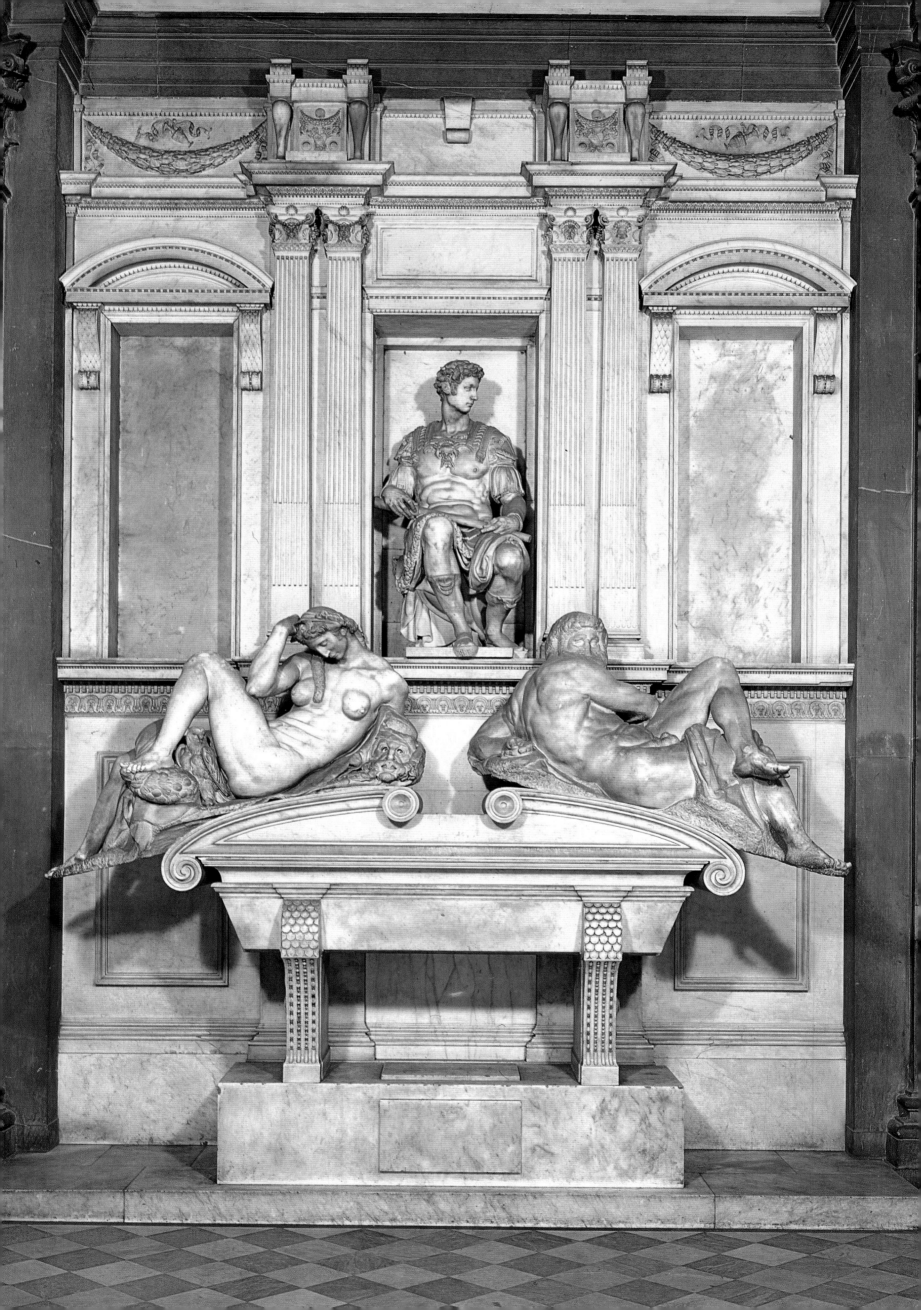

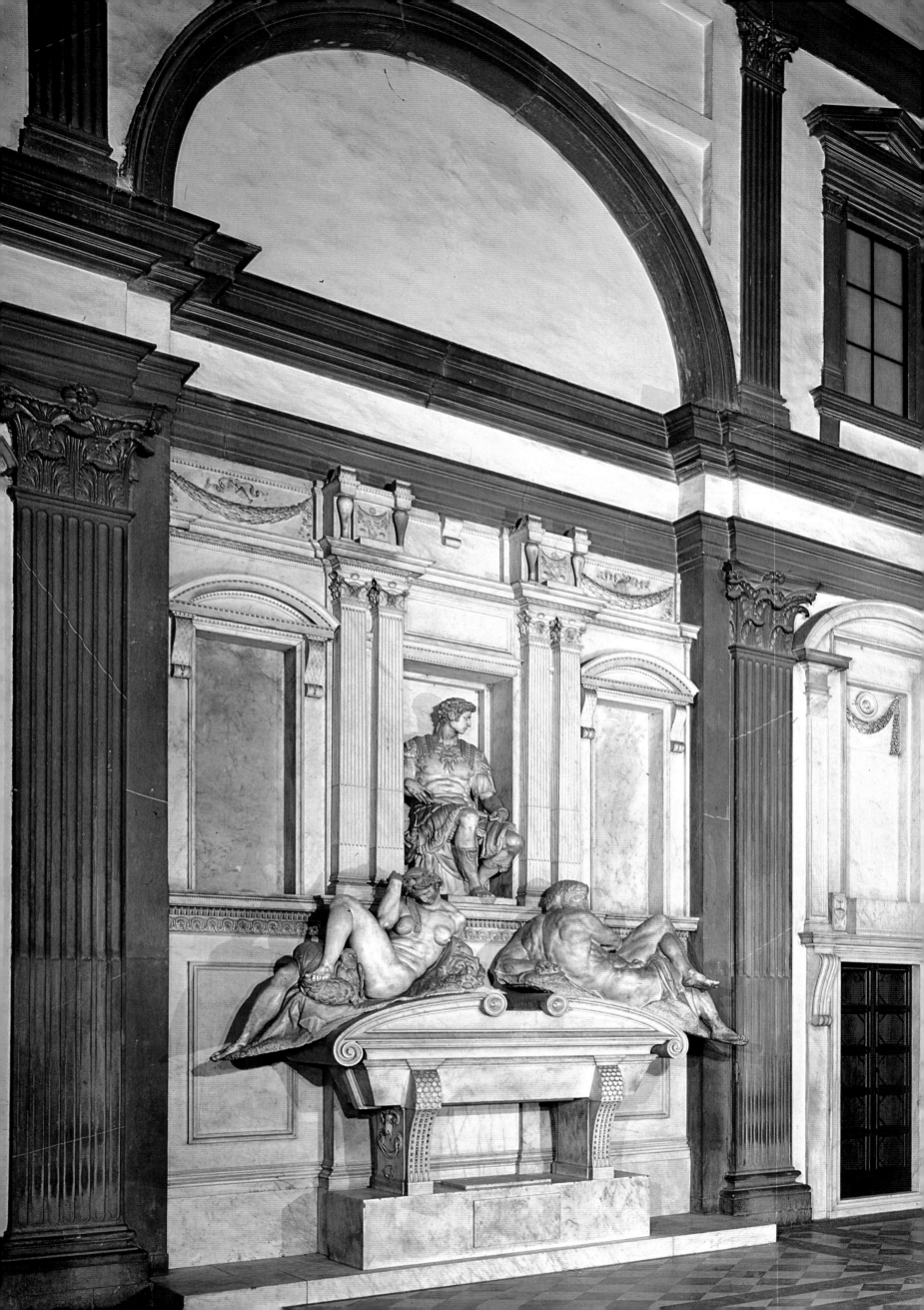

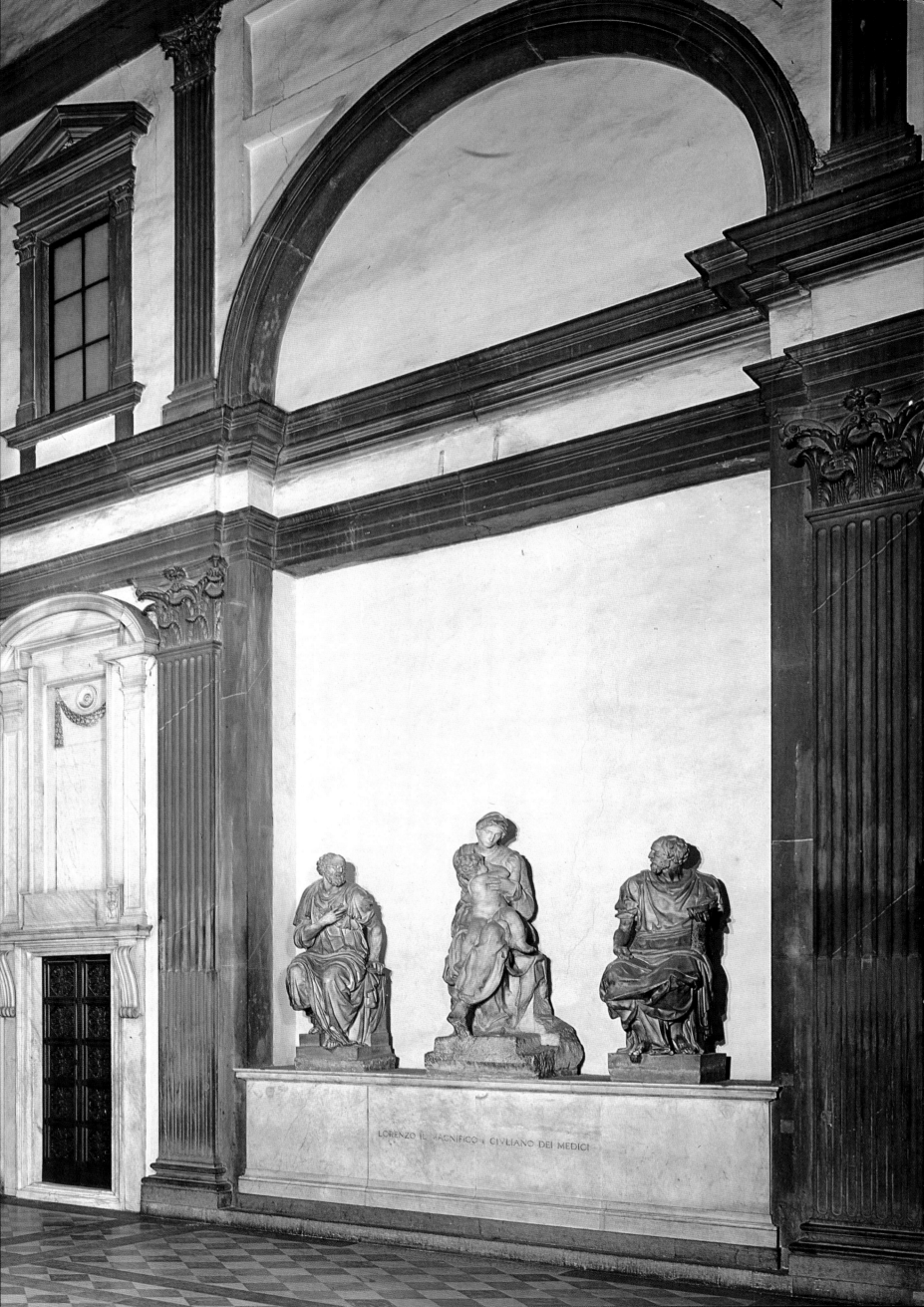

LORENZO IL MAGNIFICO E GIVLIANO DEI MEDICI

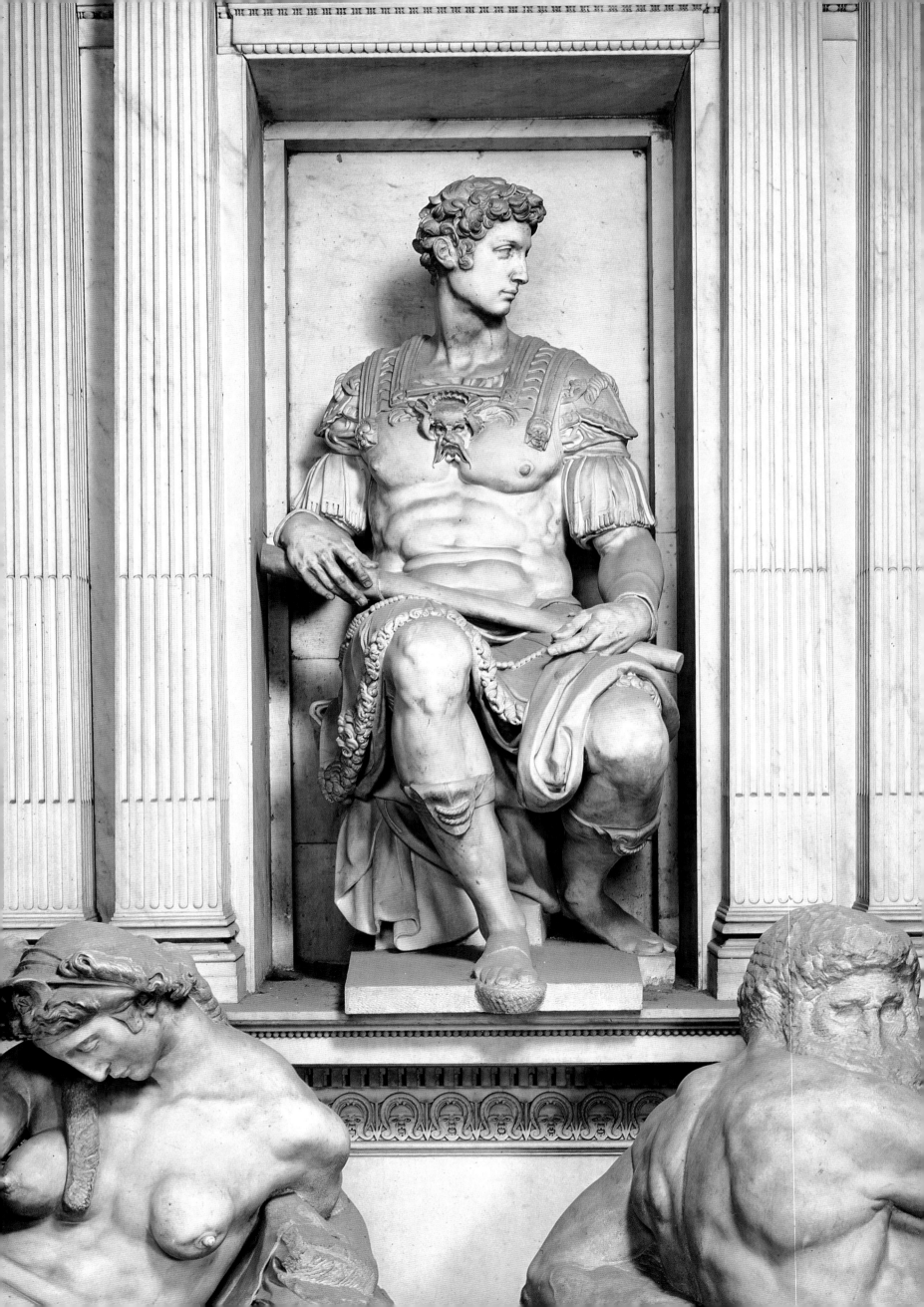

LEFT: Medici Chapel, *Giuliano de' Medici*, 1520-34, Florence, San Lorenzo. The statue of Giuliano is not intended to be a portrait; it presents him as an idealized type, probably an exemplar of the active life.

RIGHT: After Michelangelo, *Drawing for a Medici Tomb*, black chalk and pen, Paris, Louvre, Cabinet des Dessins. One of Michelangelo's many designs for tombs in the Medici Chapel. Some include reclining figures of river gods on the floor in front of the sarcophagi.

His first plan was to have all four tombs in a freestanding monument in the center of the chapel floor, a scheme reminiscent of the original proposal for the Julius Tomb. As the plan progressed it became apparent that the chapel was too small to house such a large structure, and it was decided to substitute wall tombs. Leo X died later that year and construction of the chapel was curtailed until, in 1523, the papacy was returned to the Medici with the election of Cardinal Giulio as Clement VII. Michelangelo was then under great pressure to finish both the tomb and the chapel. The situation caused him much anxiety and his letters from this period refer to recurrent melancholy, even madness. The disturbing effect of the chapel architecture and the depressive air of many of its statues must to some extent reflect Michelangel's own mood during its creation.

The chapel building was nearing completion by 1524 but progress on the tombs and their sculpture was slower. It was finally decided that there should be single tombs for the Capitani on the side walls of the chapel, and a double tomb for the Magnifici on the wall opposite the altar. The tombs would consist of marble membering framed by the dark gray pilasters of the Brunelleschian architecture, with the sarcophagi on pedestals in front. A drawing for one of the single tombs shows that in addition to the three central figures – a seated Capitano and two allegorical figures on the sarcophagus – the tombs were intended to have more elaborate decoration in the upper level, and statues of reclining river gods on the floor below. The river gods would have given the tomb group a pyramidal shape and emphasized the hierarchy implicit in the levels of the statues: from the rivers of the underworld to the idealized dead above. In 1526 Michelangelo stated in a letter that he himself would carve only the statues now on the tombs as well as the river gods, implying that the rest would be carved by others. And for the first time he made fullscale clay models of his statues to be used by assistants as a guide for carving.

Progress on the chapel stopped in 1527 when Rome was sacked and a republican government regained power in Florence. Michelangelo was an active supporter of the republic, and when the Medici recaptured the city in 1530 his life was saved only by the intervention of Pope Clement. Over the next few years Michelangelo worked on the chapel periodically, but his bitter disillusionment with the Medici gave him little heart for the project. His attachment to Florence was further weakened with the death of his brother Buonarroto and of his father. He began to spend long periods in Rome, drawn by his developing obsession with the young nobleman Tommaso de' Cavalieri. The Pope became increasingly concerned at the erratic progress of the

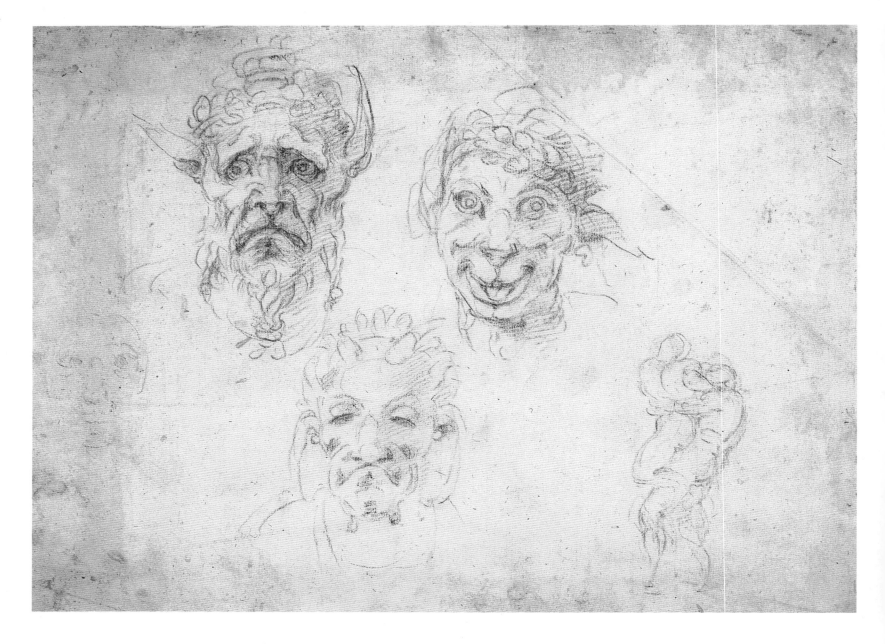

tomb statues and in 1533 three other sculptors were summoned to do the carving. Despite their assistance, the chapel was still incomplete in 1534 when Michelangelo again left Florence for Rome. Shortly after he arrived in Rome Pope Clement VII died, which precluded a return to Florence as without the pope's protection Michelangelo would be in danger from its tyrannical new ruler, Clement's illegitimate son Alessandro de' Medici. When, after

three years, Alessandro's assassination had removed this threat, Michelangelo had compelling reasons to remain in Rome. In addition to his friendship with Cavalieri, he had for the first time a close woman friend, the pious poetess Vittoria Colonna, and an important commission from the new pope, Paul III, to paint the *Last Judgment* on the altar wall of the Sistine Chapel.

Michelangelo never returned to Florence. When he left the Medici

Chapel the single tombs for the Capitani had been built in a simplified form, without the side niche figures or the reclining river gods. He had supervised the installation of the statues of Giuliano and Lorenzo in the central niches, but the unfinished allegorical figures lay abandoned on the chapel floor. These figures were placed on the sarcophagus lids by his followers in 1545. The double tomb for the Magnifici was never finished. The statue of the

RIGHT: Tomb of Giuliano de' Medici: *Night*.
Giuliano's tomb is accompaniedby figures
representing Night and Day, definite times
appropriate to the active persona. *Night* is
particularly celebrated, despite its
demonstration of Michelangelo's distinct lack
of sympathy for the female form.

Madonna and Child now on the wall
facing the altar may have been in-
tended for its central niche (or possibly
for the Julius tomb); the figures of the
two Medici patron saints, Cosmas and
Damian, which now flank the
Madonna are the work of assistants.
For the remaining 30 years of his life
Michelangelo refused to finish the
chapel, or to indicate to anyone else
how he wished it to be done.

The chapel as we see it today has only
some of the elements of the complex
and ambitious decorative program
Michelangelo planned, and we cannot
know the effect of the completed en-
semble. It does, however, contain the
most important sculptures that Michel-
angelo intended to carve himself. The
tombs of the Capitani occupy opposite
side walls of the chapel. The heads of
the statues of Lorenzo and Giuliano are
turned away from the altar to face the
Madonna on the entrance wall and the
approaching visitor. The altar too is
positioned so that the priest faces out,
toward the Madonna. The direction of
their gaze is a key to the purpose of the
chapel, which was intercession for the
souls of its inhabitants. The statues
look to the visitors to pray for their sal-
vation, and to the Madonna, and atten-
dant saints, to intercede with Christ.
This implication of a relationship be-
tween figures across the space, and
with visitors entering it, anticipates the
theatricality of Baroque schemes such
as those of Bernini.

The tombs of the Capitani are identi-
cal apart from the statues, which are
not identified. Nor are the statues in-
tended as portraits of the two men; they
are presented in a classicized, idealized
form, not as individual personalities,
but as contrasted types, perhaps exem-
plars of the active and contemplative
strands of Christian life. The pose of
Giuliano is derived from the *Moses*. He
sits erect and alert, poised to rise from
his seat, the sharp turn of his head

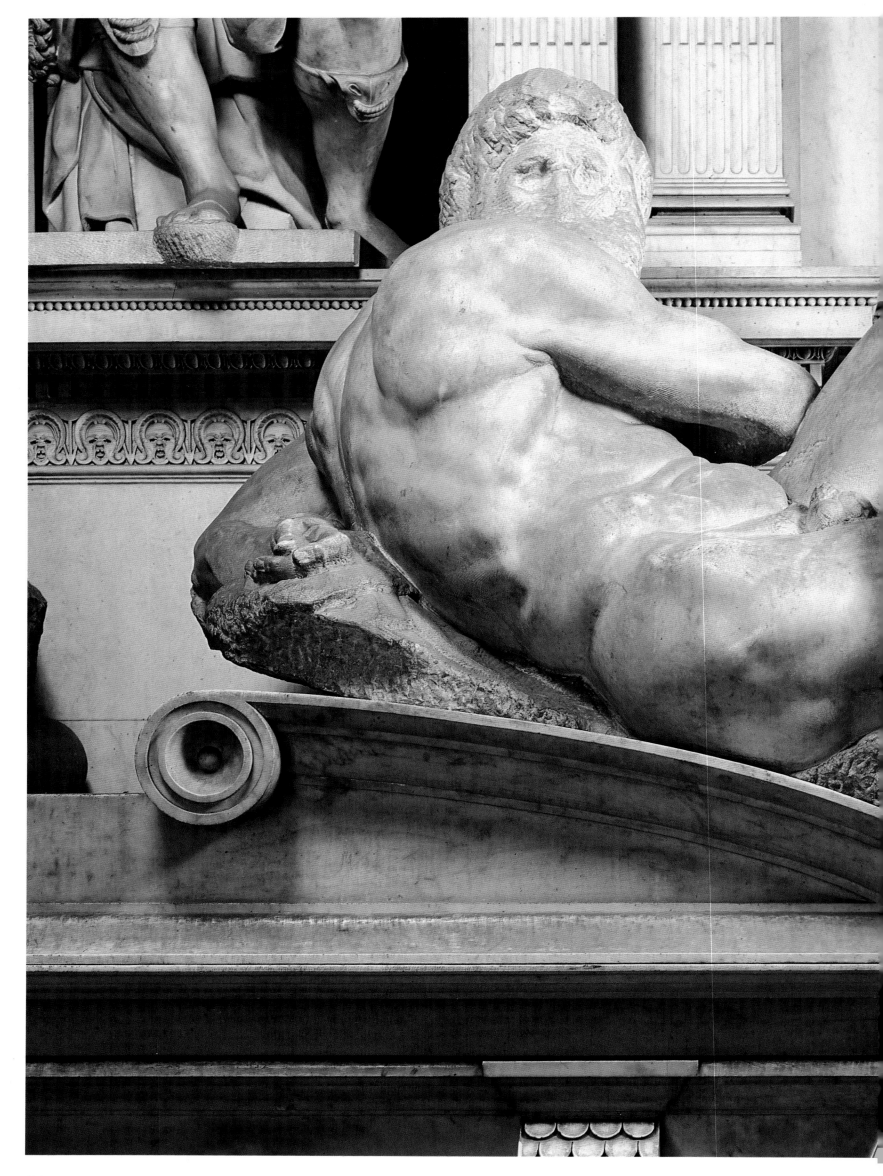

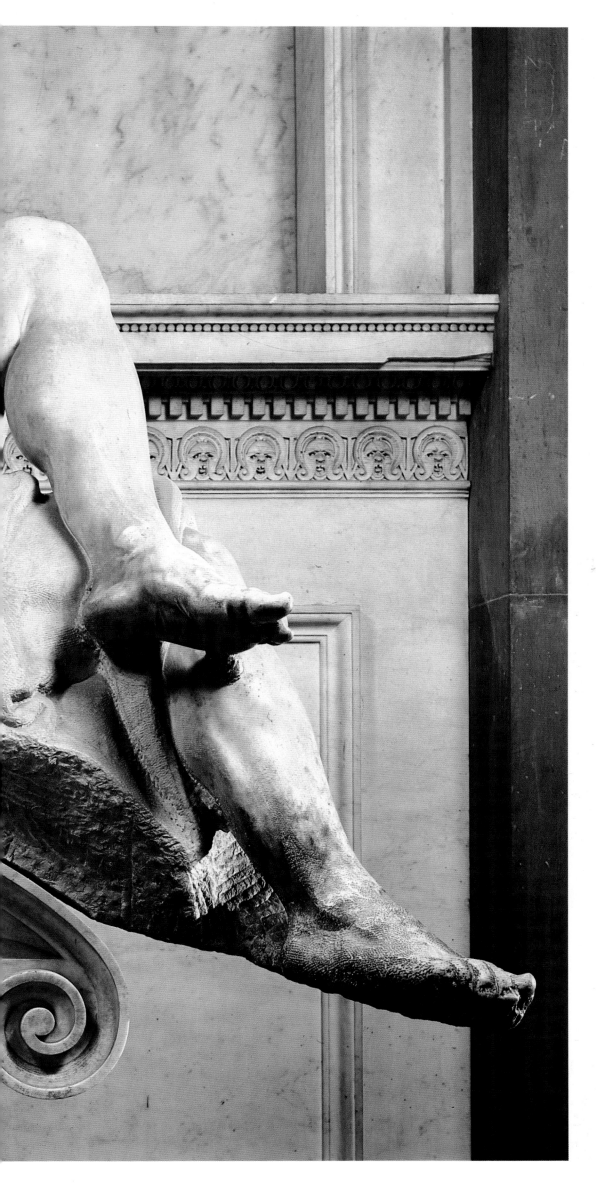

LEFT: Tomb of Giuliano de' Medici: *Day*. The brooding statue of *Day*, with its massive musculature and unfinished head, is yet another work in which Michelangelo paid tribute to the antique statue fragment, the *Belvedere Torso*.

emphasized by the long neck and the opposing turn of his upper body. He is bareheaded, with thick curly hair, and wears skin-like antique body armor decorated with a grotesque head. One hand loosely holds a military baton, the other some coins – perhaps a reference to the family's reputation for liberality. The statue of Giuliano is the most fully finished of the tomb statues and was probably begun first as it is relatively compact and detailed. In the chapel, as on the Sistine ceiling, Michelangelo's figures tend to outgrow their architectural settings. The figure of Lorenzo is massive and stolid, and seems slightly cramped by the confines of the niche. His pose is closed and relaxed, legs loosely bent, one hand raised to his mouth, his elbow resting on a curious animal-faced money box, perhaps a reference to the Medici family banking business. He wears a helmet shaped like the face of a fantastic animal, which casts his own face into deep shadow. It has been suggested that the shadowy strangeness of the figure is a reference to the fact that Lorenzo died insane, though this would be out of keeping with the idealized nature of the depictions. Rather, the shadow may suggest his passive, contemplative role in contrast to the energetic Giuliano, a distinction emphasized by the original lighting of the chapel. Similar fanciful helmets appear in Michelangelo's later drawings of ideal heads (page 128).

The contemporary drawing of grotesque animal masks may be associated with the tombs as they are a recurring feature of the Medici chapel imagery. In addition to decorating the armor and strongbox of the Capitani, they appear on one of the sarcophagus figures and on the exquisite decorative molding of the marble membering. The originality of Michelangelo's treatment of the molding is typical also of his inventive use of antique models in the chapel architecture. The cumulative effect of

RIGHT: Drawing: *Study for the figure of Day*, black chalk, 6¾ × 10½ inches (17.6 × 27 cm), Oxford, Ashmolean Museum. A typically truncated study for the Medici sarcophagus figure, made either from life or from a clay model.

BELOW RIGHT: Working drawings for a recumbent statue, pen and ink, 5¼ × 8¼ inches (137 × 209 cm), London, British Museum. Quick sketches made to calculate the size of marble block needed for one of the statues of river gods that Michelangelo planned to place in front of the Medici Chapel tombs.

BELOW: *Cleopatra* (Ariadne), c. 150 BC, marble, 62½ x 74¼ inches (160 × 190 cm), Rome, Vatican Museum. The figure of *Night* also has antique sources, possibly including this charming reclining figure which Pope Julius installed in the Vatican Belvedere in 1512.

such details contribùtes to the disturbing, slightly oppressive atmosphere of the chapel as a whole.

One of the themes of the tombs is the inexorable power of time, a reminder of man's fleeting mortality and fame. According to some scholars, the imagery may have been suggested by a passage in Dante in which he describes life as an arc that has four segments, four seasons, four times of day. The sarcophagi of the Capitani bear pairs of recumbent figures which emphasize their contrasting characteristics. Beneath Giuliano are statues of *Night* and *Day*, definite times echoing his active role; the passive Lorenzo is flanked by figures representing the imprecise times, *Dawn* and *Dusk*. The references to antique art in the accoutrements of the Capitani occur also in the sarcophagus statues (and would have been continued by the river gods). The figure of *Night* is derived from an antique statue of *Leda and the Swan*, which also inspired Michelangelo's lost painting of the subject, and a beautiful study of a head (page 126). The erotic implications of Leda's pose are echoed in the provocative position of the owl under *Night*'s leg, though Michelangelo's lack of sympathy for the female body ensured that little else about the figure was erotic. The association of Night with her children Sleep and Death is represented by the presence of poppies and a hideous mask. According to Condivi, Michelangelo intended to add another symbol to one of

these figures, a mouse, which would have clarified the meaning of the group in relation to the overall theme of time and fame for, as Condivi explains, ' . . . this little animal gnaws and consumes, just as Time devours all things'.

The statue of *Night* was particularly admired and it inspired many literary interpretations and tributes. Vasari's description of the statue focuses on her sorrowful aspect: ' . . . in her may be seen not only the stillness of one who is sleeping but also the grief and melancholy of one who has lost something great and noble'. The melancholy air of *Night* suggests a relation to another antique statue known to Michelangelo in the Vatican, the charming figure of a sleeping nymph once thought to be of Cleopatra or Ariadne. However, a poem by Michelangelo of the 1540s, in which he addresses the reader in the person of Night, indicates that the statue's mood is one not of melancholy but shame, and implies his disapproval of the current Medici regime in Florence:

Sleep to me is sweet, and sweeter to be stone,
As long as hurt and shamefulness endure,
It is better not to see or hear;
So do not waken me, but pray speak low.

Night's partner on the sarcophagus, the brooding and suspicious *Day*, also

has an antique source, the massive mutilated figure of the *Belvedere Torso*. The Torso, like the *Laocoön*, exercised an enduring fascination for Michelangelo and much of its subsequent fame is due to the attentions he paid it. The truncated figure of the Torso coincided exactly with the portion of the male body that most interested Michelangelo, and like so many of his own works it gave the impression of being unfinished. The statue of *Day* too is un-

finished, with its rough stump of head peering out over the rippling muscles of the shoulder. The pose is so unnecessarily twisted – one arm across the chest, another bent back beneath, legs crossed in the opposite direction – that it suggests another motif favored by Michelangelo, the bound figure, powerful yet helpless. Again an element of autobiography is inescapable: the image of the artist himself chained to a commission he had come to resent.

RIGHT: *Medici Madonna*, 1521-34, marble, h. 98¾ inches (253 cm), Florence, San Lorenzo, Medici Chapel. The last of Michelangelo's series of sculptures of the Madonna and infant Christ, full of autobiographical undertones. The Virgin gazes blankly into space, barely supporting her herculean child who seeks sustenance so energetically.

BELOW: Apollonios son of Nestor, *Belvedere Torso*, c. 50 BC, marble, h. 62 inches (159 cm), Rome, Vatican Museum. The fame of the Torso owes much to Michelangelo's great admiration for it. A story that he was discovered kneeling in front of it was later given a scurrilous interpretation.

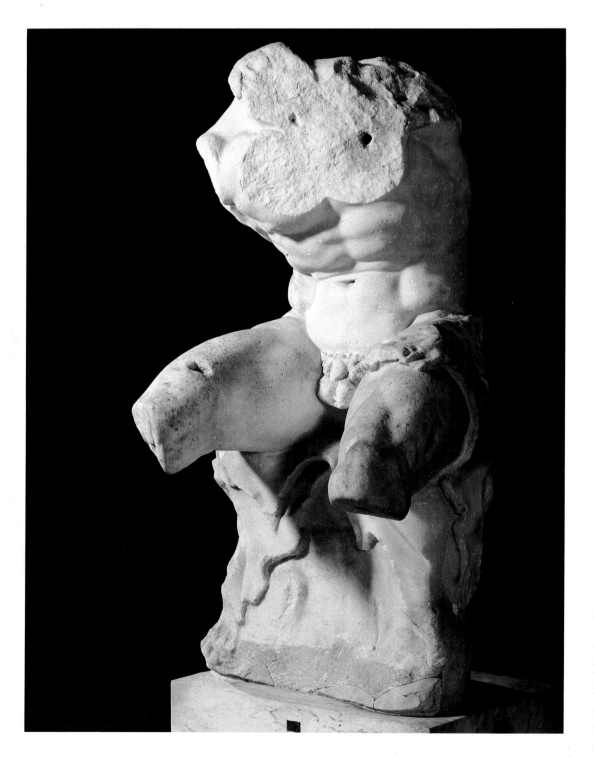

The statues of *Dusk* and *Dawn* accompanying Lorenzo are less dramatic, in keeping with his own somber aspect. Their poses are not extreme nor is their anatomy exaggerated for the sake of expression like the figures of *Night* and *Day*. By comparison they seem almost bland, an effect perhaps of their higher degree of finish, especially in the faces, which makes their impact less immediate. They are also designed for the role they perform, reclining gracefully in curves which match those of the lids they occupy. The figures of *Night* and *Day* curl against the curvature of the lid, as if resisting the role assigned to them.

The *Madonna and Child* now on the entrance wall of the chapel was not left on the chapel floor, but was found in Michelangelo's studio. It was intended as the central figure on the double tomb of the Magnifici and as the focus of requests for intercession. It too has antique origins, perhaps in a classical Muse, as does its disconcertingly casual cross-legged pose. The statue is the last of Michelangelo's many sculptural renditions of the theme of the Madonna and the Infant Christ, and is particularly interesting to compare with the *Bruges Madonna* (page 33). The fact that the Christ child turns his back to the viewer also recalls the very early *Madonna of the Steps* (page 13). Once again the mother is shown as distant and preoccupied, hardly bothering to hold the nursing child on her lap. Other drawings from this period indicate Michelangelo's renewed interest in the theme, with increasingly large and heroic infants. The statue is carved from an unusually deep narrow block and Michelangelo's difficulties with it may be inferred from the awkward angle of the Madonna's shoulder, and its unfinished state.

Although to some extent Michelangelo's abandonment of the chapel may reflect his disapproval of the Medici family, there were other factors too. The chapel was one of a number of projects he left incomplete and it is significant that these projects involved sculpture, his primary art. He had managed to finish painting the Sistine ceiling, and during the last 30 years of his life he completed another two important fresco commissions and two major architectural projects, but almost no sculpture. The technical demands of

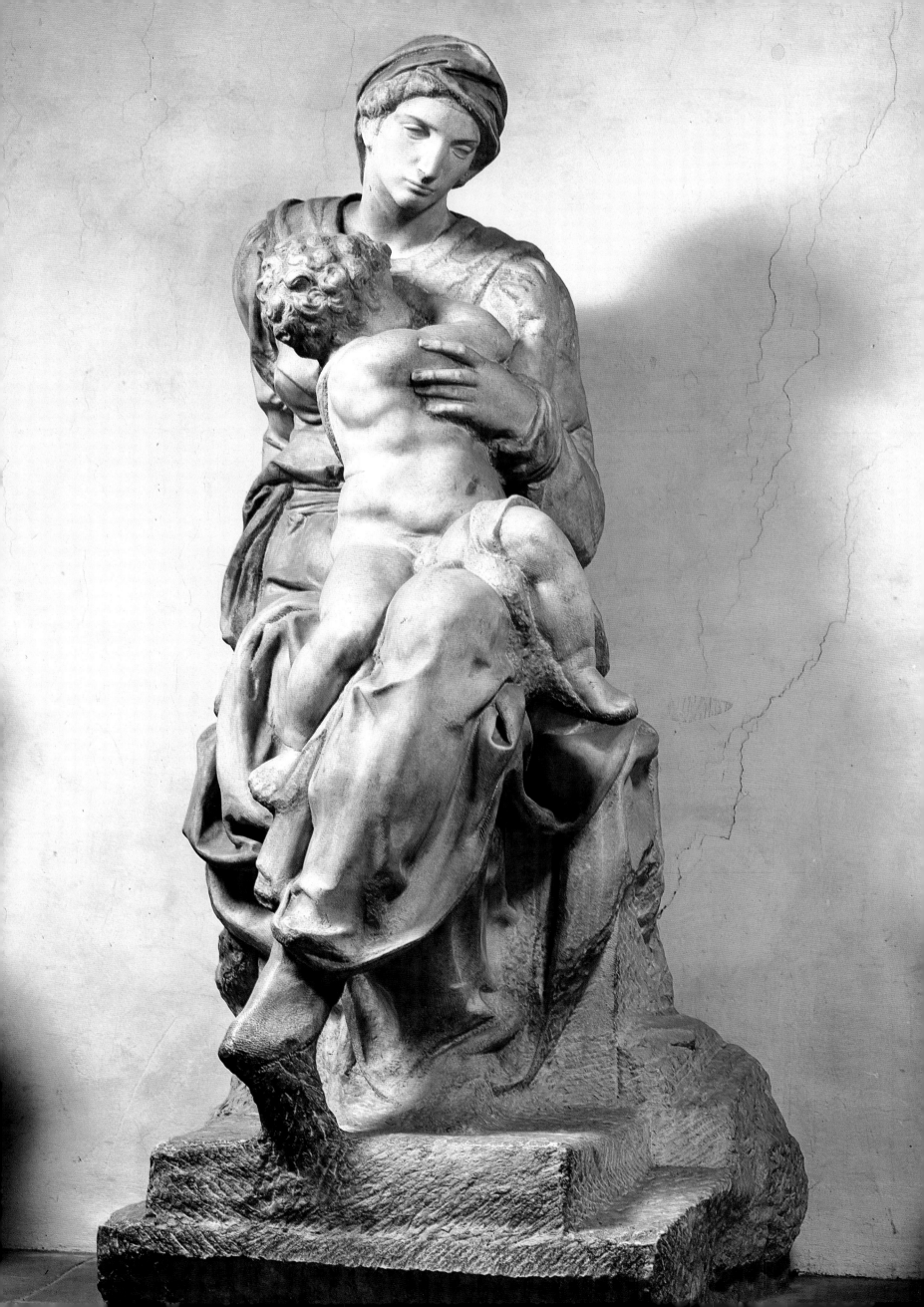

BELOW: *Drawing for the head of Leda*, c. 1530, red chalk, Florence, Casa Buonarroti. A finely finished study of a male model for Michelangelo's lost painting of *Leda and the Swan*, commissioned but never received by Alfonso d'Este.

large sculptural projects required the use of assistants to a degree Michelangelo could not countenance. Furthermore, his commitment to sculpture proper lessened as he mastered architecture and began to use it in an expressive, sculptural way. The Medici Chapel is a turning point in this development and, though incomplete, is Michelangelo's greatest sculptural ensemble and the nearest thing we have to his promised 'mirror of sculpture and architecture for all Italy'.

During the brief return of the Florentine Republic at the end of the 1520s, when Michelangelo was employed to rebuild the city's defences, he went to Ferrara to examine its famous fortifications. The Duke of Ferrara, Alfonso d'Este, brother of Isabella and a major patron in his own right, had been a fervent admirer of Michelangelo since he had visited the scaffolded Sistine ceiling. Alfonso had repeatedly requested a work, any work, by Michelangelo in letters remarkably deferential in tone – indicating the new higher status of artists, at least of important artists – and he seized the opportunity to commission a painting. Michelangelo's choice of an erotic pagan subject, Leda and the swan, may have been inspired by Alfonso's sensational set of bacchanalian scenes by Titian; a lost cartoon showing Venus entwined with Cupid also dates from this period. It may also have been linked to his old rivalry with Leonardo, who had painted a subtly sensual standing Leda. Perhaps as a conscious contrast, Michelangelo chose an explicit image, showing Leda's coupling and the resulting birth of twins from her egg. The figure of Leda was based on the same antique relief as the Medici Chapel *Night*, and there is a finely finished study for the head, drawn from a male model as was the usual practice of artists at the time. The Leda never reached its intended owner as the courtier Alfonso sent to collect the picture, described by Condivi as 'painted very rapidly in tempera', offended the artist by dismissing it as 'a trifle'. Michelangelo then refused to sell the painting and instead gave it to his assistant Antonio Mini, who moved to France and eventually sold it to another of his admirers, Francis I. The incident is often cited as an example of Michelangelo's fierce pride and his insistence on respect for his profession, though

RIGHT: *Apollo* (David), c. 1530, marble, h. 57 inches (146 cm), Florence, Museo Nazionale (Bargello). This appealing small statue was intended as a gift. Its twisted pose echoes the figures on the Medici sarcophagi but it is more gentle and natural.

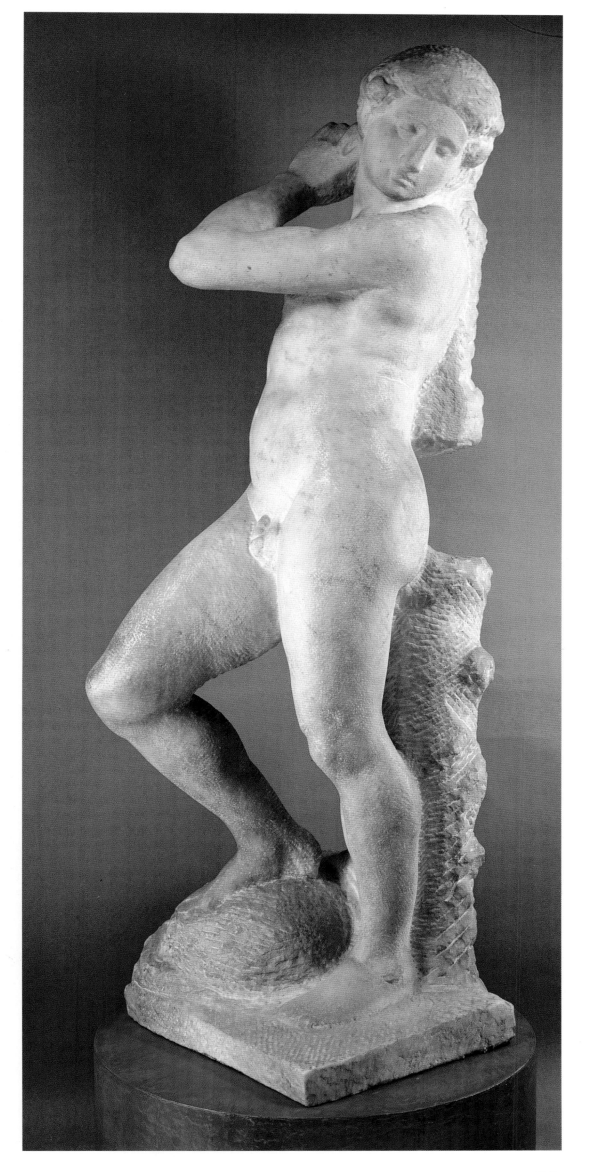

the suspicion remains that he had misgivings about the picture and contrived an excuse to avoid its exposure in Alfonso's collection. The painting was later lost, rumored to have been destroyed deliberately due to its shocking subject, though the cartoon survived long enough to inspire several later versions of the subject.

One positive result of Michelangelo's deteriorating relations with the Medici family was a graceful and appealing *Apollo*. Toward the end of the time he worked on the Medici Chapel he began carving a small statue of a male nude, perhaps originally intended to be a David stepping on the head of Goliath. When the Medici regained control of Florence in 1529 they instructed their agent Baccio Valori to imprison republican sympathizers, including Michelangelo. Michelangelo hid for about two months – probably in the crypt of the Medici Chapel, where wall drawings by him have recently been uncovered – and was saved by order of Pope Clement. To appease Valori he agreed to give him the statue, prudently converting the David, with its republican associations, into an *Apollo*. The statue was not completed when Valori left Florence, and it became part of the Medici collection. The pose is a relaxed and understated version of the contorted postures assumed by the chapel sarchophagus figures. In contrast to the neurotic intensity of *Night* and *Day*, the *Apollo* appears refreshingly simple and natural. Some of the statue's appeal is due to the surface treatment: it lacks the final high polish and, unusually, is finished to a uniform degree overall, including the face. The unpolished marble gives an effect of softness, unlike the hard shine of finished figures such as the *Dying Slave*, and without finicky anatomical details the work seems surprisingly modern, almost abstract.

BELOW: *Ideal Head*, c. 1520, red chalk, 8 × 6½ inches (20.5 × 16.5 cm), Oxford, Ashmolean. Possibly a 'presentation' drawing, one of the highly finished chalk drawings Michelangelo made for close friends. The idealized face and elaborate helmet recall the Medici tomb statues.

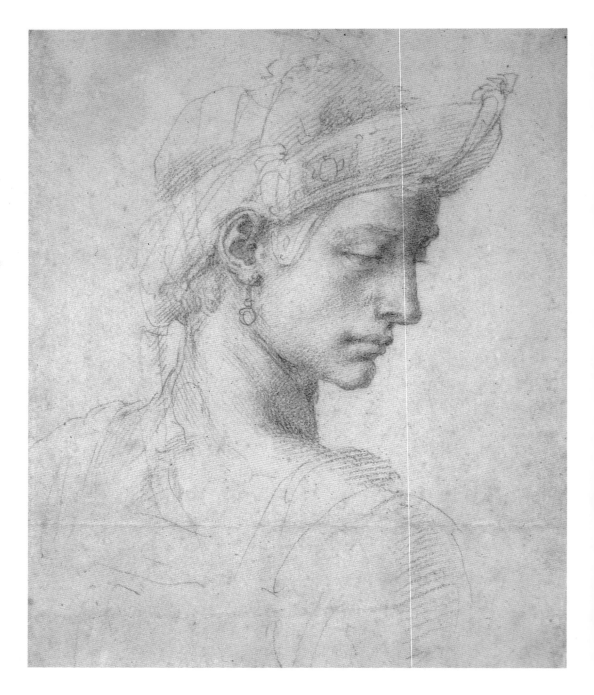

The Presentation Drawings

On one of his drawings Michelangelo scribbled a note admonishing his assistant Mini to 'draw, Antonio, draw, and don't waste time'. Michelangelo himself was a supreme draftsman, the greatest exponent of the Florentine school in which drawing, particularly the male nude, was the fundamental skill. The practice was accorded the status of an abstract principle, that of *disegno*, and to establish the structure and form of a work of art by drawing was considered the highest achievement of an artist. Its rival quality, *colore*, the speciality of the Venetian School, was seen as secondary, supplementing the form established by the drawing. *Disegno* was considered the common source of the visual arts as well as their intellectual basis. In his essay on painting Vasari makes this clear: ' . . . *Disegno*, the parent of our three arts, Architecture, Sculpture, and Painting, having its origin in the intellect, draws out from many single things a general judgment, it is like a form or idea of all the objects in nature, most marvelous in what it compasses.'

Most of Michelangelo's surviving drawings are sketches, studies for works in other media, but a few of his chalk drawings are highly finished and were intended as works of art in their own right. These are the so-called 'presentation' drawings, made for particularly close friends. The finished drawings appeared at a time when Michelangelo began to leave other works incomplete, and he may have used them as a way to express ideas more quickly than carving or even painting. The three drawings of 'divine heads' which Vasari says Michelangelo gave to a Florentine nobleman were no doubt similar to the two shown here. The red chalk *Ideal Head* is probably the earliest as the features are reminiscent of some of the Sistine *ignudi*. Though the model was most certainly male, the subject has the androgynous quality typical of Michelangelo's efforts to portray females (unlike those of Raphael to whom the work is sometimes assigned). The *Ideal Head of a Woman* was known traditionally as the Marchesa of Pescara as it was thought to represent Michelangelo's friend Vittoria Colonna. It has often been paired with a drawing known as the *Count of Canossa*, a bearded man wearing *outré* headgear, though this is now regarded as a copy of the original pendant. Michelangelo believed himself to be a descendant of the Canossa family, and as the female head bears no resemblance to Vittoria Colonna, who was

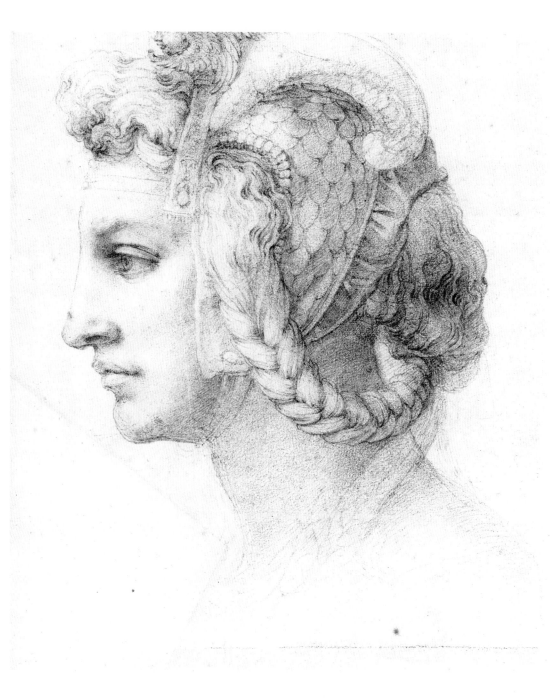

BELOW: *Ideal Head of a Woman*, c. 1525-28, black chalk, 11¼ × 9¼ inches (28.7 × 23.5 cm), London, British Museum. One of the 'divine heads', which Vasari says Michelangelo drew for friends, this was traditionally considered to be a portrait of the noblewoman Vittoria Colonna, though the subject is probably imaginery.

positively plain, perhaps it represents another idealized Canossa ancestor, the saintly Countess Matilda. The headdress and the helmet in the pendant copy are related to the fantastic helmet on the figure of Lorenzo in the Medici chapel, which suggests a date in the late 1520s. The painstaking technique of these drawings, modeled with fine parallel lines and minute stippling, is very different from the lively line and bold chisel strokes of Michelangelo's working sketches. Their meticulousness may make them less appealing to the modern viewer, but it was precisely this quality which was appreciated by his contemporaries, who enjoyed studying such works under a magnifying glass.

Michelangelo's exalted standards of beauty gave him an unusual aversion to portraiture. According to Vasari, 'he abhorred making a likeness from the life, unless the subject was one of perfect beauty'. The only portrait by him noted by Vasari was of the young Roman aristocrat Tommaso de' Cavalieri, who was undoubtedly the great love of his life. Cavalieri's worthiness for this honor is attested by the writer Benedetto Varchi, who said he demonstrated 'not only incomparable physical beauty, but so much elegance in manners, such excellent intelligence, and such graceful behavior . . .'. Although Michelangelo's infatuation with Cavalieri had obvious sexual overtones, he repeatedly asserted the chaste nature of their friendship, which lasted until the artist's death. Michelangelo's Neoplatonic beliefs led him to equate beauty with good, so that Cavalieri represented for him both a physical and a philosophical ideal. And despite the differences in their ages, the two men had many interests in common: Cavalieri was educated in the humanist tradition, wrote well, and took a particular interest in the visual arts, eventually

acquiring a fine collection of antique and contemporary works. He held a number of public offices, one of which included overseeing the rebuilding of the Capitol according to the designs of Michelangelo. Michelangelo's portrait of Cavalieri was a half-length lifesize cartoon in black chalk, reputedly showing him wearing classical dress and

holding a medal. The cartoon is lost, but something of its quality can be seen in the exquisite drawing of another young man admired by Michelangelo, Andrea Quaratesi. Quaratesi, like Cavalieri, was an aristocrat, a member of a Florentine banking family with whom Michelangelo was friendly, and it has been suggested that the artist

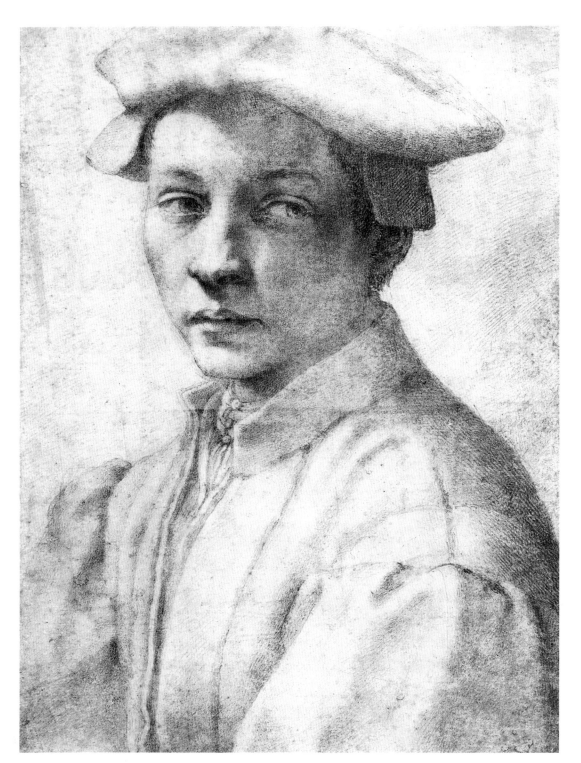

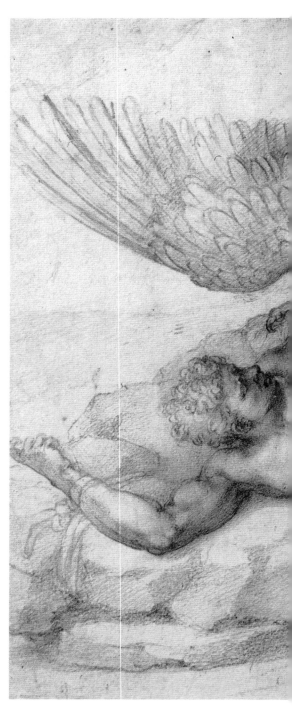

gave him drawing lessons. There are four versions of this portrait, but the particular expressiveness of the face and the slight corrections to the chin, as well as the elegance of its technique, indicate that this is the original.

During their long friendship Michelangelo sent Cavalieri many letters and sonnets, as well as a number of presentation drawings. Vasari said these drawings were intended to be used as models, and there are copies of them which could be by Cavalieri. Michelangelo's poems for Cavalieri are written in traditional verse; most are painfully formal and self-consciously literary. Although he dismissed his poems as 'jumble cakes', his use of elaborate, often obscure, language suggests that he was anxious to be seen as well trained in letters, an activity of higher status than the visual arts. In addition to a lack of confidence in his writing,

Michelangelo's poems for Cavalieri show the effort involved in expressing his love while denying its sexual aspect, which emerges nonetheless, perhaps unconsciously, in the imagery. His drawings for Cavalieri have a similar quality. The technique is highly refined and the forms tightly controled, burdened with detail, so that the effect is overwrought. The subjects are fashionable, mythological stories with Neoplatonic interpretations familiar to educated contemporaries, though the particular stories and the way they are depicted have strong homosexual implications. Their personal meaning was recognized already in the nineteenth century when they were described as 'one coherent confession'.

The four drawings generally considered to have been gifts to Cavalieri include a related pair, the *Rape of Ganymede* and the *Punishment of Tityus*. The story of Ganymede, the beautiful Trojan prince who was abducted by Zeus in the guise of an eagle and thus gained immortality, was popular in ancient Greece as a religious justification for the love of a man for a boy. By Michelangelo's day the myth had been given a

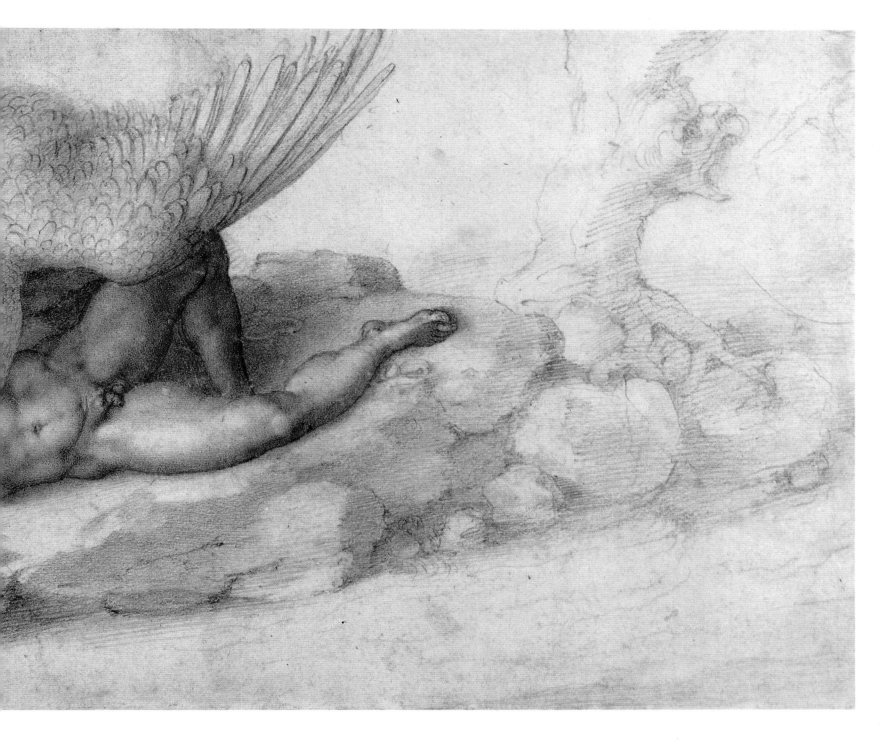

Neoplatonic gloss according to which Ganymede was said to represent the aspiration of the Christian soul, thus permitting the artist to communicate his pagan desire for Cavalieri disguised as an acceptably Christian theme. This is clear from the drawing, surviving only in copies, which shows a muscular nude youth with legs pinioned open by the claws of a huge eagle. The companion drawing depicts the torments of Tityus, who raped the mother of Apollo and was condemned to Hades to have his liver perpetually plucked by vultures. The punishment of Tityus symbolized the debasement of the soul incurred by (hetero)sexual excess, and it has been proposed that its pairing with Ganymede represented for Michelangelo a version of sacred and profane love. In the drawing Tityus,

like Ganymede, accepts passively, with legs provocatively splayed, the assault of one eagle (not the two vultures of the myth). Remarkably, on the reverse of the drawing Michelangelo traced over the figure of Tityus, transforming it into the resurrected Christ, an indication of the ease with which he could move between pagan and Christian motifs. He used a variation of the same figure for Zeus in another drawing, and for the Christ in the *Last Judgment*.

Two other drawings similar in theme and style may also have been intended for Cavalieri, *Archers Shooting at a Herm* and the *Dream of Life*. The *Archers* shows a group of nudes, including one female, running with arms out-stretched; though the target is full of arrows, none of the archers actually holds a bow. Like the Battle cartoon, the subject gave Michelangelo an excuse to draw a large number of nudes in a variety of poses, but its personal meaning is difficult to assess. Perhaps Michelangelo saw himself as the hapless Herm, pierced by arrows of desire for young men he could not reach. The *Dream of Life* is even more enigmatic. Again, a muscular youth with legs splayed is approached by a winged creature, in this case a (rare, winged) angel who blows a long thin trumpet directly into his ear. The angel is Fame, waking the dreaming youth who is seated on a box containing masks (illu-sions) and leaning on a globe. In the background are small figures of the deadly sins, apart from Pride, with Lust represented by four examples. Contemporary copies show pornographic details on the figures representing Lust which have been erased from the original drawing, though not necessarily by Michelangelo. In the sixteenth century the standard interpretation of the role of fame was recorded by Ripa: 'The trumpet of fame awakes the mind of the virtuous, rouses them from the slumber of laziness, and keeps them ever awake and vigilant.' However, the passive posture of Michelangelo's dreamer and the suggestion of aural insemination in the action of the angel, as

LEFT: *Archers Shooting at a Herm*, c. 1530, red chalk, 8½ × 12½ inches (21.9 × 32.3 cm), Windsor, Royal Collection. A 'presentation drawing' for an unknown recipient dating from the period of those for Cavalieri. The motif is antique but its allegorical significance has not been established.

BELOW: *The Dream of Human Life*, c. 1533, black chalk, 15½ × 10¾ inches (39.6 × 27.9 cm), London, Seilern estate. In this presentation drawing a young man, surrounded by dreams of the Deadly Sins, is roused by the trumpet of winged Fame. It is perhaps a warning to the ambitious against worldly distractions.

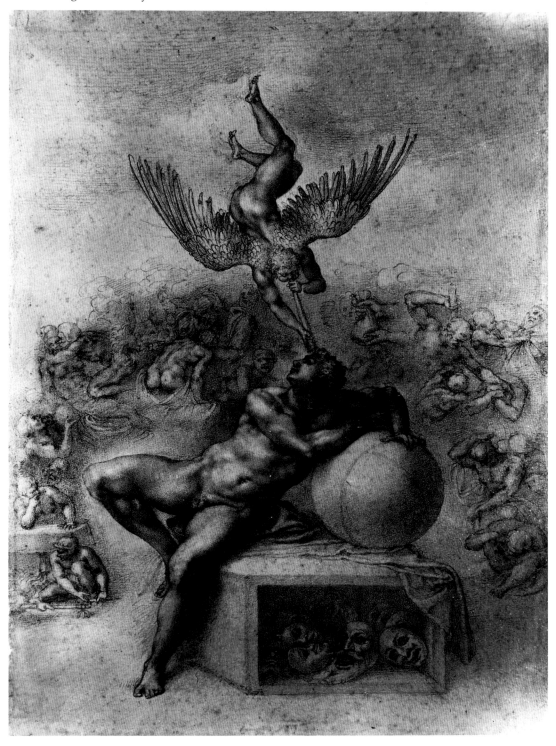

well as the activities of the background figures, make the drawing ambiguous.

The drawings for Cavalieri are unusual in Michelangelo's oeuvre, but to some extent the differences are due to their intended purpose. It is possible that the particular classical subjects were selected by Cavalieri himself, and that the chilly perfection of the technique was designed to make them easier to copy. In Linda Murray's evocative description, 'the forms emerge in chiaroscuro as if breathed upon the paper – a cold, almost feelingless technique'. But they are most interesting as a 'coherent confession', eloquent testimony to Michelangelo's enduring attachment to the real, ideal, Cavalieri.

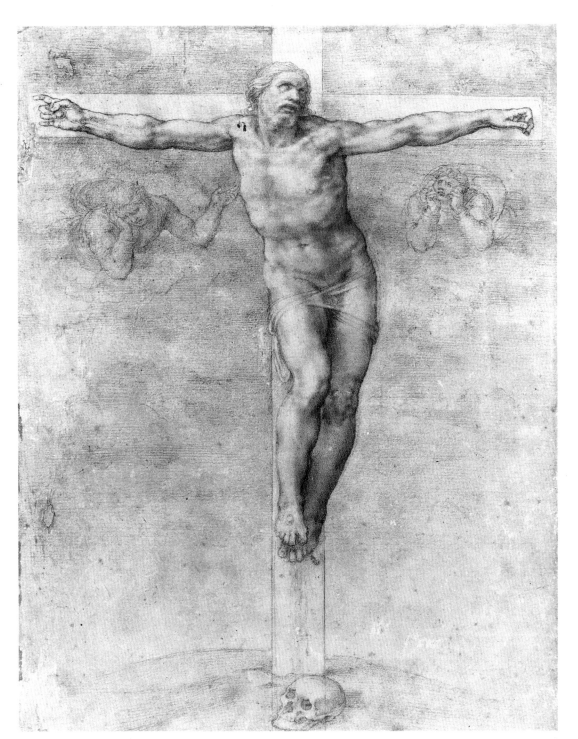

LEFT: *Christ on the Cross*, c. 1540, black chalk, 14½ × 10½ inches (37 × 27 cm), London, British Museum. Michelangelo made a number of presentation drawings of religious subjects for his one female friend, the pious Vittoria Colonna, Marchesa of Pescara.

RIGHT: *Pietà*, 1538-40, black chalk, 11¼ × 7½ inches (29 × 19 cm), Boston, Isabella Stewart Gardner Museum. Another drawing made for Vittoria Colonna.

had composed. Many of these survive, including two of his letters and two or three presentation drawings. In his poems Michelangelo shows that he looked to the Marchesa for redemption from his sensual past, as 'her beautiful features summon upward from false desire'. During their association his struggle to balance his religious beliefs and Platonic ideas was resolved, and his Christian faith deepened and strengthened.

Michelangelo's letters to the Marchesa are formal and self-abasing like those to Cavalieri, perhaps in deference to the recipients' noble origins, and the drawings are in the same meticulous impersonal technique, although the subjects are suitably Christian rather than mythological. Among his presents to her was a particularly poignant study of *Christ on the Cross*, which the Marchesa wrote to him had 'crucified in my memory every other picture I ever saw'. Condivi described the Christ as 'not in the usual semblance of death, but alive, with His face upturned to the Father'. The episode illustrated – from Matthew's account of the Crucifixion when 'Jesus cried aloud "My God, my God, why has thou forsaken me?"' – was unusual in Italian art and Michelangelo's depiction of it may reflect the growing emphasis on Corpus Domini, Christ's body as an object of devotion. Despite the fact that the subject of the drawing is Christ's suffering, the body is idealized and in a graceful *contraposto*, without the gory details favored by Northern European artists. This is the earliest known of a series of drawings of the Crucifixion that Michelangelo worked on until his death, drawings which seem increasingly like visual prayers for his own salvation. The drawing of a *Pietà* made for the Marchesa is also of an unusual type; Condivi's account suggests that both the subject and the main elements of the composition were specified by her,

After the sack of Rome in 1527 a mood of fear and pessimism entered the Church, and there was an increasing emphasis on redemption and salvation. This is reflected in the *Last Judgment* and in Michelangelo's other works of the 1530s, such as his drawings for Vittoria Colonna, the Marchesa of Pescara. The Marchesa was one of the most revered women of the time. Born into a notable aristocratic family and a granddaughter of Federigo da Montefeltro, Duke of Urbino, she became a friend of leading writers such as Ariosto and Castiglione. With the death of her soldier husband in 1525, she began to write poetry and to devote herself to spiritual matters. She was a leading member of the Spirituali and brought Michelangelo into contact with this group, which sought to reform the Church from within. Influenced by Erasmus, the Spirituali believed that man's salvation lay in faith alone, not

religious observance or good works. Such ideas were close to those of the Protestants and with the introduction of the Counter-Reformation and the Inquisition in 1542 many leading Spirituali, excluding the Marchesa, joined the Protestant movement.

This pious and austere widow was the only woman with whom Michelangelo had a significant friendship (though his reference to her as 'a man, a god rather, inside a woman' indicates a certain ambivalence about her gender). She had considerable influence on his spiritual life and their relationship is perhaps best understood through the words of a contemporary, who noted the Marchesa's ability 'to show to the most serious and celebrated men the light which is a guide to the harbor of salvation'. She spent long periods in convents away from Rome and Michelangelo often wrote to her, sending drawings or sonnets and madrigals he

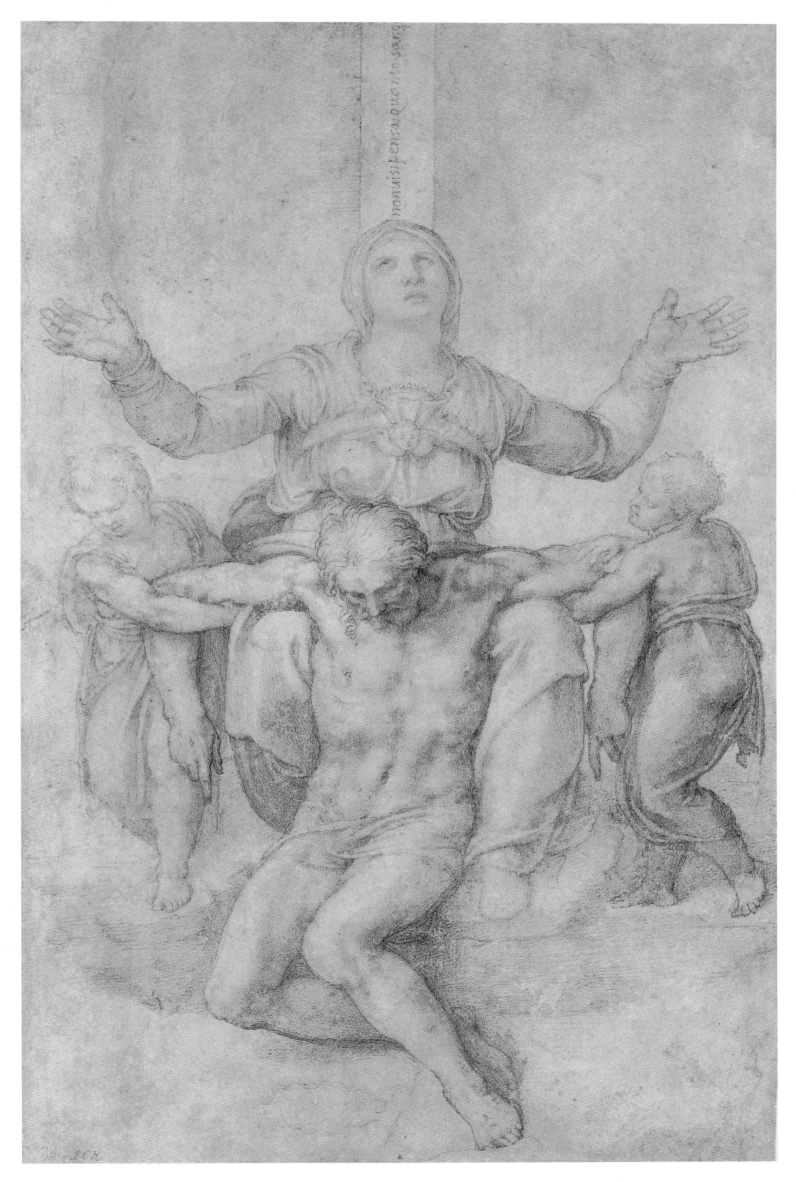

INMENTEM·SCELERIS·VE
ET·ABSTINVIT

LEFT: *Brutus*, c. 1540, marble, h. 30 inches (74 cm), Florence, Museo Nazionale (Bargello). Brutus' slaying of the tyrant Caesar made him a republican hero and Michelangelo began this bust to commemorate another tyrannicide, the murder of the mad Medici Duke Alessandro.

and the work does have a peculiarly programatic look. The symbolic cross-like poses of the figures and their symmetrical arrangement give it an artificial quality very different from the sympathetic humanity of his sculptural group for St Peter's. As Tolnay observed, the recognizably human situation has been translated here into a religious symbol. Here again the body of Christ is idealized and intact, although the inscription on the cross, 'You little think how much blood costs' (taken from Dante's *Paradiso*), emphasizes the true nature of the sacrifice. The sense of physical unity between the figures of Christ and his mother – they appear almost as one body – had a strong personal meaning for the artist and it is used even more strikingly in his final, sculpted version of the Pietà. Michelangelo was deeply distressed when the Marchesa died in 1547, an event which must have stirred memories of his earlier losses; Condivi wrote that 'recalling her death, he often remained dazed as one bereft of sense'. Her example and her friendship gave him hope for salvation and her death left him to face his own end alone.

The bust of *Brutus*, which also dates from the period of the *Last Judgment*, was probably made for another of Michelangelo's close friends, the Florentine historian Donato Giannotti, who wrote a series of dialogues involving the artist. Giannotti succeeded Machiavelli as a member of the last republican government and had become acquainted with Michelangelo during the siege of Florence. In exile he wrote a book on the republic in which he advocated tyrannicide. In 1537, when Lorenzino de' Medici murdered his brutal cousin Alessandro, the Duke of Florence, his tyrannicide was equated with Brutus' killing of Caesar. Michelangelo's *Brutus* was thus begun as a tribute to the republican spirit of Florence. The bust was never finished

and, ironically, after his death it was acquired by the Medici. An inscription was later added to the bust indicating that Michelangelo stopped work when he realized he would be glorifying a crime. This may have been Medici propaganda, though according to Giannotto Michelangelo agreed with Dante's condemnation of Brutus as a traitor. The *Brutus* was clearly inspired by Roman Imperial busts such as that of Caracalla and perhaps its proximity to portraiture contributed to Michelangelo's reluctance to complete it. He gave the bust to his pupil Tiberio Calcagni, who carved the drapery and parts of the chin and neck; Calcagni's work can be distinguished by his use of a smooth chisel rather than the clawed *gradina* used by Michelangelo. Its mixed authorship and unfinished state probably account for certain inconsistencies in the appearance of the bust, which has a noble profile but is bullish and coarse in full face.

The Last Judgment

In July 1533 Michelangelo received a letter in Florence from the painter Sebastiano del Piombo, reporting the news that Pope Clement had decided to give him a contract ' . . . for something beyond your dreams . . .'. That the 'something' was a new decoration for the altar wall of the Sistine Chapel was probably made clear to him two months later when he met the Pope in Florence; Clement was on his way to France to arrange the marriage of Catherine de' Medici to the son of Francis I. Contrary to Sebastiano's expectations, Michelangelo was decidedly unenthusiastic about the proposal. He was working on the Medici Chapel and committed to completing the Julius tomb, and was reluctant to undertake another large project. A year later he decided to accept the commission, but soon after he returned to live in Rome Pope Clement

died. Assuming the Pope's death signaled the end of the project, Michelangelo happily resumed work on the tomb. His relief was shortlived, however, for Clement's successor Paul III was determined to continue his predecessor's plan.

The career of Pope Paul III epitomizes the changes that took place in the Church between the Renaissance and the Counter-Reformation. Born seven years before Michelangelo, Alessandro Farnese received a humanist education in the household of Lorenzo the Magnificent and also studied for a time in the Medici garden. Through his sister, the mistress of the Borgia pope Alexander VI, Farnese was made a cardinal in his twenties. The fact that he then sired four children did not discourage the historian Guicciardini from describing him as 'gifted with learning and to all appearance good morals'. Despite his liberal humanistic background, once elected Pope he instituted Church reforms which opened the way to the stringencies of the Counter-Reformation. Reformist measures taken during his fifteen-year reign included the confirmation of the militant new Jesuit order, the establishment of the Inquisition in Italy and the convocation of the Council of Trent.

Pope Paul had long admired Michelangelo and claimed that he had waited 30 years to command work from him. When Michelangelo demurred because of his obligation to finish the tomb of Julius, the Pope threatened to tear up the tomb contract. He later freed Michelangelo from this commitment by convincing Julius' heirs to accept the *Moses* statue alone as the focus of the tomb, and to secure Michelangelo's exclusive services he gave the artist the unprecedented title of chief architect, sculptor and painter to the Vatican Palace. During his pontificate Michelangelo painted both the Sistine altar wall and the Pauline Chapel. He also

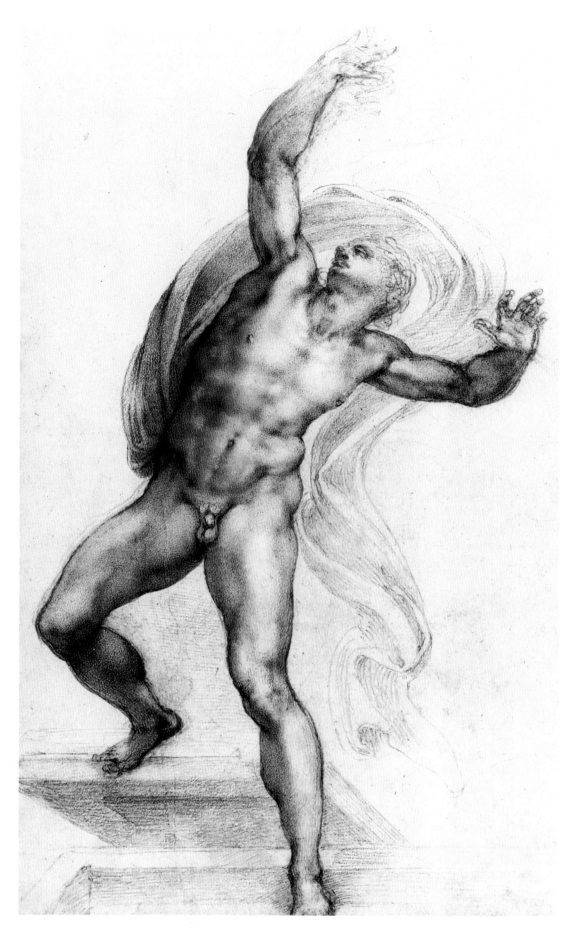

LEFT: *Drawing for a Resurrection*, 1512, black chalk, 14 × 8½ inches (36 × 22 cm), Windsor, Royal Library. A beautiful drawing made for a Sistine Chapel altarpiece, a project which was later abandoned. Michelangelo used a similar pose for the Christ in the *Last Judgment*.

ing, now in the British Museum, is an unusual treatment of the theme in that unlike traditional versions, notably that by Piero della Francesca, in which Christ is shown simply stepping out of the tomb, Michelangelo's Christ soars effortlessly upward like an antique winged victory. Vasari, who does not mention the possibility of a *Resurrection* for the Chapel, says that Clement's first plan was to have large frescoes on the two end walls, a *Fall of the Rebel Angels* and a *Last Judgment*. Condivi notes only a plan for a *Last Judgment*, which he said Clement chose to 'allow the man scope to display his powers'. In any case, when Paul III became pope it was decided that Michelangelo would paint the *Last Judgment* alone and that it would cover the entire wall, including the altarpiece.

The previous stages of the decoration of the Sistine Chapel, including Michelangelo's ceiling, had been planned to contribute to its artistic and iconographical unity; this the new project disrupted and in part destroyed. The windows on the altar wall were blocked up and the whole of its existing decoration was eliminated, including the papal effigies, Perugino's frescoes and two ancestor lunettes painted by Michelangelo himself. That Pope Paul and Michelangelo could countenance such a drastic change reflects the recent dramatic events in the history of the Church, as does the choice of subject. The *Last Judgment* was not a common subject in Italian art, but it was particularly appropriate for this troubled period of so many challenges to papal authority. It would serve as a warning to followers of rebels such as Luther and Henry VIII that salvation was exclusively reserved for members of the Church of Rome.

It was nearly two years before Michelangelo began painting the fresco. He delayed work on the cartoon, and the preparation of the chapel

became the leading architect in Rome: he was appointed chief architect for St Peter's (after the death of Antonio da Sangallo, nephew of his friend Giuliano) and he designed the new civic center for Rome, the Capitoline piazza.

The decoration for the Sistine altar wall as originally conceived by Pope Clement was inspired by necessity and was probably relatively modest. In 1525 the curtains at the back of the altar caught fire, damaging Perugino's *Assumption* altarpiece and possibly also

his wall frescoes, and two years later the Sistine Chapel suffered further damage during the sack of Rome. When Pope Clement returned to Rome after the sack and began repairs to the Chapel he seems first to have considered commissioning a *Resurrection* for the wall, leaving Perugino's *Assumption* altarpiece in place. Michelangelo did studies of the *Risen Christ* for various projects and a dozen survive, including an early one reminiscent of the Cavalieri drawings. Another draw-

RIGHT: *Annunciation*, c. 1560, black chalk, 11 × 7½ inches (28 × 19 cm), London, British Museum. Michelangelo's late religious drawings are less detailed and polished yet they convey clearly his deepening belief.

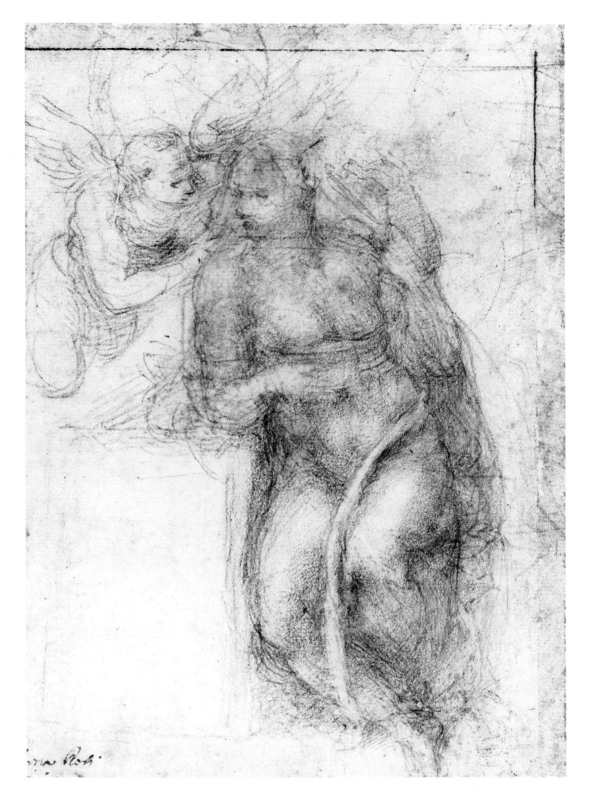

took many months as he insisted that the wall be made of special bricks and be sloped from the top to prevent dust settling on it. There was a further delay as Sebastiano del Piombo, who was in charge of the preparations, had ordered a surface suitable for oil paint, the medium favored in his native Venice. Michelangelo, who probably considered using the new method and then changed his mind, dismissed oil paint as 'fit only for women and lazy men like Sebastiano' and ordered the wall to be redone for the true fresco technique preferred by Florentines. This incident brought to a sad end his 25-year friendship with Sebastiano as Michelangelo contrived to interpret it as a deliberate affront. He conceived an enduring hatred for the painter who had been for so long his devoted friend and most talented collaborator, a man of whom Vasari said 'a better or more agreeable companion there never lived'. It is likely that Michelangelo's shabby treatment of Sebastiano was related to his involvement with Cavalieri and with another collaborator, the gifted Florentine painter Jacopo Pontormo (1494-1557). Sebastiano was devastated by Michelangelo's repudiation and painted very few works afterward. Although the replastering of the wall was complete by January 1536, Michelangelo did not begin painting until early summer. The area to be covered was vast – about 45 by 40 ft – and progress was slow as he was old and sometimes unwell. Toward the end he injured his leg in a fall from the scaffold, which further prolonged work. It was not until October 1541 that the fresco was unveiled, 29 years after the completion of the ceiling.

Michelangelo's treatment of the subject of the *Last Judgment* further emphasizes its disparity from the earlier decorations of the chapel and expresses the new militant mood of the Church. Although he retained much of the tra-ditional iconography, his conception of the subject is new, full of energy and movement. The most striking difference is the complete absence of framing devices, such as the corniced bands dividing the side walls or the fictive architecture which structures the ceiling. There is no perspective or clearly defined space as in the paintings on the side walls. Nor are the figures arranged on strictly differentiated levels as in earlier versions of the *Last Judgment*, such as Giotto's in the Arena Chapel in Padua or the mosaic wall in the cathedral at Torcello, near Venice. Michelangelo's huge frameless painting seems to explode out of the orderly, compartmentalized decorative scheme of the Chapel, as if the wall had dissolved and left an opening to a thunderous sky. The effect is disturbing and threatening, a reminder of the crisis in the Church precipitated by the demands for reform.

One precursor which did have a strong influence on Michelangelo's treatment was Luca Signorelli's series of frescoes of the *Last Judgment* (1500-04) in the cathedral at Orvieto. Signorelli, like Michelangelo, desired to show the human body in the greatest possible variety of movement. In his scene of the Damned, a seething mass of bodies is locked in desperate struggle with winged devils. Unusually the damned are not shown as skeletons but are fully fleshed and the devils are recognizably human, both ideas taken up by Michelangelo in the Sistine *Judgment*.

Time and smoke as well as deliberate mutilation have altered the effect of the vast painting. The damage includes

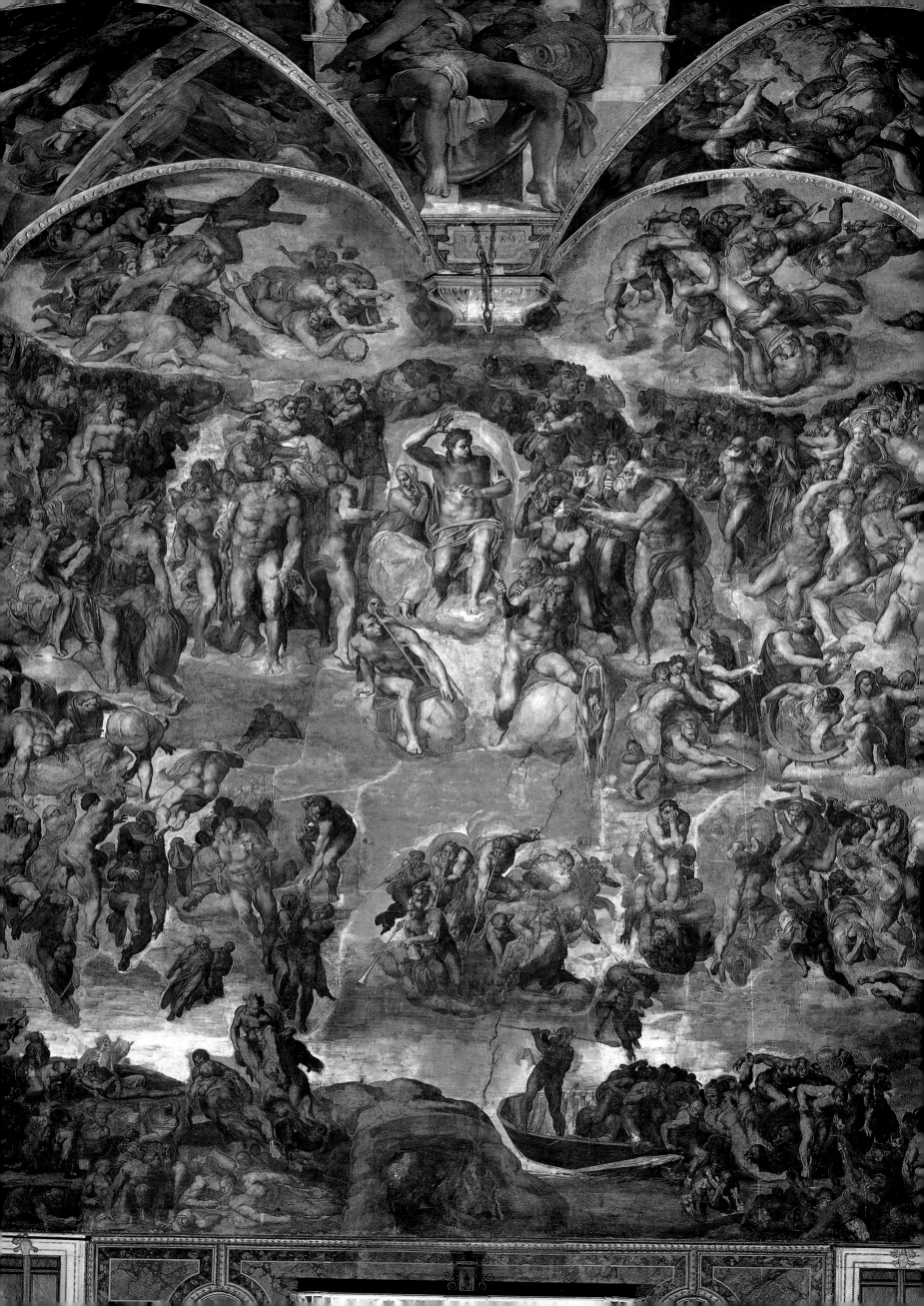

LEFT: The *Last Judgment*, 1534-41, fresco, 44 ft 6 inches x 39 feet 8 inches (13.7 × 12.2 m), Vatican, Sistine Chapel. Michelangelo's awesome vision of the Day of Judgment seems to explode into the orderly decorative scheme of the Sistine Chapel. At its unveiling Paul III fell to his knees in fear, begging forgiveness for his sins.

BELOW: Luca Signorelli, The *Last Judgment: The Damned*, 1500-1504, fresco, Orvieto, Cathedral. Like Michelangelo, Signorelli had a particular interest in depicting the human body in action and his Orvieto *Last Judgment*, which shows the Damned fully fleshed and beset by human devils, clearly influenced the younger artist.

surface cracks and darkening of the colors. Although Vasari wrote that in the *Judgment* Michelangelo 'left to one side the charm of coloring', its tenebrous tones contrast particularly strongly with the brilliance of the newly cleaned ceiling. The bodies are painted in shades of brown, and as most of them are nude there is little drapery color to give variety; the background sky, for which Michelangelo insisted on using the precious ultramarine, is now a streaky gray-blue. Until the current restoration is complete we can have only an approximate impression of Michelangelo's intended coloring.

Despite these changes the composition retains its powerful sense of movement, a huge circular sweep with the trumpeting angels summoning the dead from their graves on the left.

141

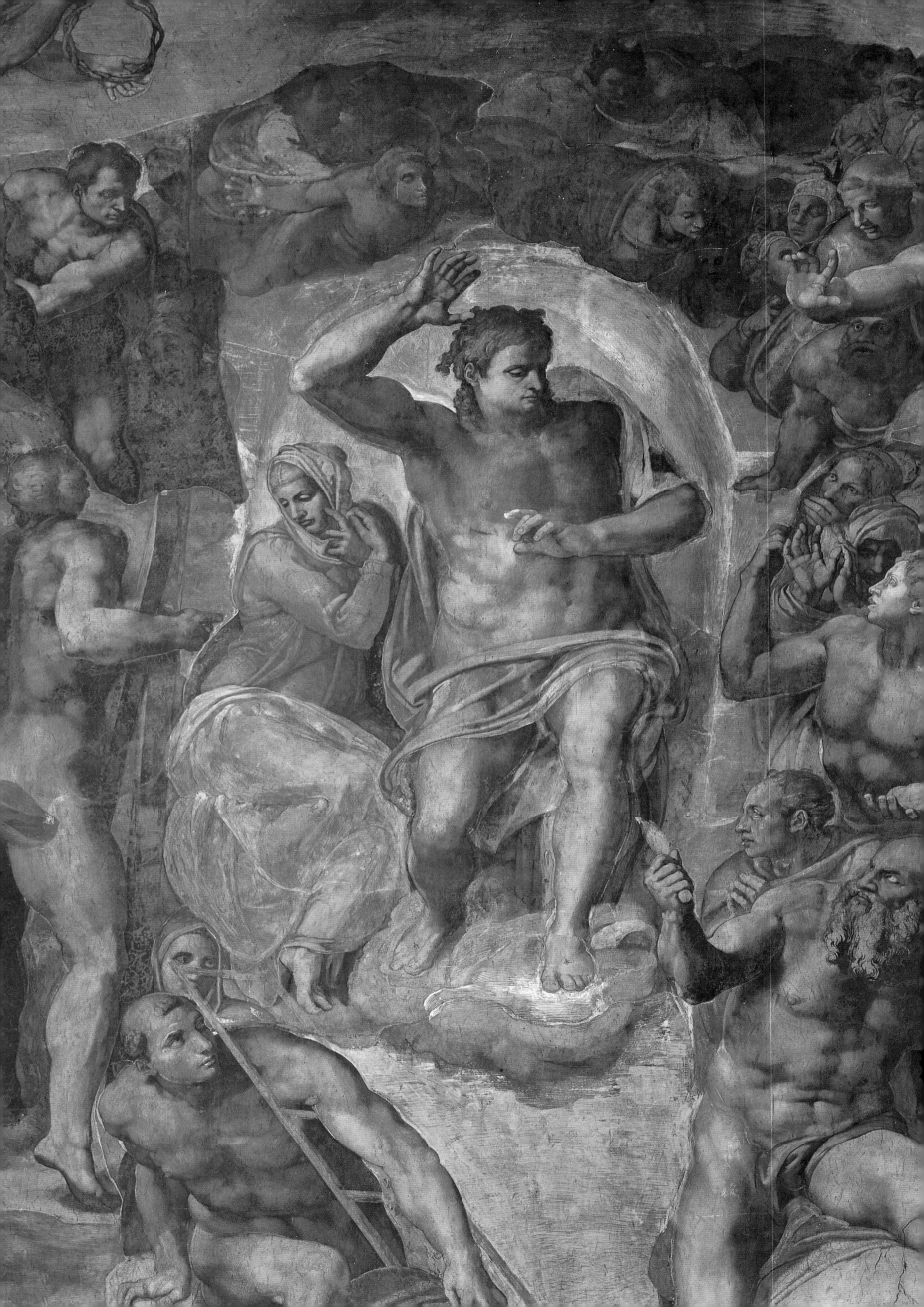

LEFT: *The Last Judgment* (detail): Christ and the Virgin. Mary crouches demurely at Christ's side, her eyes averted from the Damned, for whom she no longer has the power to intercede.

RIGHT: Drawing: *A Flying Angel*, black chalk, 15¾ × 10½ inches (40.7 × 27.2 cm), London, British Museum. Study for one of the wingless angels in the right lunette of the *Last Judgment*. Corrections to the abdomen suggest that the model was not flying but lying on the floor.

OVERLEAF: The *Last Judgment*: upper part. The raised arm of Christ sets off a great circular movement which animates the whole composition, raising the Blessed and casting down the Damned.

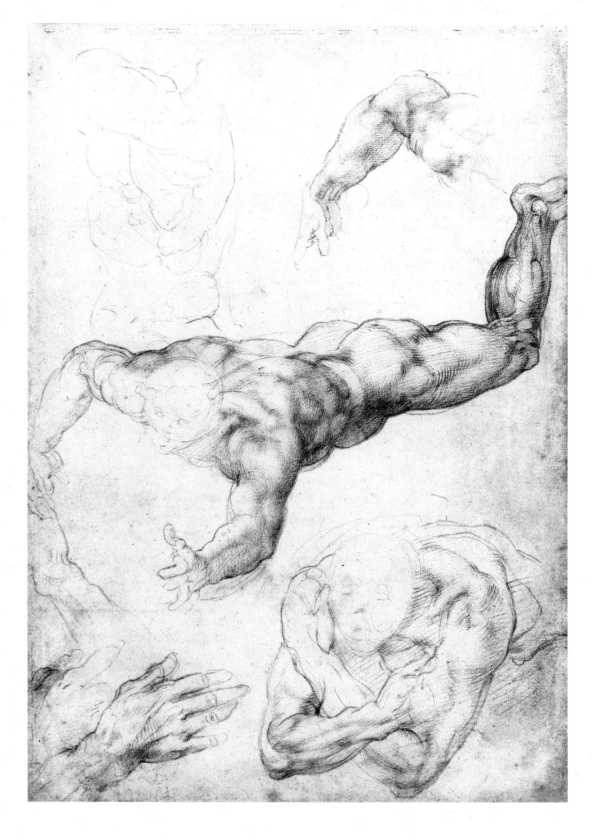

These rise toward Christ to be judged, some continuing upward to join the blessed, others cast down to Hell on the right. At the center of the motion, in a golden aura like the sun, is the figure of Christ. The Virgin cowers demurely under his right arm, averting her gaze from the fallen, for whom she no longer has the power to intercede. Although youthful and beardless, Christ has a broad, powerful body which gives him great gravity and authority. In most re-presentations of the subject he is shown as a judge firmly seated, but the stance of Michelangelo's Christ is dynamic, half rising. His gestures are also active and ambiguous, his left hand points to his wound, the right is raised as if to strike. The action of this raised arm, outlined against the golden background, sets the whole composi-tion in motion. This gesture, and the nudity of Christ, evoke associations with antique gods; his pose is related to that in the earlier *Resurrection* study but also to images of Jupiter hurling a thunderbolt, such as that in Michel-angelo's drawing for Cavalieri of the *Fall of Phaeton*.

Above Christ, in the lunettes at the top of the painting, groups of wingless angels are shown bearing the instru-ments of the Passion, on the left the cross and crown of thorns, on the right the column from the flagellation. In a (typically faceless) study of one of the flying figures it is interesting to note the curved lines added to fill out the abdo-men, showing that the model for the drawing was lying on the floor. The lunette angels seem to be struggling in their task, as if caught in the whirlwind of energy which surrounds Christ. These figures were among the most controversial elements of the painting.

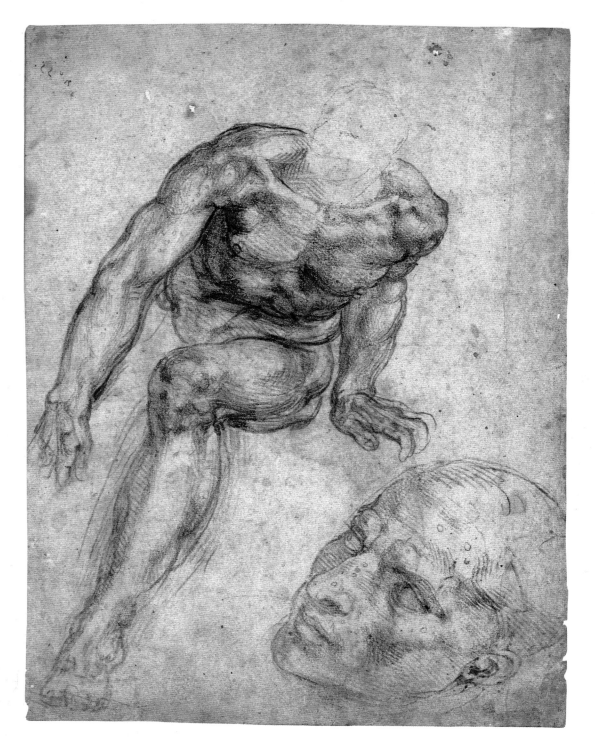

LEFT: Drawing: *Study for St Lawrence* in the *Last Judgment*, black chalk, 94½ × 71½ inches (242 × 183 cm), Haarlem, Teyler Museum. Christ is surrounded by saints who hold the instruments of their martyrdom. St Lawrence cowers just below him, his arm through the ladder-like grill on which he was burned to death.

RIGHT: The *Last Judgment* (detail): St Bartholomew. St Bartholomew glares up at Christ, brandishing a knife and his own flayed skin. The face of the skin is a gruesomely distorted self-portrait of Michelangelo.

have long been identified as an ironic self-portrait by Michelangelo, indicating that he saw himself as a sinner, doomed to be rejected like the saint's old skin. The threatening air of the saints and the other figures at the top of the painting is emphasized by their size, which is larger even than necessary to compensate for their greater distance from the viewer. The figures of the *Last Judgment* and other later works by Michelangelo do not have the slender idealized bodies of his earlier nudes such as the *David*. Not intended as a celebration of male beauty, they are heavy and thick as if weighed down by their own flesh. They are the work of an old man no longer in thrall to worldly desires but contemplating his spiritual future. As he wrote earlier in a poem, 'faced with death, the world is less than nothing'.

The lower part of the picture, with open graves spewing forth their putrified corpses and the damned tormented by hideous demons, is a medieval conception of hell. Michelangelo's vision owes much to Dante's *Inferno*, particularly his incorporation into the Christian world of Charon, the mythical boatman of the classical underworld. But Michelangelo has added to this medieval view of the physical pain of hell a modern element of mental suffering. The damned descend in full awareness that their own actions have brought about their fate. One of the most disturbing images of the painting is that of the man being dragged down by a knot of sinners, covering one eye with his hand. His other eyes stares in despair and horror, not at hell below but at the viewer and the continuing sins of the real world. At the center of the lower part of the painting the mouth of hell gapes, its outline providing a frame for the crucifix standing in front on the altar. The juxtaposition is intended as a reminder that the faithful are saved only by Christ's sacrifice.

Early criticism tended to be concentrated on their nudity, which was deemed unnecessary and inappropriate. Perhaps more striking to later viewers are their strange poses, far more extreme than required by the tasks they perform. Like the strange position of the Doni Madonna (page 00), the design of these figures does not seem to have been determined by the requirement of meaning, but of art. They are there as demonstrations of Michelangelo's virtuosity and have led inevitably to suggestions that the work has elements of Mannerism. Vasari, who shared Michelangelo's Florentine focus on the male nude as a vehicle of expression, defended his use of such figures, claiming that in the *Last Judgment* he chose to paint only the human body 'in the greatest variety of attitudes, and thereby to express the wide range of the soul's emotions and joys'.

Although the figures in the *Last Judgment* do assume a variety of attitudes, it

is debatable whether they express a similar variety of emotions. In fact, the sense of struggle and tension which animates the angelic beings in the lunettes seems to inhabit every part of composition. There is no distinct, peaceful and orderly area for the blessed, whose upward struggle is as fraught as the descent of the damned. Even the saints who surround Christ, holding the implements of their martyrdom, do not seem convinced of their salvation but appear anxious or even aggressive. To his left St Peter, the source of papal authority, glares at Christ, aiming his characteristic key like a gun. Below Christ St Lawrence cowers, his arm through the gridiron on which he roasted with such equanimity, telling his torturers 'this side is done, now turn me over and cook the other'. Opposite him St Bartholomew brandishes the knife used to flay him, and clutches his discarded skin. The distorted features of the flayed skin

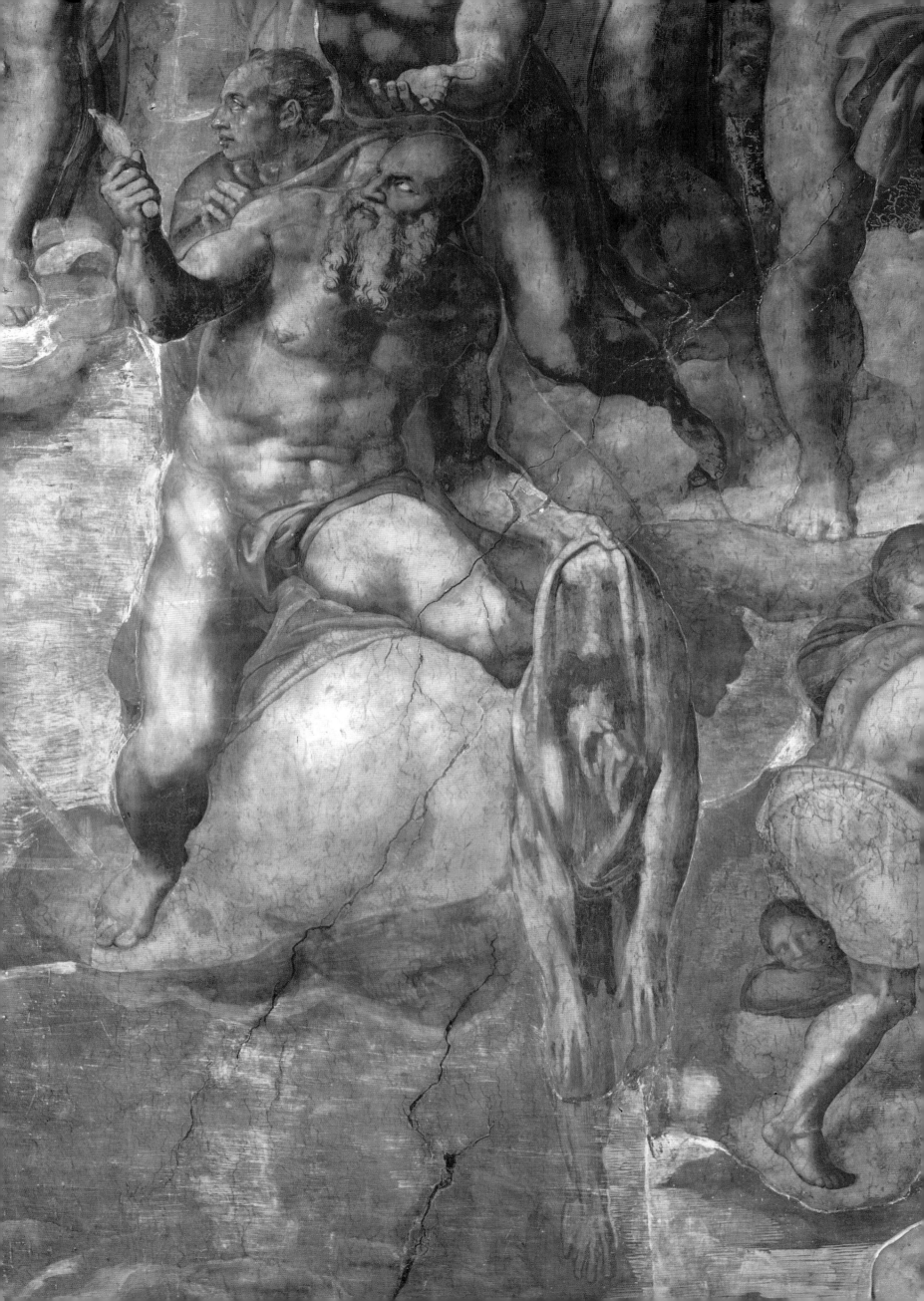

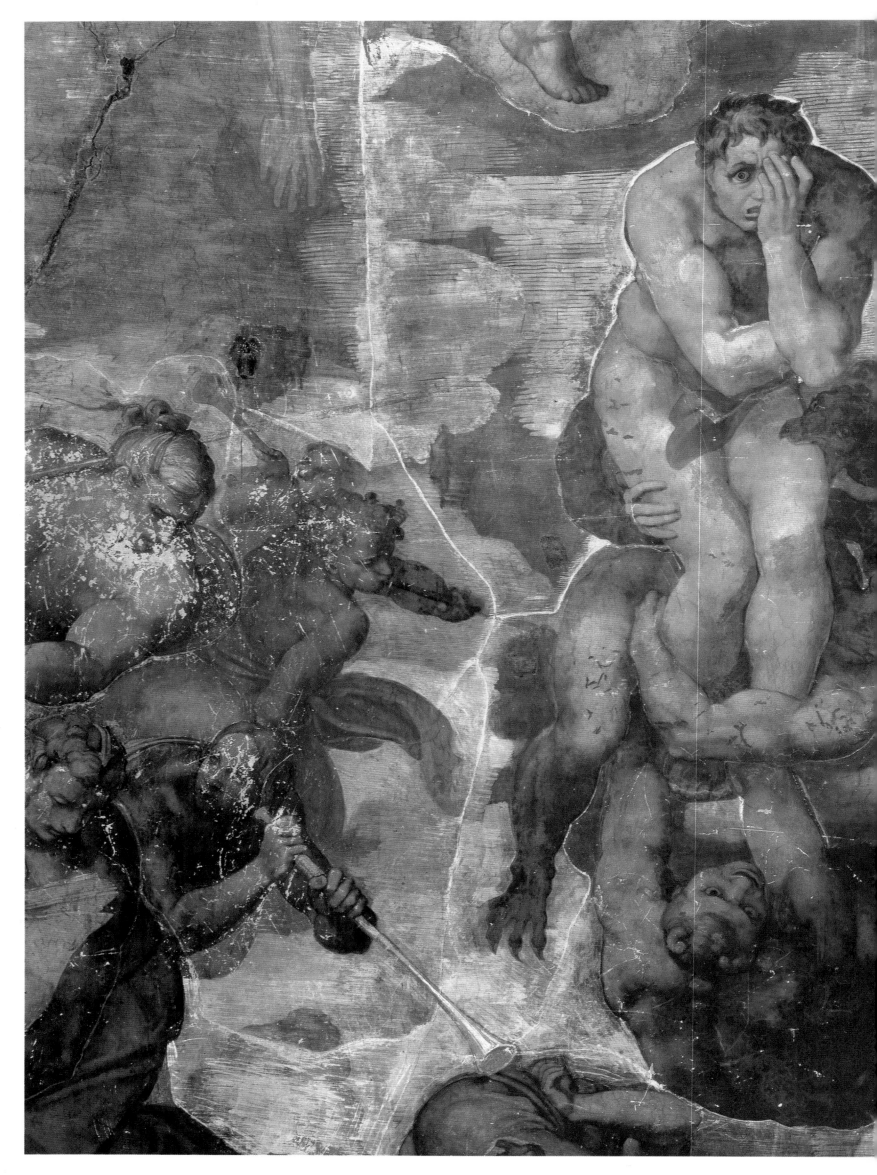

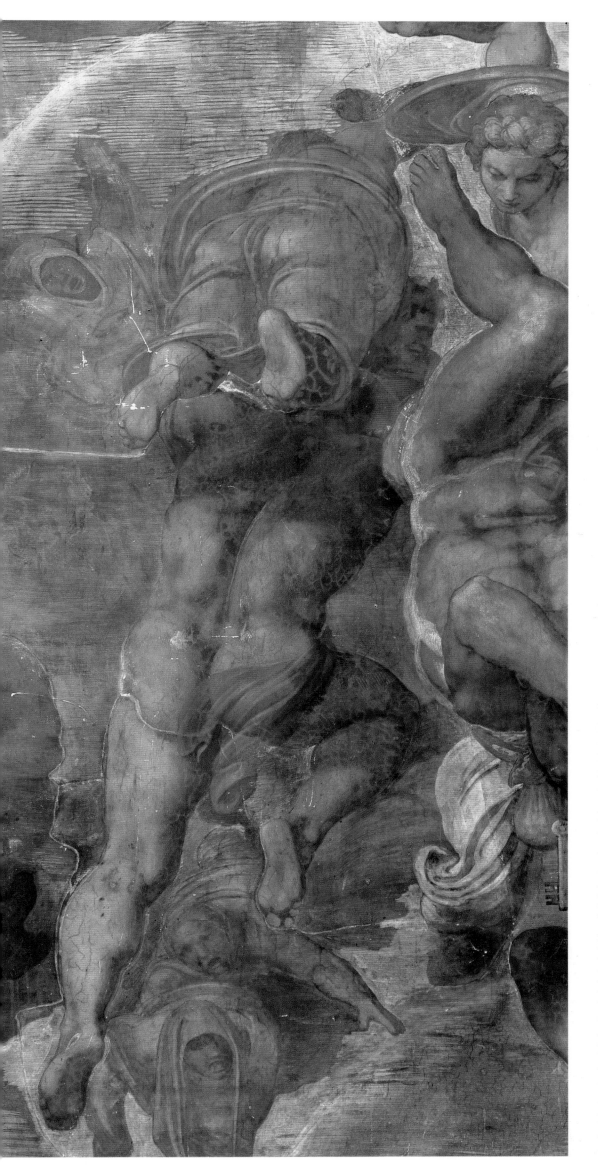

LEFT: The *Last Judgment* (detail): one of the Damned. Horror at his fate, and the realization that he has brought it on himself, is powerfully expressed by this despairing figure being dragged down by devils.

Not surprisingly Michelangelo's fearsome, apocalyptic vision of the Last Judgment provoked controversy. It was said that when Paul III first saw the finished fresco he fell on his knees begging God to forget his sins at the Day of Judgment. Pope Paul had a deep love of art and was broad-minded enough to accept Michelangelo's revolutionary treatment, but other critics, more concerned with moral issues, had strongly negative reactions. Even before the fresco was complete the Pope's Master of Ceremonies, Biagio da Cesena, complained that the large number of nudes was unsuitable in a holy place and the work was more appropriate for a brothel. His comments ensured him lasting fame, as in retaliation Michelangelo painted his portrait as another figure from Dante, Minos the judge of the underworld, shown wrapped in the coils of a serpent in the lower righthand corner of hell. When Biagio asked the Pope to have the offending image removed, Paul replied drily that he had no power over the realm of the damned. Biagio's views on the *Last Judgment* were echoed by many contemporary writers, notably Titian's boon companion Pietro Aretino, and there were repeated suggestions that it should be destroyed. The painting was protected throughout the pontificates of Paul III and his successor Julius III, but the election in 1555 of the zealous reformer Cardinal Carafa as Pope Paul IV brought an end to the climate of tolerance. Pope Paul urged Michelangelo himself to 'tidy up' the fresco, a request which received the stinging response that it was a small matter to tidy up a picture and the Pope would be better occupied tidying up the world. Paul was anxious to retain Michelangelo as the architect of St Peter's and hesitated to offend him further, but before Michelangelo's death a later pope ordered his admirer Daniele da Volterra to provide draperies for the major

149

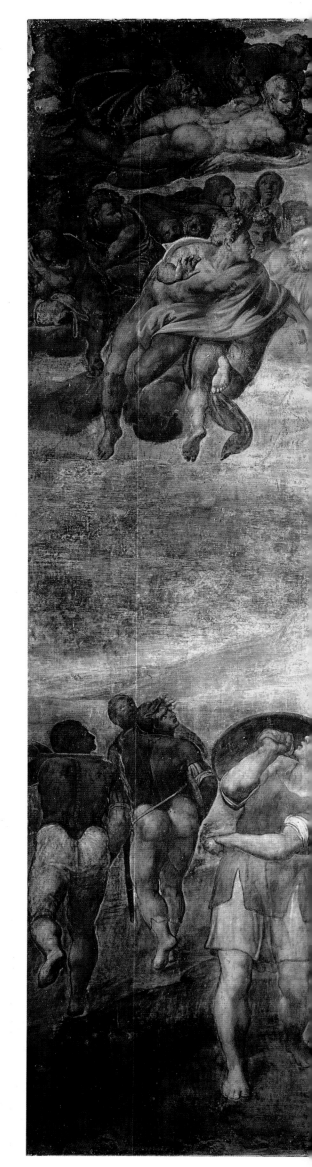

RIGHT: The *Conversion of St. Paul*, 1542-45, fresco, 242 × 260 inches (620 × 666 cm), Vatican, Pauline Chapel. Pope Paul III commissioned Michelangelo to paint two frescos in his private chapel. The Conversion of Saul shows the blinding of the Pope's apostle namesake on the road to Damascus.

offending nudes. Daniele attempted to make his interventions as discreet as possible, but his efforts earned him the shameful sobriquet of *Il Braghettone*, the breeches-maker. Later efforts at censorship were less respectful and the balance of mass and color in the composition was affected.

Throughout the sixteenth century the *Last Judgement* was generally compared unfavorably with Michelangelo's painting on the Sistine ceiling. Even today its cataclysmic vision is profoundly disturbing and it must have been more shocking to his contemporaries. The concentration of criticism on moral issues perhaps also masked reactions to the work's revolutionary form, in which great forces seem to move in an apparently unstructured space. The unsettling effect of the painting was easily associated with threats to the authority of the Church, and the censorship to which it was subjected heralded the end of the great period of artistic freedom which developed during the Renaissance. Viewers today may find it easier to accept the appropriateness of Michelangelo's treatment for this subject, its essential decorum. In fact the *Last Judgment* is clear evidence of the depth of Michelangelo's religious conviction. As Freedberg writes: 'This is the image in which Michelangelo's own *terribilità* conjoins absolutely with the meaning and the stature of the theme, and it is his most awesome creation.'

The Frescoes in the Pauline Chapel

Two projects awaited Michelangelo when he had completed the *Last Judgment*: the resolution of the tomb of Julius, and decorations for another papal chapel. The final plan for the tomb required him to carve two statues to be placed in the niches on either side of the *Moses*, to replace the *Slaves* (see page 101). The bland draped female

figures he produced were very different from the expressive nude male slaves, a difference which reflected Michelangelo's increased concern for the spiritual life and loss of interest in worldly vanities, including art. They were the last sculptures he completed and he worked on them simultaneously with his last paintings, the two frescoes for the Cappella Paolina, the Pauline Chapel at the Vatican.

The Pauline Chapel was built by Antonio da Sangallo from about 1537 as a private chapel for Paul III. From its inception Pope Paul intended Michelangelo to decorate the side walls of the new chapel, but the artist felt he could not start until the new tomb contract was approved. Explaining this in a letter to a papal official, he stressed the mental aspects of an artist's work: 'one paints with the head, not with the hands . . . until my affair is settled I can do no good work'. It was not until 1542 that Michelangelo began work in the Chapel. He was nearly seventy, with failing health, and he found fresco painting increasingly taxing. Work on the revised tomb caused additional delays in his progress on the paintings and the second fresco was completed only in 1550. The subjects of the two pictures, the *Conversion of Saul* (St Paul) and the *Crucifixion of St Peter*, reflect themes of vocation and salvation which were of particular interest to the Church at the time of the Counter-Reformation. The events depicted also served to emphasize the authority of Pope Paul, as they involved his namesake and his earliest papal predecessor.

The earlier of the two paintings, the *Conversion of Saul*, is taken from a story told in the Acts of the Apostles. Saul, a lawyer of Tarsus, took particular pleasure in prosecuting Christians. On the road to Damascus he was struck to the ground and blinded by a flash of light in which Christ appeared, asking why Saul persecuted him. Saul continued to

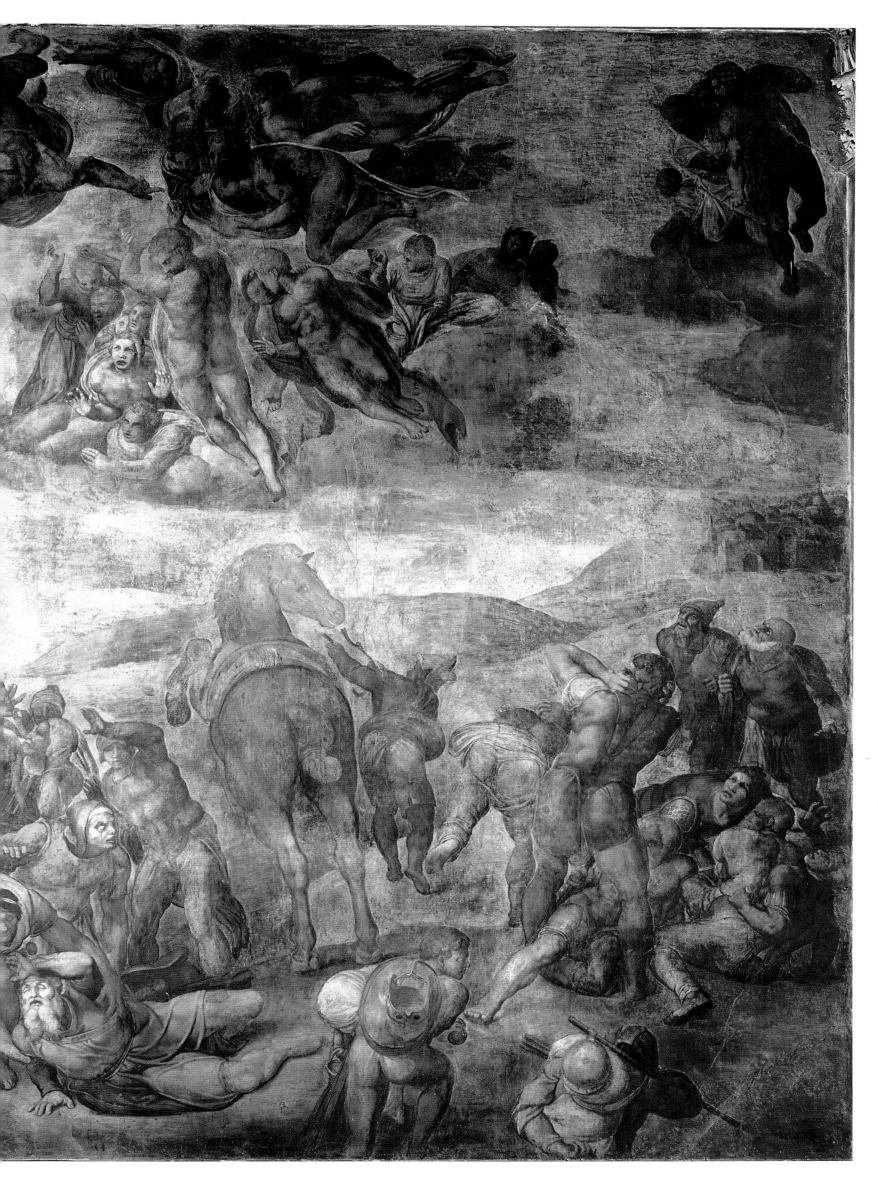

RIGHT: The *Crucifixion of St Peter*, 1546-50, fresco, 242 x 260 inches (620 × 660 cm), Vatican, Pauline Chapel. According to tradition, St Peter chose to be crucified upside down to avoid comparison with Christ. His defiant gaze at the spectator demands acknowledgment that he is dying for our sins and that our salvation comes only through the Church.

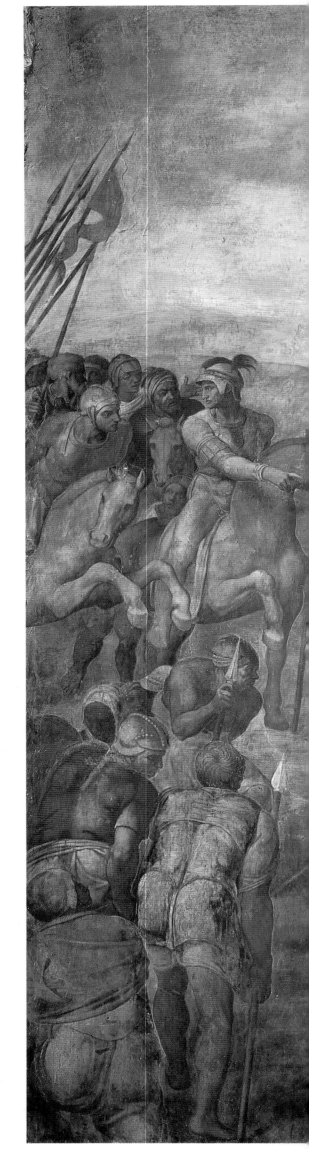

Damascus where his sight was restored and he became a Christian disciple, taking the name Paul. In Michelangelo's version of Saul's blinding there are two clusters of figures, heavenly and earthly, linked by a bolt of light extending from Christ to the stricken Saul. The figures around Christ radiate from his golden aura, while Saul's entourage explodes away from him in fear and disarray. Contrary to tradition, Michelangelo shows Saul as an old man, perhaps as a reference to his modern namesake the aged Pope Paul.

Only a few months separated the completion of the *Last Judgment* and the beginning of work on the *Conversion* yet there is a marked change of style. The narrative places the incident at midday and requires that the figures are clothed, so the painting is generally lighter and more colorful than the *Judgment*, closer to the clear tones of the Sistine ceiling. However, in contrast to the movement and energy of the *Last Judgment*, the action in the *Conversion* seems fixed and frozen, as if the figures had become statues. There is no sense of exultation in the beauty of God's creation of humanity or the surrounding world. The landscape setting is only summarily indicated, though it does include a glimpse of Damascus at the right, and the rendering of deep space is not convincing. The internal space is indicated by a few foreshortened figures such as the rearing horse (in a pose derived from one of the antique horses on the Quirinal). Although there was no mention of horses in the biblical account, Michelangelo liked them (he owned an Arab stallion) and his inclusion of one followed recent artistic precedent. Horses had featured in Raphael's cartoon of the *Conversion of Saul* made for one of the Sistine tapestries and similarities in Michelangelo's composition suggest that his sense of rivalry with Raphael had continued long after the younger artist's premature death in

1520. Raphael's cartoon, in keeping with the requirements of a tapestry, is relatively simpler and clearer and its figures are more gracefully proportioned and posed, but the work lacks the raw dramatic power of Michelangelo's treatment. The *Conversion* reveals more clearly the signs of increasing indifference to formal beauty which Michelangelo had begun to demonstrate in the *Last Judgment*. This is particularly true of his treatment of the human bodies which are generally blocky and graceless, including even those of the angels. And apart from the dramatically foreshortened Christ, few of the figures are shown in the extravagant proto-Mannerist poses which attracted criticism in the *Last Judgment*.

Michelangelo's life was relatively calm and settled in the period of his work on the *Conversion*, but in the following years he experienced much grief and upheaval. His own health deteriorated and he was deeply distressed by the illness and death of Vittoria Colonna, as well as that of his good friend and manager Luigi del Riccio. He also suffered financial insecurity when an investment failed, and his appointment in 1547 as architect of St Peter's, a position for which he refused to take a salary, involved him in lengthy and unpleasant intrigues. Finally in 1549, while he was still working on the *Crucifixion of St Peter*, Pope Paul III died. These events intensified Michelangelo's awareness of his own failing powers and he began carving a pietà for his tomb. His darkening mood is also reflected in the grim and fatalistic atmosphere of the *Crucifixion*.

The subject of St Peter's martyrdom is a difficult one to portray; the Apostle was thought to have insisted on being crucified upside down as he did not consider himself worthy to share the fate of Christ. Traditional versions, such as that by Masaccio – in which Peter is apparently standing on his

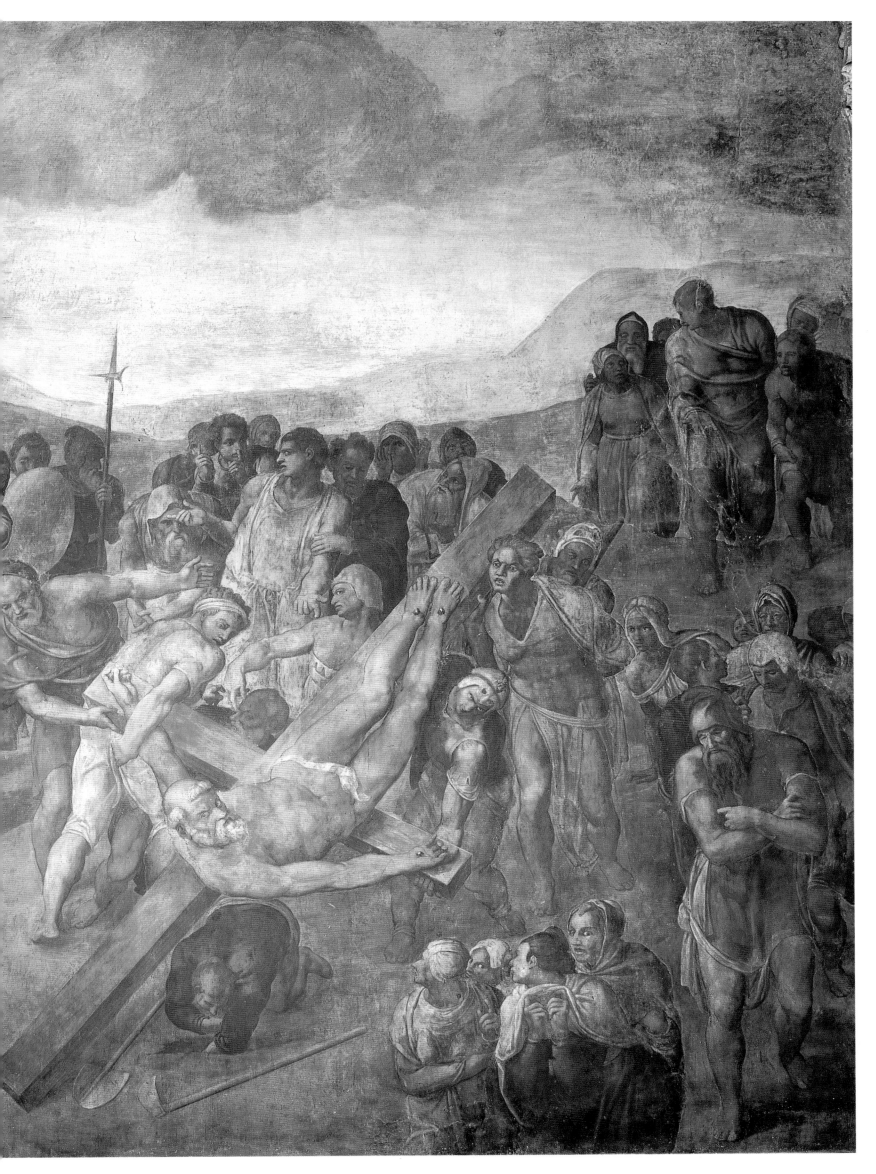

RIGHT: Drawing: *Christ on the Cross between the Virgin and St John*, black chalk with white paint, 16 × 11 inces (41.2 × 27.9 cm), London, British Museum. In his late religious drawings Michelangelo so obsessively revised the outlines that the figures seem to vibrate with the mystical intensity of his vision.

FAR RIGHT: Cartoon: *Holy Family with Saints*, c. 1553, black chalk, 91 × 64¾ inches (233 × 166 cm), London, British Museum. The figures in this large cartoon have a sturdy sculptural quality, unlike most of Michelangelo's late works. The subject is mysterious, but the relationship of the cowering child and its remote mother may have autobiographical roots.

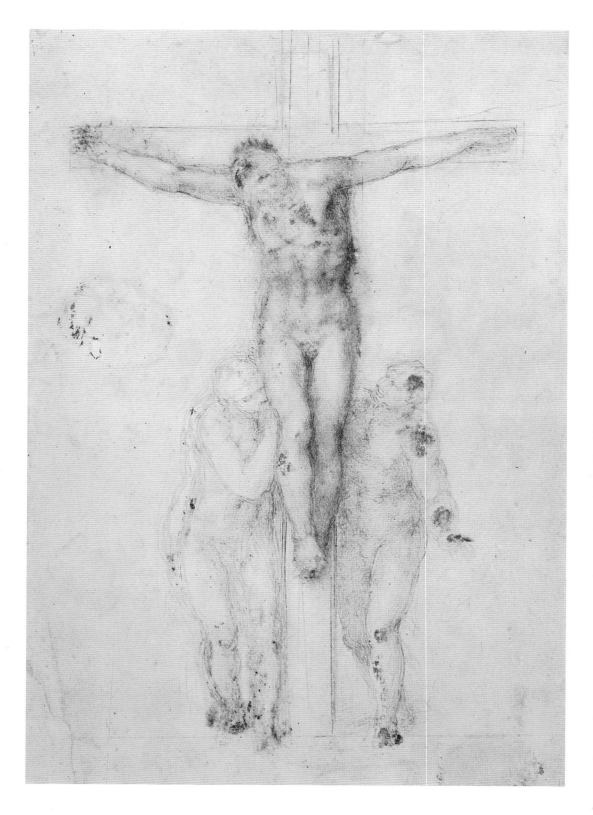

head – demonstrate the problem confronting the artist when the protagonist's expression is rendered unreadable because of his position. Michelangelo's solution is a radical departure and highly effective; the cross to which Peter is nailed is not yet erected vertically but cuts across the picture at a dramatic angle. The fierce old Apostle, a muscular nude, lifts his head and turns to glare directly at the viewer, reminding us that he is dying for our sins. His gesture conveys the Counter-Reformation message that salvation comes only through the Church, represented in the person of Peter, the rock on which it was founded. The figure of Peter has the *terribilità* of earlier figures by Michelangelo such as the *Moses*, and it has been suggested that it may be at least a spiritual self-portrait. Certainly the impressive physique and steely conviction of Peter is not matched by the other figures in the painting, most of whom simply stand upright and seemingly helpless, forming a circle around the martyr and his persecutors; their bodies are thick and clumsy and their attitudes passive. The focus on one main group gives the composition a greater coherence than the *Conversion*, but the rendering of space in the *Crucifixion* is even less convincing, with the figures ranged up the surface like a Roman relief. There is some lingering interest in the soft coloration but, apart from the impressive figure of Peter, the *Crucifixion* betrays the effects of Michelangelo's waning enthusiasm for aspects of art unrelated to religious purposes. In the *Conversion*, and to an even greater extent in the *Crucifixion*, Michelangelo turned away from heroic idealized figures in virtuoso poses designed to demonstrate the artist's skill. His position, which anticipates the anti-aesthetic stance of the Church formulated at the Council of Trent in 1562, is a repudiation of his previous achievements and aspirations and of the power

of the human will which his career epitomized.

The Pauline Chapel frescoes received surprisingly little attention from Michelangelo's contemporaries and even today they are less familiar than his Sistine paintings, probably because the Chapel remains private and can be visited only by special permission. Although they were Michelangelo's last paintings, they were followed by some of the greatest creations of his long artistic career, the architecture to which he devoted the remaining fourteen years of his life.

The Last Drawings and Sculptures

For the last decade and a half of his life most of Michelangelo's attention was absorbed by architectural projects.

After the Pauline Chapel he did no more paintings, and the sculptures and drawings he made were not for commission or presentation but were private devotional works which reflected his increasing concern with death and salvation. Many of his drawings of religious subjects were developments of themes he had treated for Vittoria Colonna (page 134-35), and the series of Crucifixion studies was probably related to his plan for a memorial to her. These late studies are technically far less assured than the highly finished presentation drawings; they are composed of tentative lines repeatedly reworked and there are many corrections visible. They are also, however, far more immediate and moving, as if they record every hesitant step of the aging artist's thought processes, and are

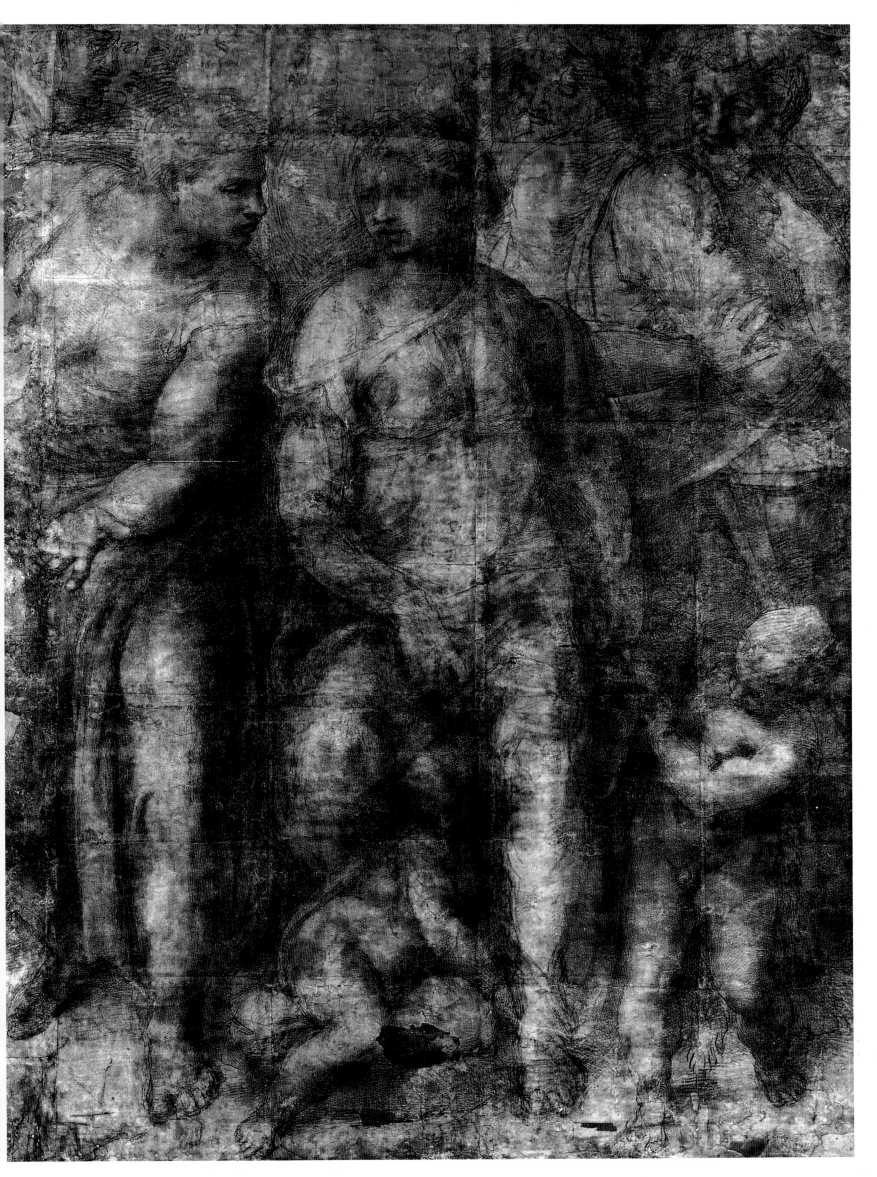

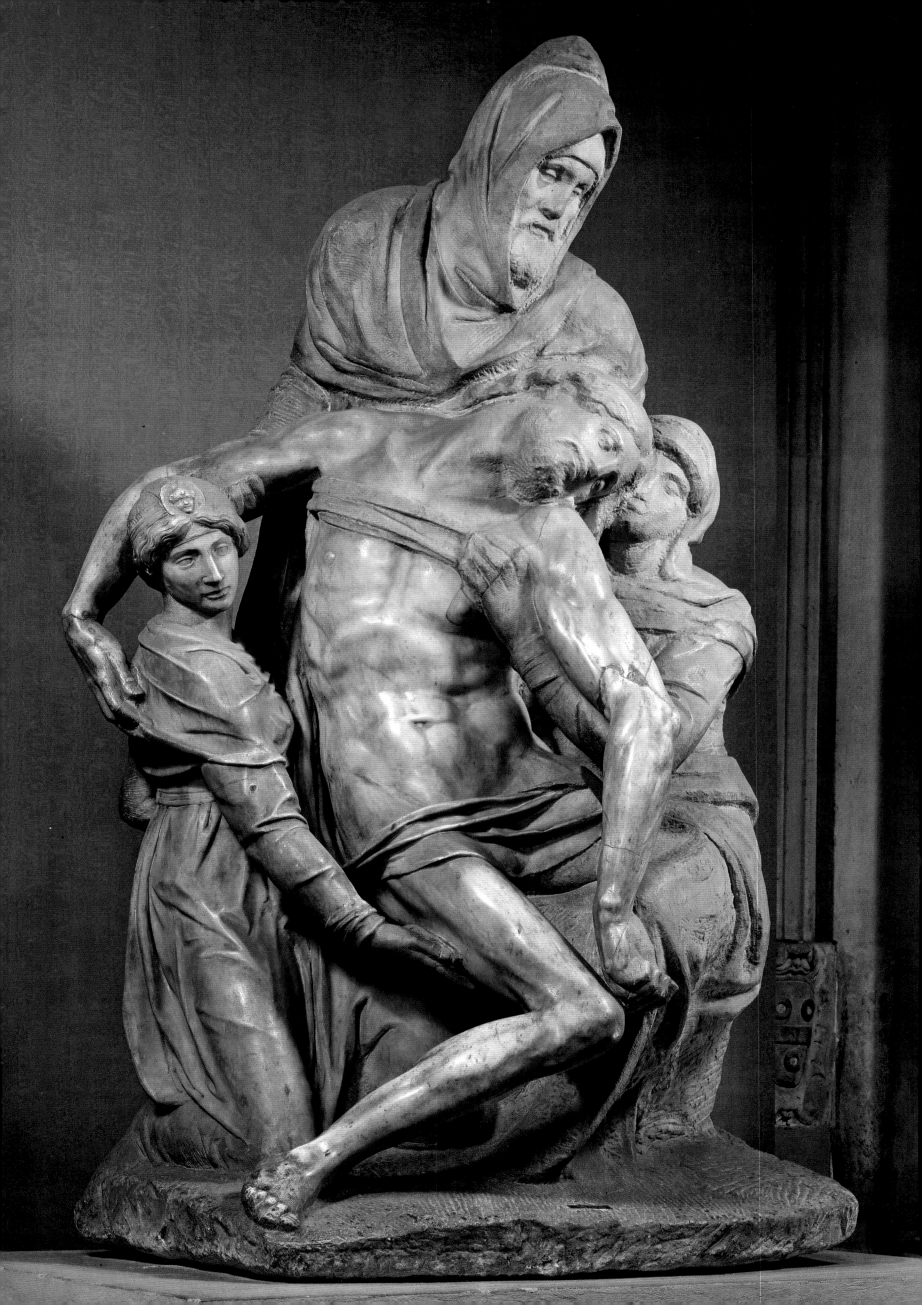

LEFT: Michelangelo and Tiberio Calcagni, *The Deposition of Christ*, c. 1547-55, marble, h. 88¼ inches (226 cm), Florence, Cathedral. Michelangelo intended this sculpture group for his own tomb, but in a mood of frustration he attacked it. Despite its broken state, and the figure added by Calcagni, the central group remains intensely moving.

further evidence of the spiritual crisis he suffered in the period between the Sistine ceiling and the *Last Judgment*. The sack of Rome in 1529 and the continuing upheaval in the Church had put an end to the Neoplatonic humanist optimism reflected in the ordered beauty of the Sistine ceiling, in which the human figure was an expression of the divine. In the *Last Judgment* there is no exultation in human beauty; the bodies of the figures are thick and heavy and are merely the earthly prison of the spirit, the *carcer terreno* mentioned in his poetry.

Michelangelo's drawings also reflect this change. Compared to studies for the figures on the Sistine ceiling, drawings for individual figures of the *Last Judgment* seem deliberately lacking in grace, their purpose simply the direct expression of Michelangelo's personal spirituality. This tendency is even more pronounced in the figures in the Pauline frescoes and in late drawings, particularly the Crucifixions. The study of *Christ on the Cross Between the Virgin and St John* is one of a series in this group which may relate to an unexecuted project for a sculpture of the Crucifixion. Like other drawings of this period, it is given a sculptural quality by the simplification of forms and the subtlety of color gradations. As so often in the past, Michelangelo has here concentrated on the torso of the central figure, leaving Christ's attendants roughly sketched. Despite the economy of finish, the tenderness with which the Virgin touches the leg of her son is eloquent. In his drawing of the *Crucifixion* for Vittoria Colonna (page 134) Michelangelo showed Christ alive, his head raised to question his fate, but in the late Crucifixion studies Christ's head hangs down in resignation or death. The change in pose perhaps reflects Michelangelo's increasing pessimism, 'with death so near and God so far away'.

A large cartoon of the *Holy Family with Saints* is probably of an earlier date, c. 1553, as it is drawn more decisively and the figures are massive and substantial, without the otherworldly quality of the later drawings. The cartoon is thought to have been made for Ascanio Condivi who did a painting based on it. The subject is not clear, but its traditional title *Epifania* has led to the suggestion that it represents the Virgin with the siblings of Christ and is a reference to the theologian St Epiphanias, who claimed they were the children of St Joseph by a previous marriage and that Joseph's marriage to Mary was not consummated. This interpretation would explain the unusual gesture of the Virgin, who seems to be pushing St Joseph away while looking at her other companion without evident sympathy. However her relation to the two infants, and theirs to one another, seems natural and charming. In fact the intimacy of the Virgin and the child who is curled up between her legs suggests Michelangelo's continuing concern with the theme of the union of mother and son, which was treated in his first *Pietà* and reached its culmination in his last sculptural works.

Before 1550 Michelangelo had begun a sculpture group intended for his own tomb, a work sometimes known as the *Florence Pietà* or, more accurately, the *Deposition of Christ*. Vasari relates that 'as Michelangelo's spirit could not rest idle . . . he took a piece of marble to make four figures larger than life size . . . because he said the use of the mallet kept him in health'. Even as an old man Michelangelo carved like one possessed, and in order to continue work on the sculpture at night he devised a paper cap which held a candle. A visitor noted that he carved 'with such impetuosity and fury that I thought the whole work must go to pieces, knocking off with one blow chips so thick . . . that he ran the danger of ruining every-

thing'. The visitor's fears were realized in 1555 when, in a fit of frustration, Michelangelo attacked the statue and broke it to pieces. Vasari suggests that he was annoyed by sparks struck from the chisel and, what is undoubtedly true, that 'his judgment was so severe that he was never content with anything he did . . . He would often say that this was why he had finished so few statues'.

The *Deposition* was saved from total destruction only by the intervention of Michelangelo's servant, who persuaded him to give it to a friend. It was repaired by Tiberio Calcagni who, according to Vasari, added numerous pieces, a practice which was anathema to the perfectionist Michelangelo. Calcagni's attempts at restoration are visible in the left arm of Christ and in the square hole drilled as a key for replacing the missing left leg. Christ's leg was originally slung over the Virgin's thigh and it is possible that the erotic implications of this pose may have been among the reasons for Michelangelo's attempt to destroy the statue. The missing member was recorded among the possessions of Daniele da Volterra in 1566 but has since disappeared. Its absence from the statue has surprisingly little effect. What is far more noticeable and unfortunate is the figure of the Magdalen on the left, made inappropriately small and bland by Calcagni and completely at odds with the central group which is so integrated in form and expression.

Like the stark figures of the *Last Judgment*, the *Deposition* expresses a spirituality so intense and personal, and so uncompromising in form, that it was not always understood or admired. The statue was brought to Florence in 1674 but Grand Duke Cosimo III did not consider it worthy of inclusion in the Medici Chapel, a decision which may simply reflect the contemporary preference for highly

LEFT: *Rondanini Pietà*, fragment. The technical refinement of this earlier head, discovered only this century, points up the rudimentary nature of the late carving.

RIGHT: *Rondanini Pietà*, 1555-64, marble, 76 inches (195 cm), Milan, Castello Sforzesco. Mother and son are almost an organic unity in the *Pietà*. Michelangelo worked on it until a few days before his death. Tragically, its attenuated forms seem to repudiate the artistic ideals to which he had devoted his life.

be seen in the truncated arm, and the head discovered only this century. The contrast between the technically refined fragments and the skeletal ruin which remains is to some extent the result of old age, but it is also what Pope-Hennessy has called Michelangelo's 'symbolic act of suicide'. It is a repudiation of his former artistic ideals, and of the idea of art itself, art to which Michelangelo had devoted his life but found of little comfort in the face of death. He wrote of his disillusionment in a famous sonnet sent to Vasari in 1554, which reads in part:

Now I well know how that passionate fantasy, which made art a monarch for me and an idol, was burdened with sin . . . no painting or sculpture now quiets the soul that faces toward that holy Love that on the cross opened Its arms to take us.

Michelangelo lived for ten years after this poem was written, years largely devoted to work on St Peter's which he hoped would make him worthy of redemption. Thoughts of redemption occupied him at his death, at the age of 88, on 18 February 1564, for Vasari relates, 'he told his friends to recall to him the sufferings of Christ'. A great crowd accompanied his body to its burial place in the church of Santi Apostoli and the Pope announced that a tomb would be built for him in St Peter's. However, like St Paul's in Christopher Wren's epitaph, 'If a monument you seek, look around you', St Peter's itself was to serve as Michelangelo's Roman memorial, for Duke Cosimo had his body smuggled back to Florence. There, Vasari relates, he was honored with an elaborate funeral of a type 'previously reserved for emperors', arranged by members of the Florentine academy, and was buried in Santa Croce, in a tomb designed by Vasari 'with statues representing Painting, Sculpture, and Architecture mourning his death'.

finished sculpture. To modern viewers, weaned on rough Rodins, the incomplete condition of the *Deposition* increases its poignancy and immediacy. In contrast to the remote perfection and passivity of the early *Pietà* for St Peter's, this late work records a moment of activity; it is more like a drama than a tableau. Christ is no longer an elegant and unblemished classical figure but is distinctly dead, his limbs arranged with an awkwardness reminiscent of North European *Pietàs*. His head sags toward the Virgin, who is described by Vasari as 'overcome by grief, without strength to support him'. She is aided by a bearded man identified either as Nicodemus or as Joseph of Arimathaea, both prominent Jews who were secret disciples of Christ and who partici-

pated in his burial. That Michelangelo made this figure a self-portrait, as acknowledged by Vasari, is an indication of the deeply personal nature of the piece for in this role, as Tolnay wrote, he 'unites the Mother and Son in a kind of . . . spiritual marriage'.

The spiritual union of mother and son demonstrated in the *Deposition* becomes virtual physical integration in the sculpture Michelangelo worked on until days before his death, the *Rondanini Pietà*, which was named for the Roman palace where it once stood. After mutilating the *Deposition*, Michelangelo looked for another block to carve and decided instead to re-work a *Pietà* he had begun earlier, probably in the 1540s. An indication of the very different style of the original sculpture can

Architecture: Florence 1515-1534

Training and Practice in Italian Architecture

MICHELANGELO considered himself first and foremost a sculptor and did not turn seriously to architecture until he was in his mid-forties. In this he was not particularly unusual. In order to understand the context in which he worked, it is useful to have some idea of the background to architectural practice in fifteenth century Italy. Unlike most other crafts there was no guild for architects in Florence, nor any form of apprenticeship that could be undertaken in order to provide a suitable training. This situation originated in the Middle Ages when the person in charge of building work was usually a senior experienced stonemason, although overall control on big projects often fell to someone outside the building trade. For instance in the fourteenth century Giotto (1266-1336), whose experience was limited to painting, was put in charge of building Florence Cathedral, the *Duomo*. The possibilities for innovation were limited, partly by lack of interest and partly by the absence of means to communicate new ideas. Imitation was the prevalent design method in all but the most prestigious commissions, where sheer size often led perforce to innovations. In other words construction of most buildings was seen as a job for an artisan, and there was therefore no need for a designer or architect.

During the Renaissance, when the demand for buildings reached new levels, this attitude to design shifted significantly. Two factors help to explain this change. The movement to reintroduce classical forms meant that the designers of buildings were working with new and unfamiliar forms; forms, moreover, that were governed by an intellectual theory. In order to be able to absorb the rapid changes and cope with the framework of rules that governed

these new forms, what had been a simple craft now became a much more intellectually based activity for which education in various related subjects became necessary. Classical architecture was based on the Greek temple principle of load-bearing columns and entablature, which was much elaborated by both Greek and Roman architects. The fundamental classical principles of symmetry, harmony and proportion, the proper style and proportions for different building types and the materials and methods of construction were encapsulated by the first century BC architect and engineer Vitruvius in his *Ten Books of Architecture*. This was accepted as authoritative and much studied by Renaissance architects. The changed attitude to architecture was actively promoted by those involved, who of course wished to improve their social standing, and the many treatises written in the fifteenth century can be seen at least in part as an exercise in raising the status of architecture. Probably the most successful was Leon Battista Alberti's *De Re Aedificatoria*, completed in 1452, which made it clear that an intellectual grasp of the theory of architecture was more important to the designer than training and manual dexterity. At the same time, due to this new status, interest in architecture spread to the rich and influential who exercised their influence both as patrons and as practising architects, keen to compete with friends and rivals to produce noteworthy buildings. Lorenzo the Magnificent (grandson of Cosimo de' Medici), for

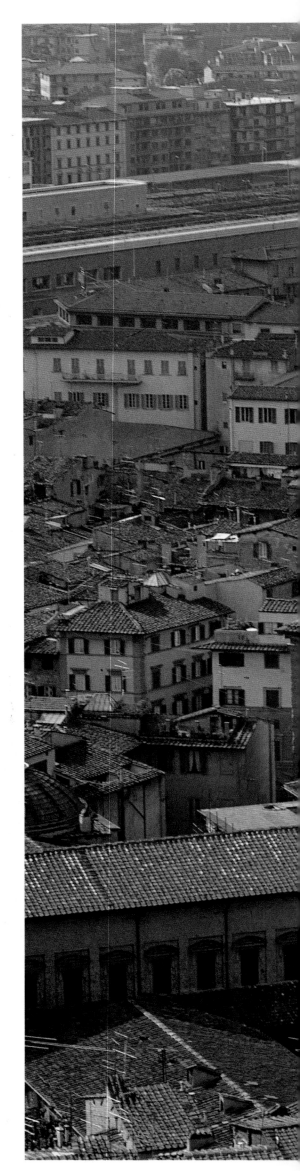

RIGHT: Aerial view of San Lorenzo, Florence, showing the church dwarfed by the later Capella dei Principe and also indicating clearly the relationship between the church (foreground right), the two sacristies and the library buildings; see also the ground plan on p. 176.

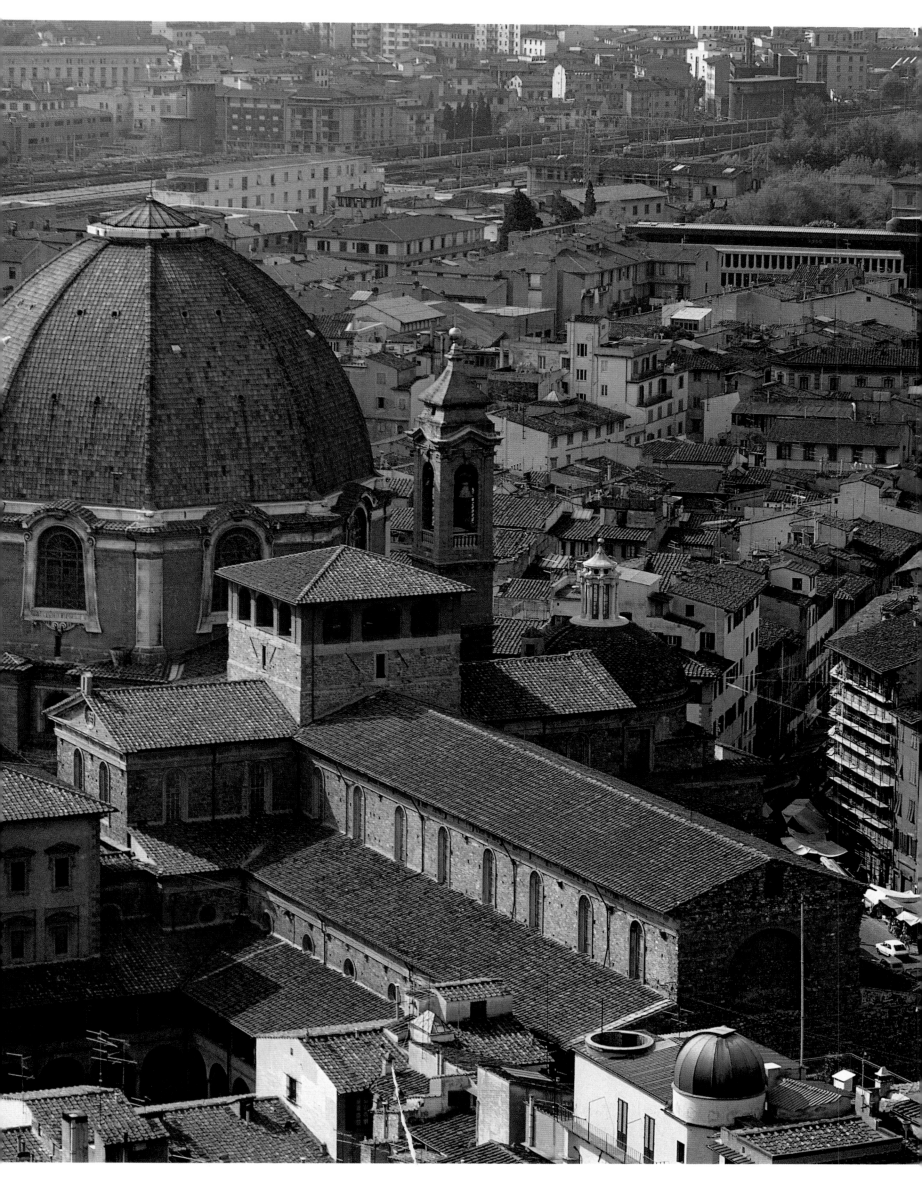

LEFT: Santa Maria delle Carceri, Prato, was begun in 1485 by Giuliano da Sangallo who was the favorite architect of Lorenzo the Magnificent.

able as that may seem to modern minds) as witness the difficulties Bramante experienced in designing St Peter's.

It is not until the sixteenth century that an example of what would now be called a 'trained' architect can be found. Antonio da Sangallo the younger (d.1546) was the nephew of the Florentine Sangallo brothers who both practised as architects, but he was apprenticed as a carpenter and worked under Donato Bramante (1444-1514) on St Peter's, eventually taking over as *capomaestro*. This training, which would seem ideal to the modern eye, was in fact looked down upon, as contemporary documents make clear. Cellini for instance, writes:

Because he (Sangallo) had been neither a sculptor nor a painter, but rather a master of carpentry only; for this reason one never sees a sign in his work of that certain noble virtue as is seen in . . . Michelangelo.

Vasari also reflects contemporary opinions when he writes:

Architecture can only attain perfection in the hands of those who possess the highest judgment and good design, and who have had great experience in painting, sculpture and wood carving.

When Michelangelo turned to architecture at the beginning of the sixteenth century he would therefore, in the eyes of his contemporaries, have been perfectly qualified for the challenge. The only thing that might have appeared unusual was the fact that he had not received any architectural commissions while he was in Rome in the early sixteenth century. This is most probably explained, as we shall see, by the enmity between him and the architectural establishment in Rome (and of course by his extremely demanding workload at the time, which included both the Sistine Chapel and the Julius tomb).

example, took an active interest in architecture. Not only did he keep up to date with new developments (for instance he asked to be sent plans and measurements of the newly designed Ducal Palace at Urbino), but he was active also both as patron and as designer. As patron, he played an important role in the design of the Sacristy at Sto Spirito, and he is known to have submitted an entry for the competition to complete Florence Cathedral. Nor are these isolated examples; Ercole d'Este, for instance, borrowed Lorenzo's copy of Alberti's treatise before he began designing his own palace. During the fifteenth century the status of both architecture and the architect was changing; the medieval stonemason was superseded by the Renaissance intellectual who often, though by no means always, came from a patrician background.

Although it might be expected that architectural workshops would be formed with commissions passing from father to son, this was not usually the case in the fifteenth century; normal practice was for men working in other fields to design the buildings. Instead of turning to the artisans who actually cut the stone or built the buildings, patrons chose men who were grounded in a creative discipline; men trained in activities such as draftsmanship, perspective or mathematics and practised in using these skills in a creative way. Hence architects were drawn from the ranks of artists (Raphael, Leonardo and Bramante to name but a few), sculptors (Sansovino), goldsmiths (Brunelleschi) and cabinetmakers (Baccio d'Agnolo). All these men would have possessed a well-developed talent for design and would in most cases have been used to incorporating architectural motifs into their work. In contrast, those who pursued purely manual crafts such as carpentry, stonecutting and walling were not considered suitable to take on the design of buildings, even though they might well have had many years of practical experience. The technological side of architecture does not seem to have received much consideration (unthink-

Born at the beginning of the last quarter of the fifteenth century, Michelangelo would have witnessed the building of many of the *palazzi* that gave Florence its Renaissance character. Although the Medici Palace was finished well before his birth, many others, such as the Strozzi – essentially a larger, grander version of the Medici Palace – were started while he was a child. However, the architectural situation in Florence was changing. By far the most expensive of the arts, architecture was also the most susceptible to unsettled conditions and the most dependent on rich, civilized and ambitious patrons. By the last decade of the fifteenth century the great building boom which had made Florence architecturally pre-eminent was fading and the political scene was becoming less stable. The city states were increasingly caught up in what are now known as the Wars of Italy; Florence herself had been involved in a war against the papacy and Naples in 1478-80; and the explusion of the Medici in 1494 had left the city without her greatest patrons. Increasingly architects were forced to look elsewhere for commissions.

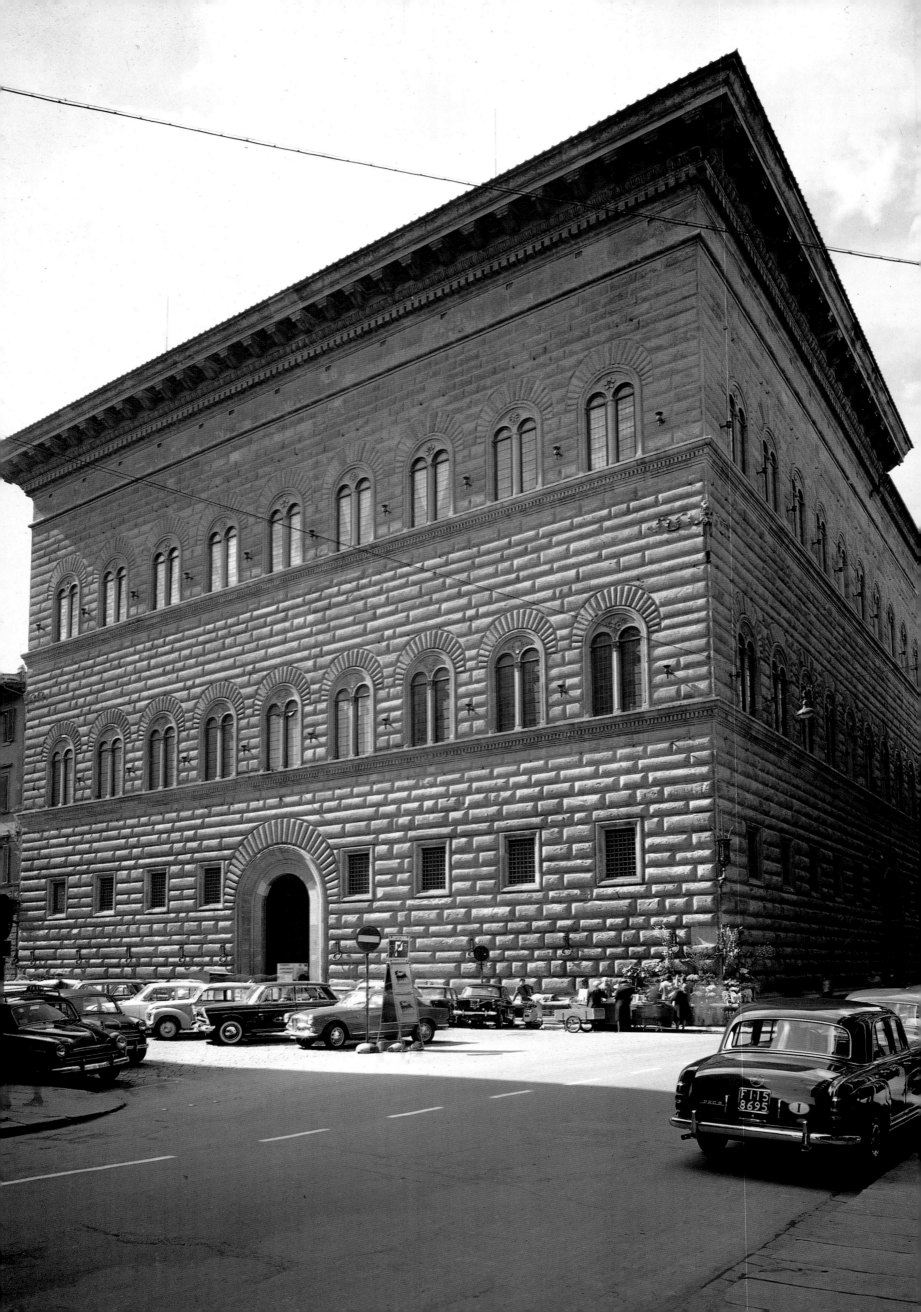

LEFT: The Palazzo Strozzi, Florence, begun in 1489, is typical of the palazzi that were being built in Michelangelo's youth.

RIGHT: The Palazzo Rucellai in Florence was begun by Alberti in 1446; the facade shows the flat two-dimensional way in which the classical orders were used in the fifteenth century.

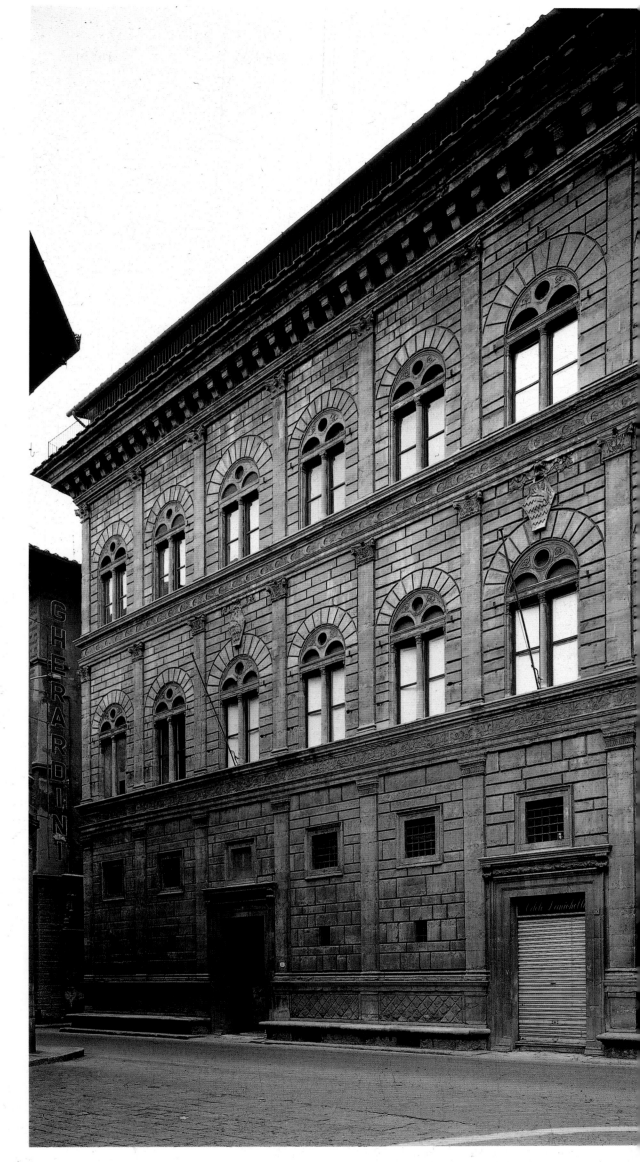

With the fall of Milan to the French in 1499, Rome soon replaced the declining city states as the artistic center of Italy. This was achieved through the vision of one man, Giuliano della Rovere, who became Pope Julius II in 1503. An ambitious and enlightened patron, Julius attracted the greatest artists in Italy to Rome with his breathtakingly grandiose plans to create a new Christian city which would rival the splendor of the ancient pagan capital. This was patronage on a scale that the Medici, even in their heyday, could not begin to emulate and from about 1505 onward architecture in Rome began to reflect the grandeur of Julius's concept with a new monumentality of style.

Michelangelo, in Rome on and off from 1505 and almost continuously from 1508 while working on the Sistine ceiling, was well placed to watch this revolution unfold. Two buildings, both built early in Julius's pontificate, encapsulate the change that was taking place in architecture. Bramante's Tempietto (c.1502) is important because it introduced a more solid, three-dimensional approach (see page 203). The flat surfaces with their applied decorative 'skins' favored by fifteenth-century architects were replaced by solid load-bearing columns which are an integral part of the design. Facade and building became indistinguishable, fused into one inseparable, organic whole. Bramante's interest was in solid form, and in modelling the thickness of the walls so that the play of light and shade gave a new, more monumental effect.

Palace design was also changing. The articulation of the facade of Bramante's Palazzo Caprini (c.1512, also known as the House of Raphael and destroyed in the seventeenth century; page 204) used three-dimensional classical motifs to articulate its facade, and its graceful use of the correct Doric order contrasts with the uncompromising blocks of the Strozzi Palace (see page 164); intellect

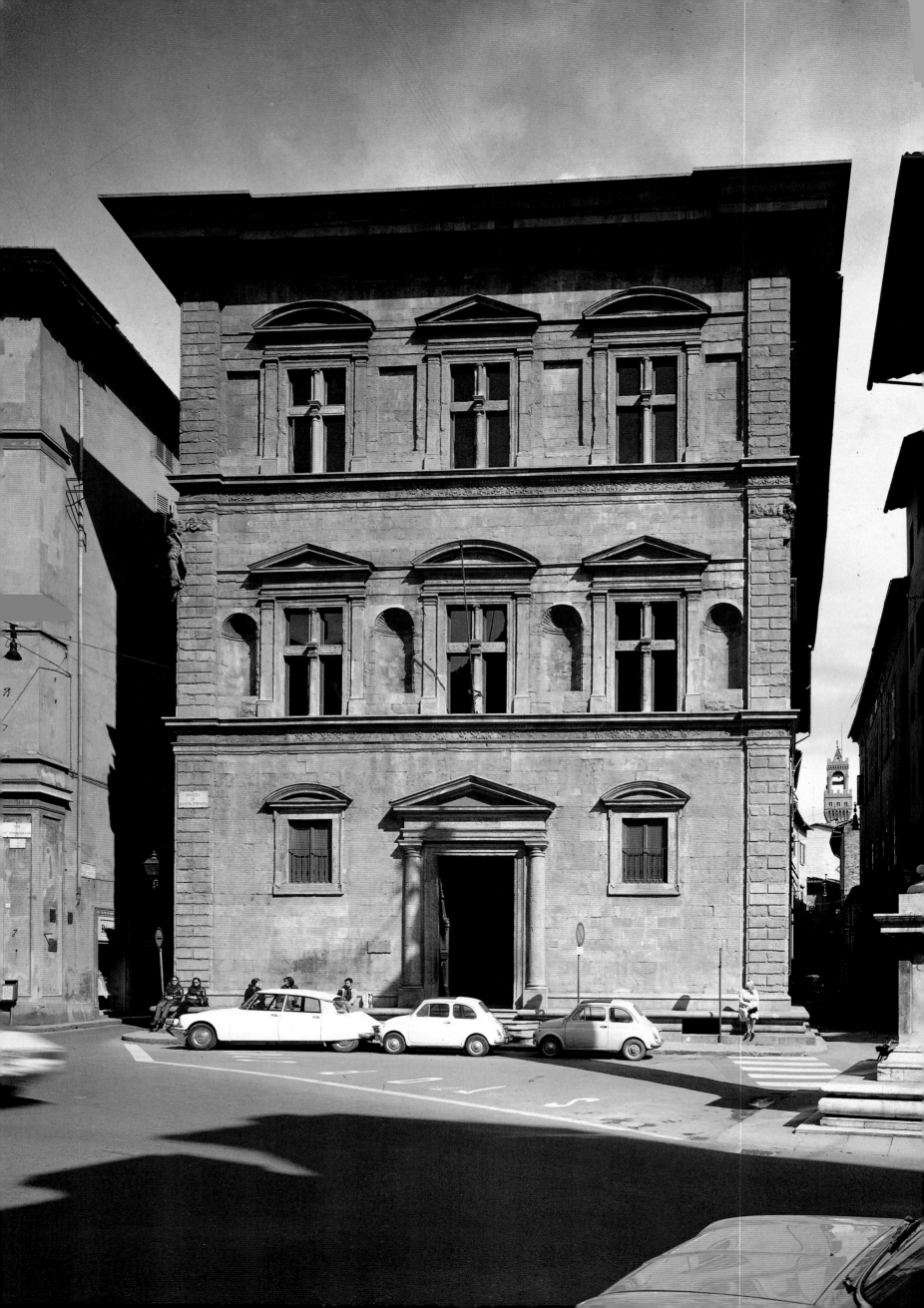

LEFT: The Palazzo Bartolini Salimberi, Florence, begun in 1517 by Baccio d'Agnolo, was the first example of the new Roman style and was ridiculed by the Florentine as looking more like a church than a palazzo.

RIGHT: *L'Architettura*, a relief by Andrea Pisano.

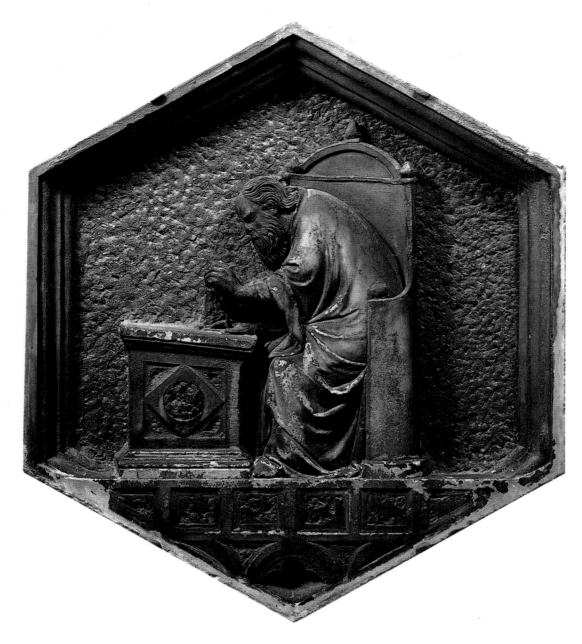

rather than power seems to be the message. Even a comparison between the most 'intellectual' palace in Florence (and one which had few imitators), Alberti's Palazzo Rucellai, and the House of Raphael shows clearly the changes that have occurred, for again the flat design of the former contrasts with the new three-dimensionality. Where the Palazzo Rucellai has pilasters so flat they do not project beyond the wall, giving the impression of being drawn on the surface, Bramante uses projecting half-columns which seem in comparison strong and functional.

The first palazzo in Florence to reflect the new style was the Palazzo Bartolini-Salimbeni, built in 1517-20, and designed by Baccio d'Agnolo (who at the same time was co-architect with Michelangelo on the San Lorenzo facade). According to Vasari it was the first palazzo to use square windows rather than the typically Florentine round-headed type, and he also made a point of recording that it had 'a portal with the columns of the door bearing an architrave, frieze and cornices'. Although this seems unexceptionable to the modern eye, the building raised extraordinarily strong feelings at the time. Apparently the Florentines felt that it looked more like a church than a palace and gave vent to their disgust by festooning the building with branches and garlands, as they would a church on feast days. This sort of reaction would have been unthinkable in Rome and demonstrates how quickly Florence, deprived of rich and powerful patrons after the expulsion of the Medici, became relegated, at least in architectural terms, to a backwater.

Michelangelo's Approach to Architecture

Coincidentally, just as Michelangelo was finishing the Sistine ceiling the political situation in Florence changed

again. In 1512 the Medici returned to Florence, expelling the republicans who had controled the city for nearly twenty years. By 1513 the family had provided the successor to Pope Julius, in the person of Cardinal Giuliano de' Medici, who became Leo X. For the first time in many years the Medici were in a position to celebrate their regained and indeed augmented status with ambitious acts of patronage.

All Michelangelo's major architectural commissions in Florence were directly related to this political change, since they all came from the Medici and centered on the Medici church of San Lorenzo. They decided to carry out improvements here on a scale that would not only benefit the people of Florence but, more important to the Medici, would demonstrate their restored prestige, power and public spiritedness. Michelangelo was ideally placed to contribute to this flowering of Medici ambitions. Not only was he familiar with both Florentine tradition and the revolutionary changes in architecture taking place in Rome, but he was also, through his training and experience, able to interpret and build upon the ideas of architects such as Bramante.

Throughout his life Michelangelo considered himself first and foremost a sculptor, and this was arguably the most important influence on this architectural career: 'I'll think about it, although it's not my job', he grumbled when asked by Pope Clement VII in 1523 to design the Laurentian Library. Michelangelo was by no means the first sculptor to turn to architecture but he was unique in the way that he so undeviatingly applied sculptural approaches to architecture. Where other sculptors modified their approach, or saw architecture as a means of displaying sculpture, Michelangelo seemed to see buildings simply as largescale sculpture, and as a result often treated them in an inherently different way from other architects. This attitude affected both the methods he used to design buildings and, more difficult to quantify, the way he felt about architecture and buildings themselves.

Sculptural techniques were ideal for developing further Bramante's more three-dimensional or 'modeled' approach to buildings. Early on in his career as an architect Michelangelo started making terracotta models, a technique common to sculptors but not

RIGHT: The inner courtyard of Giulio Romano's Palazzo del Tè, Mantua, begun c, 1526, showing the mannerist dropped triglyphs.

BELOW RIGHT: The Palazzo Branconio dell' Aquila, Rome, begun before 1520 by Raphael; with its proliferation of decoration it offers an alternative to the calm classicism of Bramante's House of Raphael (illustrated on page 204).

before seen to have any great relevance to architecture. One of the limitations of designing on paper was, of course, its essential flatness and the resulting need to separate ground plan from elevation. With terracotta models the entire form of the building was at the control of the fingertips, and no part could be separated from another. Moreover the model gave a representation of the building in its entirety in a way that drawings at this time were only groping toward. Surface and mass therefore become inseparable, as in sculpture. Just as paper encouraged flatness, so terracotta positively demanded that walls should be modeled, enabling the artist to sculpt the thickness of the wall with a push of the thumb and coax surfaces toward a new unified plasticity.

Michelangelo's approach to building also affected the drawing methods he used. With the exception of one or two very early architectural drawings, he moved away from the established precise, calculated method using dividers and rulers and turned instead to much freer sketches, using materials such as chalk, charcoal or wash, which were the antithesis of fiteenth-century practice. Quick sketches would convey the overall impression of the layout of a building; then a model would take over and drawings would be limited to areas where models were weak, such as interiors or specific details. But even here Michelangelo's preferred medium was often wash or charcoal, which gave the overall three-dimensional feel of the detail rather than precise information. He was moving away from line; his interest was in the sculptural possibilities of architectural detail and the medium he chose helped him to convey not measurements and proportional relationships, but the fall of light over modeled masses of wall surfaces, as demonstrated in his study for the central portal of the Porta Pia (see page 218).

On another level Michelangelo brought to architecture the sculptor's interest in movement, and especially the human body in movement. These subjects seem far removed from architecture, although fifteenth-century architects had for long theorized about the proportions of the human body in relation to architectural proportions. Michelangelo's only direct comment on architecture to survive, however, makes it clear that he saw architecture as being related to the human body. He wrote:

And surely the architectural members derive from human members. Whoever has not been or is not a good master of the figure, and most of all anatomy, cannot understand anything of it.

This should not be taken to mean that Michelangelo regarded the body as a source for mathematical proportions to be applied to architectural elements; rather it is clear that he saw the human body as a whole, as a construction which constantly exhibited stress and tension caused by movement. A comment in Condivi on Michelangelo's view of Dürer's drawings is revealing in this context:

Albrecht [Dürer] deals only with measurement and variety of bodies, concerning which no sure rule can be given, conceiving his figures upright, like posts. But what is more important, he says not a word about human actions and gestures.

Michelangelo felt that an understanding of anatomy was crucial for an architect and it is clear that he applied this approach to building, wishing to express the stresses, tension and muscular power visible in the human body in movement by using architectural elements such as columns, capitals and entablatures in place of muscle and bone. He was bringing a new kind of expression to the classical orders, based on his understanding of anatomy. Instead of using the orders as decorative exemplars of mathematical theory, he made them an essential working part of his buildings; instead of wall surfaces which showed no sign of the elements of construction, he emphasized the power and strength of architectural features, forcing the viewer to acknowledge the tension present in a building. It is this approach which lies behind and explains some of Michelangelo's more memorable architectural ventures, such as the Laurentian vestibule.

Mannerism

Both the Laurentian Library and the Medici Chapel have been seen as important examples of Mannerist architecture and it is therefore worth examining the role that this style played in the architectural climate when Michelangelo was working in Florence. The concept of a Mannerist style is a modern one. It originated in the 1920s when critical attention turned to an area of sixteenth-century architecture which, because of its idiosyncratic attitude to classical rules, had previously been dismissed as perverse and decadent. The word mannerist originated from the Italian word *maniera* which, although extremely difficult to pin down, is often translated as 'stylishness', leading to the phrase 'stylish style' which implies a self-conscious or contrived approach. In architecture the characteristics of Mannerism include variety (both in decoration and in the handling of classical elements), seemingly effortless grace (often in fact hiding intricate technical problems) and sophistication, often manifested in the form of visual puns such as Giulio Romano's dropped triglyphs in the court of the Palazzo del Tè (1526-34). A Mannerist architect is one who, fully understanding the classical rules, breaks or alters them for a variety of reasons. This approach can be seen as a

logical progression from buildings such as Bramante's Tempietto, where Renaissance architecture came of age; the rules had been fully understood and buildings that could stand comparison with those of antique Rome were being produced. Once understood, however, the rules of classical architecture became restrictive, limiting the architect and curtailing his expressive abilities.

In the second decade of the sixteenth century architects began to explore the effects that could be achieved by deliberately breaking or ignoring classical rules. An early example which clearly illustrates this change of priorities is Raphael's Palazzo Branconio dell'Aquila, built before 1520 and thus only a few years after Bramante's Palazzo Caprini but since destroyed, which is the epitome of classical architecture. The most notable change, recorded in a seventeenth-century engraving, is the proliferation and variety of the facade decoration. Elements of classical architecture are combined with rich sculptural decoration and on the top floor (though not included in the engraving) panels of painted decoration are used. More important is the way the classical elements are handled. The ground floor contains shops and is similar in spirit to the Palazzo Caprini; sober Doric columns uncluttered with any

decoration. On the first floor, however, the approach changes dramatically. The normal rule is to place void over void and solid over solid; classical architecture is nothing if not logical and

the idea of the orders is to form a kind of support grid throughout the building. Thus a column will support either another column or a solid wall, while a void such as a window will invariably

FACCIATA DEL PALAZZO ET HABBITATIONE DI RAFAELE SANTIO DA VRBINO SV LA VIA DI BORGHONOVO FABRICATO
CON SVO DISENGNO L'ANNO MDXII IN
CIRCA-E SEGVITO DA BRAMANTE DA VRBINO

LEFT: Palladio's Palazza Valmarana, Vicenza, designed 1566. At the end of the facade Palladio substitutes for the giant order which articulates the rest of the building a pilaster one story high supporting a statue.

RIGHT: The Tempio Maletestiano (also known as San Francesco), Rimini; the unfinished facade by Alberti shows the problems that are encountered when adding a classical facade to an earlier church.

the entablature. The placing of a weaker, decorative element in a key corner position gives the facade a disconcerting impression of instability. Giulio Romano also flouted classical rules. His own house in Mantua, built in the 1540s, was a Mannerist variant on the Palazzo Caprini, while in the Palazzo del Tè (c 1526) he demonstrated not only the flexibility that could be brought to architecture by subtly varying the rules, but also the sort of visual tricks that could be played by an architect who understood the logic of classical architecture.

There is no doubt that from the 1520s architects were experimenting with new variations and finding antique precedents for the manipulation of classical rules. Although in some parts of Italy, especially Rome, this approach did not find favor, sixteenth-century Florence seems to have welcomed it. As Vasari put it, Michelangelo:

Introduced a more varied and more novel composition than ancient and modern masters have been able to employartists therefore owe Michelangelo a great debt for having broken the chains which made them all work in one way.

Michelangelo's Florentine architecture certainly fits into the Mannerist category but it is debatable how helpful this concept is when evaluating his approach. Obviously he did not set out the be 'Mannerist' since the concept did not then exist; but neither did he set out with the specific aim of altering classical rules. What distinguishes Michelangelo as an architect, and renders the label Mannerist largely irrelevant, is the way in which he approached each commission without preconceived stylistic ideas. It was the nature of the commission itself which defined and regulated his approach. The concept of decorum, that is the suitability of a design for the function of a building, is what conditioned Michelangelo's ideas. When he

be placed over another void, ensuring that a potentially weak part of the structure will not become load bearing. While the Palazzo Caprini obeys this basic rule, with the paired columns of the first floor placed securely over the ground floor piers and the windows directly above the arches, the Palazzo Branconio dell'Aquila is very different. The columns of the ground floor do not appear to support anything, since the wall directly above them is hollowed out to form a niche. Although the windows are centered over the void beneath, the columns of the surrounds stand awkwardly on the spandrels of the arches below. The idea of a regular grid defining the building has been abandoned and instead complex rhythms are set up by using bay divi-

sions of different sizes. There seems to be no logical or technical explanation for this changed approach and it appears that Raphael was departing from classical logic in order to produce a more visually exciting facade.

Although it may well be the first, this was not an isolated example; in many parts of Italy the basic classical grid was being reorganized at this time. Palladio, often – wrongly – considered one of the most correctly classical of architects, produced a striking example of this new freedom in his handling of the facade of the Palazzo Valmarana in Vicenza. Here what seems to be a regular facade articulated by a giant order ends abruptly with a much smaller column, supporting a statue which doubles as a caryatid supporting

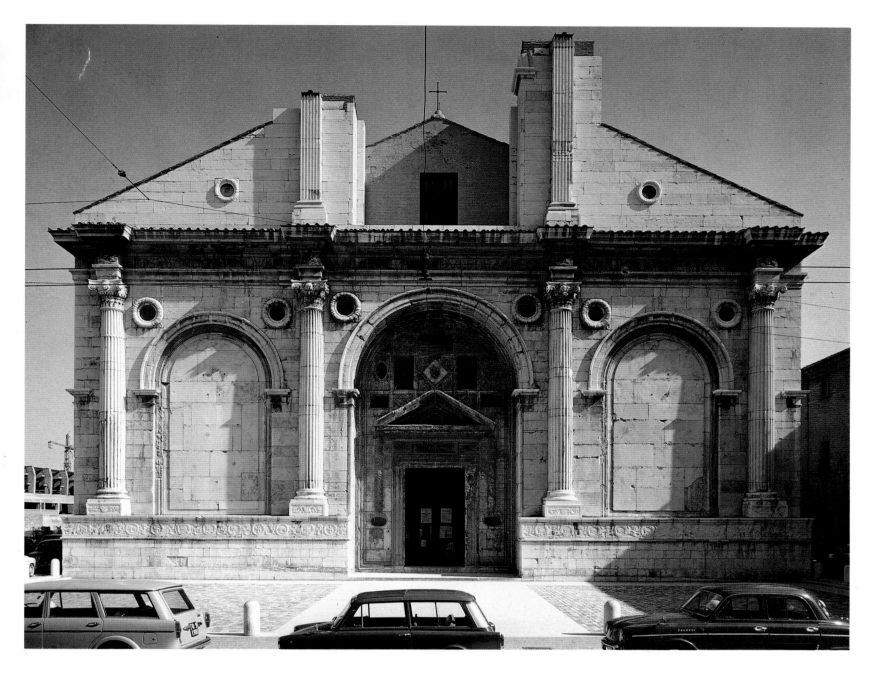

altered or manipulated classical forms, he did not do so in a deliberately wilful spirit but because he was rethinking them in terms of the specific commission. It is this independence of approach and refusal to be stylistically pigeonholed that makes Michelangelo such a rewarding architect to study.

One other aspect of Michelangelo's approach to architecture needs acknowledgment and that is his willingness to improvise. This is a characteristic which may seem to have been thrust upon him, due to the fact that nearly all his commissions involved adapting existing buildings. His ability to 'design on his feet', however, should be seen not as his response to specific problems, but rather as fundamental to his approach. Vasari reports Michelangelo as saying 'that it was necessary to have the compasses in the eye, not the hand because while the hand performs the eye judges'. Michelangelo's willingness to use his judgment was not ·unique; Vasari saw judgment as an essential quality for an architect but it is fair to say that Michelangelo depended less on classical rules and mathematical

ratios than his contemporaries, especially those of the Sangallo school. He was more willing to break rules, to improvise and to cast around more widely for ideas, because his innovations were then subjected to the critical judgment of his eye. This approach, too, is reflected in his design methods. The wooden model for San Lorenzo (see page 175), for instance, is made in two sections, upper and lower, corresponding with the two levels. Although there are other explanations, it is certainly possible that this was to allow alternative designs for the second level to be tried out as the building progressed. Similarly there is considerable evidence that the model for St Peter's was made without a dome, since Michelangelo wanted to experience the physical presence of the body of the church before designing the dome. In much the same way a full-size wood model of the cornice for the Farnese Palace was hoisted into position, so that Michelangelo could see how it looked in place rather than depend on mathematical calculations. He brought a refreshingly flexible attitude to architectural design and

in this he was in a way closer to medieval practices than to those of the Renaissance. The latter tended to depend on a fixed 'ideal' plan where mathematical ratios removed the need for judgment, whereas medieval 'architects' were willing to make decisions as the building evolved in front of them.

To understand Michelangelo's contribution to architecture, the unusual nature of his approach needs to be kept in mind. Due to the large amount of surviving documentation about the Florentine buildings, we can follow with unique clarity his early development as an architect. From the San Lorenzo facade, where he can be seen evolving his ideas about architecture and the design methods needed to carry them out, we can then follow his search for expression within classical forms; in the Medici Chapel sculpture, art and architecture were intended to be unified into an expressive whole, creating an ambience suitable to the function of the building; and in the vestibule of the Laurentian Library new ways to express his unique view of architecture were explored.

RIGHT: San Lorenzo, Florence, showing Brunelleschi's unfaced west end and, to the right, the dome and cupola of Michelangelo's New Sacristy.

The San Lorenzo Facade

It was the Medici family who were responsible for introducing Michelangelo to architecture. At the beginning of the sixteenth century they were in no position to exercise patronage on a grand scale but in 1512 the republican governor of Florence, Pietro Soderini, resigned and, along with other key officials, went into exile. The Medici regained power and their position was further strengthened by the election to the papacy of Cardinal Giovanni de Medici as Leo X (1513-21). On his triumphal return to Florence as Pope, it is likely that Leo looked around for ways of consolidating his position and emphasizing the glory of the reestablished Medici. One project that provided a suitable blend of piety and propaganda was the facade of San Lorenzo; built by the early Renaissance architect Filippo Brunelleschi for Cosimo de' Medici in the 1430s, the church had been left unfinished with a rough masonry facade dominating the piazza.

It is unclear how and exactly when Michelangelo became involved in the San Lorenzo project. Both Vasari and Condivi tell us that the Pope commanded Michelangelo to take charge of the project against his will: 'weeping, Michelangelo left the tomb (of Julius II) and betook himself to Florence', says Condivi. The reality appears to have been somewhat different. It is true that Michelangelo wrote to his father in 1515 that he was trying to finish the tomb as quickly as possible because he foresaw the likelihood of being pressed by the Pope to take up a new project. However, it is known that architects of considerable standing, such as Raphael and Andrea Sansovino, were also asked to provide designs for the facade. Since the Pope's intention was to have an impressive display of sculpture on the facade, the probability is that he

saw the project as a collaborative effort between sculptor and architect, and that the Condivi/Vasari version is part of the deliberately over-romanticized view of Michelangelo's role. Whatever the Pope's original intention, it is clear that from 1515 onward Michelangelo gradually and deliberately took over the whole project. Sansovino was dismissed because Michelangelo refused to work with him and was replaced by the least influential of the contenders, the little-known Baccio d'Agnolo. Within a matter of months the Pope had given permission for Michelangelo to drop Baccio if he felt it necessary. It is

clear that Michelangelo was unwilling to collaborate on the scheme and had deliberately maneuvered himself into a position where he was in sole command. This is a good example of Michelangelo's unwillingness to share or delegate a commission; an attitude which was to cause problems, since he took on far more work than he could possibly complete singlehanded.

In terms of design the project posed a problem which had not really been solved by the architects of the fifteenth century, that of making classical architecture flexible enough to provide a unified design for the often awkward shapes of church facades. Only Alberti had applied himself with any real rigor to the problem, and the variety and the uneasiness of some of his solutions underline the difficulty of the task. Most other architects had either provided extremely weak facades, like that at San Agostino, Rome, or had simply

LEFT AND BELOW: Two early designs for the facade of San Lorenzo. In the second one (below), Michelangelo avoids the domination of horizontals which is a feature of the earlier design. He has also heightened the end bays of the facade, bringing it to an emphatic stop rather than allowing it to tail off as in the earlier example.

avoided the problem. The shape of San Lorenzo, with its high central nave, lower aisles and side chapels which were lower still, was a particularly difficult one. Not surprisingly, many of the proposals which survive, including two designs by Giuliano da Sangallo, have simplified the outline of the church or ignored it altogether. In addition the design had to provide for the Pope's sculptural program, which at this stage consisted of some ten statues in niches, three major reliefs on the mezzanine level and smaller ones at a lower level.

From Michelangelo's surviving drawings we can follow the stages through which his design evolved. Early sketches show him wrestling with the basic demands of the commission. For instance a comparison of the two examples on this page provides a vivid example of the freedom of his preliminary sketches. The earlier example has two obvious weaknesses: in the

domination of horizontal lines at the expense of verticals, and in the way in which the building tails off at the ends rather than coming to an emphatic stop. In the second design, however, these problems have been solved; emphasis has been given to the end bays by heightening them, creating a clearer contour, the horizontals and verticals have become interwoven and a design of some authority is emerging. In fact it is a slightly more developed version of this design which was in all probability the one which gained Michelangelo the commission in 1516. One of the weak points of the Sangallo design is the failure to integrate sculpture and architecture: statues are eccentrically placed along the top of the facade. More importantly, while Sangallo's facade seems to consist of a series of elements placed one on top of the other like building blocks, Michelangelo's design unifies these into a more harmonious and integrated whole, providing a

coherent architectural context for the pope's sculptural programme.

In March 1519 Michelangelo appears to have had second thoughts, however, for when the luckless Baccio constructed a wooden model based on this design he rejected it as 'childish'. This is the first sign that Michelangelo was beginning to rethink the whole project, and it was at this stage that he started using clay to help him express his ideas. Clay was an unusual, if not unknown, material for an architect to work with and it does not on this occasion appear to have been entirely successful, since Michelangelo dismissed the resulting model as 'misshapen like pastry'. But by May 1517 the estimated cost had risen by nearly a third, indicating a pretty radical escalation of the project. What appears to have happened is that in the two months or so between the rejection of Baccio's model (and incidentally of Baccio himself) and the appearance of the clay model, Michelangelo came up with a totally new conception. Instead of designing a facade to cover the existing wall like a decorative skin, he conceived the idea of adding an extra unit to the church in the form of a porch or narthex, west of the existing nave. This freed him from the need to follow the awkward shape of the existing building, since the new version would have its own side bays and thus its own three-dimensional presence. In August 1517 Michelangelo went to Florence to supervise the making of a wooden model of the new design, which included no less than 24 wax models showing that the Pope's sculptural program had more than doubled in size.

The tendency has been to judge Michelangelo's model harshly, but a more positive approach is to ask what the new design achieves. By changing to the three-dimensional structure, Michelangelo first and foremost avoids the need to construct an awkward

RIGHT: In a slightly later design for the San Lorenzo facade the ideas emerging in that shown left below have been developed into a convincing design.

BELOW: By 1517, when he made this wooden model, Michelangelo had abandoned the idea of a simple facade and was designing an entrance porch which was no longer controled by the shape of the church behind it.

single-bay upper storey to disguise the height of the nave; and by using three-quarter columns rather than pilasters in the lower order the design gains in monumentality and grandeur. Another factor is the way Michelangelo uses texture; the columns and pilasters are all fluted, contrasting with the smooth stone surface and emphasizing the solidity of the column. This gives them a muscular strength which is lacking in earlier designs. Finally the sculpture is now clearly defined and organized into areas where it can be accentuated by the architecture, whereas earlier versions tended to produce a bewildering and jumbled array.

Had it been built this would surely have been the most impressive church facade of its time. Admittedly the project had escalated to such a degree that it is difficult to imagine Michelangelo managing to complete singlehanded both the architecture and the huge

BELOW: Ground plan of San Lorenzo, Florence.

Old Sacristy

New Sacristy

Library-vestibule

Library-reading room

**Cloister of the
Canons**

W

S — N

E

array of sculpture, but it was in part due to the interference of his patron that the project foundered. First of all the Pope insisted that marble should be obtained from Florentine territories rather than Carrara in the foothills of the Apennines, the more usual source, although Michelangelo, (according to Vasari):

declared it would involve more trouble and expense. . . . but the Pope would not listen and it was necessary to make a road of several miles through the mountain . . . in fulfilling the Pope's wish Michelangelo thus spent many years.

In fact the project occupied him from 1517-19 but in April 1519 the Pope's nephew Lorenzo, Duke of Urbino, died and Medici money appears to have been channeled into a new project, a mausoleum and memorial chapel known as the New Sacristy. The facade project was abandoned.

In Michelangelo's first important architectural commission it is arguable that architecture was being used in a secondary role; that his prime concern, as a sculptor, was the effective display of his work and that architecture was just the means to that end. Already, however, we can see many of the concerns and characteristics that were to distinguish his architecture and set him

apart from his contemporaries. These include a monumentality that was only just beginning to emerge in Rome, but more particularly an interest in the way architecture works; the stresses and tensions which keep (or appear to keep) a building standing are subtly underlined by the emphasis on the orders as (seemingly) load-bearing objects. For instance there is a kind of 'second skin' or shadow behind the pilasters of the upper order, giving them an extra robustness and moving them further away from the decorative conventions of the fifteenth century. In this context the decision to switch from a decorative 'skin' to a three-dimensional narthex was crucial. Moreover Michelangelo's willingness to abandon conventional design methods can already be seen. With his quick, sketchy designs (produced freehand with no ruler or compasses), and his use of malleable modelling materials, he allowed the building to evolve almost of its own volition, often controled only by the judgment of his eye. The result was a unified, integrated design, controled more by the architect's judgment and less by mathematical formulae. Already in this facade Michelangelo had started down the path that led to the increasingly individual buildings on which his fame rests.

The Medici Chapel

The death of Lorenzo, Duke of Urbino, in May 1519 aged 27 appears to have provided the impetus for a new Medici project: the building of the New Sacristy or Medici Chapel at San Lorenzo. Giuliano, Duke of Nemours (Lorenzo's uncle and brother of Leo X), had died three years earlier and neither man had produced a legitimate male heir. The sole surviving male representatives of this branch of the Medici family were Cardinal Giulio (shortly to become Clement VII) and Leo X, neither of whom was in a position to produce a legitimate heir. Since Giulio's first recorded conversations about the New Sacristy with his overseer Figiovanni occur a month later, in June, it is reasonable to conclude that Giulio, realizing that the dynastic hopes of Cosimo's branch of the Medici family were at an end, turned his thoughts to providing a lasting and suitable memorial to his family.

What Giulio envisaged was a family mausoleum or memorial chapel and he took as his model Brunelleschi's Old Sacristy, built 1419-28, where Cosimo's father Giovanni di Bicci and his wife were buried. The idea was to repeat Brunelleschi's building, which opened off the south transept of the church of

BELOW: Design for the bastion of the Porta al Prato, Florence. Michelangelo was appointed by the republican government to finish the fortifications started by the Medici before their expulsion.

San Lorenzo, with a similar building off the north transept. Initially the New Sacristy was to contain the tombs of the two Dukes already mentioned (often referred to as the 'Capitani') and those of Leo X's father Lorenzo the Magnificent and Lorenzo's brother Giuliano, a victim of the Pazzi conspiracy in 1478, known as the 'Magnifici'.

Work appears to have started on the chapel immediately; contracts were issued for the supply of marble in October 1519, implying that at least the main outline of the design had been decided by then, and in November the site was being cleared of the houses that had grown up round the transept. There is doubt about exactly when Michelangelo first became involved in the project and whether or not he was responsible for the exterior of the New Sacristy, which does not accord well with the interior. There is no doubt, however, that he was involved by late 1520 for in November he sent Cardinal Giulio a design for the chapel interior. Certainly by April 1521 work was well under way. While Michelangelo was in Carrara supervising the quarrying of blocks for the tomb figures, the lower order of the interior was being put in place and the cornice carved. This suggests that by April the design of the chapel must have been settled and that Michelangelo's original idea of a central tomb, still being discussed in December 1520, had been abandoned.

The death of Leo X in 1521 caused work to slow down due to shortage of funds, and according to Vasari Michelangelo returned to Rome to work on the Julius tomb. The project was revived

RIGHT: The interior of Brunelleschi's Old Sacristy at San Lorenzo, begun in 1421. Michelangelo's New Sacristy, the Medici Chapel, was planned as a companion, using the same architectural framework though with rather different functions and decoration.

OVERLEAF: The Medici Chapel was designed as a private family memorial chapel; the bench just visible behind the altar provided the only seating for members of the family.

when Cardinal Giulio became Pope Clement VII in 1523, however, and by 1524 it seems that the lantern was finished, the cupola was ready for decoration and the basic shell with its interior architectural detail was nearing completion. The tombs and their associated marble architecture progressed more slowly. Early in 1524 Michelangelo had promised to finish them within a year but, although Lorenzo's tomb was far enough advanced to make alteration to its overall form unlikely, it was not finished until 1526. The tombs of Giuliano and the Magnifici were not started until 1531 and 1533 respectively. The fault was not entirely Michelangelo's. The relationship between the overseer Figiovanni and Michelangelo was at best difficult and, even allowing for biased reporting and faults on both sides, it seems that Figiovanni did all he could to obstruct Michelangelo's ideas. Certainly he wrote to the Pope criticizing Michelangelo's work (he said, for instance, that the Laurentian Library would be better suited to a dovecote).

Another hindrance must have been the suggestion, first mentioned in 1524, to include the tombs of the two Medici Popes, Leo and Clement, and it was not until 1526 that an alternative site for these was decided upon. But above all historical events again played their part and the expulsion of the Medici from Florence in 1527 caused an abrupt halt. Michelangelo's political allegiance did not augur well for the finishing of the project. He was fiercely republican and put his talents to practical use during this period organizing the fortification of Florence against the Medici, as shown by surviving drawings. When the Medici returned in 1530 it was only through the intervention of Pope Clement that Michelangelo escaped assassination. Life in Florence could not have been pleasant; according to Condivi, 'Michelangelo lived in extreme

fear because he was deeply hated by Duke Alessandro (Medici), a fierce and vengeful man as everyone knows'. On the other hand life in Rome became increasingly attractive. In 1532 it appears that he was again working on the Julius tomb, which by then had been in hand for some 27 years; there was also his developing friendship with Tommaso Cavalieri (the first of his drawings for Cavalieri is dated late 1532) and from 1533 he was under pressure from Clement to accept the commission for the *Last Judgment*. In July 1533 Michelangelo wrote from Florence, 'I have aged twenty years and lost twenty pounds since I have been here' and in 1534 he wrote 'I shall not come back here again'. Nor did he, and he left behind him the Medici Chapel half finished, with statues in various degrees of completion lying strewn about the chapel floor.

The name New Sacristy is somewhat confusing, for although Giulio took the Old Sacristy as his model it is clear that he did not intend that the new chapel should be used in the same way. The Old Sacristy had a range of functions: it was, as the name suggests, a sacristy; it was also a burial place with the tomb placed unostentatiously (by Medici standards) under the table used for laying out the vestments. Finally it was a chapel designed for the officiating priest to stand in the traditional position, in front of the altar facing the altarpiece, and with the congregation behind him in the main body of the chapel. The function of the New Sacristy was less conventional; it was to be a private family mausoleum, and a Papal Bull of 1532 gave clear instructions as to its use. The clergy of San Lorenzo were paid to recite a certain number of masses for the dead, the entire psalter and various intercessionary prayers continuously day and night on a shift basis. The idea of continuous intercession was unique in Italy at the

time, but the practice was continued for nearly a century before the night shift was abandoned and continuous intercession during daylight hours only ceased with the fall of the Medici in the early nineteenth century.

This unique practice conditioned the layout of the chapel and accounted for many of the changes made to Brunelleschi's arrangement in the Old Sacristy, although the presence of an extra story in the New Sacristy was presumably practical, since light had to be provided from above the surrounding buildings. The altar, instead of being set back into the recess, protrudes forward into the body of the chapel, and the arrangement of the steps makes it clear that the priest was intended to stand behind the altar, rather than in front of it where no platform space is allowed. The arrangement of the New Sacristy is thus the opposite of that in the Old Sacristy. Since the chapel was entirely private there was no need to provide space for a congregation, and the body of the chapel became in a sense a three-dimensional altarpiece. A bench was provided in the traditional place behind the priest (in this case against the back wall of the recess) in case a member of the family should wish to attend the chapel for private prayer. Thus the clergy and members of the family would have in front of them a tableau whose theme reflected the purpose of the chapel.

Michelangelo's problem, once the number and disposition of the tombs was settled, was to reconcile the requirement to echo the interior of Brunelleschi's Old Sacristy with the very different function of the New Sacristy. His solution used the Brunelleschian architecture as a framework around which he constructed a decorative scheme which was originally intended to combine all three arts, producing an intense emotional experience very different from the quiet harmony of the

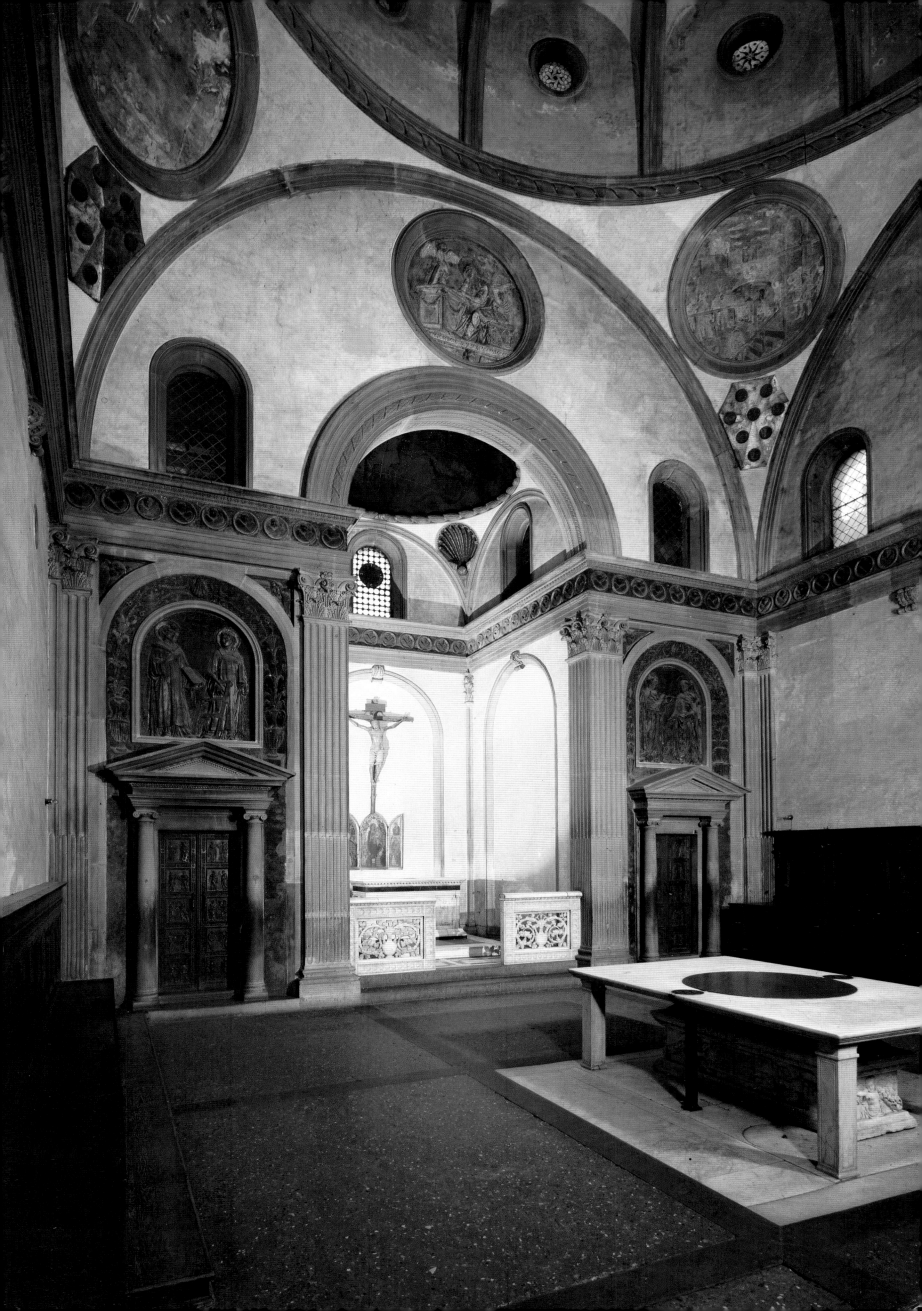

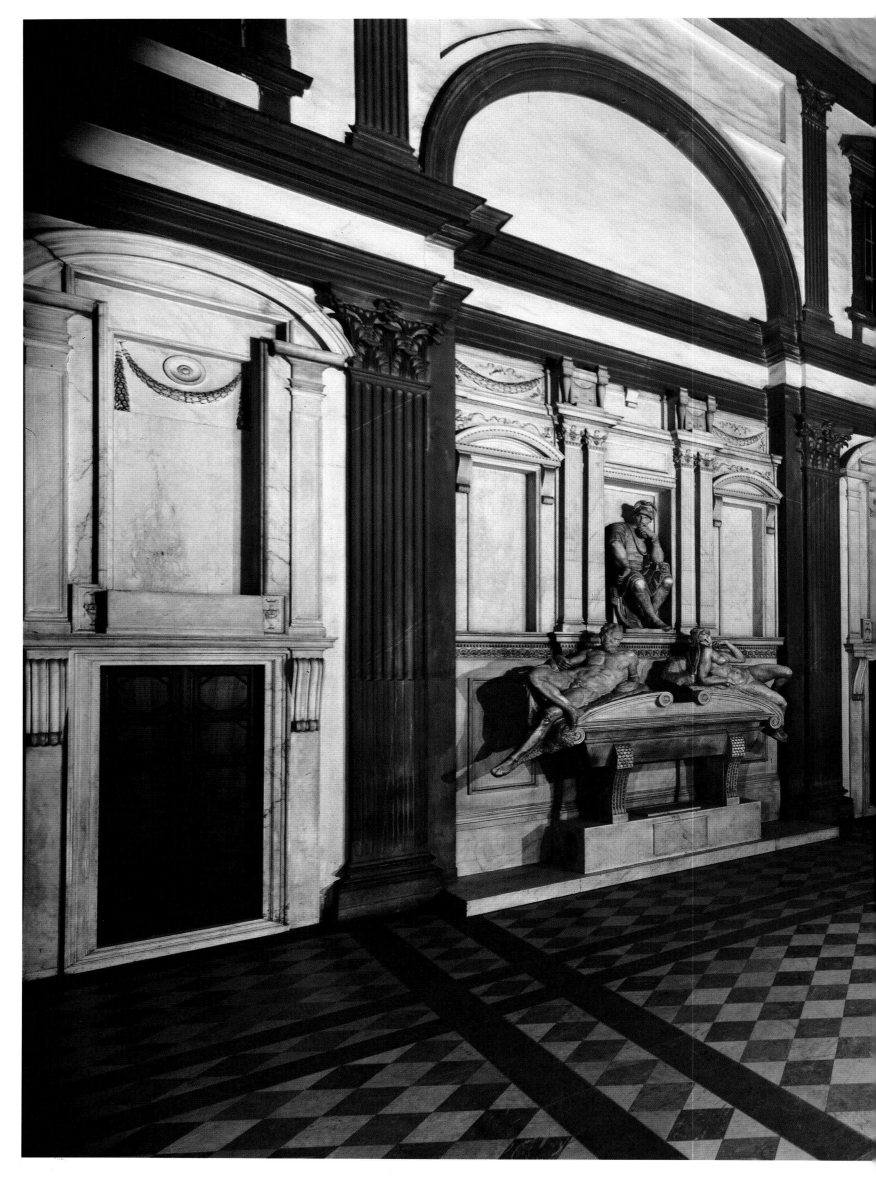

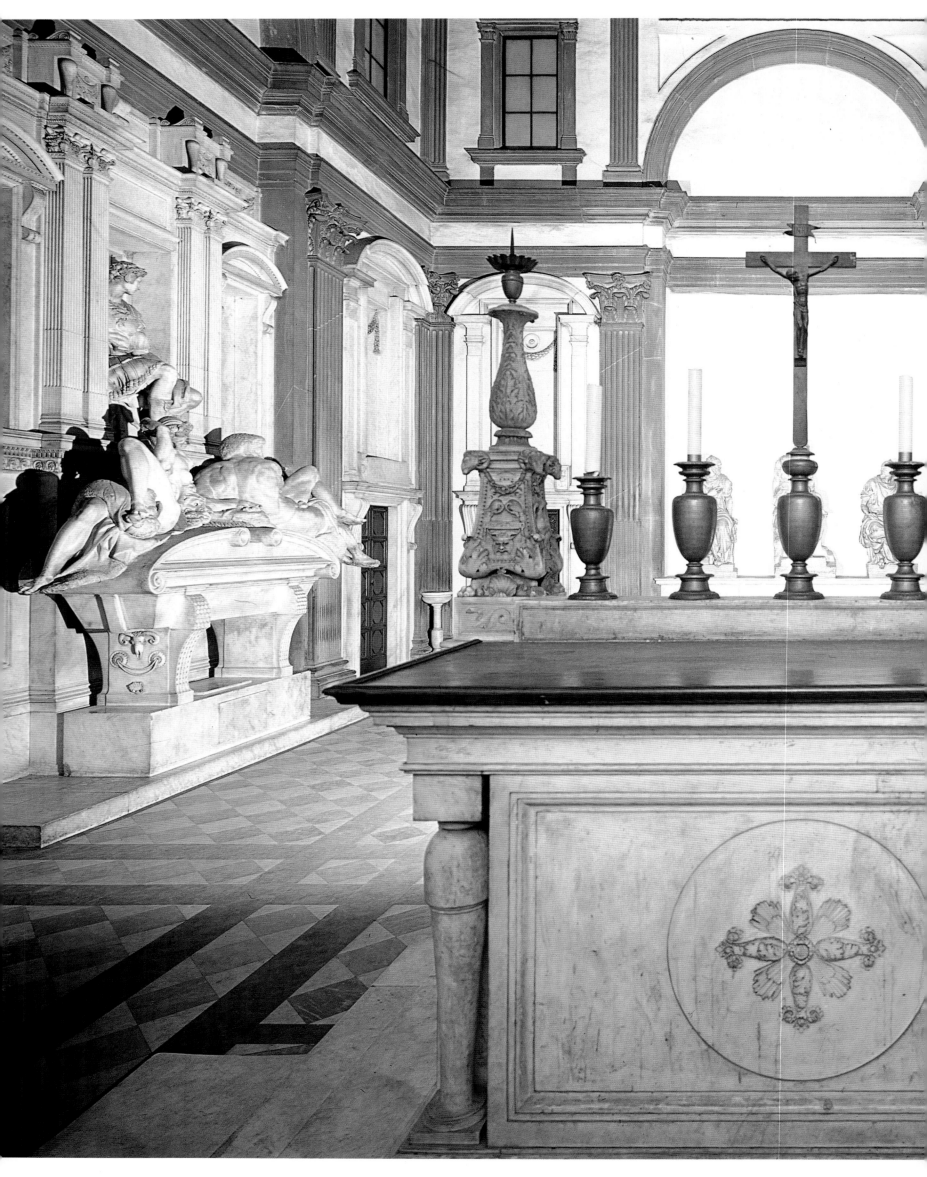

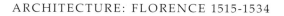

Brunelleschian interior. Vasari, commenting on Michelangelo's work, said: 'He proposed to imitate the old sacristy of Brunelleschi, but with other ornaments'. Michelangelo in fact employed two decorative systems side by side; the typical Florentine and Brunelleschian gray *pietra serena* articulation defined the basic space of the chapel, and within that the much more complex marble forms gave the chapel its unique quality.

Like Brunelleschi, Michelangelo used the fluted Corinthian order to support an entablature which runs without a break all round the chapel (although many designs show that he intended decorative cresting on the tombs which would have overlapped, and in places obscured, the entablature). The only real difference lies in the two architects' different handling of the wall. Brunelleschi's wall is flat with decorated surfaces, the overall effect being of a simple and harmonious pattern. Michelangelo in contrast emphasizes the structural stresses of the building, giving his walls an expressive force. The pilasters have a chunkier, more commanding presence than Brunelleschi's flatter, gentler counterparts. Behind them are a second layer of undecorated *pietra serena* piers, which serve the dual purpose of supporting the arches of the second story and giving added substance to the pilasters. This, together with the way in which the wall surface over the tombs is cut away, not only in the area of the arch but also in the spandrels, gives the *pietra serena* articulation a more forceful role than it has in the Old Sacristy.

Once Michelangelo had established the framework of his interior he was able to turn his attention to 'the other ornaments', that is the marble tombs and the surrounding decoration. His scheme appears to have had the aim of combining all three arts to produce a unified tableau and so, while the

183

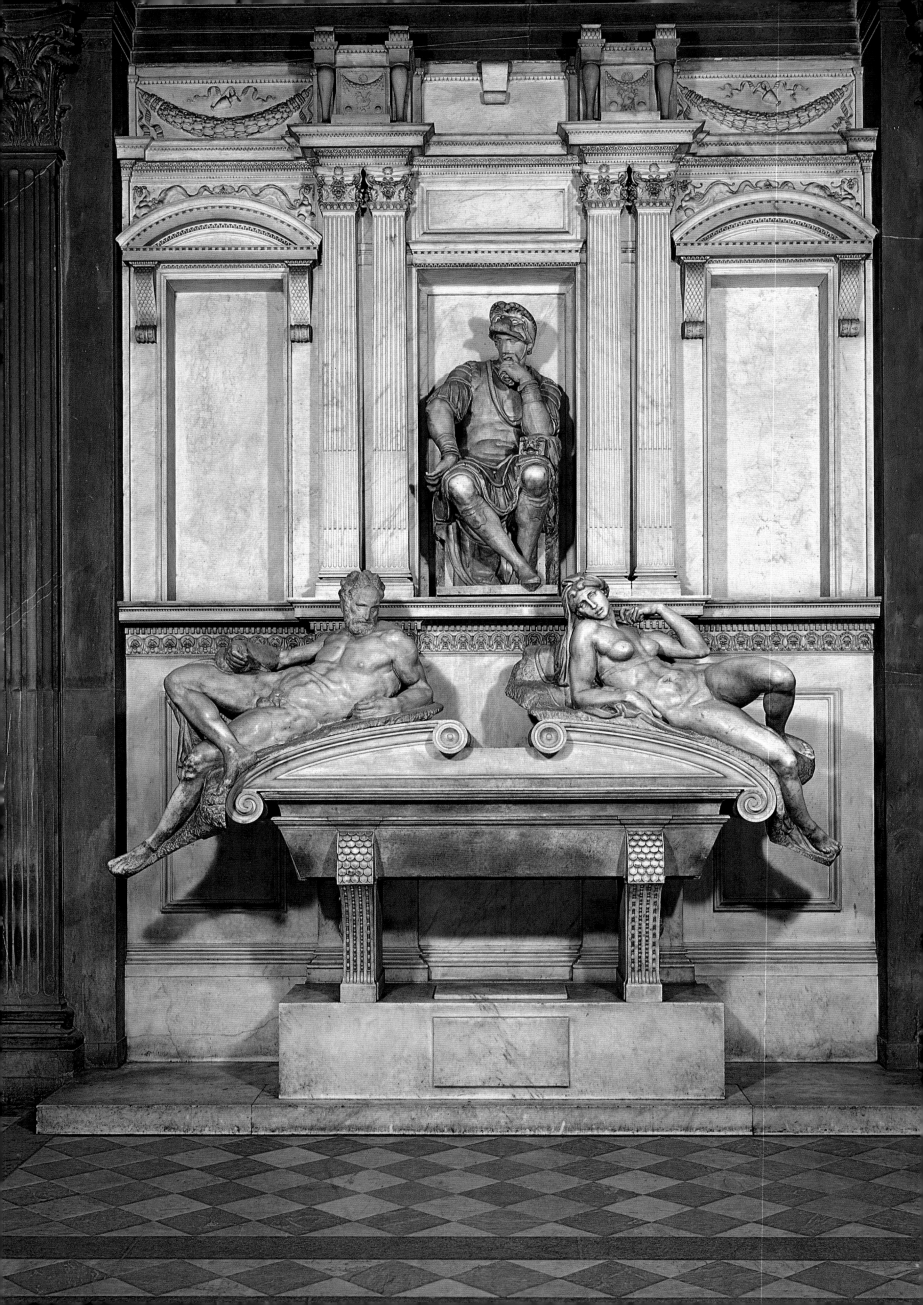

LEFT: The tomb of Lorenzo de' Medici in the New Sacristy. The central statue representing the Contemplative Life is flanked by statues of Dawn and Dusk.

RIGHT: A view of the upper parts of the chapel. It is possible that the lunettes and the rectangular shapes in the walls above were to be decorated with relief sculpture. Certainly the dome was originally painted, although it was whitewashed by Vasari a few years later.

sculptures are considered as individual works on pages 110-126, this section will discuss Michelangelo's handling of the chapel as a whole. The idea of inter-relating art, architecture and sculpture was in its infancy. The usual approach was to treat each wall in a chapel as a separate isolated surface, and until the early sixteenth century there was no attempt to make connections across the space of the chapel. The first person to do this was Raphael, whose Chigi Chapel in Sta Maria del Popolo was still under construction when Michelangelo began work on the New Sacristy. Michelangelo would certainly have known of the chapel; he claimed that marble intended for him was diverted to the Chigi project, and his friend Sebastiano del Piombo was commissioned to paint the altarpiece after the death of Raphael in 1520.

In the Medici Chapel Michelangelo's intention was to develop Raphael's approach so that the entire interior of the chapel would form an integrated monument to the Medici family. To this end he used as vehicles of expression not only the tombs and wall surfaces but also more mundane elements such as lighting and doors. Instead of identifying separate objects and decorative schemes in the chapel, it is essential to realize that everything was designed with the overall effect in mind. Had it been finished, the Medici Chapel would have represented a far more complex and subtle experience than the Chigi Chapel and would have stood comparison with a Baroque *teatrum sacrum* such as Bernini's Cornaro Chapel in Sta Maria della Vittoria, Rome (1647-52), where the use of light and color combine with sculpture and illusionist architecture to create a dramatic unity. It is impossible now to reconstruct fully Michelangelo's intentions, and as a result many different interpretations of the sculpture and the intended decorations have been put

forward. No definite answer emerges but in examining the possibilities a much clearer picture of the sophistication and intended interrelation of forms is revealed.

Entering the chapel from the transept, the tombs of the two Capitani would be on the side walls. The central figures, Giuliano and Lorenzo, are not intended as portraits (both men were bearded) but as idealized symbols of the two strands of Christianity; Giuliano (to the right) represents the Active Life, flanked by statues of Night and Day, while the Contemplative Life is portrayed by the more pensive figure of Lorenzo, with the attendant figures of Dawn and Evening. Two reclining statues of river gods (interpreted variously as the Rivers of Hades, of the World or of Paradise) were originally placed below each tomb, giving the en-

semble a wider base than it now has. It appears that originally Michelangelo manipulated the lighting in order to bring out the different qualities of the two groups. The chapel as a whole was lit by the lantern of the dome and the attic lunettes, but light also came in from an angled attic window opposite Giuliano, spotlighting the group representing the Active Life. Significantly a similar window on the other side was originally blocked up so that Lorenzo, instead of being thrown into sharp relief, would have seemed to retreat into comparative shadow. This manipulation of light in order to emphasize expressive qualities was rarely used in architecture at this time, and certainly not with this degree of subtlety. It was only in the Baroque Age in the seventeenth century that the full possibilities of this sort of approach were exploited.

RIGHT: A detail showing the delicacy of the marble decoration in the New Sacristy.

BELOW: Ground plan of the New Sacristy showing the arrangement of the sculpted figures.

FAR RIGHT: The marble tabernacles in the New Sacristy appear to overlap and squeeze the *pietra serena* pilasters.

As they are arranged at the moment (according to Vasari Michelangelo himself oversaw their positioning), both the Capitani look toward the wall that was to have contained the double tomb of the Magnifici. The design of this went through many stages and since work on it did not start until 1533, less than a year before Michelangelo left for Rome, it is difficult to be certain of its final form. A drawing in the Louvre, possibly by Michelangelo, gives some hint of the ideas with which he was playing. All that now survives is the statue of the Virgin Mary flanked by those of the patron saints of the Medici, Cosmas and Damian. None of the statues are realized in the form shown in the drawing; both the overall proportions and the poses have been changed, emphasizing that the Louvre drawing should be seen only as a guide to the general effect that Michelangelo intended. The statues now stand on a sarcophagus made from fragments of marble left in Michelangelo's studio and

both the Capitani look across the space of the chapel toward them. It has been suggested that together they form a three-dimensional *sacra conversazione*, with the Medici saints interceding on behalf of the Capitani with the Virgin Mary. If this is the case, it is more likely that the position of the Medici saints was reversed so that they look out toward the Medici.

The wall behind the altar is unlikely to have been left undecorated and it has been suggested that a sculptural crucifixion group was intended here. Again a drawing by Michelangelo exists, showing the blocking out of three pieces of marble of about the right size. Further decorations were obviously intended, since in 1531 Giovanni da Udine says in a letter to Michelangelo that the Pope had told him that there were to be scenes more than 6 foot in

RIGHT: A detail of the frieze decorating the tombs in the New Sacristy.

size in the chapel, but that he, Giovanni, could not do them since he was not a sculptor. From this it seems that the lunettes, which are about the right size, were intended to be filled with relief sculptures, and possibly the rectangular shapes in the wall above as well. The drawing of the Resurrection now at Windsor, roughly semicircular in shape, is thought to represent Michelangelo's design for one of the lunettes either above the statue of the Virgin or possibly behind the altar. Giovanni da Udine was to provide the decoration for the dome, described by Vasari as 'some beautiful foliage bosses and other ornaments of stucco and gold, diminishing gradually towards the center point'. He also decorated the ribs of the dome with 'foliage, birds, masks and figures'. Some idea of what was intended is given by a study for this decoration by Michelangelo but no trace remains, since Vasari ordered the dome to be whitewashed because the ornamentation was hardly visible.

Although we cannot reconstruct it with any great certainty from what survives, it seems that there was an overall decorative scheme, in all probability reflecting the chapel's dedication to the Resurrection. As well as the obvious decorative elements, functional objects such as doors were used in an unusually expressive way. In most buildings the door is an essential element, emphasized by the architecture in order that it should be easily accessible; in the Old Sacristy the doors feature prominently due to the strong projection of the moldings. The mausoleum, however, was intended as a private enclosed world; when the doors are shut the outside world ceases to have any importance. Doors are therefore a distraction and, rather than being easily recognizable, they are used as a motif, repeated eight times round the wall, which unifies the lower level. Only four are real doors, two leading to

the small rooms flanking the altar recess, one to the transept and one to the exterior of the church, and when all are shut there is a deliberate feeling of disorientation. In this context their idiosyncratic design becomes more logical than it first appears. They are not designed to look like conventional doors because their function is subordinated to the symbolism of the chapel as a whole, and so the moldings surrounding the doors continue across the floor, in a sense denying their function.

The role of the tabernacles should also be seen in this context; since no emphasis on the doors was intended the important eyecatching feature becomes not the door, as in Brunelleschi's Sacristy (page 178) but the tabernacle above. The strange features of these tabernacles provide a vivid example of the 'varied and more novel compositions' that Vasari mentions. Michelangelo does not depart entirely from classical rules but takes the simple form of a niche with a segmental pediment and rearranges it, so that the parts that logically should be separate now flow into one another in a way which confounds expectation. Equally puzzling is the way in which the niche, in spite of the solid block of marble which projects from the base, is not deep enough to be used in the conventional way as a background for sculpture and was obviously intended to be blank. The only decoration is the garland and the delicate urns on each side of the heavy block.

One other feature of the tabernacles which attracts attention is their relationship with the *pietra serena* articulation. Instead of allowing a margin of space round the tabernacles so that they appear as a separate entity, Michelangelo has deliberately crowded them up against the *pietra serena* capitals, jostling them in a way that is both unclassical and uncomfortable, especially at the angle of the chapel

where the capital is almost obscured. He is certainly rethinking architectural form and is moving away from correct classical architecture, but it is important to understand his motives; he is using the expressiveness created by changing the forms to create an interior which is deliberately suited to its function. Thus the unexpected forms of the tabernacles not only distract attention from the

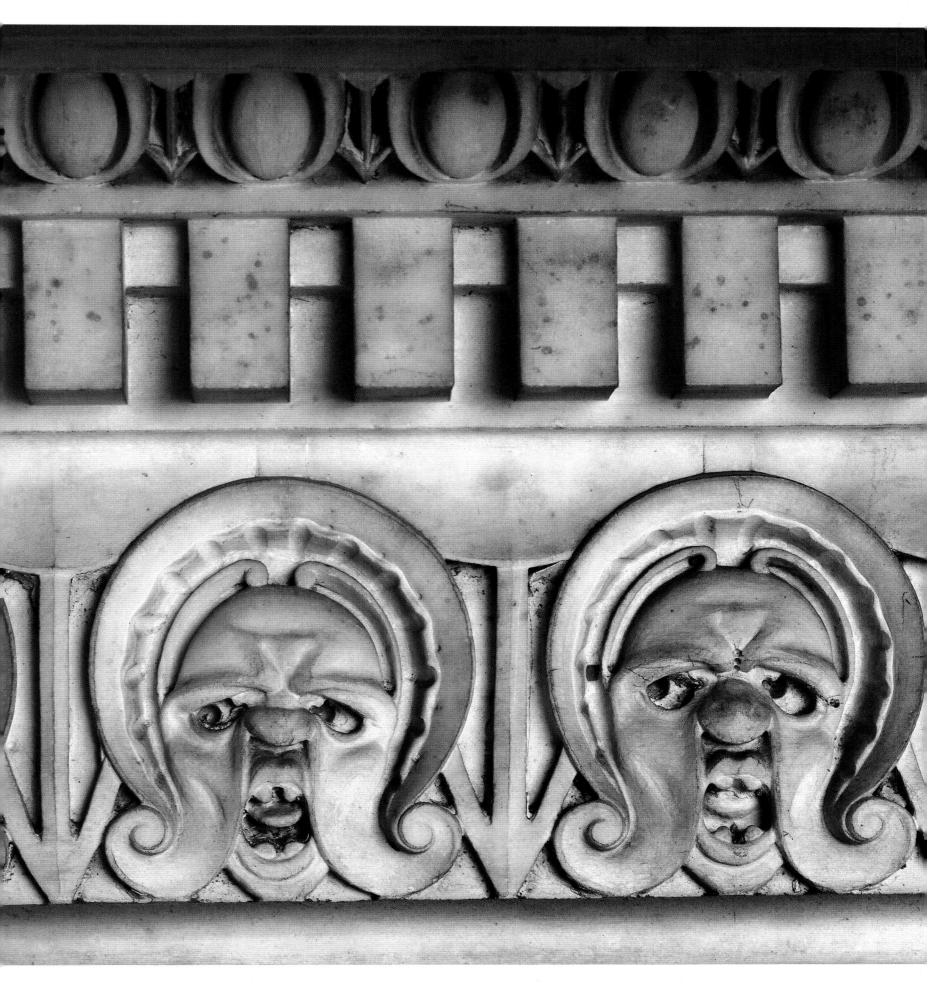

doors but also, by their unexpected blankness, convey clearly the funerary associations of the room. Equally Michelangelo makes sure that the marble surround of the tomb is no mere conventional architectural frame; details such as the frieze of masks immediately below the statues of the Capitani and the capitals of the fluted pilasters display his willingness to employ,

even in the smaller details, forms which are both expressive and inventive.

The Medici Chapel is a shadow of what was intended. Sadly Vasari's proposal in 1563 to finish the chapel according to Michelangelo's designs came to nothing. It remains a room of somewhat uncomfortable proportions in which one can admire individual elements but cannot judge it as a whole or

reconstruct with any certainty Michelangelo's intentions. Even in its half-realized state, however, it bears witness not only to Michelangelo's extraordinary inventiveness but also to the way in which that inventiveness was controled by the need of decorum, for suiting both the overall decorative scheme and the detailing to the building's function.

Laurentian Library

The magnificent collection of books and manuscripts that formed the Medici Library had been started by Cosimo in the fifteenth century. Already during Cosimo's lifetime it was recognized as one of the greatest collections in the world. Agents throughout Europe and the Middle East continued to acquire new volumes and some 45 scribes were employed to copy rare texts. Cosimo is reputed to have spent more on books and the library at San Marco than he did on the Medici Palace. After his death the policy of expansion continued and the library was moved from the farmhouse at Careggi to the Medici Palace. There it remained until it was confiscated in 1494 by the republicans who, at the suggestion of Savonarola, housed it in San Marco. Leo X bought back the collection after the Medici returned to Florence but had it sent to Rome, where it stayed until Clement VII advocated returning it to Florence and housing it in a building at San Lorenzo to be designed by Michelangelo. This commission is a good example of the enlightened and public-spirited patronage which was a hallmark of the Renaissance, although there is no doubt that it was also intended to contribute to the prestige of the Medici.

In the fifteenth century the rise of interest in scholarship and thus in manuscript and book collecting led to buildings being designed specifically for storing books and providing access to them. These were frequently attached to monasteries but were open to the public; indeed they were often seen as alternatives to the small and cramped university libraries. Generally, these libraries were functional rather than magnificent buildings. Considerations such as the avoidance of damp and fire and the provision of adequate light and reading facilities were considered more important than magnificent facades or

LEFT: Michelangelo's design for a small triangular study which was to have terminated the reading room of the Laurentian Library. It was never built.

RIGHT; Ground plan and elevation of the Laurentian library.

BELOW RIGHT: A design for the vestibule of the Laurentian Library before the decision was taken to raise the ceiling. Small subsidiary sketches show Michelangelo experimenting with the juxtaposition of pilasters and columns both along the walls and in the corners.

innovative interiors. One of the few surviving examples from the fifteenth century is the library in San Marco, commissioned by Cosimo to house the religious books he had given to the monastery.

The detailed correspondence regarding the building history of the Laurentian Library which survives between Michelangelo and the Pope's agent shows Michelangelo striving to provide suitable practical facilities while at the same time dealing with a number of other problems: the incorporation of existing buildings, sudden changes of plan imposed by the Pope, and of course the same historical events that brought work at the Medici Chapel to a halt. Because of the extent of surviving documentation, the building history of the Laurentian Library provides one of the most vivid examples of the trials and tribulations that faced an architect during this period.

Although Figiovanni, the agent, makes it clear that the library was first proposed in 1519, at the same time as the Medici Chapel, there is no record of any work being carried out before Pope Clement's formal commission to Michelangelo in December 1523, presumably because Clement had to wait until he was in a position to control the destination of the books. The choice of site appears to have been left vague to start with since Michelangelo wrote (slightly grumpily, it seems) to Clement's agent:

I learn . . . that His Holiness . . . wishes the design for the Library to be by my hand. I have no information about it, nor do I know where he wants to build it. . . . I will do what I can.

By March 1524 a site for the library had been chosen. It was to be on the west side of the cloister at San Lorenzo, with the reading room, which was situated directly above the monks' quarters, approached via a vestibule giving access from the cloister. Among possibilities rejected was the idea of having a freestanding building in the piazza, despite the fact that this would have posed fewer technical problems than adding a story on to an existing older building and would have had a considerably more conspicuous presence. Possibly this was because there was still hope that the facade of San Lorenzo, which it would have partially obscured, might be finished. The chosen site did indeed present tremendous practical problems for Michelangelo. Without causing disruption to the monks living below, he had to ensure that the existing walls could take the weight of another story; and at the same time the Pope specified that he should replace the wooden cloister ceilings with a stone vault in order to protect the library against fire.

It was not possible, therefore, for Michelangelo simply to thicken the existing walls. His solution was to design the walls of the library to be so thin and light that the old walls below would be able to carry them, with the help of some buttressing at key intervals. The exterior of the buildings shows that he achieved this by creating a skeleton (identifiable by the thicker strips) which was the load-bearing part of the wall and above which the roof

joists were positioned. The rest of the wall was much thinner and made out of the lightest possible rubble.

The interior of the reading room continues this system, with the load-bearing part of the wall defined by gray *pietra serena*, while white stucco hides the thin layer of light infill which keeps weight to a minimum. The decoration, too, is subordinated to the need for lightness; instead of the heavy eye-catching shapes often associated with Michelangelo, delicate forms are used, such as the elegant balusters which flank the upper windows. The ceiling design also becomes an essential part of this decorative language, since the joists had to lie directly over the pilasters (the only part of the wall strong enough to support them). It was in fact the Pope who wanted the ceiling to be 'unusual' and 'with small figures' and the delicate design put forward by Michelangelo not only complements the feeling of lightness that permeates (very logically) all the decoration of the reading room, but also represents a change from the normal coffered ceilings typical of the time. The reading desks are also integrated into the overall scheme. Instead of being freestanding, as at San Marco, they are pushed up against the walls, thus providing visual support for the pilasters.

If anything the vestibule of the library posed even more difficulties for Michelangelo, and again a detailed picture can be built up of the advantages and disadvantages of having an informed and involved patron. The basic plan was to form an entrance to the library out of the last three bays of the structure, dropping the floor level in order to provide an entrance directly from the cloister. The problem from the start was to provide sufficient light. Michelangelo's original plan was for the roofline of the vestibule to be contiguous with the reading room, and since two of the

walls abutted other buildings he planned to light the room by means of round skylights in the roof. This caused the Pope some concern. On November 29 1525 he wrote (via his agent) that the skylights:

Seemed very fine and novel; there is nothing to prevent you doing it, but . . . you would have to pay two Geusati friars who would do nothing but clean up the dust.

A nice glimpse of the Pope's practical turn of mind. Michelangelo, it seems (although the letter has been lost) put up a spirited defense of the skylights, pointing out that the only alternative was to raise the walls above the surrounding buildings in order to obtain light. In December the Pope wrote back commenting on the two possibilities, and wondering:

Whether the dust that will fall on them (i.e. the skylights) will not be stronger than the light they will be able to transmit?

By February Michelangelo had capitulated; the Pope had missed the chance to build the first recorded skylights and Michelangelo was left with a room of extremely awkward proportions (very high in relation to length and width) and with the all too familiar problem of heightening walls that were already under construction. Moreover, he would also have to adapt the design for the interior. The date was now January 1527 and the building was well under way – to the extent that joists for the roof (at the old level) were already in place. Michelangelo was forced to improvise.

RIGHT: The interior of the Laurentian library
reading room showing the 'unusual' ceiling
and floor decoration requested by the pope.

The drawing illustrated (page 192)
shows a design in Michelangelo's usual
freehand style (notice the way for in-
stance that the bays vary in width) that
almost certainly dates from before the
decision to raise the walls. For all its
sketchiness it contains a great deal of
information both about the way
Michelangelo worked and about the
specific ideas with which he was work-
ing. For this reason it is interesting to
compare it with the finished elevation.
Much of the final design is already pre-
sent including the most memorable ele-
ment, the huge monolithic columns re-
cessed into the wall. Other small
sketches on this sheet show Michel-
angelo experimenting with the
columns' relationship to the pilasters
on either side of them and their posi-
tion in the corners. But with the change
in plan he needed to increase the height
of the columns by about one third,
while the tabernacles remained the
same size. This change reverberated
through the design since if the columns
were to be higher they had, according
to classical rules, also to be thicker (the
diameter of a column is proportionally
related to its height). In order to gain
the wall space needed for the columns
Michelangelo dispensed with the flank-
ing pilasters, by turning them at right
angles to line the alcoves in which the
columns stand. This had the effect of
making the columns even more domi-
nant, since they are no longer compet-
ing with the pilasters but are instead
contrasted with the white flatness
which appears to be the surface of the
wall. All the subsequent changes and
additions to this elevation seemed to
emphasize the strength and magnitude
of these great columns.

However this was not the only
change of plan. Originally Michel-
angelo envisaged a conventional two-
flight staircase running along the east
and west walls and meeting in a land-
ing in front of the door to the reading

room. The diagonal in the sketch obviously represents this arrangement. But although the Pope was reported in 1524 as 'much liking the idea of a double staircase', a year later he had changed his mind and asked for a single staircase that would fill the vestibule. Thus the fantastic staircase that exists today was primarily a result of the Pope's intervention, and it is easy to follow his reasoning. The vestibule had become a room of awkward proportions and something was needed to distract attention from the extreme height. Staircases clinging to the wall would not counteract the impression of a tall empty space, but a large central staircase filling the void would. Again more alterations were made to the walls while the building was under construction, since the removal of the staircases would leave blank spaces on the east and west walls. It was at this stage that the much discussed scrolls were introduced. Their 'birth' can be seen in a beautiful drawing which is usually dated toward the end of 1525 (page 199). It is a glorious example of Michelangelo's ability to create depth by the casual use of hatching and a minimum of other detail. The drawing also shows

that Michelangelo toyed with the idea of decorating the wall panels between the scrolls. In the event he decided to leave them blank, thereby emphasizing the massiveness of the columns. A later alteration caused the scrolls to be moved up the wall so that they were positioned immediately below the columns, giving the disconcerting impression that they are providing sup-

port. Closer investigation reveals that they project much farther forward than the columns and have no structural role at all; as of course they could not, since they were an afterthought.

These examples show in some detail the ways in which Michelangelo had to revise his original ideas in response to intervention by the Pope, and provide a well documented example of Michel-

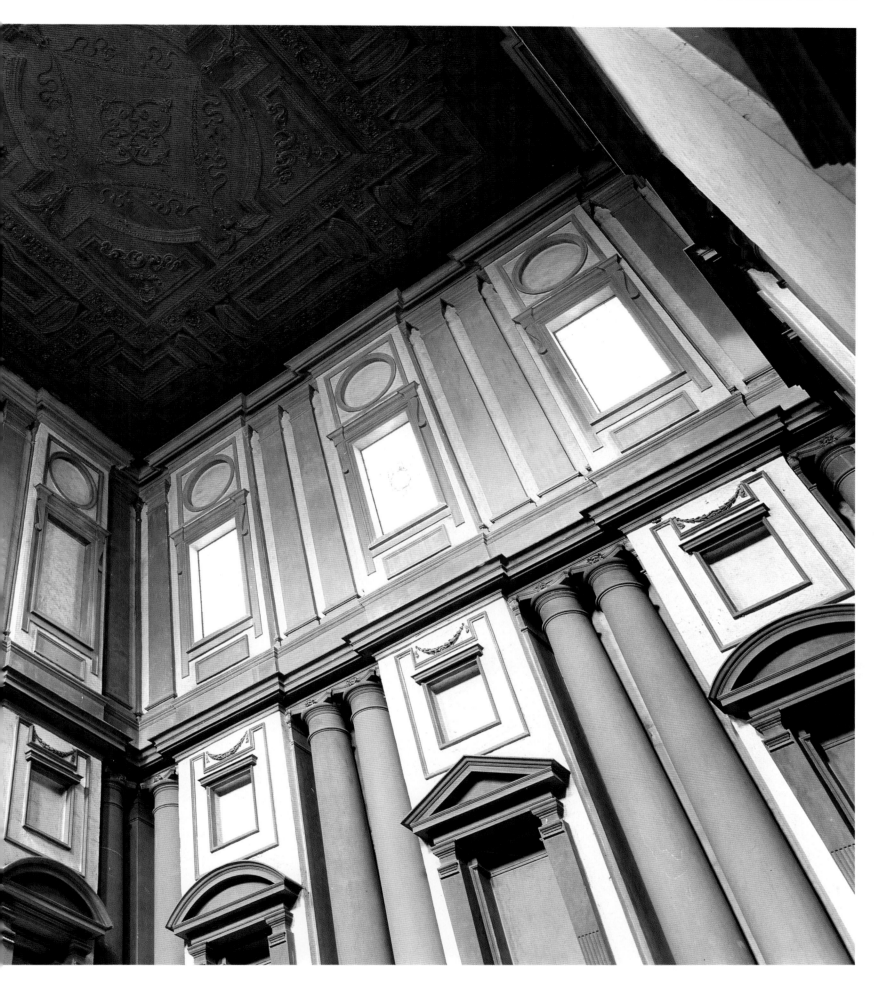

angelo's ability to adapt designs as they were being built. This was an important aspect of his approach, for the willingness to adapt ideas to physical reality as the building went up became an essential part of his working method, allowing him to exercise his judgment rather than being tied to a fixed design.

An example of Michelangelo's designs for the new stairs can be seen in the drawing on page 199, in which his original conception is converted into a freestanding version. Only in the sketch at the bottom, where he is clearly experimenting with convex and concave forms, is there any hint of the later extravagant and eccentric form that was agreed in late 1526, much the same time as the money ran out and work came to a halt. It was not resumed until 1533 when Medici fortunes prospered again, by which time Michelangelo was planning to leave for Rome. He did however undertake to see that the stairs were completed and a number of stonemasons were employed to make the stair according to 'the method, size and shape not so much of the drawings kept in the cloister but according to the small terracotta model

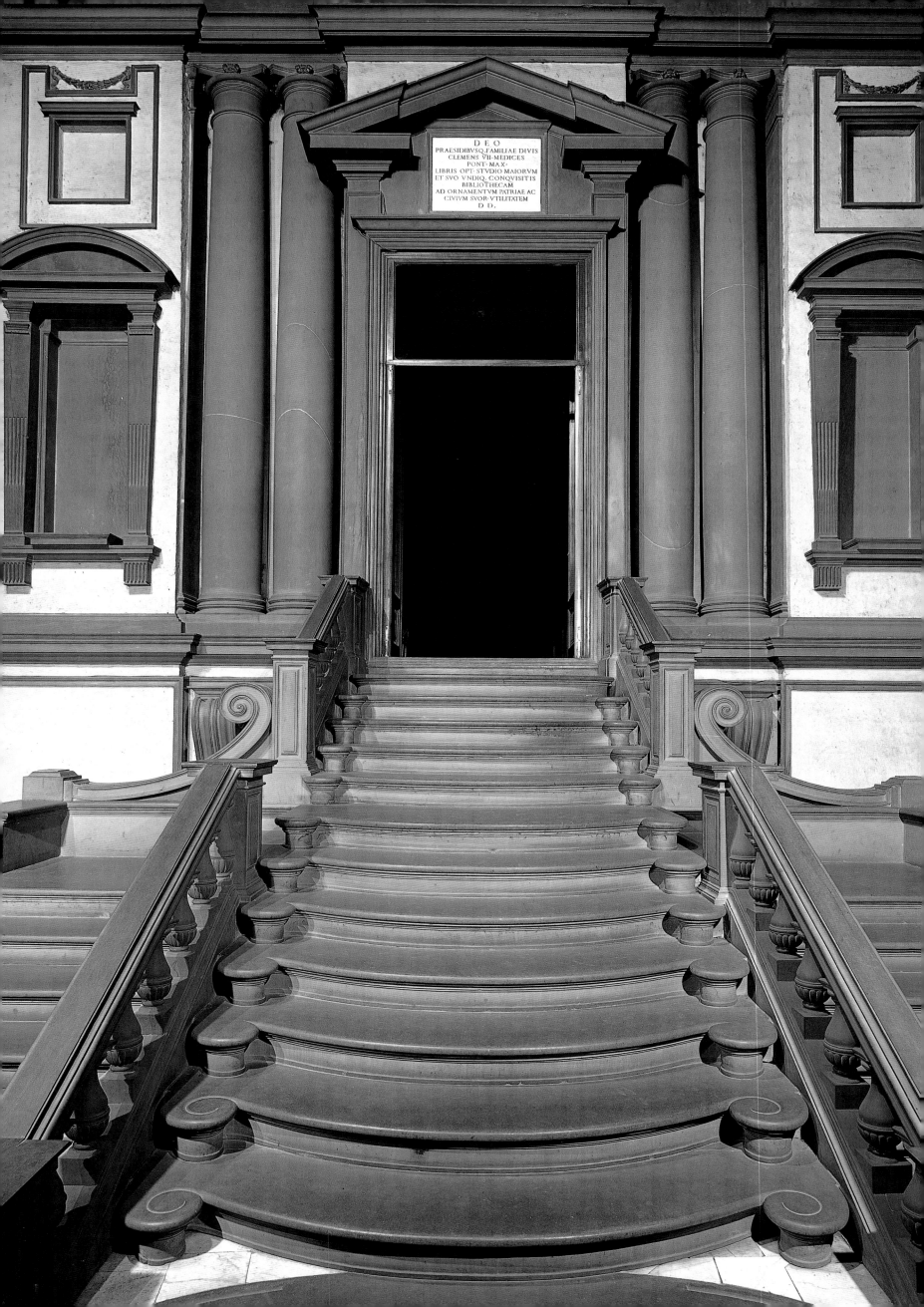

DEO
PRAESIDIBVSQ.FAMILIAE DIVIS
CLEMENS VII·MEDICES
PONT·MAX·
LIBRIS OPT·STVDIO MAIORVM
ET SVO VNDIQ. CONQVISITIS
BIBLIOTHECAM
AD ORNAMENTVM PATRIAE AC
CIVIVM SVOR·VTILITATEM
D·D·

LEFT: The stairs leading to the reading room in the Laurentian Library. Their curved shape and the way they spread outward give the impression that they have frozen as they poured out of the reading room door.

RIGHT: These studies by Michelangelo for the vestibule stairs show how he moved away from the original idea of steps flanking the side walls and began experimenting with centralized curvilinear forms.

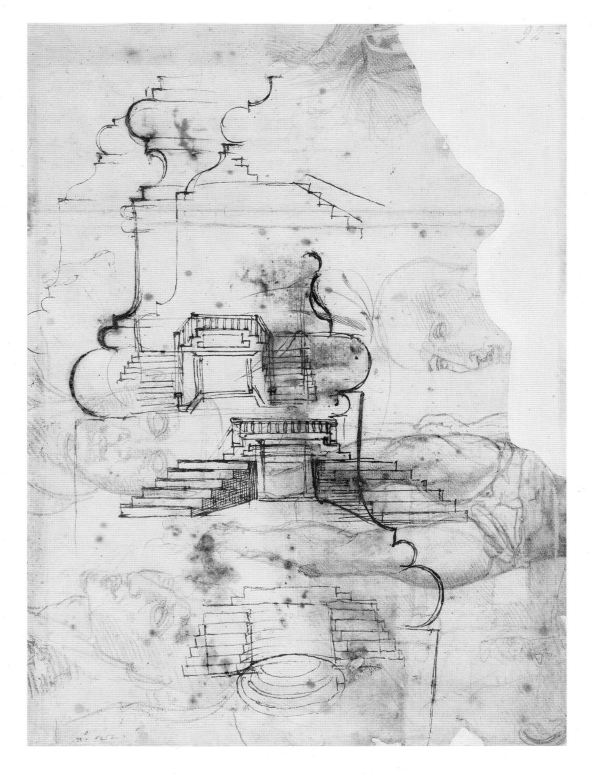

made by Michelangelo'. As a means of communicating his ideas to others the model does not appear to have been a success, for the stairs were left unfinished with a number of ready-cut steps left lying on the vestibule floor.

As we have seen, Michelangelo's departure from Florence was final. Sometime in the late 1540s, however, the Medici Duke Cosimo I revived the library project and had the reading room ceiling (with the design carefully altered to display his emblems) put in place. Then in 1549/50 a sculptor, Niccolo Tribolo, was asked to complete the stairs. Exactly what happened is unclear but it seems that Tribolo, having positioned four of the steps, was unable to work out how to continue. He was sent by the Duke to Rome to consult Michelangelo, and if possible to get him to come to Florence to help. Michelangelo refused to discuss the subject, saying 'I no longer remember the measurements or anything else'. This was clearly less than the truth, since (as we shall see) some years later he was remembering his plans for the stairs in considerable detail. What is more likely was that the luckless Tribolo had assembled the stairs wrong and Michelangelo, infuriated at his stupidity, refused to cooperate. Five years later Cosimo I sent Vasari to ask Michelangelo about the stairs, and the detailed instructions that he received proved beyond doubt that not only had Tribolo assembled the stairs wrongly but also that Michelangelo's memory of them remained extremely detailed. Finally in late 1558 the Tuscan architect Bartolomeo Ammannati was put in charge of the stairs and in January 1559 Michelangelo sent him some instructions and another small terracotta model; by 1559 the stairs were finished. Although the overall design is undoubtedly Michelangelo's, parts, most notably the balusters, newel posts and the large scrolls linking the heads of the subsidiary flights to the main staircase, are attributable to Ammannati.

Michelangelo's instructions were mainly to do with detail but one or two remarks throw light on the way he envisaged the stairs being used. In his letter to Vasari he refers to the straight side flights being for the servants, with the middle flight being reserved for the master, and in his instructions to Ammannati he says that, while the middle flight should have banisters, the outer flights are to have a place to sit down on every other step. It would be interesting to know if, when the library finally opened in 1571, the staircase was used in this way.

So far we have concentrated on how Michelangelo overcame the practical problems associated with the Laurentian Library; we must also ask how successful it is aesthetically. Vasari was in no doubt, talking of the 'handsome disposition of the windows and ceiling' (in the reading room) and 'the marvelous vestibule . . . nothing so graceful and vigorous in every part was ever seen, comprising the bases, tabernacles, corners, convenient staircase with its curious divisions, so different from the common treatment as to excite common wonder'. This makes it clear that even to contemporary eyes the vestibule was seen as unique. As a result it has been regarded as a key example of the Mannerist style, but Michelangelo's aim was not to initiate a new style or to employ forms entirely for their own sake. Rather, his aim was to push classical architecture to the limits of its expressive ability, while always keeping in mind the function of the building. Thus in the vestibule, a room which functioned purely as stairwell, Michelangelo emphasized the architectural elements, underlining the tensions of

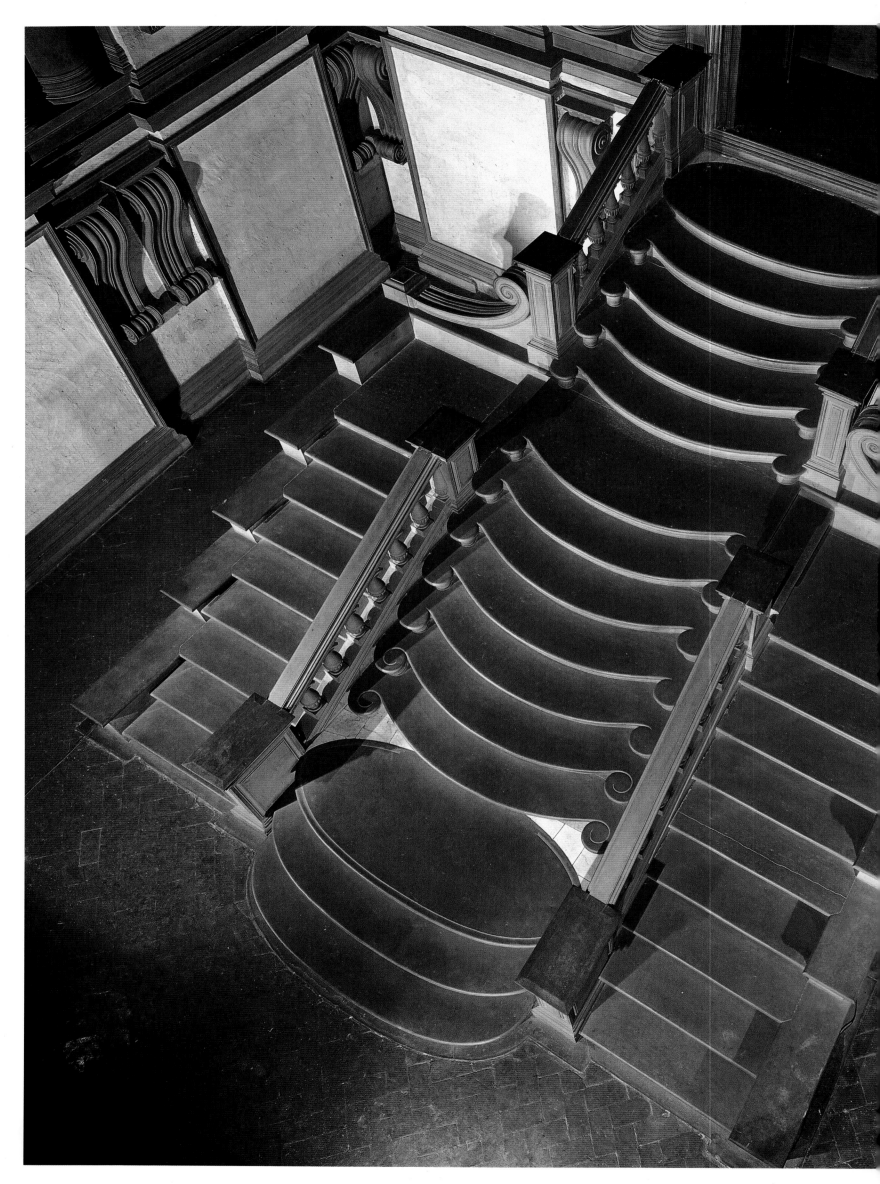

LEFT: An aerial view of the library stairs. Michelangelo explained that while the central steps were reserved 'for the master' the outer steps were for the servants.

BELOW RIGHT: A design for the reading room door; here Michelangelo uses wash rather than charcoal or ink to indicate the modelling of the door.

structure. There is a logic to their arrangement. The giant columns are functional for they support the joists and, being monoliths, are far stronger than the walls which are merely infill of varied thickness. The scrolls, often pointed out as one of the most 'Mannerist' features of the vestibule, can also be interpreted as a logical response to the specific problem of how to decorate the area below the columns after the decision was made to move the stairs away from the walls.

Michelangelo succeeds in distracting attention from the awkward proportions of the vestibule by his free use of variations on classical themes (such as the tabernacles), his innovative wall articulation (which is far removed from the simple fifteenth century approach of applied decoration to flat wall surfaces) and of course by the spectacle of a staircase which seems to flow out across the floor of the vestibule. Here the paired monolithic columns which flank the entrance to the reading room appear to be impeding the flow of the staircase, constricting it to a single channel until, free of constraint, it then spreads out to fill the room. Confronted by all these tensions, and the novel experience of moving up a staircase which has a very strong downward pull, few visitors actually notice the awkward proportions, or indeed the fact that the upper areas of wall have not been finished.

In emphasizing and expanding the huge expressive possibilities inherent in classical architecture, Michelangelo has moved away from the earlier somewhat rigid approach to classical rules. But he does not employ the new freedom in a wilful or arbitrary way. The vestibule was always meant to be seen in conjunction with the reading room and again Michelangelo's ability to take into account the function of a room is demonstrated. Critics often cite the reading room's length and monoto-

nous decoration. But the room is for reading; it does not aim to be dramatic or exciting, but soothing, understated and practical. The triumph of the reading room is the way in which Michelangelo, despite huge practical difficulties, created a space where form follows function, a room where design reflects and underlines purpose. This is the concept of decorum, the idea that a building or room should be first and foremost suitable for its purpose. One of the reasons why the over-worked epithet 'great' is applicable to Michelangelo is that he has the ability to use completely different types of architectural language chosen with the function of the particular space in mind. Indeed this is so much a characteristic of his work that it becomes impossible to trace a chronological development. Each building is unique in that it is a carefully judged answer to specific needs rather than a means through which to further develop ideas or approaches which interest the architect.

Architecture: Rome 1534-1564

MICHELANGELO arrived in Rome in 1534 with some fifteen years of experience as an architect. He might have expected to be overwhelmed with commissions but the fact was that with one exception, the reorganization of the Capitol, he had to wait another ten years before he achieved recognition as an architect. By the time he gained control of St Peter's, the most prestigious architectural commission in Rome, he was in his sixties. The reason for this slow start to his Roman architectural career may be partly due to his involvement in other commissions (the *Last Judgment* was started in 1534, the frescoes of the Pauline chapel were first proposed in the 1530s, and of course the long running saga of the Julius tomb was still continuing) but the major factor appears to have been that neither the man nor his architecture fitted in easily with the views and practices of the architectural establishment.

RIGHT: San Pietro in Montorio, Rome, usually known as the Tempietto, which was begun by Bramante early in the sixteenth century. It epitomizes the purely classicizing style favored by contemporary Rome.

BELOW: The Roman forum was still known in the eighteenth century by its medieval name 'the Field of Cows'. This etching by Piranesi gives an idea of the quantity and monumentality of the Roman remains.

202

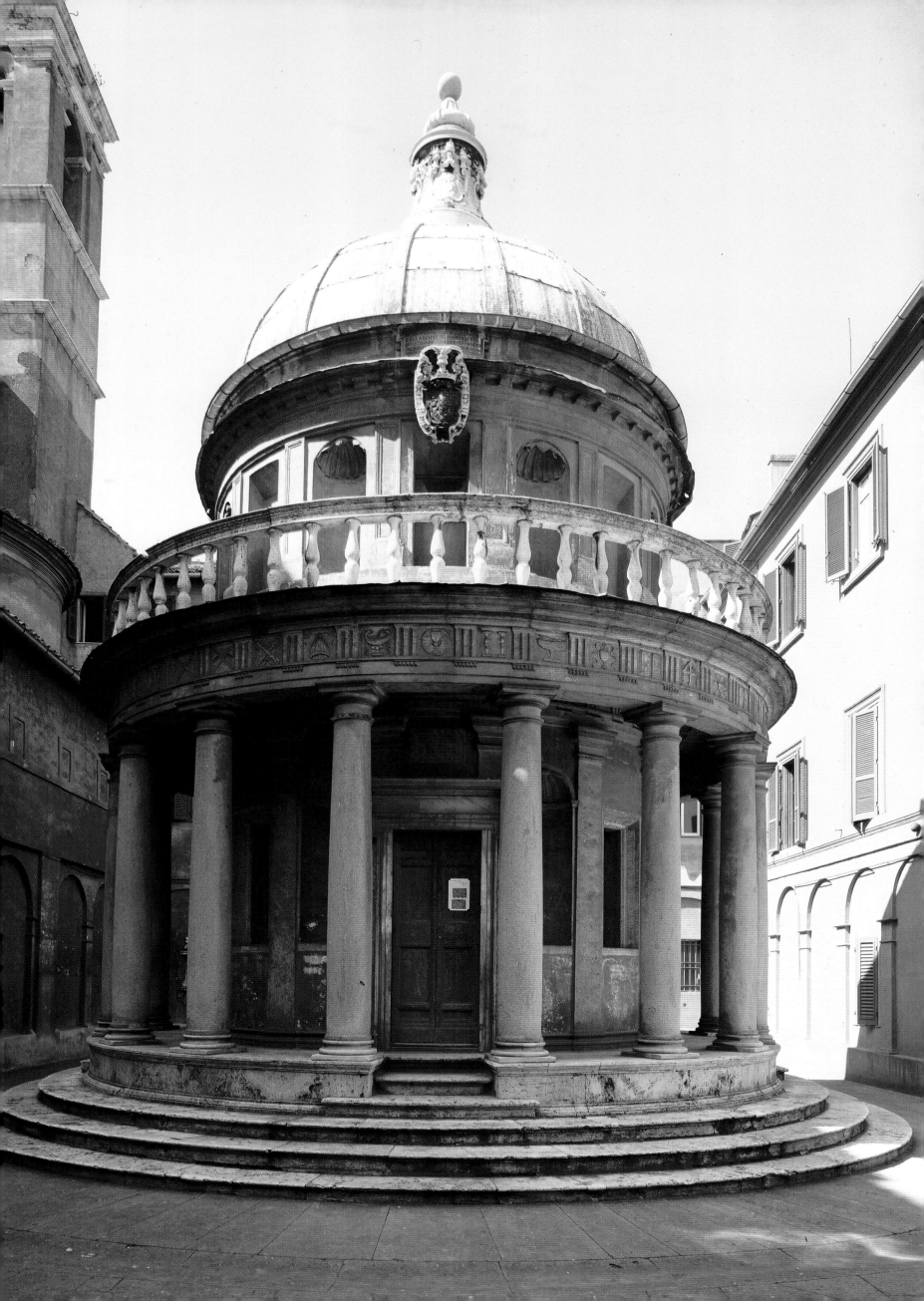

BELOW: Bramante's Palazzo Caprini or House of Raphael, built c. 1512 but since destroyed, is firmly based on classical prototypes and was immensely influential in its simplicity and strict symmetry.

The fact that Michelangelo was a Florentine was not in itself significant. Few, if any, architects who worked in Rome were Roman by birth; most came from farther north, attracted by the prestigious commissions available. For example, the Sangallo family came from Florence, while Bramante and Raphael came from Urbino (via Milan in Bramante's case) and they had all prospered. Michelangelo was different.

The most important commissions in Rome at this time were in the gift of the Pope. They tended to be largescale, with a great number of people working on them in various capacities at any one time. Although there was always a chief architect, he was to some extent head of a consortium rather than a free agent working as an individual. This in turn encouraged the establishment of an influential architectural elite who could exercise considerable control over the architectural scene. Michelangelo did not fit easily into this somewhat hierarchical scenario; we have

already seen evidence of his inability to share or delegate work, even on small-scale Florentine commissions. His ability to work as part of a team, something that was essential on largescale projects, must have seemed at the very best unproven.

Two other things would also have counted against him. One factor was his innovative and unorthodox style. Roman taste, far more than that of the Florentines, was committed to the straightforward Vitruvian view of classical architecture epitomized by Bramante's Tempietto (illustrated on page 203). It is very noticeable that in the years after Bramante's death in 1514 the great majority of important architectural commissions went to architects who supported this approach to architecture. Those who wished to experiment with more daring forms either left Rome, like Giulio Romano who designed the Palazzo del Tè in Mantua (illustrated on page 169), or limited their experimentation to private commissions. Raphael's design for St

Peter's was extremely conventional, and it was only in a private commission such as the Palazzo Branconio dell'Aquila (see page 169) that his more unorthodox qualities were revealed.

A second factor that Michelangelo had to contend with was the establishment of an architectural clique in Rome. After Raphael's death in 1520 commissions tended to go to the unimaginative, but competently correct, classicist Antonio da Sangallo the Younger who, with the help of what Vasari scathingly described as the Sangallo clique (composed mainly of relations and secondrate architects), imposed a kind of stylistic stranglehold on Rome. It is no accident that, with the exception of the redesigning of the Capitoline Hill, Michelangelo had to wait until Sangallo's death in 1546 before he gained any architectural commissions in Rome. Even then life cannot have been easy for him. Vasari comments that Pope Paul III was guided by God when he appointed Michelangelo to work on St Peter's in 1546, implying that it was certainly not the architectural establishment that influenced him. Five years later the Sangallo faction was still attempting to hinder Michelangelo. Not only did they campaign for his removal from St Peter's on the accession of the new Pope, Julius III, in 1550 but according to Vasari they also 'induced the Pope to summon all builders in San Pietro to show him by false calumnies that Michelangelo had spoiled the structure'. Michelangelo was able to defend himself but the incident gives a glimpse of the enduring tensions and factional strife within the architectural fraternity in Rome. It is quite likely that these tensions originated in an earlier feud between Bramante and Michelangelo. Vasari recounts all sorts of tricks employed by Bramante and his followers to discredit Michelangelo, suggesting that they deliberately encouraged the Pope to commission Michelangelo

RIGHT: A view of the Capitoline Hill as it was in 1535-36, by Maerten van Heemskerck.

to paint the Sistine ceiling because they felt that, as a sculptor, there was a good chance that he would not be able to do it successfully.

Michelangelo clearly won the confidence of Pope Paul III, however, and many of his commissions came from him and from his successors. In them and in the few private commissions that he undertook Michelangelo had to face the double challenge of designing in new surroundings with different traditions and materials, under the eyes of a hostile architectural establishment.

Town Planning: The Campidoglio

In the late 1530s Pope Paul III initiated a program to renovate and redevelop the area of Rome known as the Capitol (or the Campidoglio as it is now called). For over two thousand years this site had been a symbol for the aspirations and beliefs of the people of Rome. It was never an ordinary dwelling place; from the time that the marshy land was first drained in the first century BC and work started on the Forum, the rocky outcrop that formed the hill above it was regarded as a sacred spot. As the Roman territories expanded its importance increased, until it became the religious center of the pagan empire, and it is significant that early Christian buildings such as the Lateran and St Peter's were sited well away from this potent reminder of the past. By the Middle Ages, however, the fortunes of the area had changed for the worse while perceptions of it were becoming the stuff of legends. The writer of a twelfth-century guide to Rome, the *Mirabili Romae*, saw it not only as the religious center but also as the *caput mundi*, the head of the world:

Where consuls and senators abode to govern the earth. The face thereof was covered with high walls and strong, rising above

the top of the hill, and covered all over with glass and marvelous carved work'.

A nice example of time augmenting the legend, for the Capitol had never been the seat of government in ancient times. In reality its state was very different. The humanist Flavio Biondo wrote in the mid-fifteenth century:

I am ashamed . . . to show such a beautiful place in such a formless and forlorn condition. Several times Marcus Tullius has called this the hill of the gods, and Virgil called it golden; . . . but now there is a concrete house, built by Boniface IX [in the late fourteenth century] on the classical ruins for the use of senators and judges, such as even a private citizen would have spurned to inhabit.

It was the proposed visit of Charles V, fresh from his triumphs over the infidels of North Africa, which provided the impetus to renovate the area. The intention, it seems, was to accord the Emperor (who had forced Pope Clement VII to crown him in Bologna in 1529) a triumphal procession similar to those granted to ancient victors returning to Rome. Although the procession never took place, the proposal underlined the fact that Rome had no suitably grand ceremonial piazza and that the ancient center was now little more than an uncoordinated jumble of buildings and muddy slopes, fully deserving its medieval name of Hill of the Goats.

By the autumn of 1537 Pope Paul had decided to act, for the city council passed a resolution to restore the

piazza. The only immediate effect was that the great equestrian statue of Marcus Aurelius was moved across Rome from the Lateran Basilica to the Campidoglio. It arrived in the newly leveled piazza in 1538 and was placed on a base designed by Michelangelo. This is the first evidence of his involvement and shows that by then the scheme must already have been fairly well developed. The complex shape of the base is so well fitted to the final design of the piazza that it is evidently part of a unified conception for the whole area. In other words, by this date Michelangelo must already have devoted considerable thought to the design which was, in the words of Vasari, to 'give a beautiful, useful and convenient form to the Capitol'. Heemskerck's view of the Capitoline Hill, drawn after 1554, gives a vivid idea of the magnitude of Michelangelo's task. In the center is the old Palazzo dei Senatori, originally built in the fourteenth century (Biondo's concrete building) and enlarged to become a fairly typical *palazzo communale*. The large ceremonial staircase with the two statues of river gods was the first part of Michelangelo's design to be built and can be seen already in place. On the high ground to the left is the transept of the medieval church of Sta Maria in Aracoeli, while opposite it (though not at right angles to the Senatori) is the early fifteenth-century building intended to house the offices of the Conservatori and the guilds of Rome. In the center is the open space hastily leveled for the statue of Marcus Aurelius.

The most important change since the days of ancient splendor was in the orientation of the buildings. In antique times the temples would have looked out over the Forum, which lies behind the present piazza, but in the intervening period Rome had shrunk considerably, and in order to face the new smaller city the Palazzo dei Senatori had to turn its back on the ancient Forum, which was now ruined and referred to as the Campo Vaccino or Field of Cows. The impracticalities of the site are clearly shown in the drawing. There was no proper route up the hill to the piazza; all that existed was steep, unplanned tracks which were presumably almost impassable in winter. Michelangelo's daunting task was to redesign the most historically emotive space in the western world and to make out of the unpromising jumble of buildings a ceremonial piazza which would reflect not only the ancient grandeur of Rome but also the aspirations of its sixteenth century inhabitants.

The idea of imposing a cohesive character on towns, or parts of towns, was not a direct product of Renaissance thought. In the fourteenth century medieval cities like Siena had various building controls, such as limitations on height, but these provided townscapes which, though functional and pleasing, were based on irregular shapes. Architects of the Renaissance tended to be more interested in individual buildings but they did at times turn their attention to the idea of mathematically based town plans. The concept of the ideal town was discussed and a few towns were started from scratch (including Castro, the town built by Sangallo for Pope Paul's son in 1534, which was razed to the ground in the nineteenth century). In general, however, most activity focused on adapting small areas of existing towns, usually to provide new, more up-to-date piazzas.

There were two somewhat conflicting approaches to this sort of problem. Alberti believed that a variety of forms should be offered within a specific area, catering for the varying needs and for the different social standing of the inhabitants. The most famous example of this approach was the late fifteenth century rebuilding of Pope Pius II's birthplace, rechristened Pienza, where very different buildings, each expressing its different function, were grouped round the centrally or axially placed cathedral. More widely adopted was the regular or symmetrical approach, where the buildings on one side of a space as far as possible matched those on the other. An early example of this is Bramante's Piazza Ducale in Vigevano where the entire piazza is defined by matching arcades punctuated by triumphal arches. Another example, which must have been known to Michelangelo, was the creation of the Piazza SS Annunziata in Florence. Here at the beginning of the sixteenth century Baccio d'Agnolo and Antonio da Sangallo the Elder built a matching facade opposite Brunelleschi's Innocenti loggia, thus giving the town its first symmetrical space.

Although a few more examples of this sort could be mentioned they are surprisingly rare; when Michelangelo was commissioned in the 1530s to reorganize the Capitol, most piazzas would still have been irregularly shaped due to their haphazard evolution. For the first time Michelangelo was able to work with a group of buildings rather than a single unit. Not only did he impose a symmetrical regularity on the square but he also, as we shall see, exploited the possibilities offered by the idea of movement through a carefully designed space. This extra dimension was also included in his plans for the Palazzo Farnese (also for Pope Paul in the 1540s), while later in his career the Porta Pia again shows his awareness of the visual possibilities inherent in movement.

LEFT: The Capitoline Hill c. 1554-60 showing the statue of Marcus Aurelius in the center of the clearing. Behind it is the medieval Palazzo dei Senatori with Michelangelo's staircase already in position, and to the right the fifteenth-century Palazzo dei Conservatori.

BELOW: Bramante's Piazza Ducale at Vigevano is an early and rare example of a regularly planned town square.

In spite of the fact that the Campidoglio as we know it was not completed until the seventeenth century, it is possible to be reasonably clear about Michelangelo's intentions from engravings. His main objective was to impose a rational form on the site. There were two possibilities open to him: he could employ the 'varied' approach of Pius II at Pienza, or he could aim for axial symmetry as Bramante did at Vigevano. Since it was clear from the beginning that existing buildings would have to stay, the former approach would have

been the more logical. In spite of this Michelangelo chose the latter option, a decision in keeping with what we know about his views on architecture. In the famous passage about the relevance of the human body to architecture (already quoted in part, page 168) he says:

The nose which is in the center of the face has no commitment either to one or the other eye, but one hand is really obliged to be like the other and one eye like the other in relation to the sides of the body.

In other words he is commenting on the axial planning of the human body. Once Michelangelo had convinced the authorities that a second building reflecting the alignment of the existing Palazzo dei Conservatori was essential, axial symmetry was assured. The result is a trapezoidal piazza, widening out from the entrance and flanked on either side by two identical facades and with the main axis emphasized in a variety of ways. The focus of attention is the statue of Marcus Aurelius, which is placed on the central axis so that the

BELOW: A perspective view after Michelangelo of his design for the Capitoline Hill, 1569.

visitor proceeding up the *cordonata* (shallow steps) gradually becomes aware of the imposing figure seemingly gesticulating to him to enter. Various other devices also stress the central axis; the *campanile*, originally off-center, was centralized and the flights of the ceremonial staircase attached to the Senatori meet in a central balcony.

On arriving at the piazza the full complexity and subtlety of Michelangelo's plan is revealed. The unusual alignment of the buildings, which makes the entrance the narrowest point, creates the impression of entering a kind of outdoor room. This space is intended as the destination and the flanking *palazzi* are thus merely backdrops and have no obvious entrances. Their design, incorporating open loggias, may well refer back to the ancient Roman tradition of forum buildings, and at the same time provide space in

which to display some of the antique sculpture which had accrued on the Capitol. By far the most complex and original element of the design, however, is the handling of the piazza floor. Michelangelo needed to unify the unusual shape of the piazza and also to consolidate the position of the statue, which was in danger of becoming isolated in the center. This he achieved by using an oval design, which not only fitted well into the general shape of the piazza, but also emphasized rather than counteracted the longitudinal axis already established and thus enhanced the carefully arranged vista from the *cordonata*. The pattern of the piazza is not just an imposed two-dimensional design; it also has subtly incorporated three-dimensional elements. The oval is bordered by three steps leading downward on to the patterned area. On the main axis at the entrance to the

piazza these steps extend invitingly, offering a choice of routes either across or round the patterned area which rises very slightly, like a gentle dome, toward the center. The pattern is a complex stellate construction, the swirling shapes of which unfailingly lead the eye to the statue of Marcus Aurelius, making it the anchor or the focal point of the whole design.

Michelangelo's ordering of the piazza is revolutionary. He not only introduces elements which in themselves are totally original but, more importantly, by imposing choices which are based on aesthetic appreciation rather than simple logic, he forces the visitor to become involved in his surroundings. No earlier building had made these sort of demands and this was therefore a new element in the history of planning.

The new palace facades were of course dictated by the size of the existing buildings and so the central Senatori was intended to be a larger variation on the Conservatori design. The ground floor was rusticated and then partially obscured by the ceremonial staircase, a practical solution since it was here that the prisons were sited and large windows would obviously not have been appropriate. It also allowed Michelangelo to focus attention on the upper storys which were articulated with giant Corinthian pilasters and crowned with balustrades and statues, reflecting the design of the Conservatori. (Subsequent changes, especially to the size and positioning of the windows, have now lessened this effect.) The two flanking *palazzi* were designed to have a three-dimensional element which was lacking in the Senatori, for they incorporated the colonnades which formed an essential part of the piazza. As a result it is in the Conservatori that Michelangelo's interest in the stresses and tensions of architecture – the flexed muscles of the column

BELOW: Detail from an eighteenth-century view
by Bernardo Bellotto of the completed
Campidoglio from the bottom of the ramp.

BELOW: The Palazzo dei Conservatori, Rome.

– is felt. Similar preoccupations appear earlier, in the vestibule of the Laurentian Library, but a comparison between the two emphasizes Michelangelo's ability to adapt both materials and articulation to the needs of a specific commission. The demands of the Capitol were very different from those represented by the vestibule of a Florentine library. Although the giant pilasters, with the wall surface cut back to form giant load-bearing piers which actually support the heavy entablature, are comparable to the monolithic columns of the Laurentian Library, there the

similarity ends. The Florentine *pietra serena* has given way to the Roman stone, travertine, and the complex variety of forms have been replaced by a controled monumentality. The feeling of strength and tension is augmented by the smaller order of the loggia, which is clearly load-bearing rather than decorative. The overall impression is of strong and enduring buildings, in which the architectural elements are no mere applied decorations but are working parts combining together to provide tension tempered by monumentality.

The facades of the Capitol are so well known and have been so often copied that it is now difficult to appreciate the originality of Michelangelo's concept. Basic facts give some idea of the innovations: Michelangelo was the first to exploit the dramatic possibilities of the giant order (those of the Conservatori are some 45 foot high) and the seemingly effortless interweaving of two different-sized orders has been described as one of Michelangelo's most valuable and liberating inventions. It was also unusual to use free-standing, load-bearing columns (there

RIGHT: The facade of the Palazzo Farnese, Rome; only the giant cornice and the central window are by Michelangelo.

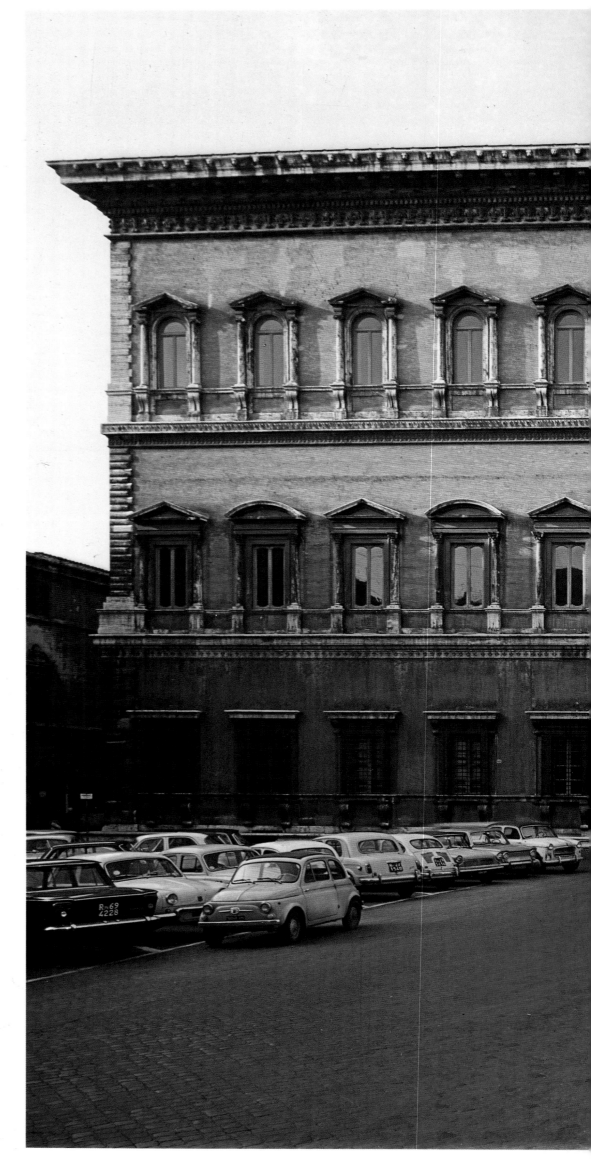

was only one other example at this time) and even the balustrade, now commonplace, was here making an early appearance.

Compared with the Capitol, Michelangelo's earlier works had been small-scale. Here he showed, through his ability to manipulate the elements of classical architecture, his understanding of the concept of decorum. The resulting designs were outstandingly suited to the functions and site for which they were intended and set the standard for monumental squares all over Europe. The Capitol also showed that Michelangelo was not idly and wilfully playing with architectural form, but was using the expressive range inherent in classical architecture to produce buildings which were both original and functional.

Town Planning: The Farnese Palace

With the Farnese Palace Michelangelo took over a building that was well on its way to completion and yet he managed to stamp it with his own individual approach, not only redesigning details such as windows and cornices but also putting forward a revolutionary plan, albeit never achieved, for opening up a vista straight through the palace and across the River Tiber.

In 1515 Cardinal Alessandro Farnese had commissioned Antonio da Sangallo the Younger to design him a palace. These plans were radically altered when he became Pope Paul III in 1534 but by 1541, when work started in earnest, the palace appears to have been intended for the Pope's son, Pier Luigi. Michelangelo's involvement is something of a puzzle. According to Vasari a competition was arranged for the design of the cornice, which Michelangelo won, and as a result he was given overall command of the project. Knowing Vasari's partisan attitude, however, and given that there is no documentary

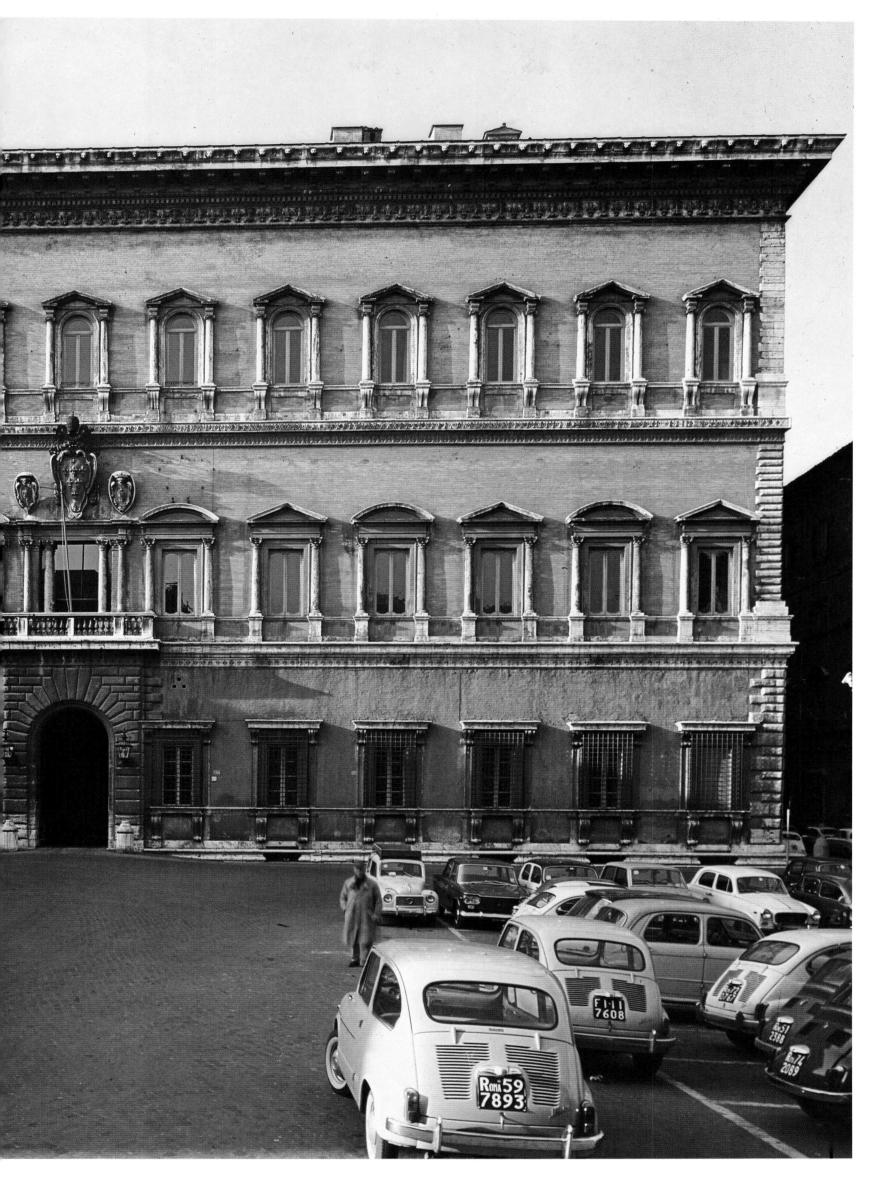

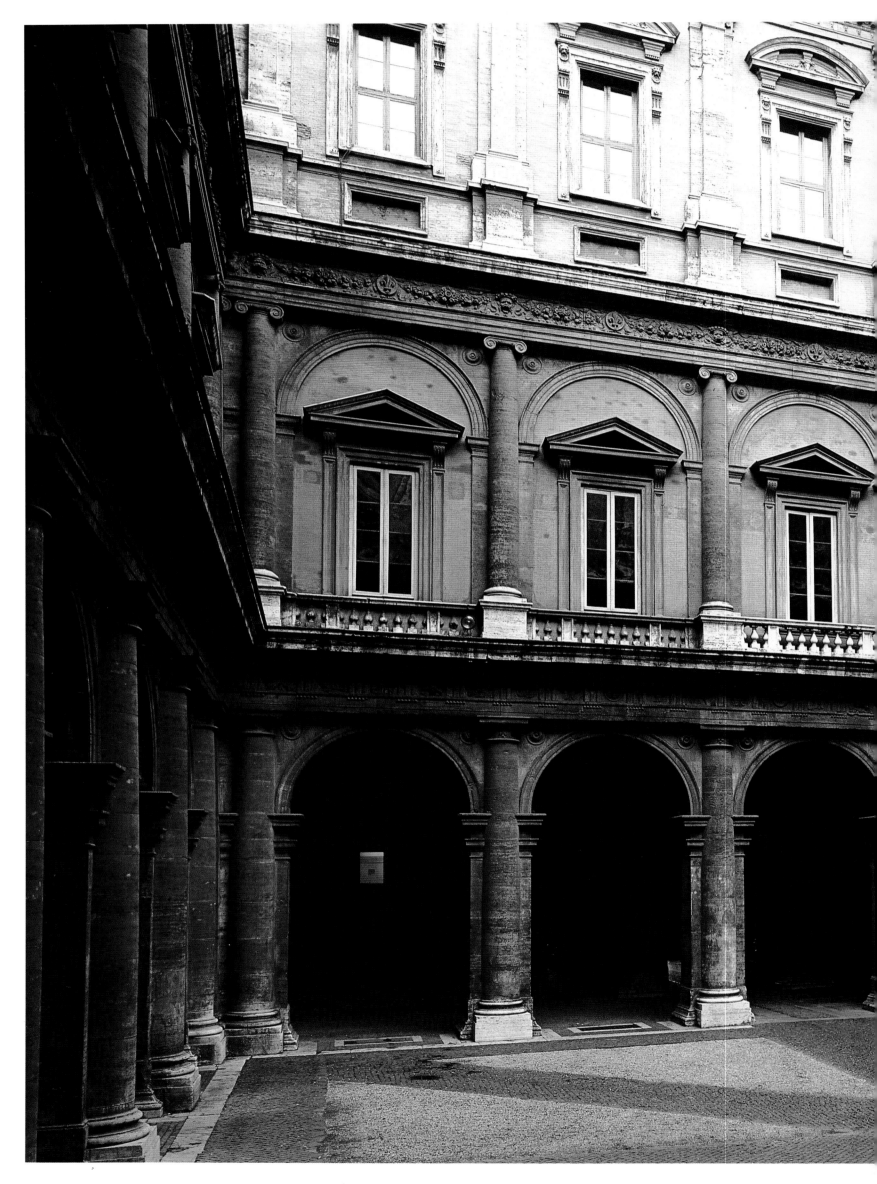

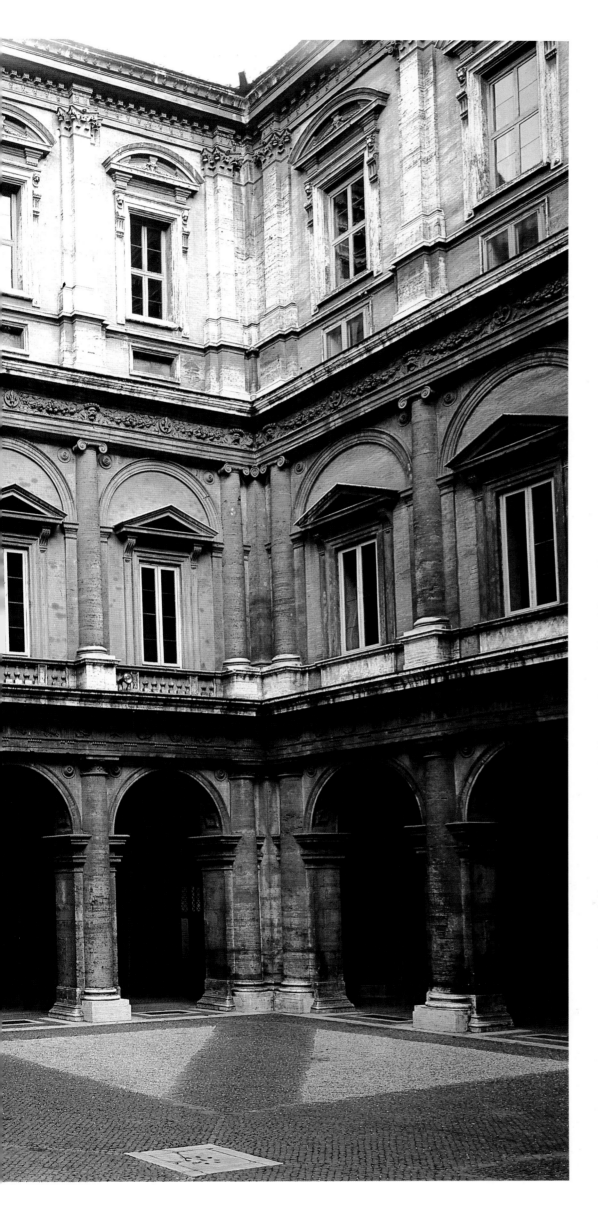

LEFT: In the courtyard of the Palazzo Farnese the ground floor arcade is by Sangallo but the second floor is by Michelangelo, illustrating the contrast between the straightforward monumentality of Sangallo and Michelangelo's more idiosyncratic approach.

evidence for this story, it is possible that Michelangelo simply replaced Sangallo on his death in 1546. Michelangelo's adjustments to the main facade were limited. Apart from altering the central window and enlarging the coat of arms above it, he did little more than raise the height of the building slightly and add the cornice. A full-scale wooden model of the cornice was hoisted aloft in 1547, demonstrating Michelangelo's predilection for designing by eye rather than relying solely on mathematical calculations.

The courtyard of the palace afforded Michelangelo more freedom. Although Sangallo's design, which used monumental and correct Roman arcades, set the tone it had only been completed to the level of the second floor. Michelangelo, instead of continuing the design in a similar manner, used the second floor as a transition to the far more individual handling of the third floor. So although the Ionic half-columns and arcades remain as Sangallo intended, the window pediments (possibly not by Michelangelo) jut sharply forward and the entablature becomes festively garlanded; highly decorative, but not strictly classical. On the third floor the same basic structure is used but handled in a much freer way. The half-columns become pilasters, given extra substance with flanking shadow pilasters, and the entablature is a compressed variation of correct Corinthian, with the architrave and frieze amalgamated and decorated with grotesque masked faces reminiscent of those in the Medici Chapel (page 189). But the most idiosyncratic feature of the design is the window frames where the pediments, completely separated from the rest of the window, rest on detached, faintly Doric capitals. Many of the elements of the design have come from earlier projects and Michelangelo's provident approach is nicely illustrated in miniature by his drawing

The inspiration for this idea came from the discovery, in the Antonine Baths, of an immense antique statue more than twelve feet square of Hercules and the Bull. This Michelangelo intended to have converted into a fountain and to serve as one of the main foci of his carefully arranged vista. To take full advantage of this new arrangement, he proposed major alterations to the design of the palace. The most important was the reduction of the rear block to the thickness of a single room, thereby providing not only a vista at ground floor level, but also a loggia extending the whole length of the garden front and giving an elevated and uninterrupted view over the carefully contrived vista across the river to Trastevere, where there was another Farnese palace. Had Michelangelo's scheme been carried out, the garden end of Sangallo's weighty and monumental courtyard would have been reduced to little more than a screen and the visitor approaching the palace would have experienced Michelangelo's vista beckoning from the darker solemnity of Sangallo's ceremonial entrance toward the lighter more festive atmosphere beyond. That it was never realized was presumably a practical reaction to the loss of room space; but enough survives of Michelangelo's plans to demonstrate the sophisticated way in which he considered the contrasting experiences that could be provided by movement down a carefully designed route.

Town Planning: The Porta Pia

In 1560 (when Michelangelo was 85) Pope Pius IV proposed the building of a great road bearing his name. The original idea was that it should start at the Palazzo Venezia, where he spent the summer, and run across the Quirinal Hill to the city walls near the Porta Nomentana. Due to practical problems such as negotiating the ascent to the

for the window, which is very probably an earlier design from the Palazzo dei Conservatori reused and adapted; beneath the existing drawing an earlier version with columns and an oval-shaped central structure similar to that used at the Conservatori can be discerned. Over this Michelangelo imposed various details, some of which were incorporated into the final design and some of which were abandoned. The result was a window that combined a number of earlier motifs and gave an impression not of the spare, pared down force of, say, the tabernacles in the Laurentian Library vestibule (page 197) but rather a festive quirkiness more in keeping with the atmosphere of a private palace.

In the town planning context, however, the main interest lies in the way Michelangelo considered the palace in relation to its site and the buildings around it. He had inherited from Sangallo an imposing but conventional inward-looking courtyard block. But Michelangelo proposed to open up a vista, a revolutionary arrangement, so that (in Vasari's words):

From the principal door of the Campo di Fiore (ie the main facade) one looked straight through the court, fountain, Strada Giulia, the bridge and the other beautiful garden right to the other door into the Strada di Trastevere, a rare thing worthy of the Pope and of the genius, judgment and design of Michelangelo.

RIGHT: This engraving of the courtyard in the Palazzo Farnese shows how Michelangelo intended to open up a vista through the building.

BELOW: The upper story of the Palazzo Farnese courtyard, designed by Michelangelo.

Quirinal and angry protests from property owners in its path, however, it was decided to start from a clearing on the Quirinal and to proceed from there down to the city wall. The character of the area through which the road passed was described in 1588 as 'a most agreeable site' which 'enjoyed the most perfect and salubrious air of all the parts of the city of Rome . . . it is full of the most beautiful gardens and pleasure spots of the most distinguished citizens'.

Like all Michelangelo's designs, the Porta Pia was a carefully judged reaction to a specific commission. To appreciate the finished design it is essential to understand the underlying circumstances. The Via Pia was to be a long straight street providing a view through one of the most attractive parts of Rome, and the function of the Porta Pia was to terminate this vista. At this time the conventional city gate was

LEFT: One of Michelangelo's studies for the central portal of the Porta Pia.

RIGHT: The Porta Pia, the Roman gate designed by Michelangelo. The upper story collapsed soon after it was built and is now a nineteenth-century replacement.

was the first Renaissance gate to be built in Rome, and the conventional solution would have been to provide decoration such as had been used on the Porta dell'Arsenale in Venice toward the end of the fifteenth century, which was adapted from triumphal arch tradition. Michelangelo, however, turned to a different and newer tradition. While theatrical designs and those for temporary wooden structures created to greet important visitors may have also been in his mind, it seems that it was principally to the burgeoning field of villa design that Michelangelo turned. The idea of building urban villas within the walls of Rome had become increasingly popular (the Farnesina, built about 1509, was an early example), and for them a distinctive style full of fantasy and variety was being established. It appears, for instance, that owners whose gardens backed on to the Via Pia competed with each other to produce gates which would give the road exactly this sort of character. It is just possible that Michelangelo was consulted in some cases. Certainly some of his surviving gate designs for this period were not intended for the Porta Pia itself; one such study shows steps leading up to the central opening and thus can only be intended as a pedestrian gate. In this vividly expressive charcoal drawing, Michelangelo catches the spirit of flamboyance and fantasy which was a prerequisite for the fashionable villa.

The Porta Pia itself does not survive as Michelangelo intended; the top story dates from the nineteenth century and there is no firm evidence about the original design. Certainly the upper story seems to have had a short life, for a fresco dated 1587 quite clearly shows a jagged edge suggesting some sort of collapse, but the lower level of the gate survives much as Michelangelo intended, and here the design emphasizes the function. The basic form is

military in function, outward looking, robust in construction and defensible. The Porta Nomentana, adjacent to the Porta Pia, is a bulky type of construction with heavy rounded towers, strategically placed. The Porta Pia was designed to be the antithesis of this convention for it is nothing more than a thin screen inside the city wall with another, plainer screen incorporated into the wall. No attempt appears to have been made to make either part of the gate defensible, and this may well be because fighting near Rome in 1556-57 had shown only too clearly that defending the city walls in the face of increasingly sophisticated firepower

was a hopeless task. Michelangelo's interest therefore centered on the inner screen, the function of which was to provide an interesting termination to the street and, by virtue of its high central bay (which rises well above the height of the city wall), to give users of the road a kind of landmark that would provide a sense of scale and a distant goal. It was therefore not only logical but necessary that it should face inward.

The Porta Pia, therefore, is not a gate in the traditional mold and marks the first move away from fortified to purely decorative gates. Clearly a different kind of vocabulary was called for. Yet it

LEFT: This foundation medal shows Bramante's original design for St Peter's, 1506, a centrally planned building.

movement and intended to provide pleasure and interest. Today this kind of experience is taken for granted but for its date in the sixteenth century it was revolutionary and the possibilities were not to be fully explored until Sixtus V set about redesigning and embellishing the center of Rome at the end of the century. It is fair to say that the underlying vision for this, the beginning of Baroque town planning, stemmed from Michelangelo.

St Peter's

By far the greatest architectural task that Michelangelo undertook in Rome was the continuation of the new St Peter's, a project which had been initiated by Julius II in 1506 with Bramante in charge. Forty years later, after most of the well-known names of that generation (including Raphael and Peruzzi) had been involved, the death of Antonio da Sangallo led to Michelangelo (then in his seventies) being offered the position as *capomaestro*. Vasari's comments make it clear that Michelangelo was not the automatic first choice:

Various opinions as to his (Sangallo's) successor obtained among the deputies about the Pope. At length the Pope inspired I believe by God decided to send for Michelangelo.

This hesitation was no doubt due to the strong feelings of the 'Sangallo sect', who were intent on preserving Antonio's conventionally classical approach and had up to now successfully excluded Michelangelo from the Roman architectural scene. Indeed five years later, if Vasari is to be believed, this faction was still plotting to discredit Michelangelo with the Pope.

Michelangelo does not seem to have accepted the task willingly, making his usual excuse that architecture was not his art. Ten years into the job he wrote

little more than a brick screen, serving simply as a neutral background on which to display innovative details. Only in the crenellations does the gate make any reference to traditional city gates, and even these have been transformed into cushion-like supports for the six Medici *palle*. It is possible that the larger end projections which now terminate somewhat abruptly were intended to support obelisks, so demonstrating Michelangelo's willingness to mix classical and medieval features.

Michelangelo's creative energies were concentrated on the central doorway and surviving drawings make it clear that from the beginning he was striving for forms that would be free of the conventional Roman architectural language; indeed the only consistent feature in the studies is the very un-Roman flattened arch. The pilasters appear to have evolved from those of the Laurentian Library tabernacles (see page 197) and provide another example of Michelangelo's reworking of elements from earlier designs. Although they incorporate references to the classical orders, these are lifted from their normal logical context and appended as purely decorative motifs. For instance the use of unusually large guttae (originally the pegs used to secure the joists) as part of the capital decoration is totally unclassical. Experiments with

triangular pediments imposed on segmental ones had appeared in designs for the Laurentian portal, while the roundels with their hanging swags appeared (but were never used) in designs for both the Medici Chapel and the library. A study of Michelangelo's drawings for the gate shows idea after idea being superimposed within a set framework, so that in its final form the Porta Pia becomes a celebration of many of the ideas and forms created by Michelangelo throughout his career as an architect. The final impression is of a great gateway with its festive and unpredictable decoration highlighted against the neutral screen wall; a huge form discernible from a distance but remaining intriguing throughout the long approach to it.

In all three of these examples, the Campidoglio, the Palazzo Farnese and the Porta Pia, Michelangelo shows his ability not only to look at the design of buildings in relation to their surroundings, but also to design groups of buildings that depend upon movement to reveal different aspects and sensations. The stately *cordonata* leading to the gradual unfolding of the piazza on the Capitoline Hill; the proposed vistas through the Palazzo Farnese and along the Via Pia: these were carefully contrived experiences depending on

BELOW: Maerten van Heemskerck's drawing shows the half built state of St Peter's before Michelangelo took over.

(according to Vasari):

I call God to witness that it was against my will that I was forced by Pope Paul III to take up the building of San Pietro . . . to abandon it now that we have come to the most difficult part would be shameful, and I should lose the fruit of labors of the last ten years which I have endured for the love of God.

This may be hagiographic licence, but it may well be true. Certainly St Peter's was a very different undertaking from anything else that Michelangelo had taken on. The huge scale of the project meant a very large number of men working on the site. Organization was a major preoccupation, and to take control of a workforce which had been led for 26 years by men antagonistic both to Michelangelo himself and to his approach to architecture could not have been an alluring prospect. Vasari gives a vivid impression of the atmosphere and the difficulties faced by both sides before Michelangelo was offered the commission:

Pope Paul had begun to fortify the Borgo, and had taken thither Antonio da Sangallo and several lords to discuss the matter. He wished Michelangelo to assist, knowing that the fortifications of San Miniato at Florence had been designed by him. After many discussions his opinion was asked. He being opposed to the advice of Sangallo and the others said so frankly, to which Sangallo retorted that sculpture and painting were his arts, not fortification. Michelangelo replied that . . . as he had thought much about fortifications and had experience, he thought he knew more than Antonio . . . and in the presence of the company he pointed out many of the errors they had committed. The dispute waxed so hot that the Pope was obliged to impose silence.

Michelangelo was taking on not only a half-completed building but also a disaffected workforce, if not the entire architectural establishment in Rome. In spite of immense practical difficulties, however, he managed to create from

RIGHT: In Vasari's view of St Peter's dated 1546, Sangallo's outer hemicycle can be seen completed up to first-story level. Michelangelo had this dismantled.

BELOW RIGHT: Sangallo's project for St Peter's, 1539-45.

BELOW: Plans for St Peter's. From the bottom, those by Bramante, Sangallo and Michelangelo.

the confusion and bad feeling a building that was indisputably his own rather than a feeble compromise forced on him by circumstances. The nature of his achievement is encapsulated by Vasari, who said that Michelangelo himself made St Peter's 'smaller but much grander'. In this statement lies the key to understanding Michelangelo's contribution, for his overall aim was to produce from Sangallo's fragmented design a building that was more compact, certainly, but more importantly one that was a unified, organic whole.

Michelangelo's opinions about earlier contributions to the building make his attitude clear. Of Bramante's design he commented:

He laid down the first plan of St Peter's not full of confusion but clear and pure . . . it was regarded as a beautiful thing, and it is obvious now that whoever departs from this order of Bramante, as Sangallo has done, has departed from the truth.

In a letter of 1547 he turns his attention to the unintegrated internal spaces of Sangallo's design, ridiculing:

The many lurking places above and below which afford ample opportunity for innumerable rascalities such as the hiding of exiles, the coining of base money, the raping of nuns and other rascalities.

According to Michelangelo 27 men would be needed to seek out those who remained hidden every night. Small wonder the Sangallo sect found the change of chief hard to stomach, but comparing the two plans it is clear why Michelangelo preferred Bramante's version. Here the basic form, a Greek cross within a square, develops outward from the center, the space appearing to unfold and subsidiary spaces related to the central area. In contrast Sangallo's approach is additive; a series of separate, almost isolated spaces. For example the apsidal ambulatories are

little more than separate passages attached to the main design, while the western areas of the building (liturgically speaking: St Peter's is not orientated in the usual way) appear almost completely unintegrated, an impression that is confirmed by looking at Sangallo's model. Michelangelo's aim was to restore the 'clarity and purity' of Bramante's design by dispensing with Sangallo's many 'lurking places'.

When Michelangelo took over St Peter's, he was not taking on academic plans sketched out on paper but a huge physical presence already looming over existing buildings. By 1546 much of the central area of the building surrounding (but not including) the dome was already vaulted; the pendentives (or supports) for the drum of the dome were in position; the south and east arms were vaulted to the beginning of the inner apses, as was part of the north arm. Building had also started on Sangallo's outer hemicycles, which can be seen in Vasari's view rising to the level of the first entablature. How was he to control a building already so far advanced? His first major decision, and the most radical, was to remove the outer hemicycles. The fact that removal of part of Sangallo's design could be contemplated as a practical solution underlines the additive, unintegrated nature of his plan. From the practical point of view Michelangelo found it easy to justify his decision, writing:

Little would be lost if they were pulled down, because the dressed stones and the foundations could not come in more useful and the fabric (freed of the cost of completing the hemicycles) would be 200,000 scudi to the good in cost and 300 years in time.

The demolition of the outer walls rectified much that was weak in the Sangallo design. It was easier to get light into the rest of the building, re-

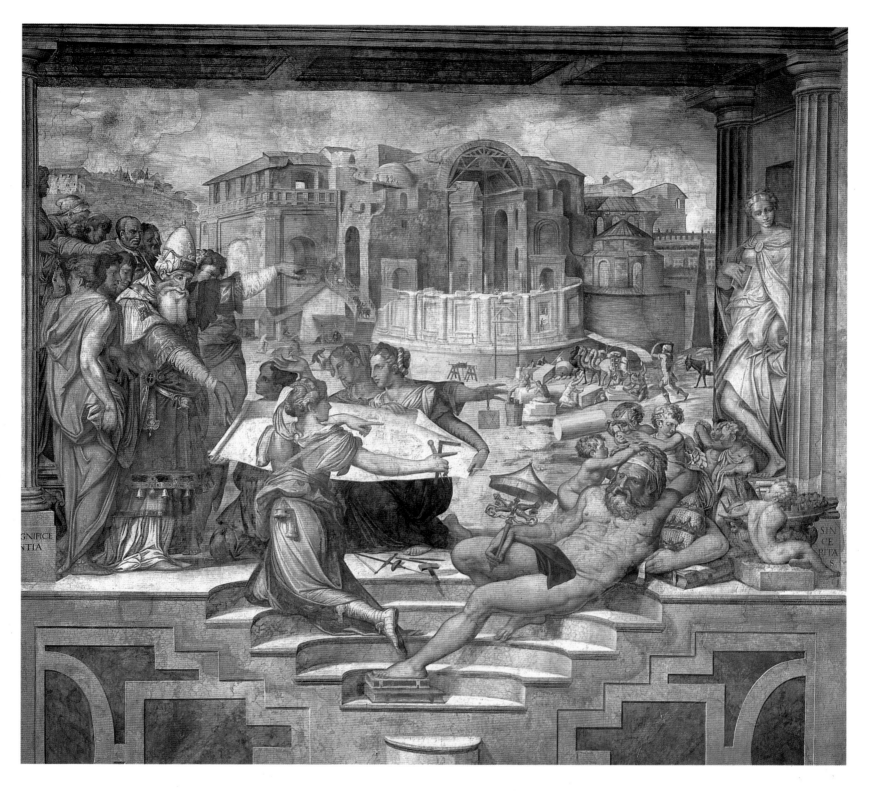

moving the dark badly lit areas suitable for 'rascalities', and the smaller structure no longer encroached on the neighboring buildings (at one stage Michelangelo was worrying that the Pauline Chapel might have to be demolished and did not think the Sistine Chapel would survive). Most important of all, it was now easier to integrate the surviving spaces to form a unified whole. The intention to build a longer nave and entrance towers was also abandoned, with the result that Michelangelo was now dealing with something much closer to Bramante's original plan. But what made his own design unique was his handling of the outer buttressing piers (identifiable on Michelangelo's plan by the circular stairs excavated within them). These were given a triangular form and incorporated into the outer wall structure.

FORMA TEMPLI D PETRI IN VATICANO

BELOW: An engraving by Dupérac based on
Michelangelo's design showing the south
elevation of St Peter's.

By doing this Michelangelo avoided Sangallo's confused array of spaces and at the same time he introduced diagonals into the exterior shape of the building. This had the effect of unifying the basic geometry of the plan so that, instead of being composed of two superimposed shapes which retained their separate identities, the form became totally integrated. This is essentially a sculptor's solution for it is a shape that might easily arise from three-dimensional experiments. That it is not a geometrical solution is underlined by the fact that the diagonals are not set at a regular angle of 45° from the main axes and thus if extended would not form a regular shape. The angle was determined not by geometry but by the simple expedient of being the shortest distance between the two spaces; again the sort of solution that would be expected when working in three dimensions rather than within a two-dimensional mathematical framework.

In a way Michelangelo's reorganization of St Peter's can be seen as the logical culmination of the way in which he worked. The radical alteration of a half-completed building was not a problem suited to paper solutions or to the 'ideal' geometrical approach, but with a malleable and three-dimensional

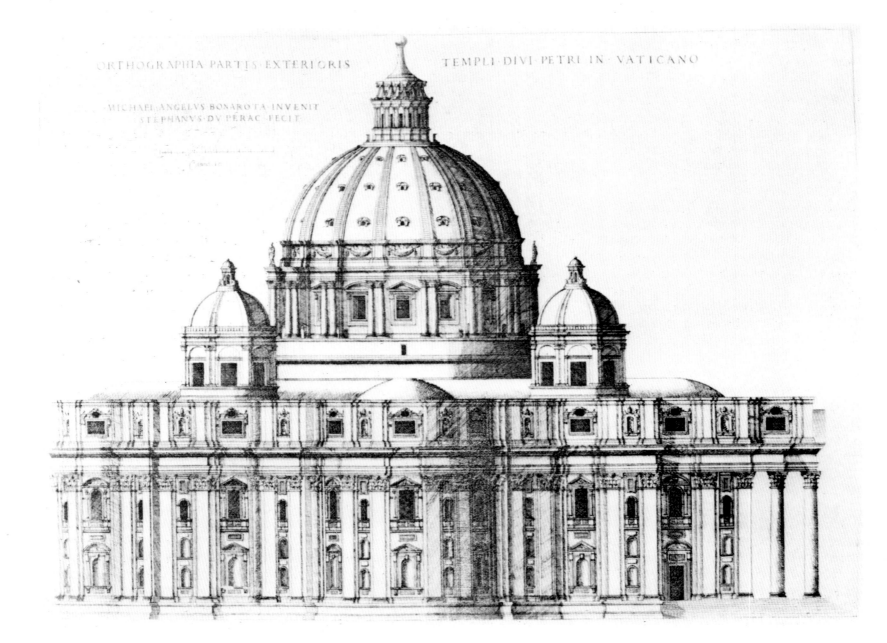

BELOW: This engraving shows the simplest alternative for the attic windows for St Peter's.

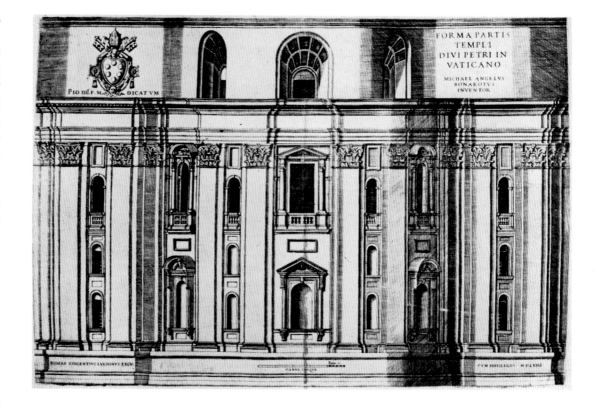

medium like clay it was possible to shape and form the material as a whole, constantly and instantly changing parts until a suitable design emerged. The adaptation of St Peter's is the most vivid example of how Michelangelo's new experimental sculptural methods produced totally integrated buildings that, once understood, seem simple, obvious and above all utterly right.

Michelangelo's reaction to Sangallo's elevation designs, which survive in the form of a wooden model, was as scathing as his remarks about the plan. Vasari reports that he:

Used to say publicly that Sangallo . . . had used too many ranges of columns on the exterior one above the other and that with his numerous projections and angles his style had much more of the German (i.e. Gothic) than the good antique or modern manner.

Basically, Sangallo was again using the additive approach; in his plan, numerous small spaces were connected to cover a large space and on his elevations numerous smallscale columns were repeated in rows over a large surface area. In applying this smallscale articulation the dramatic effect of the huge size of the building is frittered away, leaving in its place a repetitious decorative skin.

In his handling of the facades Michelangelo had a relatively free hand. Since the building had essentially been built from the center outward, as shown in Vasari's 1546 view, little had been done to articulate the outer surfaces. Michelangelo was therefore free to display his grasp of the dramatic possibilities inherent in a largescale building. In place of Sangallo's superimposed rows of columns – decorative icing on an inert cake – Michelangelo's giant pilasters, over 90 foot high, impose a monumental form on the undulating shape of this great building, constraining it to a predetermined shape and size. Above

them the entablature, monumental but absolutely plain and correct, defines and orders the complex shape of the building. This marks a deliberate change of attitude to classical forms. In the courtyard of the Farnese Palace (page 214) he used the entablature to break up light and shade and to introduce rhythm and variety; its aim is decorative and classical rules are broken to achieve a more expressive effect. But at St Peter's the need is for monumental *gravitas* and Michelangelo alters his approach accordingly.

From the 1540s the idea of reusing or reworking old forms becomes an increasingly important part of Michelangelo's design process and within the grid of the giant pilasters many of Michelangelo's earlier ideas are reemployed; the layered approach to the wall surface which was first seen at the Medici Chapel is here used to great effect, with the pilasters being given extra bulk and mass by the buttressing

strips behind them. On the straight runs of wall the handling is simple and grand, while on areas such as re-entrant angles the rhythm becomes quicker, with different levels being introduced in rapid succession. The result is that the less important areas have a restless quality which contrasts with and therefore emphasizes the stateliness of the pilasters. In the window designs, too, Michelangelo is returning to earlier ideas. The upper windows have affinities with the Conservatori windows (page 210), while those in the lower zone refer back to forms which were current during the designing of the Laurentian Library.

The windows of the attic level should be discounted, for it is now generally accepted that Michelangelo's intentions for this area were not carried out. It appears that he conceived the attic as an absolutely plain area; certainly, an engraving dated 1564 shows no pilasters, and no ornate windows. Apart

from the simple round-headed windows in the apse areas, the impression would have been of uninterrupted flatness with no vertical emphasis whatsoever. It seems that Michelangelo wanted to avoid a continuous upward thrust, and saw the function of the attic as an area of repose before the final climax of the dome.

Of the main entrance facade little is known for certain, since work on it did not start until after Michelangelo's death and of course no traces of it now remain due to the nave extension added 1609-12 by Carlo Maderno. Various suggestions have been put forward but none have any real claim to be more than possibilities. It seems from surviving ground plans (page 222) that Michelangelo intended a monumental screen of columns, two deep in the center, across the whole of the (liturgical) west end. An impression (but only an impression) of what was intended can be gained from a fresco in the Vatican Library.

Michelangelo continued to use his somewhat unorthodox design processes at St Peter's and the building was literally being designed as it went up. It seems that at first only the wall elevations were fixed. It is likely that the wooden model of 1546-47 had no dome and no facade, and that the model for the dome was not produced until twelve years later when the drum had reached entablature level and was ready to receive the dome. In other words Michelangelo delayed making a wooden model of the dome until as much as possible of the physical presence of the building had evolved. That is not to say that Michelangelo had not been considering the form of the dome from the beginning of his involvement in the project. Again the problem he faced was an awesome one. None of his predecessors had left any practical plans as to how the central space should be covered and certainly Bra-

mante would have run into severe technical problems at this stage, since his supporting piers were far too thin to carry the necessary weight. There were two precedents for covering a space of this size with a dome; the Pantheon in Rome and Brunelleschi's dome for Florence Cathedral. Bramante, as would be expected, turned to the antique Roman form of construction and his drawings show a stepped hemispherical dome very similar to the Pantheon. Michelangelo, on the other hand, was writing to Florence as early as 1547 for measurements of both the dome and the lantern; and his earliest studies of the dome seem to date from about this time. These were by no means fixed designs and they are best understood as speculative ideas which were constantly being honed and tempered by his experience of the actual building as it rose. His final resolution of the problem is open to argument, since Giacomo della Porta altered the outer part of the dome model and the pointed profile of the dome that we now see is therefore not as Michelangelo intended.

Michelangelo had two alternatives for the basic shape of the dome; a calm, static hemisphere or the more dynamic upward thrusting ribbed dome as used by Brunelleschi. It is likely that once Michelangelo had established an upward dynamic on the wall surfaces he would have wished to resolve these forces in the dome. The coupled columns of the drum take up the vertical emphasis of the pilasters, and this is carried on via the ribs of the dome which were shown as part of Michelangelo's conception in many of his drawings. The final decision seems to have been related to the profile of the dome and its relation to the lantern. If an engraving by Dupérac of the south elevation can be accepted as a guide, it appears that Michelangelo settled for a hemispherical form, but gave it a

dynamic character by the addition of ribs and a high lantern; in other words he favored a balanced resolution that combined both vigor and equilibrium. This complex solution was not understood by Giacomo della Porta, who gave the dome a pointed profile more reminiscent of Brunelleschi's dome.

Although St Peter's cannot be seen as Michelangelo intended, enough of his conception remains to bear witness to the magnitude of his achievement. At the age of over 70 and in the face of continuing practical difficulties, Michelangelo created from a half-built old-fashioned design a building that was revolutionary both in its unified, organic form and in the scale of its articulation. It was truly his design, rather than Sangallo's, and reflected Alberti's definition of beauty as 'a harmony and concord of all the parts . . . so nothing could be added or subtracted, except for the worse'.

Late Ecclesiastical Buildings

St Peter's was to occupy Michelangelo for the rest of his life, but not to the exclusion of all other architectural work. As well as the Farnese Palace, the Campidoglio and the Porta Pia, he also undertook work for successive popes. He was consulted on the vexed subject of the Vatican fortifications but was not actively involved until after Sangallo's death, probably due to his clash with Sangallo over the best methods to employ. He designed a facade for a palace for Julius III, worked on the strengthening of the Ponte Santa Maria and was also involved in the design of a staircase at the Vatican Belvedere. But he was at the same time accepting other commissions, the most important of which was from the Florentine colony in Rome who wanted their church, San Giovanni de' Fiorentini, finished. Work had started in 1520 to designs by Antonio da Sangallo, but difficulties

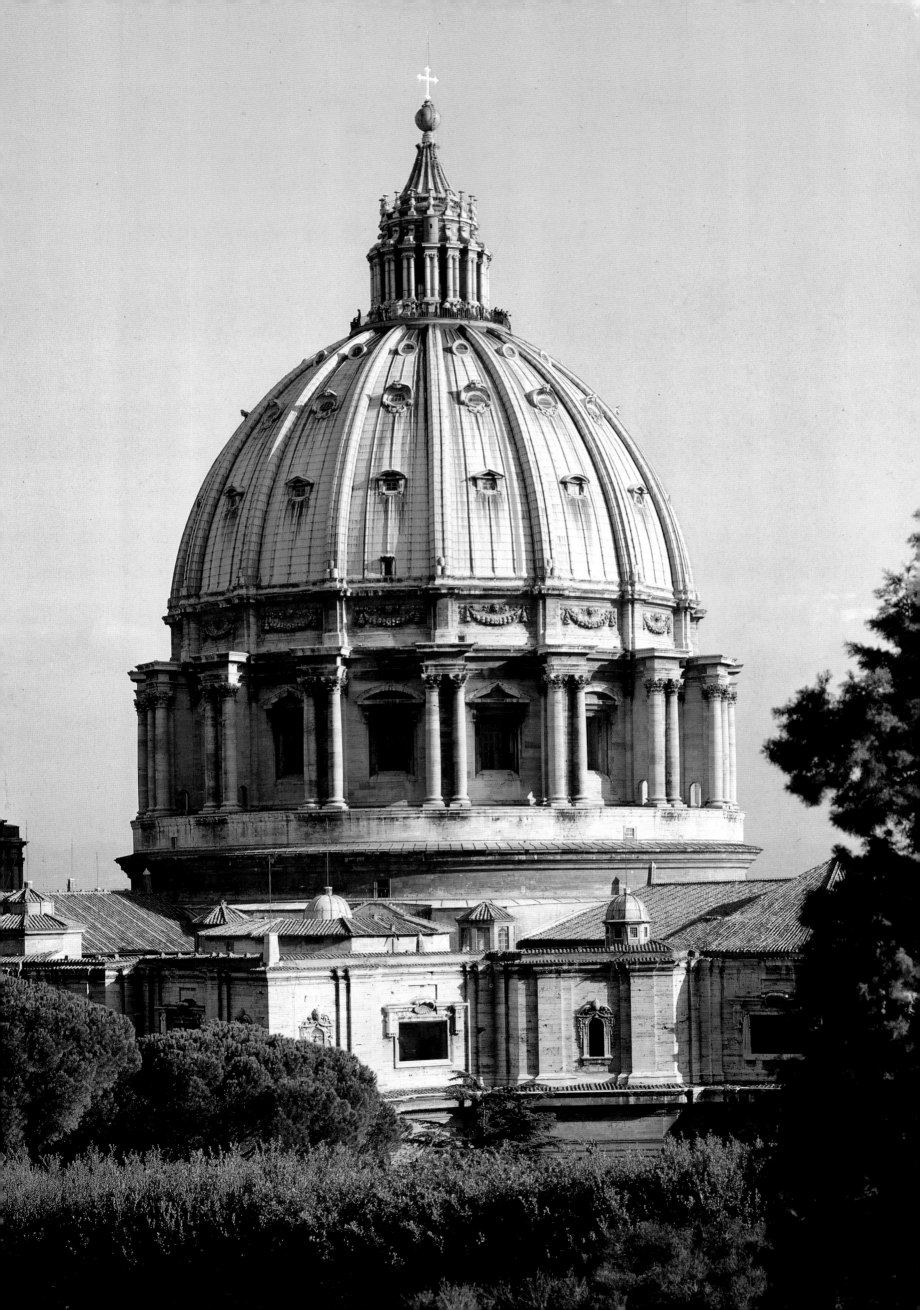

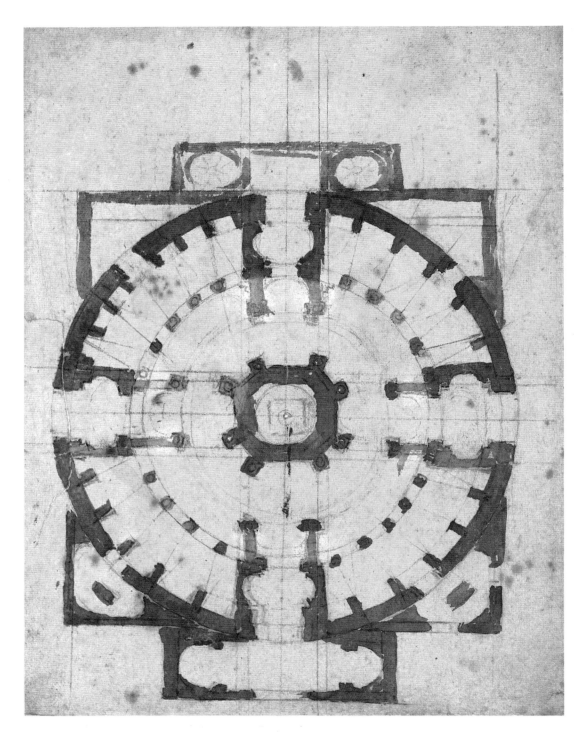

LEFT: San Giovanni de' Fiorentini: an early design by Michelangelo.

RIGHT: A slightly later design for San Giovanni de' Fiorentini than that shown left; here Michelangelo is moving away from the geometrical idea of circle within a square. In both these early designs the geometrical shapes remain unintegrated. Here the portico is very awkwardly attached to the main body of the church, almost as if it was an afterthought.

second early alternative Michelangelo introduced a strong diagonal element in the form of the side chapels. The geometrical shapes remained discrete, however; in the final design Michelangelo solved this problem, producing a smoothly integrated shape in which the projecting elements were absorbed into the fabric of the building so that they no longer had the additive feel of earlier designs. It is during the later stages that the distinctly un-Renaissance feature of oval chapels on the diagonal axes emerged. Moreover, to emphasise their oval form, their altars were placed not to align diagonally across the space but rather to mark the foci from which the shape was constructed. There were no precedents for this extraordinarily original plan, but it was to be taken up and further developed by Gianlorenzo Bernini in Sant' Andrea al Quirinale some 70 years later.

The final model shows Michelangelo's intentions for the exterior and interior decoration, and here we see him employing a new kind of expressiveness. Instead of the interest in tension of the Laurentian Library, the festive playfulness of the Porta Pia or the monumental grandeur of St Peter's, the elements of classical architecture are here being used to express a kind of serene repose. Everything is simple: the entablature is undecorated; the order is the simplest possible, as are the window frames; and the dome, in contrast to St Peter's, has no upward thrust, dynamic tension or movement of any kind. It is a simple hemisphere topped by an equally simple lantern. There is nothing to distract the attention from the 'clarity and purity' of the design, a quality which Michelangelo had so admired in Bramante's work. It is a totally integrated design. There is no separation of the parts for the entablature binds the building into one unified entity; like Bramante's Tempietto it is impossible to see the facade

arose over the cost of foundations and in the end only a temporary chapel had been erected. By 1559 the Florentines were ready to go ahead again and having decided 'to build a new erection on the old foundations' (according to Vasari), they approached Michelangelo. Although he was then 85, he:

Promised gladly to oblige them with as much good will as over anything he had ever done, as in his old age he loved to work first for the honor of God and next for his beloved country.

This account of Vasari's can be contrasted with a letter written by Michelangelo to Duke Cosimo I, also in 1559, saying:

It grieves me . . . to be so old and so at odds with life that I can promise little to the aforesaid construction personally.

Had it been built, however, San Giovanni would have demonstrated convincingly that Michelangelo had lost none of his power to produce new solutions to old problems.

A series of designs for the church survive and in them it is possible to follow Michelangelo's quest for a unified centralized form, this time unfettered by existing structures. The problem at its simplest was that in terms of unity of plan the most obvious place for the altar was in the center, but for liturgical reasons the clergy preferred an axial or peripheral altar. The first design appears to show Michelangelo using a geometrical design based on the idea of a circle within a square, but on closer inspection it lacks the regularity of conception that would make it a typical product of the geometrical school. For instance, on two sides the circle breaks free from the confines of the square, while the octagon of the central altar has alternating long and short sides. This design is not therefore based on pure geometrical forms, and in a

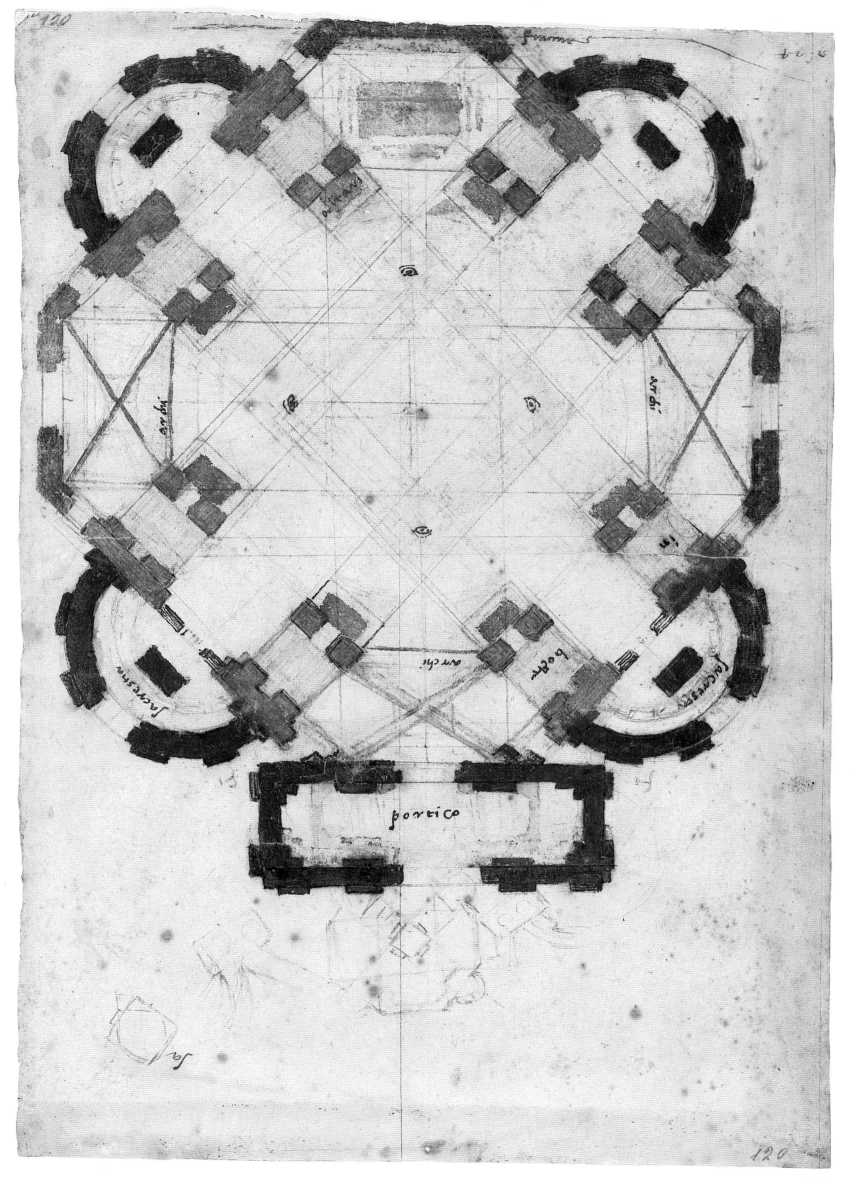

RIGHT: This view of Santa Maria degli Angeli, Rome, shows Michelangelo's transformation of the Baths of Diocletian, before the present baroque decoration was added.

BELOW: Engraving of San Giovanni.

BELOW RIGHT: Ground plan of the Sforza Chapel in Santa Maria Maggiore, Rome.

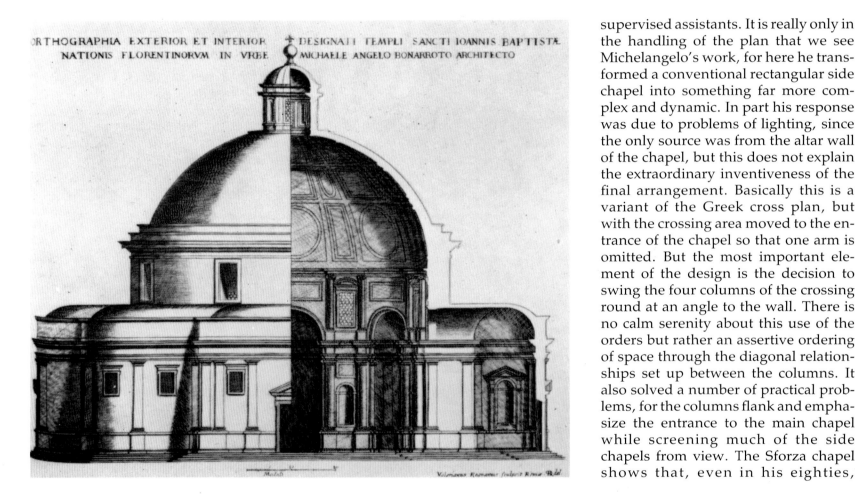

ORTHOGRAPHIA EXTERIOR ET INTERIOR ✝ DESIGNATI TEMPLI SANCTI IOANNIS BAPTISTÆ NATIONIS FLORENTINORVM IN VRBE MICHAELE ANGELO BONARROTO ARCHITECTO

supervised assistants. It is really only in the handling of the plan that we see Michelangelo's work, for here he transformed a conventional rectangular side chapel into something far more complex and dynamic. In part his response was due to problems of lighting, since the only source was from the altar wall of the chapel, but this does not explain the extraordinary inventiveness of the final arrangement. Basically this is a variant of the Greek cross plan, but with the crossing area moved to the entrance of the chapel so that one arm is omitted. But the most important element of the design is the decision to swing the four columns of the crossing round at an angle to the wall. There is no calm serenity about this use of the orders but rather an assertive ordering of space through the diagonal relationships set up between the columns. It also solved a number of practical problems, for the columns flank and emphasize the entrance to the main chapel while screening much of the side chapels from view. The Sforza chapel shows that, even in his eighties,

as an independent element. It is the overall form and mass of the church which gives it its character, not the decorative detail.

In this sense San Giovanni is conceptually the opposite of the Porta Pia, designed a year later, where the basic form is merely a screen and the character comes from the decoration applied to that screen. For this reason caution is needed in trying to identify a late style in Michelangelo's architecture. It is certainly true that San Giovanni displays a calmness not met before in Michelangelo's architecture and it is tempting to draw comparisons with his late sculpture. But San Giovanni was the only complete church designed by Michelangelo and it can just as easily be interpreted as another example of

Michelangelo's manipulation of the expressiveness inherent in classical architecture in a way he felt was suitable for a small church, while at the same time he was using classical forms in a very different but equally suitable way at the Porta Pia.

According to Vasari Michelangelo was responsible for the design of a chapel in the ancient Roman church of Sta Maria Maggiore for a member of the Sforza family, although the work was carried out by his assistant and remained incomplete due to the deaths of Michelangelo, the patron and the assistant. Certainly the facade of the chapel (now destroyed) was designed after Michelangelo's death and this and most of the detailing may well be the work of un-

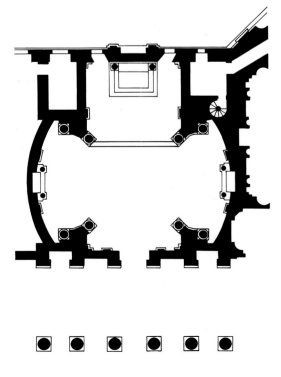

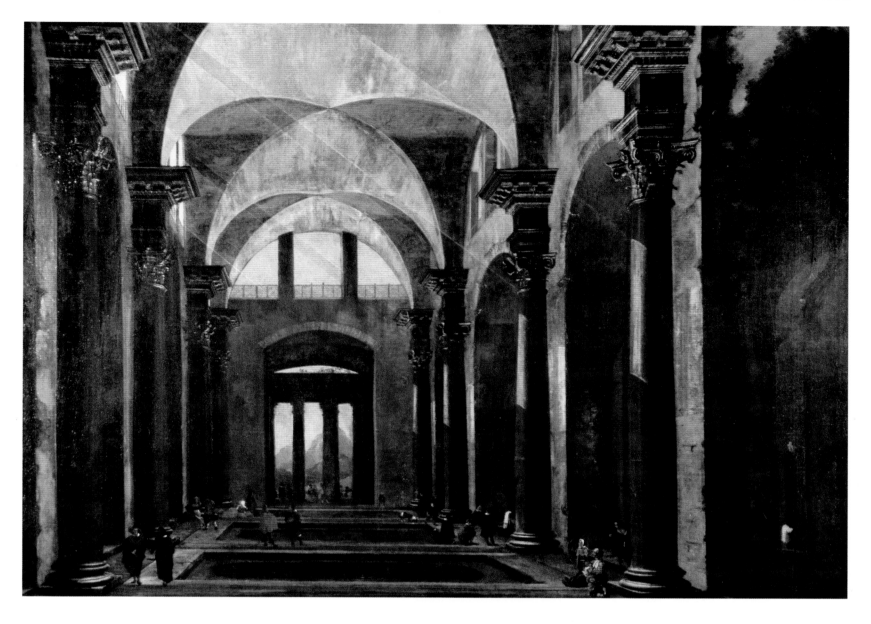

Michelangelo was able to manipulate space in a daring and original way. It was not until the emergence of Baroque architects such as Bernini and Borromini that the full possibilities of this type of spatial manipulation were realized.

Michelangelo's contribution to Sta Maria degli Angeli was not as innovative as many of his other works and it has often been pointed out that any competent architect would have been likely to have achieved a similar solution. It does, however, provide a suitable conclusion to Michelangelo's work as an architect because of the light it throws on his beliefs and on his attitude to both Christianity and classical architecture. In 1561 Pope Pius IV had the ruins of the Roman Baths of Diocletian consecrated, prior to transforming them into a church and monastery for the Carthusians. The impetus for this scheme had come not from the Pope but from a Sicilian priest who, inspired by a vision, had been trying for some twenty years to drum up papal support for the project. The fact that it was Pius who finally took an interest in his idea may have had more than a little to do with the fact that the Baths of Diocletian were just off the Via Pia and the project would obviously add greatly to its importance. Michelangelo converted the great hall of the bath building into the main central space of the church and used the existing rotunda as an entrance vestibule. At the east end a screened chancel was provided for the monks, since they were a closed order forbidden contact with the outside world, while the cloister, formed from the frigidarium, can be seen to the rear of the building. The atmosphere of the interior has now been totally lost due to the encrustations of Baroque decoration which are seen today, but Michelangelo in fact carried out a minimum of alterations and the effect would have been of a majestic and austere space, impressive not for its decoration but for its simple cavernous grandeur.

What is interesting about this project is the spirit in which it was carried out. There had been a tradition of converting pagan buildings into Christian churches – the transformation of the Pantheon into Sta Maria Rotunda is probably the best known example – but this practise, common in the Middle Ages, had died out by the fifteenth century. Although it would seem to provide the ultimate solution to the problem of reconciling Christian beliefs with admiration for the pagan past, it was not an option that appears to have been considered by the humanists and it is probably wrong to see Sta Maria degli Angeli in this light. The Sicilian priest had no interest whatsoever in classical remains; he simply wished to symbolize in the most effective way the triumph of Christianity over the pagan past. This attitude is underlined by the inscription in the apse: 'Quod fuit Idolum, nunc Templum est Virginus – Auctor est Pius ipse Pater, Daemones aufugite (What was once pagan is now a temple of the Virgin, transformed by Pope Pius himself – flee, you demons). Michelangelo's contribution to Sta Maria degli Angeli is best understood in the same spirit. We know from his late poems that he had moved away from standard humanist thought and had become deeply religious. In a sonnet to Vasari he wrote:

Now I know well it was a fantasy
That made me think art could be made into
An idol or a king. . . .

concluding

Painting and sculpture cannot any more
Quieten the soul that turns to God again.

The fact that he made a minimum of changes to the baths was not out of respect for the architecture of the ancients but rather to give added dramatic weight to the magnitude of the Christian victory over the pagan past. Seen in this light Sta Maria degli Angeli was a fitting climax to an architectural career which had occupied the last forty years of his life and in which he showed more clearly than any other architect the immensely wide range of expressive possibilities inherent in classical architecture.

Michelangelo the Architect

Michelangelo's contribution to architecture was immense, but it was also flawed. Not one of his buildings was finished as he intended and, as we have seen, although historical events and the whims of patrons played their part Michelangelo too was partly to blame. His inability to delegate and his difficulties in working with others limited his output, while his boundless imagination and the grandeur and originality of his concepts ensured that many of his projects were simply beyond the capabilities of one man. But this is the negative side of the qualities that enabled him to make a fundamental contribution to architecture. Michelangelo's buildings can be seen as evidence of a new attitude to architecture, in which an architect's individual judgment became more important than a knowledge of and obedience to the classical rules. Vasari (writing after Michelangelo's death) emphasizes the importance of this quality: 'architecture can only attain perfection in the hands of those that possess the highest judgment and design'. In Vasari's eyes Michelangelo was the first to break free from the fifteenth and early sixteenth century obsession with classical rules, and to demonstrate the possibilities inherent in a much more flexible and expressive architecture derived from, but not bound by, those rules. Vasari's opinion is clear: 'artists owe Michelangelo a great debt for having broken the chains which made them all work in one way'. Once an architect abandons the discipline of the classical rules his judgment becomes his most important asset. Michelangelo clearly realized that for he is reported (by Lomazzo) as saying that 'all the reasonings of geometry and arithmetic, and all the proofs of perspective were of no use to a man without an eye'. This approach applies not just to architecture but also to the other branches of art and is in effect the key to understanding the unique importance of Michelangelo. By rejecting the fixed standards and the accepted, mechanical techniques for achieving good design, he put a new emphasis on the imagination and judgment of the individual. It is this which distinguishes Michelangelo from earlier architects and which earned him the right to titles such as 'genius' and 'il divino'.

In spite of the fact that Michelangelo came to architecture in his forties, his career in that discipline spanned nearly fifty years. This in itself was a notable achievement but more extraordinary is the fact that, although Michelangelo was a child of the fifteenth century, his architecture even toward the end of his life was still innovative, idiosyncratic and totally individual. The majority of his commissions involved adding to existing buildings or taking over half-finished projects rather than starting from scratch, but the constrictions that these conditions imposed seemed to act as a catalyst, spurring him on to new and exciting solutions. His career as an architect centered on two cities, Florence and Rome, and he demonstrated beyond doubt that he was able to work within the individual traditions of both cities. His commissions covered a wide range of buildings, from cathedrals to city gates, thus providing a broad spectrum of ideas and examples. And yet, in spite of all this, his influence in the years immediately after his death appears to be very slight. Architects such as Domenico Fontana (1543-1607) and Giacomo dell Porta reverted to the straightforward classical approach and appeared either not to value or perhaps not to recognize Michelangelo's innovations.

In this sense Michelangelo was the antithesis of Palladio who, after his death in 1580, left a flourishing architectural practice which remained influential for centuries, spreading not only throughout Europe but also to the United States of America. Unlike Michelangelo Palladio left a detailed account of his attitude to architecture; The *Quattro Libri dell'Architettura* not only explained his theoretical approach but also contained detailed engravings of his buildings, with exact measurements. The *Quattro Libri* was thus an extremely well organized architectural crib, enabling anyone who possessed it to understand and reproduce a style that was by and large based on rules. Palladio's was an accessible style, while Michelangelo's was exceptionally personal and inaccessible. He wrote next to nothing about his ideas on architecture and his buildings cannot be seen as the product of any detailed theory, but rather of abstract qualities which could not easily be passed on.

At the beginning of the seventeenth century architects such as Carlo Maderna copied single elements such as capitals or window frames, but did not attempt to design Michelangelesque buildings. It was left to the architects of the Roman Baroque to discover the significance of Michelangelo's work. It was perhaps no coincidence that another sculptor, Gianlorenzo Bernini, (1598-1680) was the first to acknowledge Michelangelo's importance as an architect, saying that it was his

LEFT: SS Luca e Martina, Rome, by Pietro da Cortona again reflects Michelangelo's concept of the plasticity of the wall controled by the structural elements.

RIGHT: Another Baroque architect who drew much inspiration from the work of Michelangelo was Borromini; this close-up of the dome of Sant' Ivo alla Sapienza shows his use of a motif based on the Medici *palle* borrowed for the Porta Pia.

greatest achievement and referring to him (in the context of architecture) as divine. Interestingly, the three great architects working in Rome in the first half of the seventeenth century were all indebted to Michelangelo but in different ways. Bernini, interested in the interaction between art, sculpture and architecture, must have been aware of what Michelangelo was attempting both in the Medici Chapel and in San Giovanni de' Fiorentini. The Cornaro Chapel creates a unified *teatrum sacrum* while the interior of San Andrea al Quirinale combines lessons from both the plan of San Giovanni de' Fiorentini and the integrated arrangement of the interior of the Medici Chapel. Pietro da Cortona (1596-1669), who was a Tuscan, appears to have been influenced by a different aspect of Michelangelo's Florentine architecture. He certainly borrowed specific motifs, such as the interlocking niche and pediment from the Medici Chapel, or the triangular pediment surrounding a segmental one from the reading room in the Laurentian Library, both of which appear in the facade of Sta Maria della Pace. But he also showed an understanding of Michelangelo's interest in the tensions of architecture. Thus the facades of both Sta Maria della Pace and the earlier SS Martine e Luca are not flat but curved, seeming to swell out toward the center, and in both instances the columns give the impression that they are confining and defining the movement of the wall. This idea of the plasticity of the wall being controled by the structural elements originates with Michelangelo's handling of the wall in the Laurentian Library, where the wall surface seems to swell out on either side of the monolithic columns. Cortona, as well as picking up the individual motifs, had clearly also understood the thinking behind Michelangelo's approach.

Finally there is Francesco Borromini

(1599-1677), whose debt to Michelangelo is in many ways the greatest, and who perhaps explored the possibilities hinted at by Michelangelo further than anyone else. He too used motifs from Michelangelo's work. The idiosyncratic decorations from the Porta Pia, for instance, reappear on the dome of San Ivo della Sapienza but, like Cortona, Borromini's involvement with Michelangelo goes far deeper. San Carlo alle Quattro Fontane is a case in point. The facade derives from Michelangelo's interrelating giant and small orders of the Capitoline palaces, but it has been given a new, dynamic twist; both the exterior and the interior show Borromini using columns to define and control complex undulating shapes. This approach is again a development of the basic idea shown in the vestibule walls in the Laurentian Library; more than a century later Borromini has demonstrated the possibilities inherent in Michelangelo's architecture.

Nor of course was Michelangelo's influence confined to Italy. Sir Christopher Wren's dome for St Paul's Cathedral, London, built in the early eighteenth century, was derived from

St Peter's and the Capitol in Washington owed both the form of its dome (finished by Benjamin Latrobe, 1798 onward) and ultimately its name to Michelangelo. But his influence is more pervasive than is perhaps recognized and turns up in some unexpected places. Even the English architect Inigo Jones (1573-1652), normally considered a disciple of Palladio and a pure classicist, turns on occasion to Michelangelo. An early design for the tower of St Paul's contains lunettes on the dome remarkably similar to those on the dome of St Peter's, while the pediment of the Italian gate designed for Lord Arundel must derive from the Porta Pia.

Michelangelesque motifs can be found throughout the centuries but it would be a mistake to see this as his only or main contribution to architecture. It was his ability to rely on his own inner qualities rather than the mathematical paraphernalia of classical rules that enabled him to produce the buildings for which he is remembered, and which show that truly he had 'compasses in his head rather than in his hand'.

Afterword

'To write a book on Michelangelo is probably the most difficult task that an art-historian of today can undertake', Anthony Blunt once wrote. Part of the problem is that overexposure has dulled our vision. We tend to take Michelangelo for granted – genius, the greatest artist in the history of Western art, all the superlatives – without pausing to examine how he acquired this extraordinary reputation, or to consider the significance of his achievements in their historical context. He was born into a society highly suited to his talents but even in an age of considerable cross-fertilization in the arts, of the polymath Leonardo and the painter-architect Raphael, Michelangelo's range of accomplishments was extraordinary. Sculptor, painter, architect and poet, he changed profoundly all the visual arts he practised, approaching each problem with a sculptor's eye but without a formula, and indicating new directions in each discipline by expanding the limits of the possible. His influence was so powerful and pervasive that it threatened to overwhelm lesser talents. Only artists of the greatest gifts and strength of character could absorb his innovations and build on them: in sculpture, Giambologna and Bernini; in architecture, Bernini and Borromini; in painting, Annibale Caracci and Peter Paul Rubens. The example of his prodigious talent, his intellect and industry, and his strong character helped establish the dignity and independence of the artists' profession. Although his achievements brought him fame and riches previously unknown to artists, he was not compromised by success but retained his integrity and innovative approach until his death. His concern remained to fulfil himself in his own eyes, without which his success was meaningless to him. The number of works he left unfinished is tragic evidence of his pursuit of perfection and an indication that by his own impossibly exigent standards he remained a failure. However harshly he may have judged himself, to the outside world Michelangelo represented the archetypal genius, the source for the romantic idea of the artist as divinely inspired.

Select Bibliography

Ackerman, J A, *The Architecture of Michelangelo* (London, 1986)

Chastel, Andre et al, *The Sistine Chapel* (London, 1986)

Clements, Robert J (Ed.), *Michelangelo: A Self-Portrait* (Englewood Cliffs, 1963)

Condivi, Ascanio, *The Life of Michelangelo*, trans. H and A S Wohl (Baton Rouge and Oxford, 1976)

Einem, Herbert von, *Michelangelo* (London, 1973; paperback, London, 1976 and New York, 1977)

Freedberg, S J, *Painting in Italy 1500-1600* (Harmondsworth, 1971)

Gere, J A, *Drawings by Michelangelo* (London, 1975)

Hibbard, Howard, *Michelangelo* (New York and London, 1975; paperback, New York, 1976 and Harmondsworth, 1978)

Liebert, Robert S, *Michelangelo: A Psychoanalytic Study* (London and New Haven, 1983)

Murray, Linda, *Michelangelo* (London, 1980)

Murray, Peter, *The Architecture of the Italian Renaissance* (London, 1979)

Pope-Hennessy, John, *Italian High Renaissance and Baroque Sculpture* (London and New York, 1970)

Seymour, Charles, Jr, *Michelangelo: The Sistine Chapel Ceiling* (New York, 1972)

Symonds, John Addington, *The Life of Michelangelo* (New York, s.d.)

Vasari, Giorgio, *The Lives of the Painters, Sculptors and Architects*, trans. A B Hinds (London, 1970)

Index

Acknowledgments

The publisher would like to thank Martin Bristow, who designed the book, Alison Davies, who supplied the ground plans, Pat Coward, the indexer, and Jessica Orebi Gann, the project editor. We would also like to thank the following individuals, institutions and agencies for supplying photographic material.

Ashmolean Museum, Oxford: pages 43, 123 (top), 128, 216
Bargello Museum, Florence/SCALA: pages 18, 25, 26, 35, 36, 49, 127, 136
British Museum, courtesy of the Trustees: pages 52, 67, 85, 116, 125, 129, 130, 134, 139, 143, 154, 155, 220
Casa Buonarroti: pages 1/SCALA, 13/SCALA, 16/SCALA, 19/SCALA, 45/ SCALA, 174 (top and bottom), 175 (top), 175 (bottom/SCALA), 177/ SCALA, 192, 201, 228/SCALA, 229/SCALA
Musée d'Art et d'Histoire, Chambéry: page 231
Courtesy of Viscount Coke, Holkham Hall, Norfolk: page 51
Courtauld Institute Galleries, London (Princes Gate Collection): page 133
Duke of Sutherland Collection, on loan to National Gallery of Scotland: page 47
Gabinetto dei Disegni e delle Stampe, Florence/SCALA: pages 11, 126, 202, 218, 221
Galleria dell'Accademia, Florence/SCALA: pages 37, 38, 39, 105, 106
Galleria degli Uffizi, Florence/SCALA: page 45

Isabella Stewart Gardner Museum, Boston: page 135
Dr Sally Jeffery: pages 162, 169(top), 170, 210, 211
Musée du Louvre/photo RMN: pages 101, 103, 115/Cabinet des Dessins, 206/ Cabinet des Dessins
The Metropolitan Museum of Art, purchase 1924, Joseph Pulitzer Bequest (24.197.2): page 80
Museo dell'Opera dell Duomo, Florence/SCALA: page 167
National Gallery, London, by courtesy of the Trustees: pages 42, 54
National Trust Photographic Library: page 209
Nippon Television Network Corporation: pages 72, 78
Royal Academy, London: page 46
SCALA: pages 2, 9, 10, 21, 23, 33, 34, 40-41, 57, 58-59, 60-61, 62-63, 64-65, 66, 68-69, 70-71, 73, 74-75, 76-77, 79, 80-81, 82-83, 84, 86-87, 88, 89, 90, 91, 92-93, 94-95, 96-97, 98-99, 104, 107, 108, 109, 111, 112-113, 114, 117, 118-119, 120-21, 125, 140, 141, 142, 144-45, 147, 148-49, 150-51, 152-53, 156, 158, 159, 160-61, 163, 164, 165, 166, 171, 172-73, 179, 180-81, 182-83, 184, 185, 186, 187, 188-89, 190-91, 194-95, 196-97, 198, 199, 200, 203, 207, 212-213, 214-215, 217(below), 219, 223, 227, 233, 234, 235
Trustees of the National Museums and Galleries on Merseyside (Walker Art Gallery, Liverpool): page 30
Vatican Museums/SCALA: pages 29, 31, 53, 55, 122, 124
Windsor Castle, Royal Library, © Her Majesty the Queen: pages 131, 132, 138